La Grande Manière

HISTORICAL AND RELIGIOUS PAINTING IN FRANCE 1700–1800

DONALD A. ROSENTHAL

MEMORIAL ART GALLERY
OF THE UNIVERSITY OF ROCHESTER

Memorial Art Gallery of the University of Rochester
Rochester, New York
May 2–July 26, 1987

The Jane Voorhees Zimmerli Art Museum, Rutgers University
New Brunswick, New Jersey
September 6–November 8, 1987

The High Museum of Art at Georgia-Pacific Center
Atlanta, Georgia
December 7, 1987–January 22, 1988

LIBRARY OF CONGRESS CATALOGING-IN-PUBLICATION DATA

ISBN no. 0-295-96475-8

Rosenthal, Donald A.
 La grande manière.

Exhibition held at the Memorial Art Gallery, University of
Rochester, Rochester, N.Y., May 2–July 26, 1987, Jane Voorhees
Zimmerli Art Museum, Rutgers University, New Brunswick,
N.J., Sept. 6–Nov. 8, 1987, High Museum of Art, Georgia-
Pacific Center, Atlanta, Ga., Dec. 7, 1987–Jan. 22, 1988.
 Bibliography: p. 174
 1. Narrative painting, French—Exhibitions. 2. Narrative
painting—18th century—France—Exhibitions. 3. History in
art—Exhibitions. I. University of Rochester. Memorial Art
Gallery. II. Jane Voorhees Zimmerli Art Museum. III. High
Museum of Art. IV. Title.
ND1442.F8R6 1987 759.4′074′014 86-23860

COVER ILLUSTRATION
Bernard Duvivier, *Cleopatra Captured by Roman Soldiers after
the Death of Mark Antony,* 1789

This book and the exhibition it accompanies have been made
possible by grants from the New York State Council on the
Arts and the National Endowment for the Arts, an agency of
the federal government. Additional support for the catalogue
was provided by the Vanden Brul Fund.

Copyright © 1987 by Memorial Art Gallery of the University
of Rochester

Distributed by the University of Washington Press,
P.O. Box 50096, Seattle, WA 98145

Designer, Sandra Ticen
Editor, Ceil Goldman
Managing Editor, Deborah Rothman
Typography by Rochester Mono/Headliners, Rochester, NY
Printed by Flower City Printing, Inc., Rochester, NY

All works are in oil unless otherwise indicated. In dimensions
height precedes width.

PHOTOGRAPHIC CREDITS

Figures reproduced in this book have been supplied courtesy
of the owners and of the following:
Arras, Photo Leroy: 7, 28
Brussels, Institut Royal du Patrimoine Artistique: 18
Florence, Alinari: 51
New York, Didier Aaron, Inc: cat. no. 39
Paris, Bulloz: 5, 9, 12, 41, 42, cat. no. 14
_____ , Service Photographique, Union Centrale des Arts
Décoratifs: 39
_____ , Service de Documentation Photographique de la
Réunion des Musées Nationaux: 3, 4, 6, 10, 11, 13, 14, 15, 16,
17, 19, 25, 27, 29, 30, 33, 34, 37, 40, 44, 52, cat. no. 22

Contents

MEMORIAL ART GALLERY OF THE UNIVERSITY OF ROCHESTER

Foreword

*L*a Grande Manière: Historical and Religious
Painting in France, 1700–1800 *is the third in an* impressive series of exhibitions on French
painting organized by the Memorial Art Gallery during the past five years. Donald Rosenthal's crit-
ically acclaimed Orientalism: The Near East in French Painting, 1800–1880 *and the popular and
insightful* Artists of La Revue Blanche, *curated by Bret Waller and Grace Seiberling, brought national
attention to the Gallery's fine exhibition program and certainly stimulated the art community in Rochester.* La
Grande Manière, *also curated by Dr. Rosenthal, continues this worthy tradition.*

French Rococo painting is most often identified
with the delicate, sensuous genre and portrait com-
positions of such masters as Watteau, Fragonard, Char-
din and Boucher. Less well known to students of art,
however, are the monumental historical and religious
paintings of the period. *La Grande Manière* introduces
us to these important works and enables us to under-
stand and appreciate more fully the diversity and com-
plexity of 18th-century French painting.

Donald Rosenthal, curator of European Art of the
High Museum of Art in Atlanta and former chief cura-
tor of the Memorial Art Gallery, has written extensively
on 18th- and 19th-century French painting. His catalog
essay is a solid contribution to art historical scholarship
since it establishes historical and religious painting of
18th-century France as a vital link between the heroic
age of Poussin and the rise of Neoclassicism. Equally
significant in his study of these didactic compositions
is his refutation of the generally accepted idea that the
"*ancien régime* was solely an age of frivolity." For the
scholar of 18th-century art, *La Grande Manière* offers a
long neglected area of French painting for study and
re-evaluation; for the layman, it presents an oppor-
tunity to become re-acquainted with historical and re-
ligious images that reflect many of the profound values
of Western culture.

The Memorial Art Gallery is delighted to inau-
gurate our new exhibition facilities with this important
show. And we are pleased that the exhibition will travel
to the Jane Voorhees Zimmerli Art Museum at Rutgers
(The State University of New Jersey), and to the High
Museum of Art in Atlanta. We are grateful for the assis-
tance and cooperation of Dennis Cate and Gudmund
Vigtel, directors of these institutions.

GRANT HOLCOMB
Director
Memorial Art Gallery

Acknowledgments

This exhibition was initiated during the directorship of Bret Waller, who contributed substantially to the definition of the project, and completed during that of Grant Holcomb III. The assistance received from the Museum Program of the National Endowment for the Arts enabled me to travel in this country and in France in search of eighteenth-century historical and religious paintings. Gudmund Vigtel, director of the High Museum of Art, has generously allowed me time to continue working on the project since my move to Atlanta.

Several scholars have offered their suggestions on possible approaches to the subject. Rémy Saisselin read a draft of the text and made many useful comments. Pierre Rosenberg, in conversation, and Robert Rosenblum, in correspondence, have shared with me their thoughts on the nature and development of French history painting. They bear no responsibility, however, for the concept of the exhibition and the selection of paintings, which are my own.

For help in locating relevant works I wish especially to express my thanks to Joseph Baillio, Jacques Foucart, and Eric Zafran. Many curators and the staffs of the lending institutions, as well as private collectors, have provided much helpful information and photography relating to the works in the exhibition. In the publication of the text the designer, Sandra Ticen, and my editor, Ceil Goldman, have as in the past given me the benefit of their experience and careful attention to detail. Phillip Dennis Cate and Jeffrey Wechsler of the Jane Voorhees Zimmerli Art Museum have offered the full extent of their cooperation. Other scholars and art dealers whom I would like to thank for providing information or advice on eighteenth-century issues include Ann Uhry Abrams, Colin Bailey, Alden Gordon, Mary Jane Harris, Patrice Marandel, Guy Stair Sainty, Alan Salz, and Allen Staley.

At the Memorial Art Gallery Marie Via has capably coordinated all aspects of the project. I would also like to express my appreciation to other staff members who have contributed in various ways, particularly Brian Aranowski, Bernard Barryte, Mark Donovan, David Henry, Daniel Knerr, Penny Knowles, Eileen Lenahan, Sandra Markham, Edmund Pease, Deborah Rothman, and Katherine Smith. In Atlanta Rhetta Kilpatrick provided able assistance in typing and proofreading during the final stages of production.

DONALD A. ROSENTHAL
Atlanta
January 13, 1987

List of Lenders

ALBUQUERQUE
University Art Museum, University of New Mexico

ATLANTA
High Museum of Art

AUXERRE
Musées d'Art et d'Histoire d'Auxerre

CHICAGO
The Art Institute of Chicago
The David and Alfred Smart Gallery,
 The University of Chicago

CLEVELAND
The Cleveland Museum of Art

COLUMBIA, SOUTH CAROLINA
The Columbia Museum

DAYTON
The Dayton Art Institute

DETROIT
The Detroit Institute of Arts

GREENVILLE, SOUTH CAROLINA
Bob Jones University Art Gallery and Museum

HARTFORD
Wadsworth Atheneum

HOUSTON
Sarah Campbell Blaffer Foundation
The Museum of Fine Arts, Houston

LAWRENCE, KANSAS
Spencer Museum of Art, University of Kansas

LOS ANGELES
Los Angeles County Museum of Art

MINNEAPOLIS
The Minneapolis Institute of Arts

NEW ORLEANS
New Orleans Museum of Art

NEW YORK
Didier Aaron, Inc.
Mr. and Mrs. Arthur Frankel
Mr. and Mrs. Morton B. Harris
Stair Sainty Matthiesen
Wheelock Whitney & Co.
Wildenstein & Co., Inc.

NORTHAMPTON, MASSACHUSETTS
Smith College Museum of Art

NOTRE DAME, INDIANA
The Snite Museum of Art, University of Notre Dame

PARIS
Musée du Louvre
Musée du Petit Palais

PONCE, PUERTO RICO
Museo de Arte de Ponce, The Luis A. Ferré Foundation

PROVIDENCE
Museum of Art, Rhode Island School of Design

RICHMOND
Virginia Museum of Fine Arts

ROCHESTER
Memorial Art Gallery of the University of Rochester

SALT LAKE CITY
Utah Museum of Fine Arts

SAN FRANCISCO
The Fine Arts Museums of San Francisco

STANFORD, CALIFORNIA
Stanford University Museum of Art

TOLEDO
The Toledo Museum of Art

TWO ANONYMOUS LENDERS

Introduction

Writing a decade ago, Pierre Rosenberg commented on the growing revival of interest in the study of eighteenth-century French art.[1] Among the monographs or exhibitions that had dealt with aspects of this art were those examining particular time spans during the century or specific genres, such as landscape or portraiture. Rosenberg noted, however, that French history painting still had not been the exclusive subject of a major exhibition. This omission, which has continued, has deprived museum audiences of access to a fascinating and neglected aspect of eighteenth-century art.

For the general public the history of eighteenth-century French art, formulated by nineteenth-century taste, was long limited to the *fêtes galantes* of Watteau, the genre scenes and still lifes of Chardin, the mythologies of Boucher, and the erotic genre pieces of Fragonard. Only at the end of the century, in the works of David and his school, were a revitalized moral seriousness and a return to grand historical subjects supposed to have put to flight the frivolity of the Rococo taste. This view is now known to ignore the complexities of eighteenth-century art history and that century's opinion of its own achievements in painting. Throughout the period commissions for major religious paintings continued to be awarded, while large-scale treatments of historical subjects conveying morally edifying messages never lost the prestige they had held during the preceding century, the era of Poussin and Claude Lorrain. Even Watteau, Boucher, and Fragonard, regarded today as great masters of genre painting, were not averse to undertaking commissions for religious works when the occasions arose.

In the eighteenth century the term history painting had a broad meaning that could refer to all works, other than everyday (genre) scenes, that were dominated by the human figure in action. The best-known of these subjects were Bible stories or the lives of the saints. Examples of courage or noble behavior from Greek and Roman history, material familiar to all educated persons of the time, formed an equally prestigious category of subject matter. During the course of the century the sources for paintings of this kind widened substantially to include famous works of imaginative literature, both ancient (the *Iliad*, the *Aeneid*) and modern (the *Divine Comedy, Don Quixote*). Medieval, Renaissance,

and modern history, particularly of France, also became increasingly acceptable in the latter part of the period as a subject for history painters. Mythology, too, with its fanciful and erotic tales of the Classical gods, was considered a subcategory of history painting. *"M. Boucher, peintre d'histoire,"* derived much of his prestige from his mythological pictures of naked Venuses rather than his boudoir genre scenes, portraits, or religious paintings.

In recent scholarship there has been little agreement on a precise definition of history painting. Thus in the catalogue of the splendid exhibition of Dutch Baroque history painting held at the National Gallery in Washington in 1980, the category is defined as "the depiction of ethical ideas through biblical and mythological scenes or allegories."[2] A few pages later in the same publication, however, we are told that "a history is a painting in which a biblical, mythological, legendary or other event takes place,"[3] thus eliminating the need for ethical content. Many Dutch Baroque mythological paintings were in fact subject to moralizing or allegorical Christian interpretations,[4] but this tradition was very much weaker in France in the eighteenth century.

The organizers of the Washington exhibition excluded the "static single figure," as well as landscapes with small figures, a definition that, if followed here, would have eliminated such works as François Lemoine's *Cleopatra* (cat. no. 33) or Hubert Robert's *The Finding of the "Laocoön"* (cat. no. 47). The Dutch history painter and art theorist Pieter de Grebber, however, writing in 1649, had a different attitude: "If the history requires only one figure, you should try to create coherence by way of the accessories."[5]

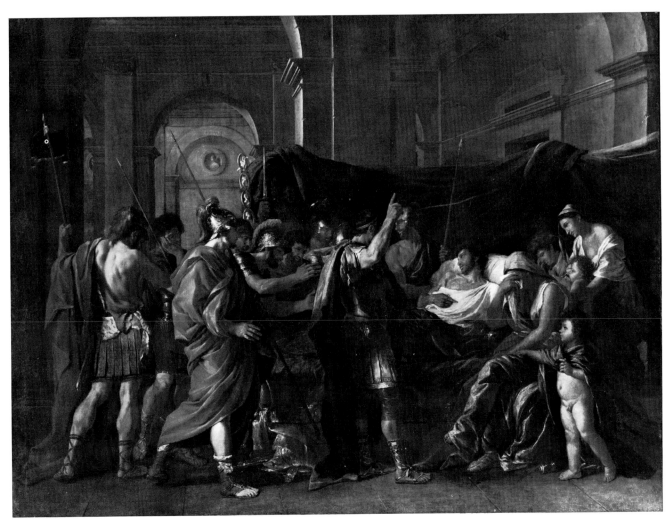

Fig. 1—Nicolas Poussin
The Death of Germanicus
The Minneapolis Institute of Arts

The concept of the hierarchy of genres, by which large-scale figural paintings telling a story were held in far higher regard than portraiture, landscape, or still life, was already cited in France by the late seventeenth century in the theorist Félibien's *Entretiens*.[6] *La grande manière* (or *le grand style* or *le grand goût*), as it was described by eighteenth-century art critics, always referred to large biblical, historical, or mythological paintings.[7] Such an approach is foreign to modern ways of thinking about art. To contemporary viewers who are not steeped in Classical lore from the beginning of their education there seems little difference, other than of scale, between a Boucher *Venus* and a nude from a boudoir genre scene by the same artist. Traditional European history painting has become associated with the idea of moral seriousness and the desire to instruct, whether by religious teaching or by reference to the virtuous acts of men and women who lived in the past.

In accordance with this narrower definition of history painting we have decided to limit the works in this exhibition and text primarily to religious and historical subjects, generally excluding mythological and literary themes. This distinction is somewhat arbitrary: some mythological subjects popular in the eighteenth century (*Hercules Choosing between Vice and Virtue, The Death of Alcestis*) clearly were meant to ennoble and instruct, while some biblical themes (*Lot and his Daughters, Susannah and the Elders*) were aimed (despite pious claims) mainly at titillation. And at least one literary source, the *Iliad*, gave rise to countless pictures celebrating heroic virtues. A few allegorical paintings, composed of biblical or historical figures in arrangements intended to instruct, have been included in the exhibition.

The exclusion of mythological subjects from an exhibition of "history paintings" may appear to be con-

troversial. In taking this approach, we do not mean to deny the prestige that mythology had in eighteenth-century French painting. Our intention rather is to emphasize the didactic aim of much history painting of the period, a quality more readily evident in religious or historical than in mythological works. It was this moralizing or didactic tendency, the "noble" subject, especially when combined with large scale and complex composition, to which the critics of the period referred when they spoke of the *grande manière*.

In choosing to survey the entire eighteenth century, rather than only the better-known Neoclassical period, we have sought to stress the continuities in French history painting of the period. Similarities not only in subject matter but in grandeur of scale, ambitiousness of conception, and dramatic force characterize many paintings done throughout the century. Works of this kind served as a link between the "golden age" of Poussin and Philippe de Champaigne and the era of Neoclassicism, a link that was not only iconographic but, in the works of artists like Favanne and Restout, stylistic as well.

Robert Rosenblum has written of the growing significance from the 1760s onward of "the *exemplum virtutis*—the work of art that was intended to teach a lesson in virtue," often based on events from Greek or Roman history.[8] The importance of such works in the latter part of the century is well established. We nevertheless should not neglect examples of the *exemplum virtutis* that appeared in the art of the first two thirds of the century, whether based on Greek or Roman models or, more traditionally, on the lives of the saints and other stories from sacred history. Just as much "Rococo survival" genre painting continued to be produced even at the height of the Neoclassical era,[9] so also serious, morally elevated subjects were to be found throughout the period that was dominated by the lighter themes of the Rococo taste.

Despite the continuities of subject matter from Poussin's era through the eighteenth century, and par-ticularly the Neoclassical period, the intentions of French history painters changed considerably during these two centuries. Jacques-Louis David, in producing an *exemplum virtutis* like *The Lictors Bringing Back to Brutus the Bodies of his Sons* (see cat. no. 15), in the 1780s, was strongly influenced by the *mise-en-scène* of such works by Poussin as the *Death of Germanicus* (1627; Minneapolis Institute of Arts, fig. 1). Yet David's great seventeenth-century predecessor intended the *Germanicus* not as a lesson in virtuous behavior but rather as a study of the passions, a demonstration of his ability to render emotions through dramatic gesture and facial expression. The didactic aspect of French history painting, evolving from religious works toward a predominance of Greek and especially Roman subjects, increases steadily throughout the eighteenth century until, at its climax during the Revolution, it becomes inseparable from political propaganda.[10]

As in previous loan projects of the Memorial Art Gallery, selection has been limited primarily to works available in American collections. Intensive American collecting in this field is a relatively recent phenomenon, and a few newly established regional or university galleries have better collections of French history paintings than do some of our oldest and largest museums. The number and quality of history paintings that have been acquired in a short period are truly remarkable. At the same time, works by several key artists are still rare outside France, and we have been fortunate in obtaining the cooperation of several French national and regional museums in lending works of a kind that were not available to us in American collections.

Few extended publications on French history painting have appeared since Jean Locquin's still-essential *La peinture d'histoire en France de 1747 à 1785* (Paris, 1912), which, however, deals only with a portion of the century. By augmenting the text with illustrations of major works not included in the exhibition, we hope to survey the major aspects of the development of this important tradition in eighteenth-century French art.

Academy and Administration

In recent years a number of books have been written and exhibitions organized on the Academic *system in French art of the eighteenth and nineteenth* centuries.[11] *As a result of such exhibitions as* The Grand Prix de Rome: Paintings from the Ecole des Beaux-Arts, 1797–1863 *(Washington, International Exhibitions Foundation, 1984), the stages in the academic career of a typical successful painter during this long period are now more familiar to the museum-going public. First, such a boy (often the son of a skilled artisan) was introduced and apprenticed to an established painter, himself a member of the Academy. In his master's Paris studio the young artist performed such basic tasks as mixing colors and preparing the master's palette; in return, he was taught the rudiments of drawing and handling brush and colors.*

Armed with the necessary letter of introduction from his master, the young artist was then enrolled as a student at the Royal Academy of Painting and Sculpture (after 1797 the Ecole des Beaux-Arts). There he was instructed almost exclusively in drawing; painting techniques were to be learned in his master's atelier. Instruction was limited first to copying drawings or engravings of anatomical details, then of the entire figure. He then would be allowed to draw from sculptural works, usually casts of ancient sculptures. Finally, the young artist was permitted to spend several years drawing from the nude male model. Some instruction was also given in anatomy, perspective, history, and literature. Small competitions, as highly organized as the curriculum, allowed the artist to test his skill against his fellows.

Once a year a competition was held for the grand prize (*Grand Prix*), or *Prix de Rome:* the winner would receive the coveted award of three years in Rome as a pensioner of the French Academy. Following a procedure that was applied democratically but not designed to produce great originality, the final candidates painted an assigned subject, generally drawn from biblical or Classical history; the works were then evaluated by the entire membership of the Academy. From 1749 until 1775 a winner in the competition (which also took place in other categories, such as sculpture and architecture) spent several additional years at the Ecole des Elèves Protégés in Paris. There he received further training for Rome and his career as a history painter by studying history, literature, anatomy, and perspective

and through additional experience in life drawing. This training was continued during the three years in Rome, where the curriculum included making studies of the nude, copies of the old masters, and a painted head expressing some emotion. The omnipresence of Antique and Renaissance monuments in the Eternal City ensured that the young artist would be confronted with the most admired models for his future works.

His schooling completed, the artist could aspire to a career as a history painter, by far the most prestigious category at the time. The way to success as a history painter was through membership in the Academy. The artist submitted a work on the basis of which, if approved by the academicians, he was provisionally admitted (*agréé*). He was then expected to submit within a reasonable time a reception piece, upon the acceptance of which he was received (*reçu*) as a member of the Academy. Though the Academy included members in such categories as genre painter, portraitist, and landscape painter, all of the higher officers of the institution (*Recteur, Directeur*) were history painters or sculptors.

The absence of women artists from this account of the training and careers of history painters is worthy of comment. Eighteenth-century French society was relatively open to the professional careers of women artists. Thus in the 1720s the Venetian pastel portraitist Rosalba Carriera had a great success during her visit to Paris. In the latter part of the century the Academy admitted a number of famous women artists, including the still life specialist Anne Vallayer-Coster (1770) and the rival portraitists Elizabeth Vigée-Lebrun and Adélaïde Labille-

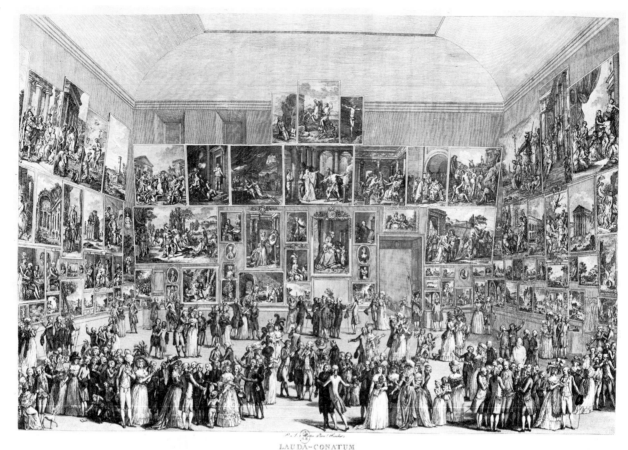

LAUDA-CONATUM

EXPOSITION au SALON du LOUVRE en 1787.

à Paris, chez Basset, Peintre Rue Guénégaud N° 24 et à Londres N°... S¹ Georges Row, Hyde Park.

Fig. 2—Pietro Antonio Martini
View of the Salon of 1787, engraving
Paris, Bibliothèque Nationale

Guiard (both 1783). The reception pieces by these art-
ists were usually allegories (Vigée-Lebrun presented a
Peace Restoring Abundance), but their subsequent work
was limited to their genre specialties.

What accounts for the scarcity of history painters
among women artists? Outside of France the contem-
porary Swiss-born Angelica Kauffmann, a founder
member of the Royal Academy of London, painted
many historical subjects, including a *Death of Leonardo
da Vinci.* Kauffmann, like most earlier European women
history painters, was trained in an artist family. It was
the exclusion of women from academic training—spe-
cifically, drawing from the nude male model, the corner-
stone of the teaching program—that limited the oppor-
tunity of women to become history painters. Their
skills as portraitists or still-life painters were acknowl-
edged without question but, as already noted, accept-
ance in these categories precluded advancement to the
highest ranks of the Academy.

Academicians had numerous exclusive privileges,
including the right to enroll their students in the Acad-
emy school and, in particular, the right to show their
paintings at the Salon, the important exhibition held
every year or two at the Louvre (fig. 2). For a long time
this remained nearly the only way for an artist to show
his work to a large public: the exhibition was heavily
attended and was commented upon by reviewers whose
opinions, published in journals or in book form,
reached an even wider audience.

The government's ministry responsible for the fine
arts had a structure as rigid and centralized as that of
the Academy.[12] Because large history paintings were
more suitable for public buildings like palaces or
churches than for private homes, the government,
when funds were available, was heavily involved in
commissioning work of this kind. Royal commissions
for art and architecture were the province of the *Direc-
teur général des Bâtiments du Roi,* an official usually

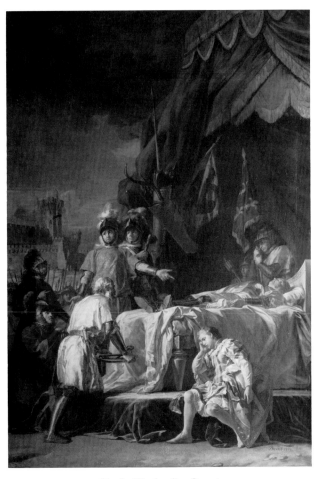

Fig. 3—Nicolas-Guy Brenet
The Death of Du Guesclin
Versailles, Musée National

directly responsible to the *Contrôleur général*, or minister of the treasury. During the first third of the century the office of *Directeur général* was held by a succession of men of talent such as J.-H. Mansart and the Duc d'Antin, none of whom were able to accomplish much because of the depleted condition of the royal treasury at the end of the reign of Louis XIV and the beginning of the reign of Louis XV. The Duc d'Antin did succeed in organizing a history painting competition in 1727 in which such academicians as François Lemoine, Jean-François de Troy, and Noël-Nicolas Coypel took part. Most of the entries, however, such as Coypel's *The Rape of Europa* (Philadelphia Museum of Art), were relatively lighthearted mythological pictures and did little to revive interest in the more sober history painting characteristic of the preceding century.

Antin's successor as *Directeur général*, Philibert Orry (1737–45), was a financial bureaucrat with little interest in art. He was replaced by Lenormant de Tournehem (1745–51), the uncle of the King's influential favorite, the Marquise de Pompadour. During Lenormant's regime such critics as La Font de Saint-Yenne and Jean-Jacques Rousseau began to complain of the low moral level of eighteenth-century art and to demand a return to the high seriousness of history painting as it had been practiced by such masters as Raphael and Poussin.[13] Lenormant himself took administrative steps to strengthen instruction at the Academy and to improve the position of history painters: the opening of the Ecole des Elèves Protégés in 1749 was perhaps the most significant of these measures. He also organized a competition of academicians in history painting in 1747, recalling the one held by the Duc d'Antin in 1727: many of the leading painters, including Boucher and Jean Restout, submitted works on this occasion. Depictions of Antique fortitude dominated the competition, heralding the increasing public acceptance of moral seriousness in history painting.

Lenormant groomed as his successor his nephew, the future Marquis de Marigny, brother of Madame de Pompadour. Marigny's long tenure as *Directeur général des Bâtiments* (1751–73) was marked by growing official encouragement of high-minded, ambitious works of history painting. Though prepared for his position by a lengthy trip to study the masterworks of Italy, Marigny in his own collecting preferred the genre scenes of Boucher, Chardin, and Carle Van Loo, Greuze's *Village Betrothal*, and paintings by the Dutch school. In his official capacity he tried to support history painting in the grand manner within the constraints of a severely limited budget.

After a brief tenure by the Abbé Terray, the Comte d'Angiviller, Louis XVI's *Directeur général* (1774–91) brought French history painting to the zenith of its governmental support in the eighteenth century. As the financial situation improved, more support was given to the teaching programs of the Academy. Believing in the educative power of history painting to set examples of virtue and promote loyalty to the state, Angiviller commissioned numerous large works depicting not

Fig. 4—Louis-Jacques Durameau
The Continence of Bayard
Grenoble, Musée de Peinture et de Sculpture

14

only the Classical world but also the history of France, such as Brenet's *Death of Du Guesclin* and Durameau's *Continence of Bayard* (figs. 3 and 4), both shown at the Salon of 1777. Administrative centralization increased with the suppression of the Ecole des Elèves Protégés and of the ancient Guild of Saint Luke and its school, and with the complete reorganization of the school of the French Academy in Rome under the directorship of the pioneer Neoclassical painter Joseph-Marie Vien. French provincial academies, which provided some basic artistic instruction, were kept strictly subordinate to the royal institution in Paris.

The *Directeur général* had a hand in several key appointments, the most important of which was the post of First Painter to the King (*Premier Peintre du Roi*). In addition to a large annual stipend, the *Premier Peintre* could look forward to ennoblement by the King through appointment to the prestigious Order of Saint-Michel. By the end of the century even hereditary titles were within range of a *Premier Peintre* like Vien, who was made a Count by Napoleon. The *Premier Peintre*, who might also be the director of the Academy, was always a history painter and often a dominant artistic figure of his time. Some, like Van Loo (1762–65) or Boucher (1765–70), enjoyed the honors of their position without meddling extensively in administrative affairs. Others, and in particular Jean-Baptiste-Marie Pierre (1770–89), virtually abandoned their artistic careers to concentrate on administration and art politics, gathering a nearly total control of patronage for the benefit of their students and other favorites.

Almost as prestigious as the post of *Premier Peintre* was that of director of the French Academy in Rome, a position held by such diverse artists as Vleughels, de Troy, Natoire, Noël Hallé, Vien, Lagrenée *l'aîné*, and Ménageot. The job might serve as a consolation prize for an artist who had failed to be appointed *Premier Peintre*, such as de Troy, to whom François Lemoine had been preferred. The directors varied greatly as taskmasters and in popularity with their students, but all could anticipate a comfortable style of life in Rome, with some of the glamor of an ambassadorial assignment.

Royal and Public Commissions

*B*y the beginning of the eighteenth century the heroic age of commissioned works by Le Brun and his assistants at Versailles was long past, a casualty of Louis XIV's costly military adventures. Two large royal projects, both in churches, nevertheless continued during the first decade of the century: the apse, nave vault, and tribune of the Chapelle Royale at Versailles, painted respectively by Charles de La Fosse, Antoine Coypel, and Jean Jouvenet, and the vaults of Saint Louis des Invalides in Paris, painted by La Fosse, Jouvenet, Noël Coypel, Bon and Louis de Boullogne, and Michel Corneille. The grandiose apse by La Fosse at Versailles, with its recollections of Italian Baroque illusionistic ceiling paintings, was of a type that was not to be widely imitated during the coming century. Nevertheless, many large works commissioned for specific churches in the early eighteenth century continued the dramatic yet dignified conventions of French religious painting: examples include Jouvenet's Miraculous Draught of Fishes (fig. 5) and Jean Restout's moving Death of Saint Scholastica (fig. 6).

Mythological paintings of only slightly less imposing scale were commissioned by the Duc d'Orléans, Regent of France from 1715 to 1723, for his residence, the Palais-Royal. There Antoine Coypel completed a gallery dedicated to the *Story of Aeneas*, the vault painted in 1706, the wall scenes in 1714–18 (fig. 7). Other major mythological decorative commissions for royal residences were awarded sporadically throughout the first half of the century; the most important by far was François Lemoine's painted ceiling for the *Salon d'Hercule* at Versailles (1736). Despite Lemoine's "modern" style of sensuous colorism, so influential for François Boucher, the concept of this massive and expensive decorative scheme was a throwback to the taste of the High Baroque, and was not repeated in subsequent eighteenth-century decorative projects.

More typical of decorative schemes of the time was a series of eight large, square canvases (440 cm.) on *The Life of the Virgin* installed in the choir of Notre-Dame, Paris, in 1714–17. The pictures, by Jouvenet, La Fosse, Antoine Coypel, Claude-Guy Hallé, and Louis de Boullogne are now dispersed, though their original disposition can be reconstructed. A church might commission a large set of matched canvases from a single artist, as in Carle Van Loo's *Life of Saint Augustine* series for the church of Notre-Dame-des-Victoires, Paris (1753–55). In huge scenes like *Saint Augustine Disputing with the Donatists* (400 x 550 cm.), Van Loo demonstrates his mastery in placing groups of figures engaged in a specific action, and in subtly differentiating the psychology of the principal actors in the scene. Van Loo is generally regarded today as a painter of rather trivial genre scenes. Nevertheless, the *Saint Augustine* pictures have a sobriety and directness new to the religious painting of the day and prefiguring the more radical Neoclassical simplifications of the last decades of the century. These works fully justify Van Loo's reputation as one of the leading history painters of his time, the factor that led to his selection as *Premier Peintre* (over Boucher) in 1762.

Whether a large work was commissioned by the state or some other body (a municipality or religious sodality, for example) for a public building or church, the artist followed a standard procedure in preparing for his task. The subject was usually specified by the patron rather than the artist, who would begin by making rapid, often rather slight compositional sketches for his own use. Having fixed the composition in his mind, he might make more detailed drawings of individual figures or groups, nude or draped, in the process of developing his ideas for different parts of the picture. A free sketch of the entire composition in oils would establish the color relationships—a matter of great importance, particularly in the first half of the century.

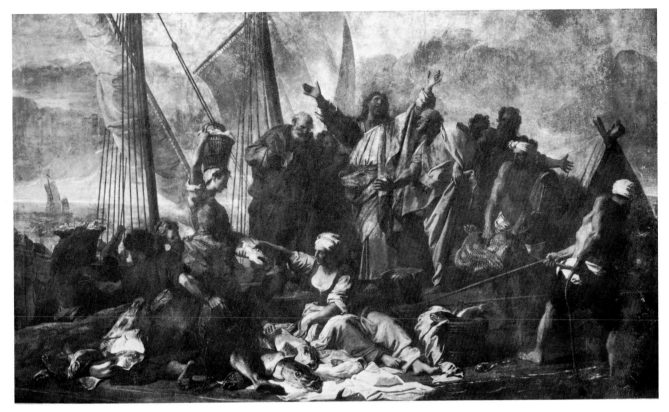

Fig. 5—Jean Jouvenet
The Miraculous Draught of Fishes
Paris, Musée du Louvre

Any or all of these preliminary efforts might be shown to the patron before a highly finished, easel-sized oil sketch was presented for final approval. With the patron's assent the artist would execute the final version, usually on a large canvas, much less often in fresco. Finally, the painter might make a reduced replica in one or more formats for favored private patrons after a successful large composition; such replicas, unless documented, are usually difficult to distinguish from finished preliminary sketches.

Commissions of history paintings for private homes were relatively rare in the early eighteenth century. In 1728 the financier Samuel Bernard commissioned a set of four scenes from Roman history from Jean-François de Troy. One of these, *The Continence of Scipio* (Neuchâtel, Musée d'Art et d'Histoire, fig. 8), is painted in a sober and deliberate style that is out of keeping with the more ornamental treatment of historical subjects by most painters of the era. At least in a work like this one de Troy approaches the elevated tradition of history painting carried on by Jouvenet and Jean Restout. Another wealthy bourgeois, the *Directeur général* Philibert Orry, commissioned six paintings on the reign of Clovis, including Natoire's *The Siege of Bordeaux by Clovis* (1737; Troyes, Musée des Beaux-Arts, fig. 9).[14] The choice of a subject from medieval French history was exceptional for the early part of the

century. Natoire, however, makes no attempt at archaeological exactness, showing the medieval warriors dressed in ancient Roman armor, much as they would have been costumed in a theatrical or operatic performance of the time.

Commissions for biblical or historical compositions also came from the Gobelins tapestry works, where such series as de Troy's *The Story of Esther* (1738–42; fig. 10) were used as cartoons for sets of luxury tapestries. Since these works were meant to be decorative, the cartoons rarely strive for a profound interpretation of the chosen theme. The *Esther* paintings of de Troy are no exception in this regard, though they convey on a large scale a richness of exotic costumes and dramatic gestures worthy of the young Rembrandt.

In the latter half of the century large historical commissions connected with the royal family took a decidedly moralizing or didactic turn. In 1764 the art theorist Charles-Nicolas Cochin was instrumental in commissioning a series of pictures from the lives of virtuous Roman emperors for the Grande Galerie of the Château de Choisy; the artists selected were Van Loo, Lagrenée *l'aîné*, Noël Hallé, and Vien. Hallé's *The Justice of Trajan* (1765; Marseilles, Musée des Beaux-Arts), while depicting noble behavior, is executed in a light style recalling the graces of Rococo painting. Louis XV never-

Fig. 6—Jean Restout
The Death of Saint Scholastica
Tours, Musée des Beaux-Arts

theless did not care for the moral lessons of these paintings and soon had them replaced with more pleasing works.

At the very end of the reign, in 1773, a series of large paintings on *The Life of Saint Louis* was commissioned by the Ministry of War to decorate the royal chapel at the Ecole Militaire. The saint (Louis IX of France) had always been closely associated with the devotions of the royal family (fig. 11). Works were executed for the chapel by Brenet, Noël Hallé, Doyen, Vien, Durameau, Lagrenée *l'ainé*, N.-B. Lépicié, Beaufort, Taraval, and Jean-Bernard Restout, and a number were shown at the Salon of 1773. A work like Doyen's enormous (600 x 300 cm.) *Last Communion of Saint Louis* (1773; Paris, Chapelle de l'Ecole Militaire, fig. 12), with its recollection of Domenichino's *Last Communion of Saint Jerome,* is a noble echo of Italian Baroque classicism rather than a forerunner of the impending Neoclassical movement.

Under the supervision of the Comte d'Angiviller, the encouragement of history painting became an active official policy during the reign of Louis XVI. It was at this time that subjects from the lives of the great men of France began to be commissioned, in sculpture as well as painting, on an equal basis with Classical and biblical themes; Brenet's *Death of Du Guesclin* and Durameau's *Continence of Bayard* have already been noted. Examples from the 1770s and 1780s are too numerous to mention; among the most original are Vincent's *President Molé Stopped by Insurgents During the Fronde* of 1779, now in the Chambre des Députés, and Ménageot's *François I Comforting the Dying Leonardo da Vinci* (1781; Amboise, Hôtel de Ville, fig. 13).

Commissions for large pictures of antique Republican virtue continued to be awarded by the Crown until the very beginning of the Revolution. David's grim *Brutus* (1789; Paris, Louvre; cat. no. 15), a picture liable to incendiary interpretations, was completed under royal sponsorship and shown at the Salon after the insurrection had already begun. Major religious commissions likewise continued unabated until that fateful

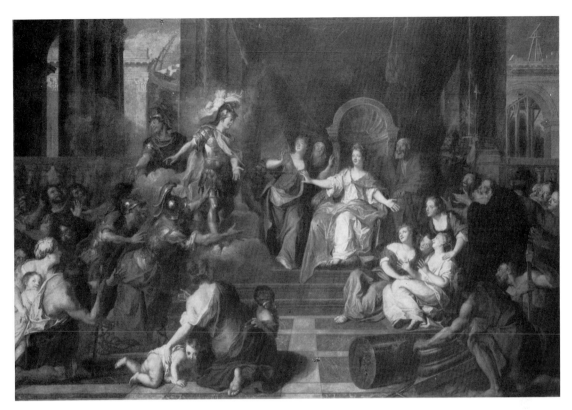

Fig. 7—Antoine Coypel
Aeneas Appearing to Dido
Arras, Musée

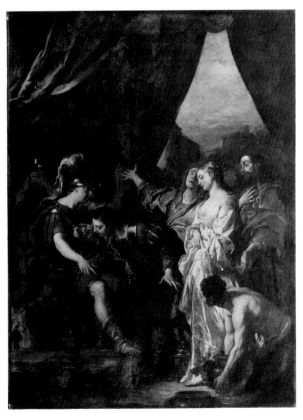

Fig. 8—Jean-François de Troy
The Continence of Scipio
Neuchâtel, Musée d'Art et d'Histoire

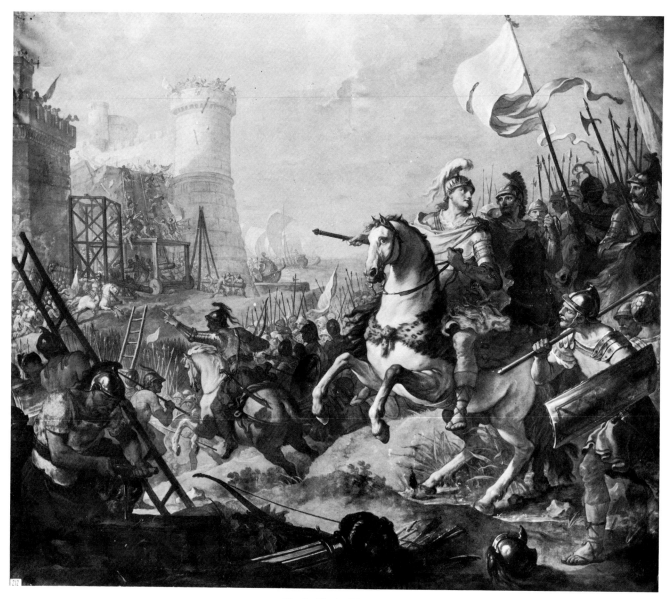

Fig. 9—Charles Natoire
The Siege of Bordeaux by Clovis
Troyes, Musée des Beaux-Arts

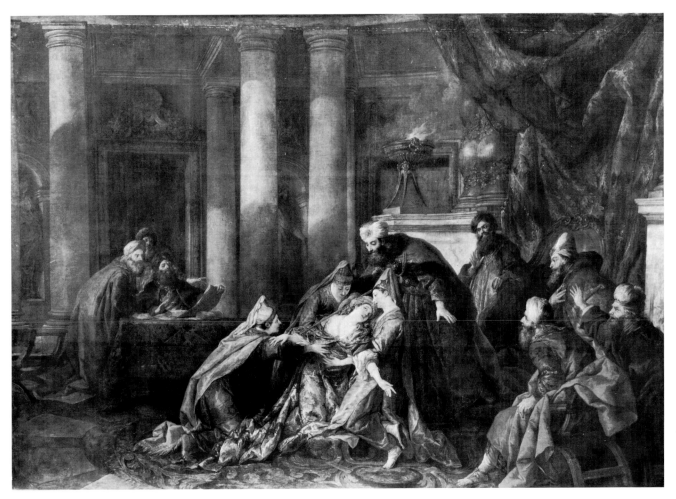

Fig. 10—Jean-François de Troy
Esther Fainting before Ahasuerus
Paris, Musée du Louvre

year: Regnault's somber *Descent from the Cross* (Louvre; fig. 14), commissioned by d'Angiviller for the Chapel of the Trinity at Fontainebleau, and Perrin's *Death of the Virgin* (Versailles, Grand Trianon; fig. 15) for the Carthusians, were both shown in the same Salon with great success.

Throughout the eighteenth century state commissions for paintings of historical or mythological subjects often took on overtones of political allegory. All of the rulers of France, from the *ancien régime* through the Revolutionary government, co-opted historical personalities for political purposes. At the beginning of the period Louis XIV was frequently associated with the image of Alexander the Great. This allusion was made as early as 1665 in Gianlorenzo Bernini's celebrated marble bust of the King, who, like Alexander, stares upward in "divine" inspiration. The bust (Versailles, Musée National) was to rest on a large globe, never completed, that emphasized Louis's connection with the world conqueror.[15] Well-known painted depictions

of the Alexander theme include Charles Le Brun's four large battle scenes (Salon of 1673; Louvre) and the versions of *The Family of Darius before Alexander* by Le Brun (1661; Versailles) and Pierre Mignard (1689; Leningrad, Hermitage). Mythological paintings associating Louis with the sun god Apollo were also fairly numerous.

Louis XV too was compared to Alexander, with still less reason than his predecessor, in works such as the *Allegory of the Peace of Aix-la-Chapelle in 1748* by Jacques Dumont "le Romain" (1761; Paris, Musée Carnavalet). The series of works by Natoire on the life of Clovis commissioned in the 1730s for the home of Philibert Orry (fig. 9) also probably was intended as a complimentary reference to the accomplishments of Louis XV. Cochin's 1764 commission for the series on the "good emperors" for the Château de Choisy was meant in part to associate the King's rule with the virtues of Augustus, Titus, Trajan, and Marcus Aurelius. In this intent the series recalls the "typological" association of

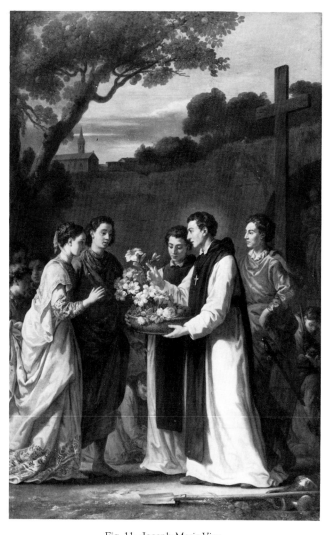

Fig. 11—Joseph-Marie Vien
Saint Louis and Marguerite of Provence
Versailles, Musée Nationale

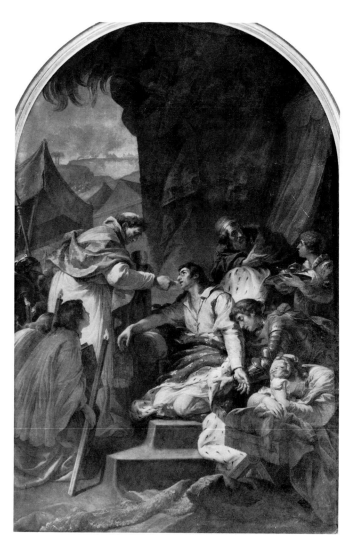

Fig. 12—Gabriel-François Doyen
The Last Communion of Saint Louis
Paris, Chapelle de l'Ecole Militaire

Old Testament themes with incidents from the life of Christ in Christian iconography since the medieval period.

The intentional revival of interest in scenes from the history of France under Louis XVI and d'Angiviller was aimed at associating the weak regime with the glories of the royal past. The *Life of Saint Louis* series for the Ecole Militaire, already commissioned at the end of Louis XV's reign, is an important early example of this trend. The same intention is evident in many scenes from the life of the Renaissance king François I, such as Ménageot's *Death of Leonardo da Vinci* (1781; fig. 13), in which the monarchy derives reflected glory from its support of a great artist. David's superb series of historical pictures from the 1780s was in part commissioned by the state, apparently with the goal of inspiring patriotic feeling in a divided country; in the political context of the time, however, these works could also be inter-

preted as advocating revolutionary change. Under the Revolutionary government the state, while still encouraging Antique themes of patriotism and self-sacrifice (fig. 16), also turned explicitly to commissions of subjects from contemporary events as a means of symbolizing its political legitimacy.

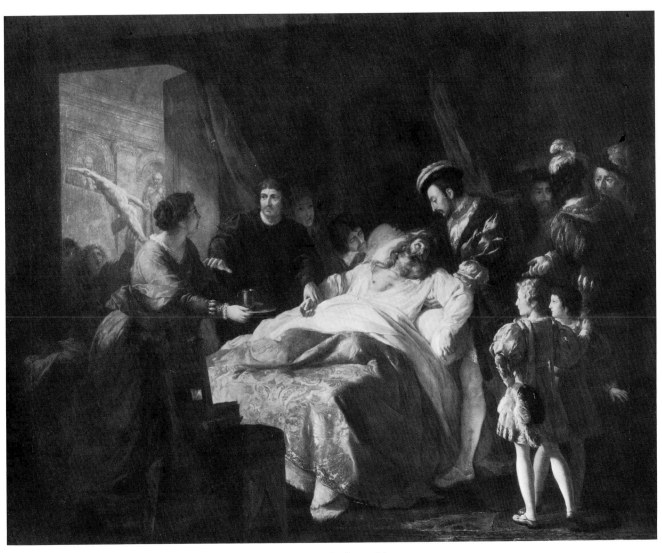

Fig. 13—François-Guillaume Ménageot
François I Comforting the Dying Leonardo da Vinci
Amboise, Hôtel de Ville

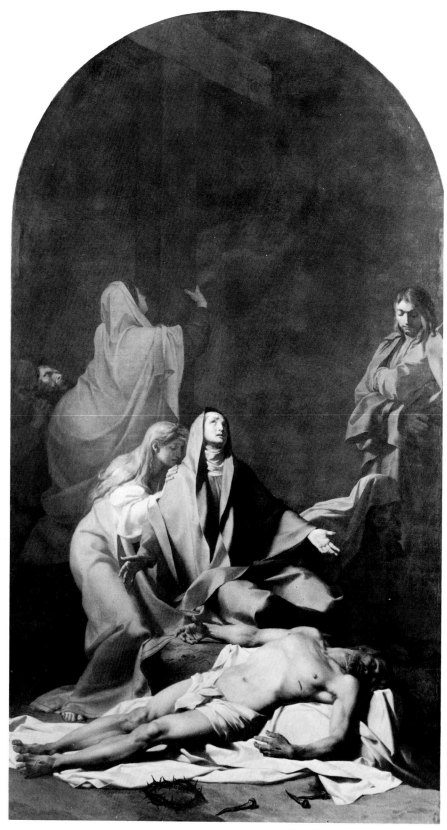

Fig. 14—Jean-Baptiste Regnault
Descent from the Cross
Paris, Musée du Louvre

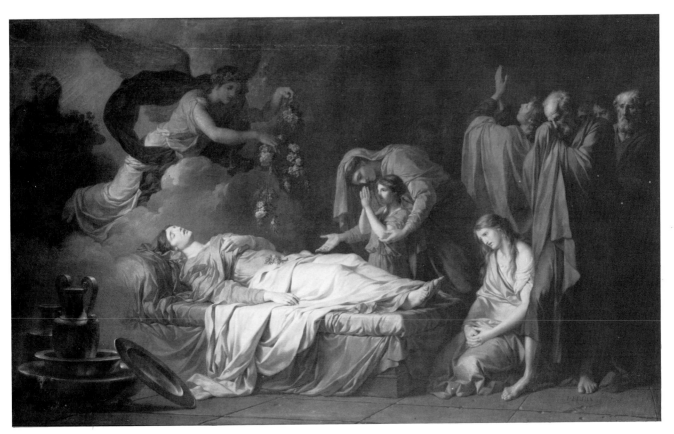

Fig. 15—Jean-Charles-Nicaise Perrin
Death of the Virgin
Versailles, Grand Trianon, Chapelle

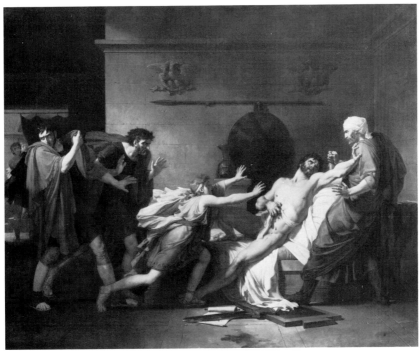

Fig. 16—Pierre-Narcisse Guérin
The Death of Cato of Utica
Paris, Ecole Nationale Supérieure des Beaux-Arts

The Painting of Contemporary History

*P*ainting of subjects from contemporary or very recent history, though not unknown, was rare in European art before the late eighteenth century. Some major examples from the preceding century actually belong to other categories of painting: The Swearing of the Oath of Ratification of the Treaty of Münster *by Gerard Ter Borch (London, National Gallery) is a group portrait, while Rubens's* Life of Marie de' Medici *series and Largillierre's paintings of Bourbon dynastic history contain substantial elements of allegory. Commissions for relatively unvarnished depictions of recent events were isolated in the seventeenth century: one of the most important was the series of battle paintings commissioned by Phillip IV of Spain for the Buen Retiro Palace in Madrid. The series consisted of a dozen depictions of Spanish military victories between 1621, the beginning of Phillip's reign, and 1633; many of the country's leading artists, including Velásquez and Zurbarán, were invited to participate. The most celebrated of these paintings, Velásquez's* The Surrender of Breda *(1635; Madrid, Prado), commemorates an event that had taken place only ten years earlier and was still fresh in the memory of many participants.*

The general exhaustion of the French monarchy in the eighteenth century, its military setbacks and financial difficulties, and the unheroic nature of the reigning monarchs all discouraged major commissions for depictions of contemporary events in elevated terms. Even the revival of interest in French history that began around mid-century and was actively encouraged by the government from the 1770s onward rarely extended to subjects more recent than the reign of François I. Examples of noble or heroic conduct by Frenchmen in the past were sought to bolster support for an ineffectual regime that very rapidly was approaching a crisis.

The establishment of contemporary history as a major category within history painting seems to have taken place in England. Despite its position of leadership in bourgeois socioeconomic progress, England had never strongly supported history painting through either private, church, or state commissions; nearly all English artists of the eighteenth century made their living as portraitists or as topographical or animal painters. Artists of American origin played a conspicuous role in the development of the genre of modern history painting, perhaps because of their unfamiliarity with the European Classical tradition. The most influential example of the new genre was Benjamin West's *The Death of General Wolfe* (1770–71;

Ottawa, National Gallery of Canada), recounting a celebrated incident of the Battle of Québec in 1759. Though depicted in modern dress, West's figures have the large scale and elevated gestures typical of traditional history painting in the "grand manner." Other major Anglo-American canvases on modern events (usually memorializing an heroic demise) include John Singleton Copley's *The Death of the Earl of Chatham* (1779–81; London, Tate Gallery) and *The Death of Major Peirson* (1782–84; Tate Gallery).[16]

In France under the *ancien régime* commissions were occasionally given for large works depicting key moments in the current history of the dynasty, such as Largillierre's allegorical paintings of the family of Louis XIV or Doyen's *Louis XVI Receiving the Homage of the Chevaliers du Saint-Esprit at Reims* (1775; Versailles, Musée National).[17] Such works were remnants of the Baroque tradition and were usually regarded as group portraits rather than history paintings. Louis XVI's *Directeur général*, d'Angiviller, planned as early as 1774 to commission a series of portraits of great men from French history in sculpture and Gobelins tapestries, but only the sculpture project was substantially completed. The vast majority of state commissions for painting continued to go to works on Classical or religious themes, while contemporary subjects were

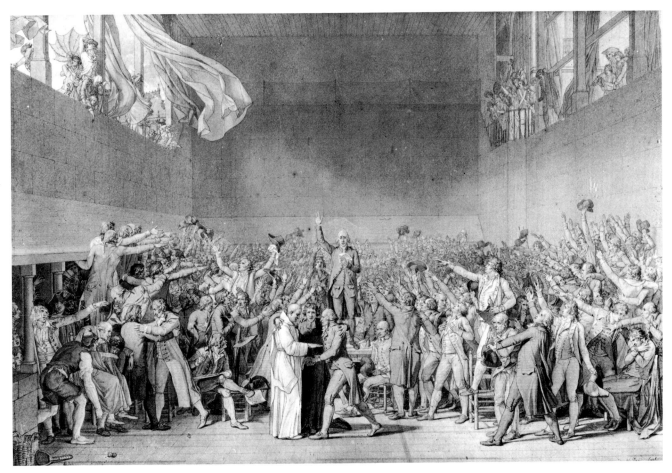

Fig. 17—Jacques-Louis David
The Tennis Court Oath, drawing
Versailles, Musée National

completely discouraged.

The rare modern subjects shown at the pre-Revolutionary Salons usually met a hostile critical reception. Pierre-Alexandre Wille's *The Death of Duke Leopold of Brunswick* (Salon of 1787; Moscow, Pushkin Museum)[18] depicted a well-known event of 1785—the duke's heroic death while attempting to rescue victims of a flood near Frankfurt. Significantly, the subject had already been treated successfully in England by James Northcote in 1786.[19] At the Salon, however, Wille's painting was harshly criticized as being too realistic and genre-like. Momentous events of the period, like the American Revolution, were seldom represented aside from allegorical portraits of such celebrities as Benjamin Franklin and George Washington.

It was the Revolution that made the painting of contemporary history a major genre in France in the last decade of the century. The stirring events of the time were already represented at the first Revolutionary Salon (1789) by the history painter Durameau in his sketch, now lost, of *The Meeting of the Estates-General at Versailles, May 5, 1789.*[20] Durameau wanted to paint a picture thirty feet wide for the Salon d'Hercule at Versailles (the site of François Lemoine's great mythological ceiling decoration), but the idea was not well received and the work was never executed.

The leader of the movement toward contemporary history painting was Jacques-Louis David, celebrated for such scenes of Classical history as the *Brutus* (see cat. no. 15) and *The Death of Socrates.* The Revolutionary government, seeking to legitimize its own actions and obliterate memories of the past, commissioned large paintings such as David's *Tennis Court Oath.* The huge work was proposed by the radical Jacobin Club, of which David was a member, in 1790 and was soon approved by the National Assembly.[21] The preparatory ink and wash drawing, with its echoes in modern dress of David's stern *Oath of the Horatii*, was shown at the Salon of 1791 (Versailles, Musée National, fig. 17). The large canvas, however, was never finished, probably because shifting political currents rendered accurate depiction of the scene impossible.

As the violence of the Revolution increased the demand for pictures of the events of the day grew pro-

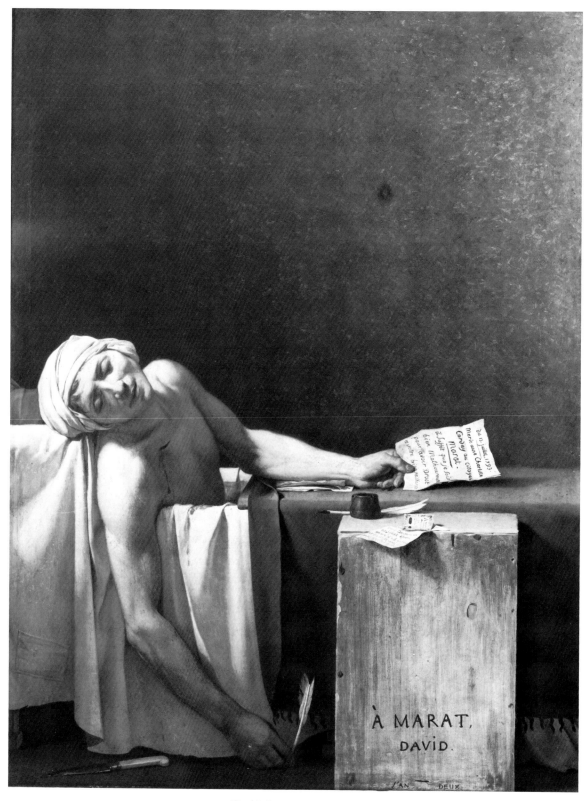

Fig. 18—Jacques-Louis David
The Death of Marat
Brussels, Musées Royaux

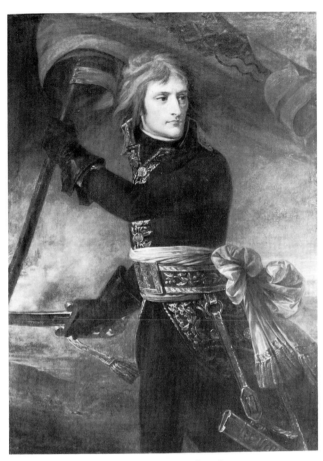

Fig. 19—Baron Antoine-Jean Gros
Bonaparte at the Bridge of Arcole
Versailles, Musée National

portionally. David led the movement with a series of Revolutionary martyrdoms: *Lepeletier de Saint-Fargeau on his Deathbed* (1793; destroyed but known from an engraving), in which an assassinated deputy is shown with a sword, the instrument of his death, displayed above; and *The Death of Bara* (1794; Avignon, Musée Calvet), depicting a dying thirteen-year-old soldier as an idealized, nude Greek ephebe. The undoubted masterpiece of the group is *The Death of Marat* (1793; Brussels, Musées Royaux, fig. 18). Here the sordid murder of the uncouth Revolutionary writer Marat is presented truthfully, yet in an ennobled manner. As has often been noted, the reference here, as in the pictures of West and Copley, is to earlier depictions of Christian martyrdoms. In this case the most direct exemplars of the painting, with its stark lighting and empty upper area, are the scenes of saintly deaths by Caravaggio.[22] Many other paintings record the grim events of the subsequent Reign of Terror; an example showing the last days of a doomed Revolutionary leader is Hubert Robert's *Camille Desmoulins in Prison* (cat. no. 48).

Despite the impoverished condition of the government, the Revolution was a golden age for history paint-ers of a radical persuasion, with numerous state commissions and a *prix d'encouragement*. The period has been described as "a time when large-scale history painting was considered the only art worthy of a true revolutionary."[23] The dealer and art historian Jean-Baptiste-Pierre Le Brun, who espoused a precocious taste for Dutch and Flemish genre painting rather than the *grande manière*, was at some danger of being seen as frivolous and reactionary in the reigning climate of political hysteria. In 1794 Le Brun was accidentally shot in the back under unclear circumstances, though he survived and retained his political acceptability.[24]

As the decade progressed, and particularly as the cult of Napoleon took hold, the painting of contemporary events became more firmly established. Baron Gros's vivid *Bonaparte at the Bridge of Arcole* (1796; Versailles, Musée National, fig. 19) is an early example of Romantic hero worship; by the time of David's *Bonaparte Crossing the Saint Bernard Pass* (1800; Versailles), the depiction of this contemporary event has become as remote and hieratic as any medieval rendering of Christ in glory. During the first decade of the nineteenth century under the Napoleonic regime contemporary history painting was to surpass Classical history in quality, popularity, and importance in such famous and monumental works as David's *Coronation of Josephine by Napoleon* and Gros's *Bonaparte at the Pesthouse of Jaffa* and *Napoleon on the Field of Eylau*. Ultimately, later in the century, this trend was to lead to the depiction of sensational or even everyday events involving ordinary people, by artists like Géricault and Courbet, on the grandiose scale formerly reserved for the great events of Classical and religious history.

History Painting and the Great Masters

Great French masters of the eighteenth century praised in the critical writings of the Goncourt brothers are, with the exception of David, regarded today primarily as genre painters; all, however, were involved to varying degrees in painting historical, religious, or mythological subjects. Antoine Watteau is widely considered the greatest painter of eighteenth-century France, if not of Europe; this is particularly true if David is regarded as a transitional figure in the development of nineteenth-century painting. If we think of Watteau as the leader of the French school (though his art did not lend itself to imitation, and he had only one pupil, Pater), he differs from earlier dominant figures like Poussin or Le Brun in that he was primarily a painter of genre scenes. This fact, as well as the artist's poor health and withdrawn personality, excluded him from the high and lucrative official posts for which his great talents might otherwise have qualified him.

Much has been made of the fact that Watteau was admitted to the Academy in 1717 as a painter of *fêtes galantes*, a category created expressly for him. This rightly has been seen as a recognition by the academicians that Watteau's unique gifts could not be defined by any of the traditional categories. Nevertheless, this honor also suggests the Academy's possible embarrassment in wishing to avoid admitting such a brilliant talent into the lowly category of genre painting. Several of Watteau's greatest works are pure genre subjects presented in a highly personal manner: the most famous example is the monumentally scaled *Signboard of Gersaint* (c. 1720–21; Berlin, Charlottenburg Castle), which served briefly as an art dealer's shop sign. The same may be said for the artist's numerous pictures of characters from the *commedia dell'arte*, such as the mysterious (and again very large) *Gilles* (c. 1717–19; Paris, Louvre), which probably combines portrait elements with theatrical references that were familiar to Watteau's audience but are no longer fully understood. On occasion the artist worked in categories that were invariably regarded as Flemish genre specialties, particularly in the military camp scenes of his youth.

Watteau's status as a genre painter caused the artist to be ignored or scorned by many of the leading art critics of the mid–eighteenth century. Voltaire, in *Le temple du goût* (1731), described the great painter thus: "Watteau was a Flemish painter who worked in Paris, where he died some years ago. He succeeded with little

figures which he drew and grouped very well, but he never did anything great; he was incapable of it."[25] Diderot dismissed Watteau as "a painter of overdoors,"[26] while according to Dézallier d'Argenville "The taste that he followed is properly speaking that of *bambochades* [Flemish peasant genre scenes] and not suitable for the serious."[27]

Like many genre painters throughout the century, Watteau was also on occasion a painter of mythologies and of religious themes. Some charming mythological subjects in the master's characteristic style, from the grand *Ceres* (*Summer*) of c. 1712 (Washington, National Gallery) to the small *Judgment of Paris* (Louvre), have survived and are well known. Watteau's paintings of religious history have fared less well, and most are known only from documentary sources. The artist tended to do this kind of work only during times of need, and these atypical productions evidently were less likely than his genre works to be carefully preserved.

Though his talents ultimately lay in other directions, Watteau in his youth had ample opportunities for study of earlier history painters and personal contact with those of his own time. His first master in Valenciennes, Jacques-Albert Gérin (d. 1702) was, by general consensus of Watteau's biographers, a mediocre painter whose style had little influence on Watteau's development. Gérin nevertheless was an industrious producer of religious paintings for the churches, monasteries, and convents of the region. Before he had been

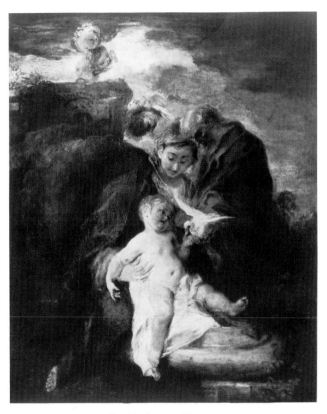

Fig. 20—Antoine Watteau
Holy Family
Leningrad, Hermitage Museum

in Paris very long Watteau became acquainted with a number of gifted history painters, including Nicolas Vleughels, in whose house Watteau lived around 1717–18. Of this group the artist with the greatest influence on Watteau's style was Charles de La Fosse (see cat. no. 30), advocate of colorism, leader of the *Rubenistes*, and admirer of Titian and Veronese, whose works he had studied in Venice.

Watteau knew La Fosse through their friendship with the rich connoisseur Pierre Crozat, who owned an immense collection of 19,000 drawings, many attributed to famous Italian masters. Watteau had considerable freedom to study and copy these works of the Renaissance, thereby making up in large part for his failure to make a study trip to Rome. Crozat's home was a meeting place for distinguished artists, and in 1716 he introduced Watteau to Sebastiano Ricci. The meeting came too late to have a significant effect on Watteau's mature style; if anything, the influence went in the other direction, since Sebastiano admired Watteau's military scenes.[28]

During his difficult early years in Paris, around 1702, Watteau had worked for a hack painter on the Pont Notre-Dame who specialized in mass-produced devotional images. Watteau's particular specialty was his pictures of *St. Nicholas*, which proved so popular

that none of the other apprentices were allowed to do works of this kind. For the *Prix de Rome* competition of 1709 Watteau submitted a painting on the assigned Old Testament subject, *David Pardoning Abigail;* he took second place to the now-forgotten Antoine Grison, and no trace of his painting remains. Around 1713 he provided an illustration of a related subject, *David Waiting upon Divine Inspiration,* for Fra Calmet's *Bible.*

When on his deathbed at Nogent-sur-Marne, in 1721, Watteau painted a *Christ on the Cross* (now lost) for a M. Carreau, the local curate. The Comte de Caylus, who mentioned the painting in 1748, commented: "If this work lacks the nobility and elegance that such a subject requires, it has at least the expression of pain and suffering that the sick man who painted it was experiencing."[29]

The lost religious subjects included at least one painting of a penitent saint, and various pictures of Saints Francis, Bruno, and Anthony attributed to Watteau appeared in sale catalogues throughout the eighteenth century.[30] Among surviving religious works attributed to the artist the one with the best claim to authenticity is the *Holy Family* (or *Rest on the Flight into Egypt*) of c. 1717–19, now in Leningrad (Hermitage Museum, fig. 20). This work was engraved by Dubos in 1732 and is perhaps a *Repose of the Holy Family* Watteau told Jullienne he had given to the Abbot of Noirterre.[31] The subject was a very popular one throughout the century with artists (such as Boucher and Fragonard) who preferred to avoid dramatic or tragic themes in their religious paintings. On the other hand, the time-honored theme leaves little room for the masterful treatment of psychology that is such a crucial element in Watteau's *fêtes galantes* and genre scenes. All of these religious subjects are painted with a naturalism recalling Flemish peasant genre scenes or, on the grander level of *The Holy Family,* the more elegant religious paintings of Rubens or Van Dyck.

There is a strong personal element in both Watteau's choice of subjects and in his relationships with

his patrons. He certainly knew some clerics among the circle of connoisseurs around Crozat. It is reasonable to assume that, had Watteau lived longer, he would have continued to produce an occasional religious picture for a friend, either on commission or as a gift. Nevertheless, as Watteau's disinterest in purely historical themes suggests, religious painting would have remained only a secondary aspect of his work.

Of the most important artists of the next generation, the only one who does not seem to have attempted history painting was Jean-Baptiste-Simeon Chardin (1699–1779), the famous painter of still life, genre scenes, and pastel portraits. Chardin studied with the history painters Pierre-Jacques Cazes and Noël-Nicolas Coypel and was made a member of the Academy with the support of the influential Nicolas de Largillierre. Given the nature of his early training, it would not be surprising if Chardin had made some early essays in the field of historical painting, but none have survived. His contemporary François Boucher (1703–70), on the other hand, though today regarded mainly as a specialist in erotic genre, was considered in his own time to be a history painter, both for his numerous mythologies and his occasional religious subjects. It was the prestige of his large works of this kind that brought Boucher the post of *Premier Peintre* in 1765.

The style of Boucher's earliest religious paintings is indicated by his *Joseph Presenting his Father and Brothers to Pharaoh* (cat. no. 4). The warm colors and loose, flickering brushwork show the influence of works by contemporary Italian artists, particularly Venetians like Sebastiano Ricci. Boucher had already treated similar biblical themes in paintings such as *The Judgment of Daniel* (1720; lost), as well as in drawings.

Boucher's reception picture for the Academy in 1734 was a popular literary theme, *Rinaldo and Armida*, from Torquato Tasso's *Gerusalemme Liberata*. Most of the artist's masterpieces are mythologies, justly famous for their colorism, sensuality, and charm: examples include *The Birth of Venus* (1740; Stockholm, National-

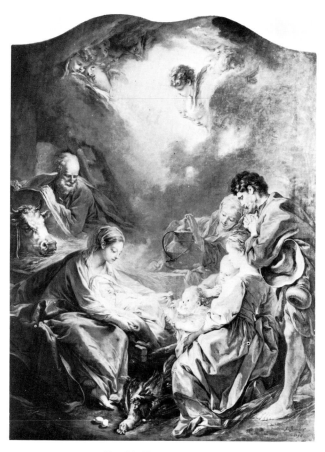

Fig. 21—François Boucher
The Nativity
Lyons, Musée des Beaux-Arts

museum) and *The Rising and Setting of the Sun* (1753; London, Wallace Collection). The majority of Boucher's Old Testament pictures, on the other hand, are early (c. 1720–35) and tend to be small in size, including such subjects as *Noah Entering the Ark, Laban Searching for his Household Gods, Hagar and Ishmael in the Desert,* as well as the somewhat larger *Tobias and the Angel* (Schweinfurt, coll. Georg Schäfer).[32]

The religious paintings of Boucher's maturity (c. 1750–65) are almost entirely on New Testament themes and are often commissioned works of substantial size. Nearly all of these major works were connected in some way with Madame de Pompadour and the court at Versailles. The first and perhaps the finest of these is a *Nativity,* or *Adoration of the Shepherds,* commissioned for the chapel of the Château de Bellevue and owned by Pompadour until her death (1750; Lyons, Musée des Beaux-Arts, fig. 21). With its large scale, reflective mood, balanced composition, and painterly treatment, the *Nativity* recalls the great altarpieces of both Rubens and the more aristocratically inclined Van Dyck. Such a work reflects a type of piety of the time that was more attuned to sweetness and charm than to moral grandeur.

32

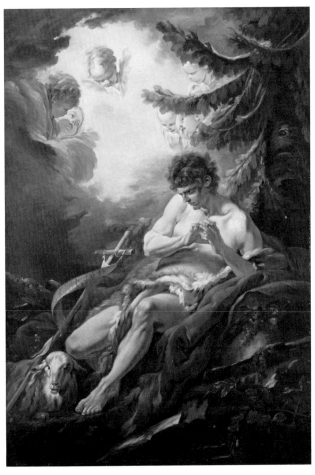

Fig. 22—François Boucher
Saint John the Baptist
The Minneapolis Institute of Arts

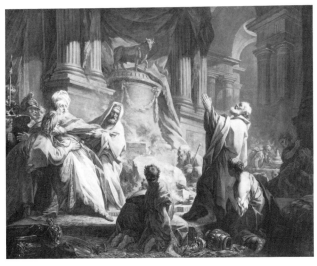

Fig. 23—Jean-Honoré Fragonard
Jeroboam Sacrificing to the Idols
Paris, Ecole Nationale Supérieure des Beaux-Arts

Other major religious paintings of the 1750s belonging to Madame de Pompadour included the *Saint John the Baptist* now in Minneapolis (fig. 22) and the *Rest on the Flight into Egypt* of 1757 (Leningrad, Hermitage) painted for the chapel of the Palace of Versailles. The *Rest on the Flight* subsequently belonged to Catherine the Great, who also owned Watteau's more intimate version of the same subject (fig. 20). The rather theatrical posturing of St. Joseph in the Leningrad picture, together with the Virgin's cool reserve, seem to mark a retreat from the more successful emotional balance achieved by Boucher in the earlier *Nativity.*

Boucher's later religious paintings display the loss of inspiration that characterized the artist's last years. A picture of *Mary with the Sleeping Child Jesus* (1758; Moscow, Pushkin Museum) aroused the sarcasm of the young critic Denis Diderot when it was shown at the Salon of 1759: "...I assert that its coloring is false... that there is nothing so ridiculous as a boudoir couch with a canopy in a subject of this kind..." On the other hand, the virtuosity of Boucher's talent evoked Diderot's grudging admiration: "I would not mind owning this painting. Every time you came to my house you would speak badly of it, but you would look at it."[33]

Boucher's last major religious works, and his largest, a *Saint John Preaching in the Desert* and a *Christ Walking on the Water* (Versailles, Cathédrale Saint-Louis) were not completed until 1764 as part of a decorative program involving commissions to other painters. Though large in conception, they do not deal with the type of subjects most congenial to Boucher's genius.

Boucher's most famous pupil, Jean-Honoré Fragonard (1732–1808) differed from his master in that his most ambitious history paintings were executed at the beginning rather than the end of his career. Fragonard won the *Prix de Rome* competition in 1752 with *Jeroboam Sacrificing to the Idols* (Paris, Ecole Nationale Supérieure des Beaux-Arts, fig. 23), in which Rembrandtesque Old Testament figures swathed in Oriental robes gesticulate

dramatically. Entering the *Ecole des Elèves Protégés* for a three-year period, and later during a long stay in Rome (1756–61), Fragonard unquestionably saw his future as that of a history painter. His precocious talents led to a major commission for the chapel of the Brotherhood of the Holy Sacrament in his native city of Grasse: a large (400 x 300 cm.) *Christ Washing the Feet of the Apostles* (1755; Grasse, Cathédrale). The picture, badly damaged in a fire in 1795, was restored in a Neoclassical manner that masks the artist's original intentions.

In 1757 at the French Academy in Rome the director, Natoire, had his pupils copy Pietro da Cortona's *Saint Paul Regaining his Sight*, Guido Reni's *Saint Michael*, and the Carracci *Entombment*, all in Rome's Capuchin church. Natoire reported that Fragonard was still working on his copy of the Cortona in October 1758.[34] The habit of copying the masters seems to have stayed with Fragonard, for he painted a number of versions of Rembrandt's *The Holy Family*. (The original, then in the Crozat collection, Paris, is now in the Hermitage, Leningrad.) Several other small religious pictures by Fragonard, including *The Visitation*, *The Education of the Virgin* (fig. 24), and *The Rest on the Flight into Egypt*, though difficult to date, are probably productions of the artist's youth. Works of this type seem to have been well appreciated: an *Adoration of the Magi* sold in the de Véri sale in 1785 for 9501 *livres*, the highest auction price paid for a work by Fragonard during the artist's lifetime.[35]

In Paris in late 1761 Fragonard, according to Mariette, was already working on a large (309 x 406 cm.) history painting, *The High Priest Coresus Sacrificing Himself to Save Callirrhoë*, a work the artist executed "with difficulty."[36] Fragonard was *agréé* by the Academy in 1765 on the basis of the finished picture (Louvre, fig. 25), which was received with great acclaim and purchased by the Crown for the Gobelins tapestry works. The story deals with Coresus, a priest of Dionysus in Calydon, whose passionate love was spurned by the young Callirrhoë. The Calydonians were then struck with a plague of madness, and the oracle of Dodona decreed that it would not cease until Coresus sacrificed to Dionysus either Callirrhoë or someone who had the courage to die in her stead. At the moment of sacrifice Coresus's resentment was overcome by love, and he killed himself instead of Callirrhoë. The story had a doubly grim ending: Callirrhoë, filled with remorse, soon committed suicide.

Although the painting's theme of self-sacrifice might have appealed to the nascent Neoclassical taste in Italy and France, the treatment is entirely within the extravagant tradition of late-Baroque drama. This theatrical manner has led to the suggestion that the painting was inspired by an opera on the subject by Destouches and Roy (1712).[37] Since the opera had not been performed in Paris since 1743, however, it seems more likely Fragonard derived the story of Coresus and Callirrhoë directly from its Classical source, the chronicler Pausanias's *Description of Greece*.[38]

Despite this auspicious beginning as a history painter, Fragonard drifted away from the path of academic success after 1765. He showed few works of significance at the Salon, and he never bothered to submit his reception picture to the Academy. He had no royal commissions and was not patronized by Madame de Pompadour or her brother Marigny, the *Directeur général*. Later, Fragonard's great decorative series, *The Progress of Love* (New York, The Frick Collection), was to be rejected by Madame du Barry for reasons that remain unclear. He still exhibited religious works from time to time: as late as 1781 he showed a large watercolor *Holy Family* at the *Salon de la Correspondance*.[39] In effect, however, Fragonard had become known as a painter of genre and, more specifically, of boudoir subjects. His success was due to purchases and commissions by private collectors. Such reliance on private patrons had been rare among earlier academicians, who depended on the Salon to show their works to the public. No doubt Fragonard chose this nonconformist path because it was better suited to his talents than was

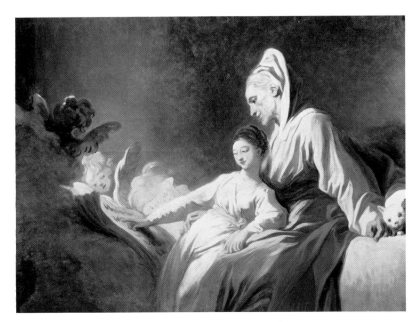

Fig. 24—Jean-Honoré Fragonard
The Education of the Virgin
The Fine Arts Museums of San Francisco

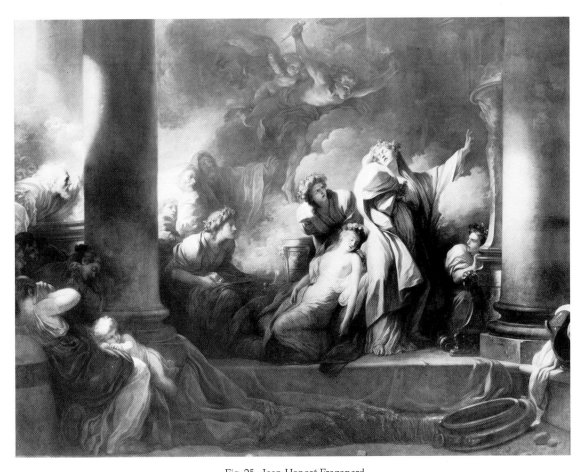

Fig. 25—Jean-Honoré Fragonard
The High Priest Coresus Sacrificing Himself to Save Callirrhoë
Paris, Musée du Louvre

la grande manière, and because of the greater imaginative freedom that resulted from being able to choose his own subjects without reference to existing texts.

The other major painter of Fragonard's generation was Jean-Baptiste Greuze (1725–1805), an artist whose historical importance is widely recognized, though his popular reputation has proved less secure than that of Fragonard or Boucher. Provincial in background and abrasive in manner, Greuze studied drawing at the Academy school in Paris but was largely a self-taught painter. His sensational debut showing at the Salon in 1755, the year he was *agréé* by the Academy, consisted entirely of portraits and genre paintings. The most admired of the latter was *A Father Reading the Bible to his Children* (Paris, coll. Baron Rodolphe Hottinguer), a scene of middle-class domestic virtue of a type that was to make Greuze's reputation with a public that was already beginning to weary of Boucher's goddesses and shepherds.

Greuze's vocation as a genre painter was clear to the critics who reviewed his work in 1755. His debt to the great Flemish and Dutch genre painters of the seventeenth century was also evident: one critic described the artist as "…this young emulator of Teniers and Brouwer…"[40] Even at so early a stage of his career, however, Greuze was already being urged by some critics to adopt the "nobler" role of a history painter: "…the superior talents of M. Greuze have made all those who have seen these pictures wish that the author elevate his muse to a genre a bit more noble; it seems that he would be capable of doing something more grand…"[41] Pressure of this kind seems to have encouraged Greuze (who had not competed for the *Grand Prix*) to make a lengthy Italian journey in 1755–57. Though he saw many famous works of the Italian masters, Greuze appears to have gained little of lasting use from this trip.

During his early career Greuze showed an intermittent interest in history painting. Before leaving his native Tournus in the mid-1740s he painted a *Saint Francis of Assisi* for the Couvent des Récollets (Tournus, Church of La Madeleine).[42] The large figure of the saint, his hands raised and stigmata prominently displayed, has a stark drama not unlike that of seventeeth-century Spanish paintings by artists such as Ribera. Also early are two mythologies treating the female nude, *The Triumph of Galatea* (Aix-en-Provence, Musée Granet) and the Titianesque *Danäe* (Metz, Musée; sketch, Louvre). In 1760 he made copies from Rubens's celebrated *Life of Marie de' Medici* series (Louvre), climbing a ladder to examine the large paintings in detail.[43]

Above all, his early genre compositions, like *A Father Reading the Bible to his Children* and *The Village Betrothal,* show Greuze restating in modern bourgeois terms the shallow, stagelike antique settings and elevated tone of the history paintings of Poussin. This relationship, which defines Greuze's historical importance as a precursor of both Neoclassicism and nineteenth-century monumental genre realism, was grasped as early as the 1760s by Greuze's supporter Denis Diderot. The great critic's *Essai sur la peinture* contains this evaluation: "Still I protest that the *Father Reading to his Family,* the *Ungrateful Son,* and the *Betrothal* of Greuze…are for me as much history painting as the *Seven Sacraments* of Poussin, the *Family of Darius* of Lebrun or the *Susannah* of Van Loo."[44]

Greuze's intense involvement with history painting was limited to the relatively brief period of 1767–69. In 1767 Greuze was informed that, because of his excessive delay in submitting his reception picture for full membership in the Academy, he would not be permitted to exhibit at the Salon that year. Greuze, aspiring to membership in the highest category as a history painter rather than as a genre specialist, immediately began to search for a suitable subject. He executed several small canvases, including a *Lot and His Daughters* (Strasbourg, coll. Otto Kauffman),[45] a *Roman Charity* (Paris, priv. coll.) derived from Rubens's version of the subject,[46] and a *Queen Thalestris before Alexander* (location unknown).[47] Other subjects apparently considered by

Fig. 26—Jean-Baptiste Greuze
The Penitent Magdalen, drawing
Cambridge, Mass., Fogg Museum of Art

Greuze and known from drawings include *The Rest on the Flight into Egypt, The Death of Cato of Utica,* and *Vespasian and Sabinus.* The artist also experimented with some mythological subjects at this time, including the large, unfinished *Aegina Visited by Jupiter* (New York, Metropolitan Museum of Art).

Greuze finally chose as the subject of his *morceau de réception* a theme from Roman history, *Septimus Severus Reproaching Caracalla* ("The Emperor Septimus Severus reproaching his son Caracalla for having wished to assassinate him in the passes of Scotland, and saying to him: If you desire my death, order Papinian to kill me with that sword.") The obscure subject is an event of the year A.D. 210 recorded in Cassius Dio's *Roman History.* Diderot saw an early sketch of the work in August 1767 and enthusiastically reported: "He has jumped in a single step from genre painting [*la bambochade*] to history painting [*la grande peinture*], and with success, so far as I can see."[48]

The submission of the final version (Louvre, cat. no. 24) to the Academy, in 1769, was one of the most notorious fiascos in the history of the institution. The other academicians, and later the critics at the Salon, were nearly unanimous in attacking the work: drab color and brushwork, inaccurate drawing, confusing narrative, and unsuccessful imitation of Poussin were among the most frequent objections. Greuze, who defended his work, was admitted to the Academy as a genre rather than history painter, and in protest with-

drew from active membership in the institution. The *Septimus Severus* is not one of Greuze's most appealing works, and the artist seems to have had difficulties in some passages, such as the right arm of the Emperor. The picture nevertheless is "advanced" for 1769 in its sober technique, archaeological correctness of detail, and emphasis on antique fortitude. Modernizing Poussin's reliance on dramatic gesture, the painting lacks only the electrifying emotional intensity with which David was to infuse the Neoclassical style in the 1780s.

Greuze's withdrawal from the Academy interrupted his involvement with traditional history painting for more than twenty years. Instead, he poured his finest efforts into such remarkable "domestic history paintings" as the large *The Father's Curse: The Ungrateful Son* and *The Father's Curse: The Punished Son* (1777–78; Paris, Louvre). In the 1790s the artist, in financial difficulties, began to experiment again with historical subjects. Around 1790 he painted a nude, blond *Saint Mary of Egypt,* now lost but known from a half-length study in the Claude Dreyfus collection and related drawings.[49] Brookner dates to the early 1790s a pen and brush drawing of the *Lamentation over the Dead Christ* formerly in the Lord Clark collection,[50] and a study for a clothed *Penitent Mary Magdalen* (Cambridge, Mass., Fogg Museum of Art, fig. 26) probably also belongs to this period.

The large *Repentance of Saint Mary of Egypt in the Desert,* now in Norfolk, Virginia, commissioned in 1800, is a repetition with variations of the lost blond version of *Saint Mary of Egypt.* The grand scale of the painting reveals Greuze's continuing ambitions as a history painter. On the other hand, the choice of a subject requiring a nude young woman seems an excursion into moralized erotic genre. In this aspect it resembles such female figures as *The Morning Prayer* (Montpellier, Musée Fabre), where Greuze, working on a smaller scale, had contented himself with revealing only a bare shoulder or ankle. The saint's regretful expression recalls such earlier exercises in *sensibilité* as

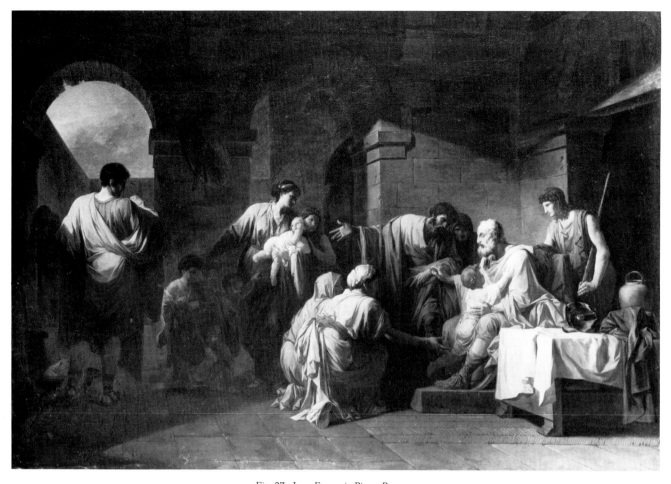

Fig. 27—Jean-François-Pierre Peyron
Belisarius Receiving Hospitality from a Peasant who Had Served under Him
Toulouse, Musée des Augustins

the *Young Girl Weeping over her Dead Bird* (Louvre). Remarkable as it is, the work is an unresolved compromise between history and genre painting, between a moralizing lesson and erotica.

Many of the elements of style and content that were to characterize Neoclassicism were developed by minor artists during the 1760s and 1770s. A fine example of this trend is Jean-François-Pierre Peyron's small *Belisarius Receiving Hospitality from a Peasant who Had Served under Him* (1779; Toulouse, Musée des Augustins, fig. 27). The dramatic gestures, Poussinesque friezelike setting, and emphasis on the depiction of noble behavior are already in evidence.

After twenty years of hesitant experimentation, the Neoclassical movement in French painting finally reached its full development in the works of Jacques-Louis David. In a series of monumental paintings—the *Belisarius* (1781; Lille, Musée des Beaux-Arts); *Andromache Mourning Hector* (1783; Paris, Ecole Nationale Supérieure des Beaux-Arts); *The Oath of the Horatii* (1785; Paris, Louvre); *The Death of Socrates* (1787; New York, Metropolitan Museum); and the *Brutus*

(1789; Louvre)—David dealt with increasingly emotion-charged subjects of individual self-sacrifice for the greater good of society. These stern themes, so different from the erotic subjects of a Fragonard or the sentiment of a Greuze, were treated with an uncompromising severity of drawing, composition, and color. They established the depiction of ancient history as the leading art form of the time, and they drew a host of talented pupils to David's atelier.

During the 1780s David had completely abandoned religious painting. The most important iconographic development in David's art of the following decade was his absorption in the painting of contemporary history in such uncompleted works as the *Tennis Court Oath* and *The Death of Bara*, and the great *Death of Marat* (fig. 18). These works reflect David's deep personal involvement in the maelstrom of revolutionary politics or, with the later *Bonaparte Crossing the Saint Bernard Pass*, his attachment to the cult of Napoleon. The intense emotional commitment David had brought to his antique subject pictures reaches its peak in these heroic scenes of the events of the artist's own time.

Genre Specialists as History Painters

*D*espite the hierarchy of genres by which some artists were received into the Academy as history painters and others in less prestigious categories, the compartmentalization of the genres was far from rigid. Most of the leading specialists in historical or mythological painting occasionally executed portraits, genre pieces, or still life. Conversely, nearly all the leading artists of the century specializing in other genres also produced some history paintings. (The exception is Chardin, whose early efforts at history painting may simply have been lost.) It is surprising to learn that many artists famed today solely for their work in other fields actively practiced history painting.

Among the leading portrait painters at the turn of the century Nicolas de Largillierre (1656–1746) maintained a significant activity in the field of religious subjects. Dézallier d'Argenville records that, as a youth studying in Antwerp, Largillierre secretly painted a fine *Holy Family* on oiled paper.[51] Early in his career Largillierre seems to have received a number of commissions for religious paintings. Lastic[52] notes a group of works painted for the Collège Ecossais de Douai in 1688, other works for the church of Saint-Merry, Paris, and four paintings for the Jesuits that he situates in 1695–1700. These commissioned works (most of which have been lost) are proof that the artist did not pursue the historical genre solely for his own enjoyment.

Admitted to the Academy in 1686 as a painter of both portraits and history, Largillierre gained success as a portraitist to the wealthy bourgeoisie. He also produced a series of works, usually allegorical, celebrating the events of contemporary dynastic history: *The Convalescence of Louis XIV* (1687), *Allegory of the Marriage of the Duc de Bourgogne* (1697), *Allegory of the Succession of Phillip V to the Spanish Throne* (1702), and *Arrival of the Spanish Infanta in Paris* (1722).

At some point in his career Largillierre undertook an important series of paintings on the Passion of Christ: *The Entry of Christ into Jerusalem* (Musée d'Arras, fig. 28), *Christ on the Mount of Olives, Christ Carrying the Cross* (Genoa, private collection), *The Elevation of the Cross, The Crucifixion, The Entombment,* and perhaps a *Resurrection of the Dead.*[53] Most of the paintings are lost but are known from engravings by François Roettiers. The dating of the series is uncertain: Rosenfeld thinks most of these works belong stylistically to the 1690s, while Lastic situates them c. 1705–15.[54] The scarcity of similar dated works by Largillierre makes placing the series particularly difficult. Since Orlandi in 1719 described *The Crucifixion* as recently finished,[55] some of the group at least must belong to the later period.

One dated history painting from late in Largillierre's career is *The Finding of Moses* of 1728 (Louvre, fig. 29), a relatively rare Old Testament subject in the painter's oeuvre, though typologically related to the story of the birth of Christ. As we might expect of an artist who was trained in Antwerp, Largillierre, in the presumably early *Entry of Christ into Jerusalem*, with its subdued colors and crowd of small figures, is strongly influenced by Flemish painting. The late *Finding of Moses* has fewer figures, more elegantly dressed and proportioned, and a brighter color scheme. The subject had been treated earlier by Charles de La Fosse (fig. 30), who in turn was strongly aware of the work of Rubens. We may postulate that the mature Largillierre turned for inspiration in this history painting not only to Rubens but ultimately to Venetian Renaissance artists, particularly Veronese.

The catalogue of Largillierre's atelier sale in 1765 reveals that, in addition to most of the Passion series, the artist had a number of other unsold pictures of the life of Christ, as well as a *Hagar and Ishmael* and a *Saint James,* now all lost.[56] Dézallier d'Argenville, in discussing Largillierre's fine Paris house, mentions that it contained the entire Passion series (except the *Resurrection of the Dead*), including a *Consummatum Est,* as well as pictures of the life of the Virgin (*The Annunciation*) and eight heads of apostles. He added: "His history paintings are very mannered."[57] Largillierre also executed a series of rather conventional half-length pictures of saints, including *Saint Francis Xavier*[58] and

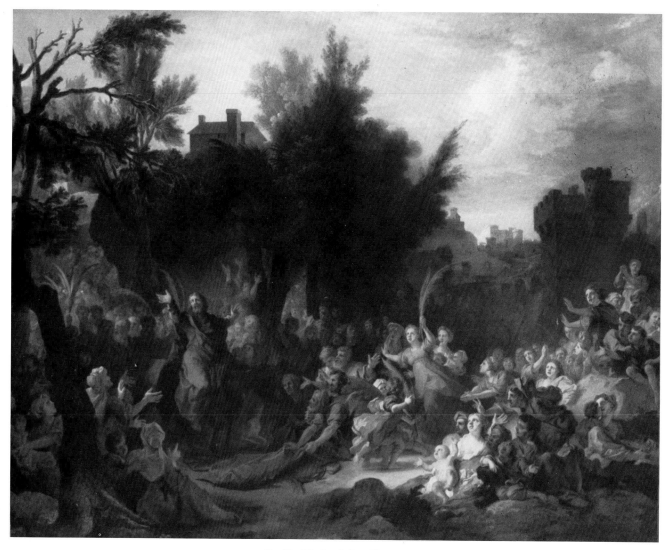

Fig. 28—Nicolas de Largillierre
The Entry of Christ into Jerusalem
Arras, Musée

Saint Louis of Gonzaga (known from engravings by C. M. Vermeulen) and *Saint Margaret* (engraved by Etienne Gantrel).[59] The inventory of the artist's possessions made after his death included no fewer than thirty-five religious paintings and seven mythological subjects, apparently the great majority of his works in these genres. In addition to works already mentioned, the inventory noted a *Lot and his Daughters* and numerous paintings of saints.[60]

Another kind of history painting, closer to Largillierre's professional specialization, was the historiated portrait. Since the Renaissance, wealthy patrons had sometimes sought to have themselves portrayed in mythological or historical disguises, as in Bronzino's *Portrait of Andrea Doria as Neptune.* The practice was quite common in late seventeenth-century France and was particularly favored by the court painter Pierre Mignard. Largillierre's *Saint John* (Geneva, Musée d'Art et d'Histoire, fig. 31) has all the iconographic attributes of Saint John the Baptist, yet the intensely portraitlike quality of the face suggests that this is less a religious picture than a representation of an unknown contemporary of Largillierre in disguise. Despite its hybrid nature, the *Saint John*, rather than his more traditional history pictures, conveys the essence of Largillierre's talent.

Largillierre's rival Hyacinthe Rigaud (1659–1743), the favored portraitist of the court and the aristocracy, was also an occasional history painter. Rigaud's career demonstrates the hierarchy of the genres, for he was admitted to the Academy twice: as a portraitist in 1687, and again as a painter of history and of portraits in 1700. It was undoubtedly this second admission that enabled Rigaud to rise through the ranks to the positions of *Recteur* (rector) and *Directeur* (director) of the institution (1733–35).

40

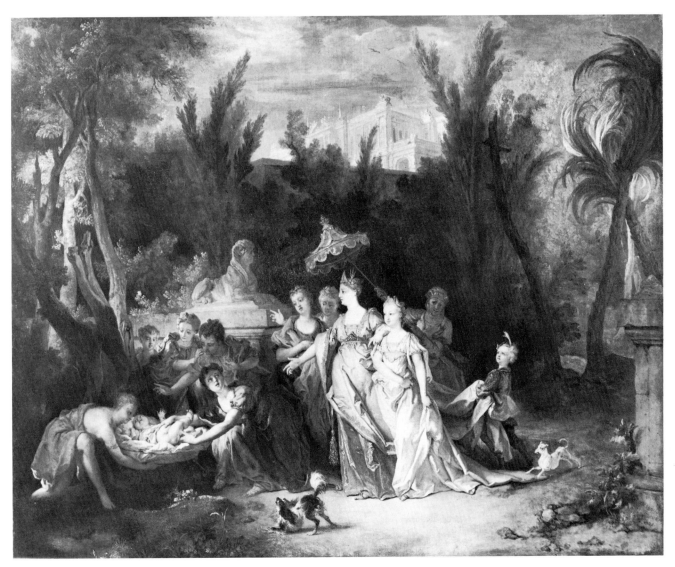

Fig. 29—Nicolas de Largillierre
The Finding of Moses
Paris, Musée du Louvre

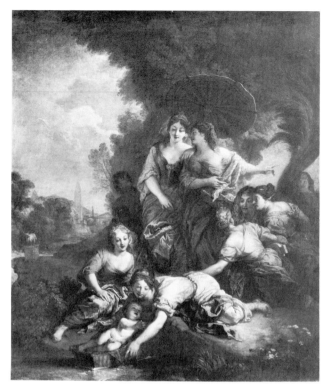

Fig. 30—Charles de La Fosse
The Finding of Moses
Paris, Musée du Louvre

In the competition of 1682 Rigaud had received the *Grand Prix* for his *Cain Building the City of Enoch*. In view of his talent as a portraitist, however, the *Premier Peintre*, Le Brun, is said to have counseled Rigaud to devote himself to that genre and to renounce history painting and the trip to Rome. Dézallier d'Argenville records that, for his admission to the Academy as a history painter in 1700, Rigaud offered as a reception piece an historiated portrait of Desjardins and also showed an unfinished *Crucifixion* with several figures.[61]

Already a successful artist by 1700, Rigaud collected numerous works, including history paintings, by the old masters. In a document dated December 13, 1703, Rigaud listed works in his possession, among which were religious paintings attributed to Rubens (*Adoration of the Magi, Saint John the Evangelist, Saint George, Christ and the Pharisee*), Van Dyck (*Virgin with Angels, Assumption of the Virgin*), and Veronese (*The Circumcision*), as well as an historical subject, *Mucius Scaevola*, given to Jacob Jordaens. "Copies by my hand after the great masters" were based on such works as a *Mary Magdalen* by Guido Reni and a picture of the Virgin by Carlo Maratta. Many of these works were still in Rigaud's possession in 1742, when he willed two paintings by Rubens to a friend.[62]

Rigaud's history paintings, unlike Largillierre's, seem to have been almost always uncommissioned private works. Only a few were on public display in Paris; the younger Dézallier d'Argenville, in his guidebook of 1749, noted only a half-length *Saint Peter* and a *Saint Paul* in the chapel of the Jacobins in the Rue Saint-Honoré.[63] Most of these works are of Christian subjects, and in Rigaud's last will, which contains numerous expressions of piety, several of the paintings are bequeathed by the artist. In a draft dated June 16, 1726, Rigaud willed to the Academy a *Purification of the Virgin*.[64] In a codicil dated June 17, 1742, however, he noted that, the Academy having already received from him a *Saint Andrew*, the "picture of the Virgin" he had earlier left to it would be bequeathed to the King.[65] The

Saint Andrew (Paris, Ecole des Beaux-Arts), an heroic seminude figure gazing toward heaven, is based on Italian Baroque prototypes such as the works of Guido Reni. A more convincing depiction of a tragic subject is the moving *Christ on the Cross* (Perpignan, Musée Rigaud, fig. 32), which the artist painted for his mother. This work is dependent on Flemish or Dutch antecedents; it is possibly the unfinished work that Rigaud showed to the Academy in 1700, though it lacks subordinate figures.

Dézallier d'Argenville wrote of Rigaud: "His propensity to execute history paintings occasionally burst. He has done . . . a *Presentation in the Temple* in the manner of Rembrandt which he bequeathed to the King at his death." He added that, in addition to the *Saint Andrew* and *Crucifixion*, Rigaud painted a small *Nativity* that was engraved by Drevet.[66] Rosenberg believes the *Presentation in the Temple*, now in the Louvre (fig. 33), was almost completed at the time of Rigaud's will of April 9, 1741,[67] while according to his *Livre de raison*, Rigaud added the last touch in the year of his death;[68] this would date the painting c. 1741–43, making it one of Rigaud's last works. It is also possible, however, that there is some confusion of this painting with the "picture of the Virgin" that Rigaud bequeathed first to the Academy and later to the King. If so, the *Presentation* may have been largely completed at the time of the first bequest in 1726. This dark picture with its small figures

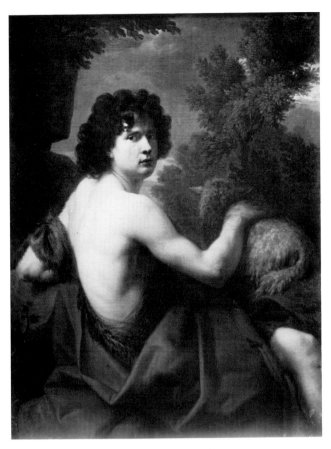

Fig. 31—Nicolas de Largillierre
Saint John the Baptist
Geneva, Musée d'Art et d'Histoire

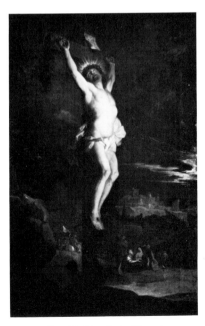

Fig. 32—Hyacinthe Rigaud
Christ on the Cross
Perpignan, Musée Rigaud

is clearly related to the biblical pictures of the young Rembrandt, such as the *Simeon in the Temple* of 1631 (The Hague, Mauritshuis); Rigaud at various times in his life owned seven works by the great Dutch artist. Though highly competent as a history painter, Rigaud, like Largillierre, displayed a larger variety of sources and a less well-defined personal style in this field than in his portraiture.

Several other artists known today exclusively as genre painters showed some interest in historical subjects. François Desportes (1661–1743), the leading painter of animal subjects at the turn of the century, seems to have done a few works of this kind: the story, always popular with artists at that period, of *Apelles Painting Campaspe* (Compiègne, Musée, fig. 34), as well as at least one mythological subject.[69] Desportes's younger colleague Jean-Baptiste Oudry (1686–1755) worked much more seriously in this vein. Known today almost exclusively as a painter of still life and hunting scenes, Oudry at the beginning of his career seems to have taken a less specialized, more experimental approach to subject matter. He executed numerous portraits, landscapes, and still life paintings, and perhaps for a time thought of becoming a history painter.

A student of the Marseilles-based history painter Michel Serre and of Largillierre, Oudry in 1708 was admitted to the Academy of Saint Luke, the older and less prestigious rival to the Royal Academy. His reception piece was a bust-length *Saint Jerome*, now lost. His earliest surviving history painting, a small *Saint Peter Delivered from Prison* (Schwerin, Staatliches Museum, fig. 35) is painted in a Rembrandtesque chiaroscuro not dissimilar to the style of the late religious paintings of Rigaud.

Several religious paintings by Oudry were on view in Paris churches in the eighteenth century. The choir of Saint-Leu-Saint-Gilles contained a *Nativity* and a *Saint Giles in Benedictine Habit with the Doe that Nourished him in his Cave and the Dog that Led to his Discovery*[70] (evidently an opportunity for Oudry to display his talents

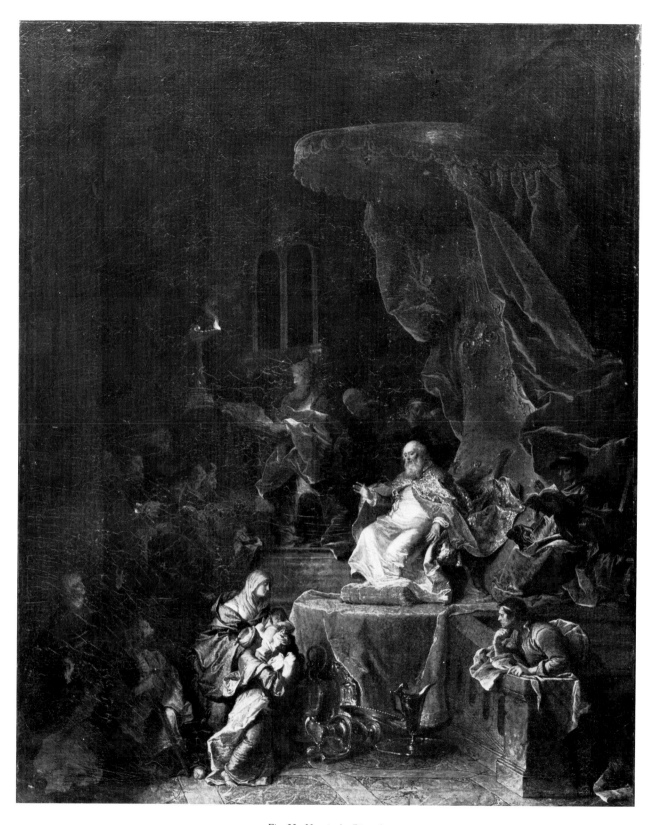

Fig. 33—Hyacinthe Rigaud
Presentation in the Temple
Paris, Musée de Louvre

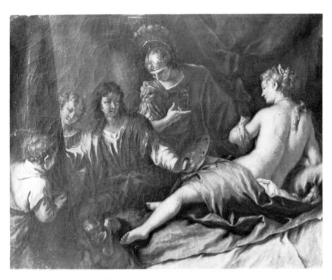

Fig. 34—François Desportes
Apelles Painting Campaspe
Compiègne, Musée

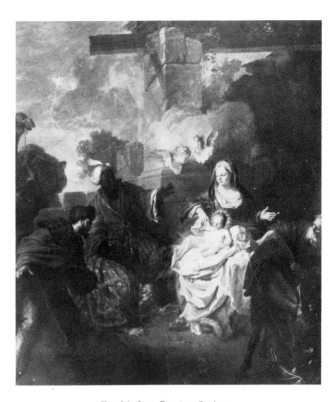

Fig. 36—Jean-Baptiste Oudry
Adoration of the Magi
Villeneuve-Saint-Georges, Eglise Saint-Georges

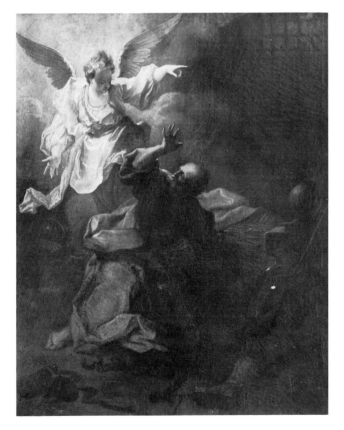

Fig. 35—Jean-Baptiste Oudry
Saint Peter Delivered from Prison
Schwerin, Staatliches Museum

as a painter of animals); both paintings are now lost. Opperman discusses the possibility of another lost history painting, a *Birth of the Virgin* of c. 1715–16, known from a finished preparatory drawing in the Louvre and an engraving by Louis Loisel, inscribed *J. B. Oudry delineavit et pinxit.*[71] The loss of such a large percentage of Oudry's history paintings undoubtedly has influenced the modern perception of this artist as solely a genre specialist, a view that did not dominate to the same extent during his lifetime.

When *agréé* by the Royal Academy in 1717, Oudry exhibited an *Adoration of the Magi* intended for the church of Saint-Martin-des-Champs (Villeneuve-Saint-Georges, Eglise Saint-Georges, fig. 36). His largest (291 x 255 cm.) and most ambitious history painting, the *Adoration* seems to have been painted with the intent of winning Oudry admission to the Academy as a history rather than a genre painter. Executed in a somewhat *retardataire* Baroque style looking back to Rubens and some of his French followers, the painting still has an imposing grandeur. Oudry abandoned history painting after completing this major work, however, preferring to concentrate on his lucrative specialty as a genre painter.

Foreign Influences

At the beginning of the eighteenth century Paris was the only city outside Italy with a strongly established Academy providing a continuing program of training and awards for history painters. The vast building and decorative painting programs at Versailles and Paris under Louis XIV had served as a training ground for a team of ambitious painters working under the direction of Charles Le Brun. Therefore, despite the relative affluence of the French aristocracy, there was less demand than in Germany, England, or Spain for the importation of history painters. Those foreign artists (usually Italian) who came to France to execute large decorative commissions were sometimes perceived as unwelcome competition by the members of the Academy, and such visits were largely confined to the earlier part of the century. For much of the period France was in fact an exporter of history painters: to Spain, to Russia, and even to Italy.

The first foreign artist to arrive in Paris after the turn of the century was the Neapolitan painter Paolo de Matteis (1662–1728). A pupil of Luca Giordano, whose style he modified in a classicizing direction, de Matteis attracted attention in Naples for his up-to-date religious paintings for Monte Cassino and other ecclesiastical buildings. In 1702 he was invited by the Comte d'Estrées to Paris, where he remained for three years. He seems to have worked for the Dauphin, and he frescoed several large galleries in the city, including that of the Compagnie des Indes (c. 1703). At this time he painted the library ceiling at the monastery of the Petits-Pères, in the Place des Victoires.[72] Mariette also mentions de Matteis's paintings for the gallery of M. Crozat in the Place Louis le Grand and for that of Jean Thevenin in the Rue Neuve des Petits-Champs.[73] Other works by the prolific de Matteis in Paris included the gallery of the Marquis de Clerambault in the Rue de l'Université and an altarpiece, *Saint Leo Meeting Attila the Hun,* for the Duc de Gesvres's chapel in the church of the Celestins.[74]

Unfortunately, nothing remains of de Matteis's Parisian decorations. The Regent, a patron of Italian artists who had tried to convince Francesco Solimena to come to Paris, had a mythological painting by de Matteis in his celebrated gallery at the Palais Royal. This work, *Salmacis and Hermaphrodite,* is lost but is known through an engraving by Romanet.[75] The picture may have been commissioned, though the Regent left the principal decorative painting of his gallery to a native

artist, Antoine Coypel. Other easel paintings by de Matteis were in eighteenth-century Parisian collections: the sale of the important Conti collection in 1777 included his *Hercules and Omphale* and *Charity.*[76] Nevertheless it is difficult to gauge the influence de Matteis might have had on the French school. Mariette, whose attitude was typical of that of the leading French connoisseurs of the period, was highly critical of de Matteis. Though noting the artist's facility with both oil and fresco, Mariette described him as an uninspired journeyman and a weak colorist who was poorly received in Paris. His compositions were very competent but not, according to Mariette, above the level expected of most Italian painters.[77]

In this judgment the critic echoed comments published as early as 1706 by the Abbé Brice, who in his guidebook to Paris described the Crozat gallery as:

> . . . painted in 1703 by a Neapolitan named Paul Matheï, who worked with more speed and energy than correctness and good taste . . . The choice of this master easily allows one to judge that bad taste and prejudice still reign in some quarters in Paris, despite the fairness that should be rendered to our capable painters, who would, no doubt, have done better than this foreigner, so anticipated for his attainments.[78]

Brice showed the same distaste for the speed with which de Matteis painted the Petits-Pères fresco: he was scandalized that the artist was able to cover twelve

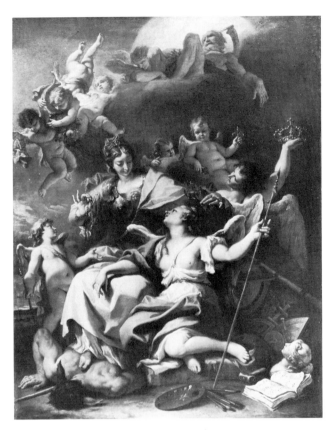

Fig. 37—Sebastiano Ricci
Allegory of France
Paris, Musée du Louvre

square meters in eighteen hours.[79] This hostility toward the Italians' facility and lack of "correctness," and the desire to support neglected French masters of decorative painting, were to characterize much French criticism during the first half of the century. Despite the strictures of Mariette and Brice, however, Paolo de Matteis, at the height of the ascendancy of the *Rubenistes,* represented a movement away from Baroque emotionalism toward more classicizing form and cool, delicate colors. He may thus have served as a precursor of the Rococo style that became dominant in France a generation later.

The greatest source of painters of large decorations was Venice; the Republic, economically incapable of providing sufficient architectural projects, exported its painters throughout Europe. Among the most famous of these international travelers were Jacopo Amigoni and Giovanni Battista Tiepolo. Another distinguished Venetian, who had closer contact with France, was Sebastiano Ricci, who visited Paris in 1712 and 1716. Ricci was in contact with French patrons as early as 1692, when La Teulière, director of the French Academy in Rome, wrote to the *Directeur général,* Colbert de Villacerf, that Ricci had been recommended to make a copy of a *Coronation of Charlemagne,* then attributed to Raphael, in the papal apartments.[80] By March 1693 La

Teulière had visited the Vatican with the Venetian artist, who promised to complete the copy with care, "being persuaded, as he is, that the task will help him perfect the correctness of his drawing, which is usually the weakest gift of the painters of that city." La Teulière expressed admiration for Sebastiano's handling of color and mentioned his eagerness to see France. Ricci's copy, completed in 1694, was on view at the Academy in Rome until at least 1727; it must therefore have been familiar to a full generation of *Prix de Rome* competition winners studying the intricacies of history painting.

Sebastiano's introduction to Paris came belatedly, after his international success as a decorative painter in London and other capitals. He was received into the Academy on May 28, 1718, one of the few Italian history painters so honored during the century, despite the reciprocal prominence of French painters in Rome's Academy of Saint Luke. His reception picture, an allegorical subject (Louvre; fig. 37), typifies the interchangeable vocabulary of Baroque hyperbole in which the Italian artists specialized. An old catalogue describes it as follows:

> France, under the form of Minerva, clothed in a costume half civil and half military, tramples Ignorance under her feet, and crowns Courage seated on the ground, and holding a lance. The Genius of the Arts, a torch in his hand, and other Genii bearing the attributes of France, and a horn of Plenty, surround the principal group. In the lower part of the painting, a pallet[te], a music book, and several accessories relating to the Arts and Sciences.[81]

Again the artist's work was represented in local collections: the sale of the Pelt collection in 1774 included Ricci's *Tarquin Trying to Prevent Lucretia from Stabbing Herself* and his *Death of Cleopatra.*[82] Ricci's stay in Paris seems to have been too brief, however, to have exerted a significant direct effect on French art.

The most important of the expatriate Venetians in Paris was Giovanni Antonio Pellegrini (1675–1741), an artist influenced by the fluid styles of Luca Giordano, Giovanni Battista Gaulli, and Sebastiano Ricci. Active

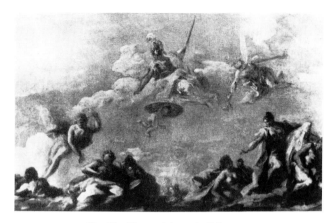

Fig. 38—Giovanni Antonio Pellegrini
Pallas, History, Time and Truth
Venice, private collection

mainly in the Germanic countries and England, Pellegrini visited Paris in November 1719 and met with the Scottish financier John Law, whom he had known in Venice. The Regent of France, Philippe d'Orléans, was captivated by Law's "system," a financial scheme based on speculative investments in the French colonies. For the Salle des Conseils of the new Banque Royale in the former Hôtel Mazarin, Law commissioned a vast ceiling painting, the theme of which was to be "the benefits of the Bank."[83]

Pellegrini returned early in 1720 and spent a year completing the immense decoration. The allegorical program was unusually elaborate even by the standards of the time: Mariette's description, dated June 10, 1721, and published by Bernard Lépicié in 1752, runs to several pages.[84] In the cloud-filled center, a figure of Religion and a hero representing the Regent held up a portrait of the King. The border area of the ceiling was filled with numerous figures, including personifications of such qualities as Munificence and Magnanimity, together with Classical deities, the river Seine embracing the Mississippi, and scenes of commerce with the American colonies. The allegory, heavily based on formulas from emblem books of the period, was intended to glorify the government of the Regent while associating it with the advantages of the bank.

Law's so-called system soon collapsed in bankruptcy, and the financier fled the country even before the completion of the ceiling. By 1722 the bank was being converted into a royal library and the ceiling painting, now an embarrassing reminder of the financial disaster, was soon removed. Pellegrini, despite vigorous legal action, never received full payment for his work on the project. From Lépicié's description an oil sketch attributed to Pellegrini in a Venetian private collection has been identified as depicting a group of figures from the composition: *Pallas, History, Time and Truth* (fig. 38).[85] A better idea of the general appearance of the decoration may be gained from François Lemoine's rival, unexecuted project for the ceiling (Paris,

Musée des Arts Décoratifs, fig. 39), subsequently engraved by Nicolas Charles Silvestre. Lemoine's purpose was to demonstrate "that it was unjust to give to foreigners commissions that Frenchmen could execute," reported the critic Caylus, who thought Lemoine's project in many respects superior to Pellegrini's.[86]

The brief existence of Pellegrini's ceiling may have limited its influence on works by other artists, but the vast project was widely seen and noted. Pellegrini was proposed for membership in the Academy by the end of 1720, though he does not seem to have satisfied the requirements for admission until 1733. The painter's light, delicate colors and his very loose, rapid technique, apparent in the oil sketch of *Pallas, History, Time and Truth* and characteristic of the Venetian decorative style of the period, did not meet with the full approval of Parisian art critics. In general, the Venetian *fa presto* approach was considered careless and undisciplined compared to the work of the French school since Le Brun. Lépicié criticized the composition of the ceiling, the weakness of the drawing, and the color of the clouds.[87] Mariette, who had watched the artist work on the ceiling, was more indulgent about the composition, praising the liveliness of the groups, but he found them too hastily painted to bear close examination and sternly predicted that none of Pellegrini's work would survive.[88]

The tradition of large allegorical ceilings as practiced by the Venetians was in fact on the decline in France, due to economic factors and a change in taste toward more intimate decorations. The only major later surviving example, Lemoine's *Apotheosis of Hercules* ceiling at Versailles, completed in 1736, certainly benefitted from the artist's earlier work on a project for the Banque Royale and perhaps also from his knowledge of Pellegrini's lost ceiling. In general, however, series of canvases on related subjects, such as Antoine Coypel's *Story of Aeneas* gallery at the Palais Royal (c. 1714–18) or

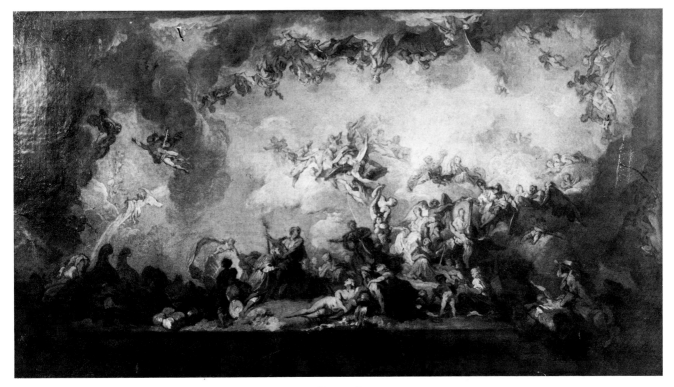

Fig. 39—François Lemoine
Sketch for the Ceiling of the Banque Royale
Paris, Musée des Arts Décoratifs

the pictures by various artists on *The Life of the Virgin* installed in the choir of Notre-Dame, Paris (c. 1715–17), were to become a more common mode of decoration, leading eventually to the state commissions on historical subjects in the latter half of the century.

Opportunities for Italian decorative painters declined sharply in Paris during the later years of the century. The continuing chauvinism of French connoisseurs and their criticism of Italian working methods were decisive factors in this trend. In 1770, in Paris, Mariette was introduced by Joseph Vernet to the Roman decorative painter Gregorio Guglielmi (1714–73).[89] Guglielmi, who had received extensive royal patronage in the Germanic countries, was not offered any major commissions in France. The criticisms of his work made by Mariette are familiar: absence of correct drawing or learned composition and a reliance on painterly *brio* and bright color to please the eye.

Despite the reduction in the number of major commissions, the reputation of Paris as a place for young history painters from other countries to study grew steadily throughout the century, and mainly at the expense of Rome. Already in 1708 Charles Poerson, director of the French Academy in Rome, had remarked: "Painting here has fallen into such bad taste that it's pitiable.... The reputation of Rome is only sustained by the celebrated works of those who are dead."[90] This attitude was perhaps shared by those artists from other French-speaking countries who came first to Paris to establish their careers. The Flemish painter Joseph-Benoît Suvée (fig. 40) established an influential atelier there that, for a time in the 1780s, almost rivaled the fame of that of David; subsequently, he completely reorganized the French Academy in Rome. His countryman and pupil Bernard Duvivier (cat. no. 18) changed both his name and citizenship to settle in France at the end of the century. Others, like the Swiss artist Jean-Pierre Saint-Ours, spent many years training in Paris before returning home, though they might exhibit at the Salon as corresponding members of the Academy.

If foreign history painters had only modest influence in France, the century saw an increasing number of expatriate French painters who eventually were to surpass the Italians in international influence. The trend began slowly and often followed political events. When Louis XIV succeeded in placing his grandson on the Spanish throne in 1700 as Phillip V, a stream of French history and decorative painters followed the new king to Madrid. The history painter René-Antoine Houasse (1645–1710), director of the Academy, was employed for a time at the Spanish court, where he was followed by his son Michel-Ange Houasse (1680–1730), an artist active mainly as a portraitist and painter of mythologies. The gifted Henri de Favanne (see cat. no. 20) also spent some years in Madrid, though little of his

work survives there. These French artists had an undoubted influence on the Spanish school, then at a low ebb, transforming it into a rather provincial dependency of the French style during the first half of the century.

The flow of French painters, sculptors, and architects to the countries of northern Europe, and even America, increased steadily as the century progressed. Among expatriate history painters the most distinguished was probably Gabriel-François Doyen (1726–1806), one of the most famous artists of the French school in the 1760s. Doyen's Baroque, Rubenesque technique (fig. 41) no longer pleased after the advent of Louis XVI and the Comte d'Angiviller in 1774, and the artist received no important government commissions. He emigrated to Russia in 1791, spending the rest of his career at the court in Saint Petersburg.

The foreign country that received the greatest influx of French talent was Italy, for centuries the leading center of European art. This importation of French artists is not surprising, since most of the best history painters studied at the French Academy in Rome, and all who could afford it regarded an Italian "grand tour" as essential to their artistic formation. Already in the preceding century such outstanding painters as Valentin de Boulogne, Nicolas Poussin, and Claude Lorrain had chosen to make their entire careers in Rome. This career pattern was less common in the eighteenth century, but the presence of the Academy lent prestige to the French artistic community in Rome. The directors of the French Academy often played a prominent role in Rome's Academy of Saint Luke; several, like Poerson and Jean-François de Troy, were elected to leadership of the venerable Roman institution. The directors had less influence on Roman artistic life through their own work, since they were either hindered artistically by their administrative responsibilities or tied to commissions from Gobelins or other sources in France.

Young French painters of exceptional ability might be offered commissions in Italy during or immediately after their student phase. A good example is Carle Van

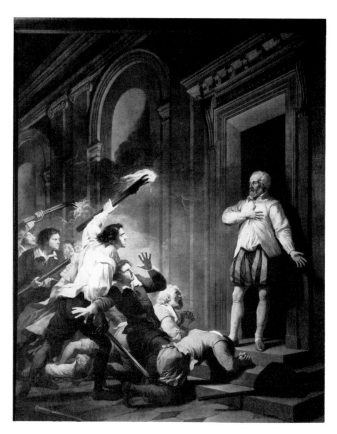

Fig. 40—Joseph-Benoît Suvée
The Death of Admiral de Coligny
Dijon, Musée des Beaux-Arts

Loo: while a pensioner at the French Academy in Rome (1728–32) he was given the opportunity to carry out a decorative commission for a ceiling at the Roman church of San Isidoro. From 1732 to 1734 he was occupied in Turin, where he worked at the Palazzo Reale and the palace of Stupinigi and painted a number of altarpieces. Only then did he return to begin his career in Paris, where he used the experience gained at Turin in his celebrated decorations for the Hôtel de Soubise.

The outstanding expatriate career of the century was that of Pierre Subleyras (1699–1749), who arrived in Rome in 1728 and, aside from a stay in Naples for health reasons, remained there until his death in 1749. Though his early patronage was from French dignitaries in Rome, such as the Duc de Saint-Aignan, Subleyras was eventually taken up by the highest authorities in the Church. Exceptional for French artists since Poussin, he received a commission for Saint Peter's for a large altarpiece, *The Mass of Saint Basil* (1747; now Rome, Santa Maria degli Angeli). In particular he was a favored painter for the religious orders, including the Olivetans of Perugia, the Camillans (*Saint Camillo de Lellis Saving Patients of the Ospedale di Santo Spirito from a Flood of the Tiber in 1598*; 1746, Rome, Museo di Roma), and the Dominicans (*Marriage of Saint Catherine De Ricci*; 1746, Rome, coll. Marchese Sacchetti; see cat. no. 51). Subleyras's serious, restrained style was in

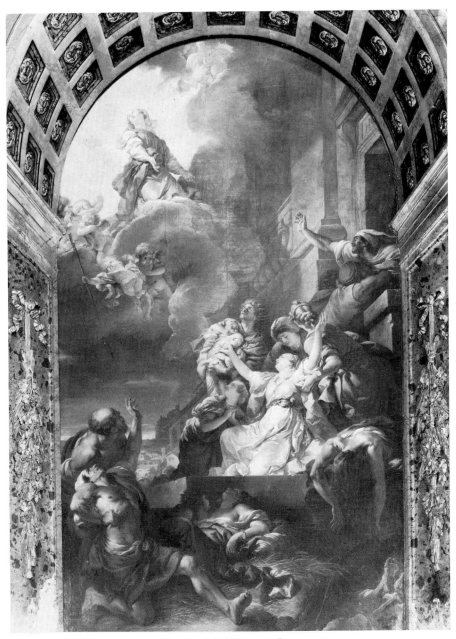

Fig. 41—Gabriel-François Doyen
Saint Geneviève Interceding for the Plague-Stricken
Paris, Saint-Roch

tune with the mood of quiet piety favored by the orders in their commissions, and he played a significant role in the evolution of a more classical style in Roman painting during the 1740s.

In the last decade of the eighteenth century the pace of emigration of painters from France increased as the political situation grew more chaotic. The famous portraitist Madame Vigée-Lebrun emigrated as early as 1789, and Doyen's departure for Saint Petersburg in 1791 may have been related to the increasing disturbances of the Revolution. Most emigré artists chose to return to Paris after 1800, with the establishment of Bonaparte's more stable regime; a few remained in per-

manent exile. An example was the promising history painter François-Xavier Fabre (1766–1837), who was a pensioner at the French Academy in Rome at the time of the Revolution. He fled in 1793 to the greater safety of Florence, where he was patronized by the large colony of wealthy foreigners. Predictably, he was employed mainly as a portraitist, but he also received commissions for history paintings (cat. no. 19), some of which eventually were shown at the Salon in Paris. Still, by settling in the provincial atmosphere of Florence, Fabre became isolated from the most exciting new artistic developments in Paris; his history painting gradually lost its vigor, and in time he gave it up completely.

51

Conclusion

H ow may we characterize the achievement of religious and historical painting in eighteenth-century France? Certainly the practitioners of la grande manière (aside from David and his best followers) have not been as celebrated as the genre specialists admired in the nineteenth century by the Goncourt brothers, and their works are still critically controversial today. The religious paintings of even such famous artists as Watteau, Boucher, and Fragonard remain little known. Has the relative obscurity of eighteenth-century historical painting been due to deficiencies in the work itself or simply to changes in taste, education, and religious belief?

The traditional critical view of French historical painting has recently been restated by Francis Haskell:

> If one compares almost any of the French religious or historical pictures discussed by [Philip] Conisbee with works by their Italian contemporaries, it is surely the lack of fluency, the sense of strain, which are most immediately striking—weaknesses which are quite absent from the mythologies or allegories of Boucher or Fragonard. It is as if the more elevated the subject the more self-conscious the effort that had to be made to live up to it, and to earlier traditions depicting it (though, ironically enough, an authentic sense of gravity now seems to us to be just the quality most lacking in such pictures).[91]

Haskell also states:

> It is true that "history painters" (here taken to include painters of serious allegory and of religion as well as of history) were honored more, encouraged more and often paid more than the "painters of minor genres" . . . , but it is also true that, for most of the eighteenth century, these history painters were nearly always felt to be lacking in stature . . . their achievements failed, with only rare exceptions, to match up to the expectations aroused by the prestige with which they were surrounded.[92]

The general lack of enthusiasm eighteenth-century French critics expressed for history painters may also, however, be interpreted as reflecting the much higher standards they set for history than for genre productions. As for the greater fluency that Haskell finds in Italian history painting, it does not seem, from the viewpoint of the present, to carry greater moral or dramatic conviction than is found in the French examples, whether of religious or historical subjects. French critics of the period certainly did not think so, for, as Haskell is aware, they roundly condemned the allegories of such artists as de Matteis, Pellegrini, and Guglielmi as false and superficial in style and banal in content. The awkwardness sometimes found in the religious paintings of artists like Restout or Vien (fig. 42) is less indicative of false piety than of sincerity. Haskell himself acknowledges this quality of French painting in praising the qualities of reserve and deep emotion expressed by Subleyras, who had a highly successful career as a painter of religious subjects in Italy. Did Subleyras work in Rome because "he . . . felt that it was only in Italy that his true merits would be fully appreciated,"[93] or rather was he admired in Italy precisely because his painting conveyed emotional conviction more convincingly than did the religious works of native artists?

If Haskell's comments represent a view that has been established since the time of the Goncourts, changes in taste during the past ten or fifteen years generally have favored a revival of interest in eighteenth-century history painting. The new enthusiasm for "academic" art, particularly that of the late nineteenth century, was associated in the 1970s with trends in contemporary art, such as that toward Photorealism. Is French religious and historical painting of the eighteenth century "relevant" to current avant-garde trends, and is such a relationship necessary to validate interest in the earlier period? Charles Rosen and Henri Zerner would answer the latter question in the affirmative; in their opinion, "revisions of taste are rarely if ever significant, except as they bear on living art."[94]

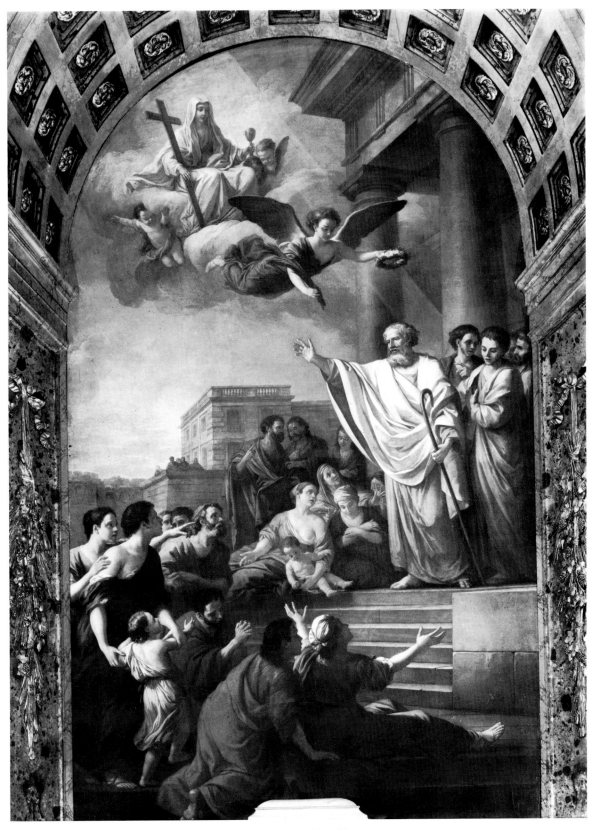

Fig. 42—Joseph-Marie Vien
Saint Denis Preaching
Paris, Saint-Roch

Fig. 43—Eric Fischl
A Visit To/A Visit From the Island
New York, Whitney Museum of American Art

The most influential stylistic trend of the past decade, both in the United States and in Europe, has been toward large-scale, painterly figural works. Some leading artists have returned to subjects that, in however fragmentary or elliptical a manner, tell a story, as was traditional for centuries in Western history painting. In certain pictures the artists also seem to be stating a moral lesson related to contemporary social and political conflicts: the praise of virtue is less often at issue than the implied denunciation of vice. If the loose technique of these contemporary artists has little to do with that favored by most eighteenth-century history painters, the role of moral commentary assigned to ambitious paintings in both periods has a curious parallelism.

In recent American art this trend may be seen in the paintings of Leon Golub, whose *Mercenaries* and *Interrogation* series depict, on a large scale, scenes of violence or torture in which anonymous victims are preyed upon by anonymous oppressors. The reasons for the conflict are not made clear, though the reference seems to be to Third World dictatorships propped up by secret police with the participation of American or European mercenaries. Compared to the saints of traditional religious paintings, the victims here have neither distinct identities nor a clearly defined cause. The casual, unrepentant quality of the oppressors' violent acts adds force to the artist's condemnation, which is expressed in the broadest possible terms rather than as specific political propaganda.

Expressions of implied criticism of social, sexual, and political behavior are found in the work of another American artist, Eric Fischl. In his *A Visit To/A Visit From the Island* (1983; New York, Whitney Museum of American Art, fig. 43) the artist, in a canvas fourteen feet wide, presents a parable of the relationship between America and Third World societies. The two scenes are seemingly unrelated: the left panel shows a group of hedonistic (though not entirely anxiety-free) tourists at play at a resort in a tropical setting, while at the right figures grieve over the corpses of drowning victims washed up on a stormy shore. The allusion here seems to be to Haitian refugees killed accidentally while trying to enter the United States illegally.

On one level the picture may be described solely in terms of parallelisms (anxiety, nudity) between the images. If one "reads" the painting from left to right, however, as was traditional in Western series of history paintings in earlier centuries, one may imply a causal relationship between the two scenes: the indifference and political naïveté of the affluent tourists on the island is indirectly responsible for the tragedy experienced by impoverished local inhabitants in their attempt to escape from this "paradise." Unlike the saints or Revolutionary heroes of eighteenth-century French pictures, these modern martyrs are faceless; yet, as in the earlier period, the viewer is meant to draw a moral conclusion about the behavior not only of individuals but of entire societies.

Whatever its parallels to contemporary art, the best

religious and historical painting of eighteenth-century France may be enjoyed on its own terms for many qualities: its largeness of conception, its high standards of drawing and composition, its skill in telling a complex story, its flair for the dramatic. From the vantage point of the present, however, we may be in a particularly good position to appreciate the high aims set for painting in an earlier age: to instruct, to inspire belief, and to touch the conscience through the moral force of art.

NOTES

[1] In Princeton University Art Museum, *Eighteenth-Century French Life-Drawing*, 1977, p. 10.

[2] Washington, National Gallery of Art, *Gods, Saints and Heroes: Dutch Painting in the Age of Rembrandt*, 1980, p. 9.

[3] *Ibid.*, p. 18.

[4] For a discussion of moralizing interpretations of mythological stories in Dutch history painting, see Eric J. Sluijter, "Depiction of mythological themes," *Ibid.*, pp. 55–64.

[5] Pieter de Grebber, *Regulen welcke by een goet Schilder en Teyckenaer geobserveert en achtervolgt moeten werden; Tesamen ghestelt tot lust van leergierighe Discipelen* [*Rules which a good Painter and Draftsman must observe and follow; Compiled for the delight of serious Pupils*], Haarlem, 1649; translated in Washington, *Gods, Saints and Heroes*, p. 32, n. 32.

[6] A. Félibien, *Entretiens sur les vies et sur les ouvrages des plus excellens peintres anciens et modernes*, 5 vols., Paris, 1666–88.

[7] For the use of these terms in connection with eighteenth-century criticism, see Jean Locquin, *La peinture d'histoire en France de 1747 à 1785*, Paris, 1912, pp. 139, 147, 288, and 289.

[8] Robert Rosenblum, *Transformations in Late Eighteenth Century Art*, Princeton, 1967, p. 56.

[9] *Ibid.*, p. 54, n. 13. Professor Rosenblum, in a letter, has also stressed to me the importance of mythology in serious "history painting;" often the distinction between myth and history is vague.

[10] I am indebted to Pierre Rosenberg for his comments on the evolving nature of French history painting during the seventeenth and eighteenth centuries.

[11] See in particular Philip Conisbee, *Painting in Eighteenth-Century France*, Ithaca, N.Y., 1981, which attempts to redress the balance between academic history painting and the genre subjects favored by nineteenth-century critics such as the Goncourt brothers, and Albert Boime, *The Academy and French Painting in the Nineteenth Century*, London, 1971.

[12] The most complete study of art administration in eighteenth-century France is still Locquin, *La peinture d'histoire en France de 1747 à 1785*.

[13] La Font de Saint-Yenne, *Réflexions sur quelques causes de l'état présent de la peinture en France*, Paris, 1747, and Jean-Jacques Rousseau, *Discours sur les lettres et les arts*, Paris, 1750.

[14] On Natoire's *Clovis* series see Conisbee, *Painting in Eighteenth-Century France*, pp. 88–90.

[15] See D. Rosenthal, "A source for Bernini's *Louis XIV* monument," *Gazette des Beaux-Arts*, 6th ser., LXXXVIII, 1976, pp. 231–234.

[16] On English contemporary history painting of this period and its influence, see Edgar Wind, "The revolution of history painting," *Journal of the Warburg Institute*, II, 1938–39, pp. 116–127.

[17] For an extended discussion of the painting of contemporary history in France before and during the Revolution, see William Olander, *Pour Transmettre à la Postérité: French Painting and Revolution, 1774–95*, dissertation, 2 vols., New York University, 1983.

[18] Detroit Institute of Arts, *The Age of Revolution*, no. 206.

[19] Olander, dissertation, p. 60.

[20] *Ibid.*, p. 108.

[21] *Ibid.*, p. 162ff.

[22] For the relationship between Christian and Revolutionary imagery, see Rosenblum, *Transformations in Late Eighteenth Century Art*, p. 82ff.

[23] Francis Haskell, *Rediscoveries in Art*, Ithaca, N.Y., 1980, p. 20.

[24] *Ibid.*; see also Henry Lapauze, ed., *Procès-verbaux de la Commune Générale des Arts de Peinture, Sculpture, Architecture et Gravure...*, Paris, 1903, pp. 367–368; 8 Nivos l'an 3ème (28 December 1794).

[25] Quoted in Pierre Marcel, *La peinture française au début du dix-huitième siècle 1690–1721*, Paris, 1906, p. 299.

[26] *Ibid.*

[27] Antoine-Joseph Dézallier d'Argenville, *Abrégé de la vie des plus fameux peintres*, Paris, 1762, IV, p. 407.

[28] Letter of December 22, 1716, from Crozat to Rosalba Carriera, the Venetian portraitist. See Ettore Camesasca, *The Complete Paintings of Watteau*, New York, 1968, p. 85.

[29] Comte de Caylus, *La vie d'Antoine Watteau, lue à l'Académie Royale, le 3 Février 1748*; see Hélène Adhémar, *Watteau, sa vie—son oeuvre*, Paris, 1950, p. 182.

[30] See Camesasca, *The Complete Paintings of Watteau*, no. 50.

[31] *Ibid.*, no. 194. The authenticity of Watteau's letter to Jullienne has been questioned by some authorities.

[32] Alexandre Ananoff, *François Boucher*, Lausanne and Paris, 1976, nos. 28, 29, 44, and 120.

[33] Denis Diderot, *Oeuvres complètes*, ed. J. Assézat, Paris, 1875–77, vol. X, p. 102.

[34] Georges Wildenstein, *The Paintings of Fragonard*, Garden City, N.Y., 1960, p. 49.

[35] *Ibid.*, cat. no. 90.

[36] P.-J. Mariette, *Abécédario*, ed. Ph. de Chennevières and A. de Montaiglon, Paris, 1851–60, II, 1853–54, p. 263.

[37] Wildenstein, *The Paintings of Fragonard*, p. 250.

[38] *Description of Greece*, VII, 21.

[39] Wildenstein, *The Paintings of Fragonard*, p. 54.

[40] [Baillet de Saint Julien], *Caractères des peintres françois actuellement vivans*, Paris, 1755, p. 3; cited in Edgar Munhall, *Jean-Baptiste Greuze, 1725–1805*, Hartford, 1976, p. 9, n. 2.

[41] *Lettre sur le Salon de 1755 addressée à ceux qui la liront*, Amsterdam, 1755, pp. 38–39; quoted in Munhall, *Jean-Baptiste Greuze*, p. 13, n. 15.

[42] Ill. in Edgar Munhall, "Quelques découvertes sur l'oeuvre de Greuze," *Revue du Louvre et des Musées de France*, XVI, pt. 1, p. 89, fig. 9.

[43]See Munhall, *Jean-Baptiste Greuze*, cat. no. 25.

[44]Denis Diderot, *Oeuvres esthétiques*, Paris, n.d., p. 725; cited in Munhall, *Jean-Baptiste Greuze*, p. 13, n. 16.

[45]Munhall, *Jean-Baptiste Greuze*, cat. no. 57.

[46]Edgar Munhall, "Les dessins de Greuze pour 'Septime Sévère'," *L'Oeil*, CXXIV, April 1965, p. 24, fig. 4.

[47]Discussed in Anita Brookner, *Greuze: The Rise and Fall of an Eighteenth-Century Phenomenon*, London, 1972, p. 109.

[48]Diderot, *Correspondance*, VII, pp. 102–103; Munhall, *Jean-Baptiste Greuze*, p. 149, n. 12.

[49]Munhall, *Jean-Baptiste Greuze*, cat. no. 113.

[50]Brookner, *Greuze*, fig. 83.

[51]Dézallier d'Argenville, *Abrégé*, 1762, IV, p. 295.

[52]Georges de Lastic, "Largillierre à Montréal," *Gazette des Beaux-Arts*, 6th per., CII, 1983, pp. 35–38.

[53]See Myra Nan Rosenfeld, *Largillierre and the Eighteenth-Century Portrait*, exh. cat., Montreal Museum of Fine Arts, 1981 [1982], cat. no. 4.

[54]Lastic, "Largillierre à Montréal."

[55]Rosenfeld, *Largillierre*, cat. no. 4.

[56]*Ibid.*, p. 386.

[57]Dézallier d'Argenville, *Abrégé*, 1762, IV, p. 301.

[58]Ill. in Rosenfeld, *Largillierre*, p. 388, fig. B.

[59]Thieme and Becker, *Allgemeines Lexikon*, XXII, 1928, p. 383, mention a *Saint Francis of Assisi* and *Saint Ignatius Loyola* as also engraved by Vermeulen.

[60]Georges de Lastic, "Nicolas de Largillierre: Documents notariés inédits," *Gazette des Beaux-Arts*, 6th per., XCVIII, 1981, pp. 1–27.

[61]Dézallier d'Argenville, *Abrégé*, 1762, IV, p. 312.

[62]Daniel Wildenstein, *Documents inédits sur les artistes français du XVIIIᵉ siècle*, Paris, 1966, pp. 129 and 137.

[63]Antoine Nicolas Dézallier d'Argenville, *Voyage pictoresque de Paris*, Paris, 1749, p. 89.

[64]Claude Colomer, *La famille et le milieu social du peintre Rigaud*, Perpignan, 1973, p. 130.

[65]*Ibid.*, p. 137.

[66]Dézallier d'Argenville, *Abrégé*, 1762, IV, p. 318.

[67]Pierre Rosenberg, *The Age of Louis XV*, Toledo, Ohio, 1975, no. 87.

[68]J. Roman, *Le livre de raison de peintre Hyacinthe Rigaud*, Paris, 1919, pp. viii and 221.

[69]*Diana the Huntress*, New York, anonymous sale, Dec. 11, 1930; Bénézit, *Dictionnaire*, 1976, III, p. 532.

[70]A. N. Dézallier d'Argenville, *Voyage pictoresque*, p. 123.

[71]Hal Opperman, *J.-B. Oudry 1686–1755*, Fort Worth, 1983, figs. 52, 53.

[72]Marcel, *La peinture française au début du dix-huitième siècle*, p. 138.

[73]Mariette, *Abécédario*, III, 1857–58, p. 290.

[74]*Ibid.*, note 1 (by de Chennevières and de Montaiglon), citing G. Brice, *Description nouvelle de la ville de Paris . . .*, Paris, 1706, IV, p. 62, and II, p. 290.

[75]Arnauld Brejon de Lavergnée, "Le Régent, amateur d'art moderne," *Revue de l'Art*, LXII, 1983, pp. 45–48, ill. fig. 4.

[76]Bénézit, *Dictionnaire*, VII, pp. 265–266.

[77]Mariette, *Abécédario*, III, p. 291.

[78]Brice, *Description nouvelle*, I, pp. 187–188.

[79]*Ibid.*, I, p. 273.

[80]For the following account, see A. de Montaiglon and J. Guiffrey, eds., *Correspondance des Directeurs de l'Académie de France à Rome avec les Surintendants des Bâtiments du Roi*, I, Paris, 1887, pp. 341–358.

[81]Paris, Musée du Louvre, *Guide through the Galleries of Paintings of the Imperial Museum of the Louvre*, 1855, p. 136, no. 343.

[82]Bénézit, *Dictionnaire*, VIII, pp. 732–733.

[83]See Klára Garas, "Le plafond de la Banque Royale de Giovanni Antonio Pellegrini," *Bulletin du Musée Hongrois des Beaux-Arts*, XXI, 1962, pp. 75–93.

[84]Bernard Lépicié, *Vies des premier peintres du roi*, Paris, 1752, II, pp. 122–127; also Mariette, *Abécédario*, 1857–58, IV, pp. 95–98.

[85]Garas, "Le plafond de la Banque Royale," p. 78.

[86]Lépicié, *Vies des premiers peintres*, p. 93.

[87]*Ibid.*, p. 92.

[88]Mariette, *Abécédario*, IV, p. 92.

[89]*Ibid.*, II, p. 339.

[90]Montaiglon and Guiffrey, *Correspondance des directeurs*, III, p. 240 (letter of October 20, 1708).

[91]Francis Haskell, "Contre Goncourt," *London Review of Books*, March 18–31, 1982, pp. 14–15.

[92]*Ibid.*

[93]*Ibid.*

[94]Charles Rosen and Henri Zerner, *Romanticism and Realism: The Mythology of Nineteenth-Century Art*, New York, 1984, p. 211.

Catalogue

Jacques-Antoine Beaufort
Paris 1721–1784 Rueil (Seine-et-Oise)

The rather obscure Beaufort showed a variety of historical subjects at the Salons from 1767 to 1783: *The Doubting Thomas, The Death of the Hindu Philosopher Calanus,* and a popular subject from French history, *The Death of the Chevalier Bayard.* He was *agréé* by the Academy in 1766 and made a full member of that institution in 1771. Beaufort took part in the commission for the chapel of the Ecole Militaire, Paris, in the 1770s, painting *Saint Louis, Afflicted with the Plague during the Siege of Tunis, Exhorting his Son on his Deathbed.* Works mentioned in sales catalogues of the period hint that the artist may also have painted mythologies and landscapes.

Nearly all of Beaufort's work is lost. What survives indicates that the artist, though very up to date in his choice of dramatic Classical subjects, still painted in a colorful, sketchy Rococo manner. Transitional though it is, Beaufort's style may have been important for the development of the young Jacques-Louis David.

1. *The Oath of Brutus,* c. 1771
Oil sketch, 24¾ x 31½ in. (63 x 80.2 cm.)
Albuquerque, University Art Museum, University of New Mexico

PROVENANCE: London, coll. Barnett Hollander; private collection, on extended loan to the Museum.

EXHIBITIONS: Albuquerque, *French Eighteenth-Century Oil Sketches from an English Collection,* 1980 (cat. by Peter Walch), no. 2.

BIBLIOGRAPHY: Robert Rosenblum, "Gavin Hamilton's 'Brutus' and its aftermath," *Burlington Magazine* CIII, 1961, pp. 8–16, ill. fig. 29; Jean Seznec, *Diderot Salons,* IV, Oxford, 1967, pp. 145–146, 203–204, fig. 83; Virginia Lee, "Jacques-Louis David: The Versailles Sketchbook," Pt. I, *Burlington Magazine,* CXI, 1969, p. 199, n. 9, and Pt. II, pp. 360–373; Robert Rosenblum, "A source for David's 'Horatii'," *Burlington Magazine,* CXII, 1970, pp. 269–275, fig. 6; Pierre Rosenberg and Antoine Schnapper, "Beaufort's *Brutus,*" *Burlington Magazine,* CXII, 1970, p. 760; Anita Brookner, *Jacques-Louis David,* New York, 1980, p. 77, ill. fig. 38 (attrib. to David).

This picture has been the focus of considerable attention as a possible link in the development of Jacques-Louis David's seminal Neoclassical work *The Oath of the Horatii* (1784; Paris, Louvre). It is generally agreed that the origin of the oath-taking theme for both Beaufort and David is the large, precocious *Oath of Brutus* painted by the Scottish artist Gavin Hamilton in Rome in 1763–64 (London, Theatre Royal, Drury Lane). Hamilton's composition was well known throughout Europe through Domenico Cunego's reproductive engraving of 1768. In all three compositions a male group, placed off center but parallel to the picture plane, swears a martial oath while dead, dying, or swooning female figures appear to one side.

At the Salon of 1771 Beaufort exhibited an *Oath of Brutus,* now recognized as the picture in the Musée Municipal, Nevers.[1] In one of the most celebrated incidents of early Roman history Lucretia, wife of the nobleman Collatinus, was ravished by Tarquinius Sextus, son of the king Tarquinius Superbus. The humiliated Lucretia committed suicide and Collatinus and others, led by Brutus, vowed to drive the harsh Tarquins from the throne. This pact signaled the birth of the Roman republic.

Some critics have suggested that the Albuquerque painting is not by Beaufort, or that it is even a free copy by the young David.[2] Though the picture is close in composition to the definitive version, there are numerous small variations of costume, pose, and decor, and the technique is far more colorful and painterly. Such differences between sketch and finished work were not unusual in the eighteenth century, however, and there is little reason to doubt that this is an early preparatory sketch by Beaufort for the Nevers picture. Another sketch of very similar technique and size (64 x 80 cm.; Rouen, coll. André Marie) but much closer in detail to the final version strengthens the attribution of this work to Beaufort.[3]

When the larger version (129 x 167 cm.) of Beaufort's picture was shown at the Salon, the general critical approval was contested by Denis Diderot, who wrote:

> Its composition is weak, and by a man who could not transport his imagination to Collatinus's estate, to see Lucretia stabbed there and, Roman for the moment, fire the genius of fury against the Tarquins to their ruin and avenge the death of Lucretia; the painter who could not in this moment make himself either Roman or Brutus has not at all felt what it is to be Brutus and to see a Tarquin on the throne.[4]

Whatever the merits of Diderot's critique, Beaufort's picture seems to have been noticed by David, who made a drawing of nude figures after the principal group in the Nevers composition in a sketchbook now at Versailles.[5] The Albuquerque oil sketch is not far removed, in its Baroque dramatic style, agitated brushwork, and vivid colors, from Davidian sketches of the same period, such as *The Death of Seneca* (cat. no. 14). The dramatic potential of Beaufort's composition was stored in David's memory until it emerged thirteen years later in the far more highly charged and monumental *Oath of the Horatii.*

[1]Rosenblum, "A source for David's 'Horatii'," fig. 1.
[2]Brookner, *Jacques-Louis David,* fig. 38
[3]Rosenberg and Schnapper, "Beaufort's *Brutus,*" fig. 46.
[4]*Salon of 1771;* cited in Lee, "Jacques-Louis David: The Versailles Sketchbook," I, p. 199, n. 9.
[5]*Ibid.,* II, p. 361, fig. 33.

Cat. No. 1

Jean-Simon Berthélemy
Laon 1743–1811 Paris

A pupil of Noël Hallé, Berthélemy won the *Grand Prix* in 1767 for his *Alexander Cutting the Gordian Knot* (Paris, Ecole des Beaux-Arts). Little is known of his artistic activity during his residence in Rome (1771–74). He was *agréé* by the Academy soon after his return in 1777, however, and received as a full member in 1781 with his *Apollo with the Body of Sarpedon* (Langres, Musée).

Berthélemy had a highly successful official career during the closing years of the *ancien régime*. Between 1779 and 1789 many works were ordered by d'Angiviller for the Gobelins tapestry works and were shown at the Salon, including subjects from biblical, Classical, and French history: *The Freeing of Eustache de Saint-Pierre by Queen Philippine de Hainaut at the Siege of Calais* (1777), *Manlius Torquatus Condemning his Son to Death* (1785), *The Entry of the French Army into Paris, April 13, 1436* (1787), and *The Death of Eleazar* (1789). During this period Berthélemy was also prominent as a ceiling painter, working at the Hôtel de Saint-Florentin, the Hôtel de Vaudreuil, and at Fontainebleau. An assistant designer of costumes at the Opera from 1787, he was the designer from 1791 to 1807. He also executed numerous church decorations and some portraits.

After the Revolution, with which Berthélemy did not associate himself, he again rose to prominence under the Directory. In 1796–98 he was in Italy working with a commission to choose captured works of art to be brought to Paris. From 1799 to 1802 he was an honorary curator at the Louvre. Berthélemy continued to receive state decorative commissions and to exhibit at the Salon until 1808, though in his last years his reputation suffered something of an eclipse.

One of the most active history painters of his generation, Berthélemy retained an exceptional interest in the free brushwork widely practiced during his youth, while continuing work on the grand subjects and historical accuracy in demand at the end of the century. These differing aspects of his style were seen as conflicting by some critics of his time. In his later works he moved toward a polished manner more in keeping with the developing Neoclassical taste. The dramatic, sometimes theatrical movement in his pictures recalls Berthélemy's late-Baroque artistic antecedents.

2. *Saint Charles Borromeo Administering the Last Sacrament during the Plague of Milan*, 1778
Oil on canvas, diam. 26⅛ in. (66.3 cm.)
Signed, bottom center: *Berthelemy 1778*
Houston, Museum of Fine Arts

PROVENANCE: Paris, coll. Georges Cain, 1930; Mme. Cain estate sale, Paris, Hôtel Drouot, March 9, 1939, no. 77; Paris, Galerie Cailleux; Museum purchase with funds provided by the Laurence H. Favrot Bequest Fund, 1970.

EXHIBITIONS: Paris, Salon of 1779, no. 163.

BIBLIOGRAPHY: Paris, Bibliothèque Nationale, Cabinet des Estampes, coll. Deloynes, XI, 1779 (*Mercure de France*), p. 775, no. 230; Bellier and Auvray, *Dictionnaire général*, I, 1882, p. 78; Du Pont de Nemours, "Lettres sur les Salons de 1775, 1777, et 1779," *Archives de l'art français*, II, 1908, p. 83, n. 1; J. L. Schrader, "Recent acquisitions: Classical Baroque and Rococo styles of France seen in two oil sketches," *Houston Museum of Fine Arts Bulletin*, n.s. II, March 1971, pp. 2–6, ill. in color; Nathalie Volle, *Jean-Simon Berthélemy (1743–1811), peintre d'histoire*, Paris, 1979, p. 82, no. 51, ill. fig. 38; Houston, Museum of Fine Arts, *A Guide to the Collection*, 1981, pp. 81–82, no. 144, ill.

In this work Berthélemy combines his experience as a painter of ceiling decorations with his lesser-known activity in depicting subjects from sacred history. On other occasions he painted a *Martyrdom of Saint Peter* (also Salon of 1779; Douai, Church of Saint-Pierre) and *The Holy Family in Egypt* (1784–91; Monthléry-Linas, parish church). According to the Salon *livret* the subject is "The plague of Milan, in which St. Charles himself brings the viaticum to the plague-stricken." St. Charles Borromeo (1538–84), nephew of Pope Pius IV, was Archbishop of Milan and one of the most important figures of the Counter Reformation. Pictures of the saint's activities, particularly during the plague of 1575, were popular in seventeenth-century Italy but relatively rare in France. Berthélemy perhaps undertook the sketch without a commission, since there is no record of a larger work that would have been his only ceiling painting on a religious subject.

The sketch, one of the earliest of Berthélemy's surviving works, shows the influence of the artist's student years in Italy. The open, cloud-filled center with its figures of flying angels follows the decoration of many Roman churches, such as Lanfranco's cupola for Sant'Andrea della Valle (1625–28).[1] The figures of the plague-stricken crowd together and lean over an illusionistic stone border, and attention is drawn to the red-robed figure of the saint, who strides forward energetically to give the sacrament to a dying woman. The loose, vigorous brushwork, while common to many eighteenth-century oil studies, particularly recalls the first half of the period. The dynamic composition and bright, cool colors in the central area also are reminiscent of the Rococo manner, of which the young Berthélemy, like Fragonard, may be considered a late practitioner. Soon after *Saint Charles Borromeo* Berthélemy was to modify his style toward a more fashionable Neoclassical manner, gaining in precision and grandeur but losing perhaps in painterly *brio*.

[1] J. Patrice Marandel in Houston, Museum of Fine Arts, *A Guide to the Collection*, p. 82.

Cat. No. 2

Nicolas Bertin
Paris 1668–1736 Paris

Bertin came from a family of artists: his father was a sculptor, as was his brother Claude, who worked at Versailles. Orphaned at the age of four, Bertin became the protégé of the powerful Louvois, *Directeur général des Bâtiments* to Louis XIV. After studies with Guy Louis Vernansal the elder, Jean Jouvenet, and Bon Boullogne, he won the *Prix de Rome* competition. Bertin spent four years at the French Academy in Rome and two in Lyons before returning to Paris. There he was received by the Academy in 1703 and made a professor in 1716.

Decorative commissions completed by Bertin included designs for the Gobelins tapestry series *L'Histoire du roi* and paintings such as *Vertumnus and Pomona* for the Grand Trianon at Versailles. He executed numerous works for German princes, including decorations for the Badenburg of Nyphenburg Palace outside Munich. Bertin also had numerous religious commissions, including pictures in the church of Bury and Saint-Germain-des-Prés, Paris; the most ambitious of these was the decoration of the entire chapel of the Château of Plessis-Saint-Père, completed in 1718.

Bertin was not suited by nature to be a courtier, however, and he avoided permanent court appointments; he also declined the Duc d'Antin's offer of the directorship of the French Academy in Rome. In addition to his large decorative works, he painted numerous small historical, mythological, and biblical scenes, often on copper, as well as genre subjects.[1]

[1]See A. Schnapper, "A propos d'un tableau de N. Bertin," *La Revue du Louvre*, XXII, 1972, pp. 357–360, and Thierry Lefrançois, *Nicolas Bertin (1668–1736): Peintre d'histoire*, Neuilly-sur-Seine, 1981.

3. *Kings and Prophets of the Old Testament Adoring the Name of Jehovah and Awaiting the Messiah*, 1718
Sketch for ceiling of the chapel of the Château of Plessis-Saint-Père
Oil on canvas, 51¼ x 37⅜ in. (130 x 94.8 cm.)
Signed (bottom center): *N. Bertin invenit/Pinxit*
Houston, Museum of Fine Arts

PROVENANCE: Possibly coll. Jules Burat, sale, Paris, Galerie Georges Petit, April 28, 1885, no. 5 (120 x 100 cm.); London, Heim Gallery; Museum purchase with funds provided by the Laurence H. Favrot Bequest Fund, 1969.

EXHIBITIONS: Atlanta, High Museum of Art, *The Rococo Age*, 1983, no. 1, color pl. 1.

BIBLIOGRAPHY: "La chronique des arts," *Gazette des Beaux-Arts*, Feb. 1970, ill. no. 317; J. L. Schrader and Philippe de Montebello, "Recent acquisitions: Two Baroque sketches," *Houston Museum of Fine Arts Bulletin*, n.s.I, 1970, pp. 14–17, ill. in color; Rouen, Bibliothèque Municipale, *Choix de dessins anciens*, text by Pierre Rosenberg and Antoine Schnapper, 1970, p. 12; Antoine Schnapper, *Jean Jouvenet (1644–1717)*, Paris, 1974, pp. 128 and 170, ill.; Houston, Museum of Fine Arts, *A Guide to the Collection*, 1981, pp. 65–66, no. 117, color pl. 19; Thierry Lefrançois, "Phaéton conduisant le char du Soleil, de Nicolas Bertin," *Revue du Louvre*, 1981, IV, pp. 282–283, ill., and *Nicolas Bertin (1668–1736), peintre d'histoire*, Neuilly-sur-Seine, 1981, pp. 53–55, 145–146, no. 74, 169–170, ill. fig. 86.

This canvas is a rare surviving example of a finished sketch for a large architectural decorative painting. In 1718 Bertin, his reputation as a decorator well established, was given the commission for the ceiling, wall paintings, and altarpiece of a private chapel at the Château of Plessis-Saint-Père (Essonne), undoubtedly by the owner, François Pinault, Sieur de Bonnefonds.[1] Though the ceiling was destroyed in 1827, it is known from a literary description by Dézallier d'Argenville *père* (*Vie des peintres*, Paris, 1745) to have corresponded closely to the signed Houston sketch, which must have been approved by the patron.

The work is typical of late Baroque allegorical schemes—particularly of Italian inspiration—in its complexity and its easy mastery of composition, which was praised by Dézallier. In the center a transparent pyramid bearing the name of Jehovah in gold Hebrew letters is borne aloft by angels and cherubs in a cloud-filled sky. The Old Testament figures are disposed around the edges of the composition and would have seemed to rest illusionistically on a cornice built around the chapel below the ceiling. The bottom group, placed over the high altar, consists of Moses flanked by Joshua, who bids the sun to stand still, and the high priest Aaron, who looks down toward the altar. The group on the left is led by Abraham, that on the right by David, who plays his harp in praise while below Noah gestures toward the Ark. Prophets hold scrolls bearing their writings, and the cartouche at the bottom center bears an inscription in Latin: "He has proclaimed the power of His works to His people/He has given them the inheritance of the nation."[2] The altarpiece, an *Adoration of the Magi*, completed the ambitious iconographic scheme by identifying the fulfillment, in the birth of Christ, of the Old Testament promise symbolized on the ceiling, while four more paintings by Bertin, now lost, for the walls of the chapel conveyed scenes from the lives of Christ and the saints.[3]

Bertin's work derives from a long Italian tradition of illusionistic ceiling painting—from Correggio and the Venetian masters of the Renaissance to the decorative frescoes of Baroque Rome. Perhaps the most relevant Roman example is Giovanni Battista Gaulli's spectacular *Triumph of the Name of Jesus* (1672–85) on the ceiling of the church of Il Gesù, completed soon before Bertin's arrival in the city as a student. The blue and red tonalities of the sketch are sharper than those found in the works of the Venetians or of Bertin's immediate French predecessors, like Charles de La Fosse. The colors are also somewhat higher keyed and cooler than in Baroque decorative schemes, anticipating subsequent developments in the works of Lemoine and Boucher. This sketch gives us a glimpse of early eighteenth-century French grand decorative programs, many of which are no longer in existence.

[1]Lefrançois, *Nicolas Bertin*, p. 170.
[2]Psalm 111:6.
[3]As described by Dézallier d'Argenville *fils* (*Voyage pittoresque des environs de Paris*, Paris, 1755, 1762 ed., p. 224), these were: *Saint John the Baptist Preaching in the Desert*, *Christ Raising Lazarus from the Dead*, *The Virgin Appearing to Saint Francis of Assisi*, and *Saint Ignatius of Loyola in the Grotto of Manrese Writing the Rules of the Jesuit Order at the Dictation of the Virgin*.

Cat. No. 3

François Boucher
Paris 1703–1770 Paris

An artist whose style epitomizes the middle decades of the century, Boucher was a pupil of François Lemoine. Though he later claimed to have learned little from Lemoine, Boucher showed, in his mature work, an awareness of the older artist's bright, colorful, sensuous style. Much of Boucher's early training came from practical experience providing drawings for the engraver Laurent Cars and for Maurice Baquoy's plates for P. Gabriel-Daniel's *Histoire de la France*. He also worked as an engraver for Julienne's *Figures de différents caractères,* after Watteau. Boucher did not share Watteau's psychological perceptiveness or his tendency toward melancholy, yet the elegant realism of Watteau's style provided another important element of Boucher's formation.

After winning the *Grand Prix* in 1723, Boucher spent the years 1728–31 in Rome. Following his return to Paris and his reception by the Academy, the artist was employed on decorative projects at Versailles, Fontainebleau, and other royal residences. The prolific Boucher was involved in an astounding variety of design projects, including cartoons for the Beauvais tapestry works, sets for the theater and the Opera, book illustrations, and designs for Sèvres and Vincennes porcelains; he also painted numerous mythological and genre scenes, landscapes, and portraits. By 1755, under the patronage of Madame de Pompadour, he was named *Surinspecteur* of the Gobelins tapestry works. His academic career was already highly successful: after the death of Carle Van Loo in 1765 Boucher became both director of the Academy and *Premier Peintre* to Louis XV. Despite this official success, Boucher was subject to increasing criticism by Diderot and others after 1760, for his late work showed repetitiveness and a decline of inspiration.

Boucher's stylistic sources are complex, ranging from the Italian Baroque to "Flemish" realism. The characterization of Boucher as a disciple of Rubens holds true, if at all, only for the artist's early masterpieces of warm colorism like *The Triumph of Venus* (Stockholm, Nationalmuseum) and *The Rising and Setting of the Sun* (London, Wallace Collection). His later works are harder and cooler in color, with slick surfaces and a predominance of blue tones. Until his last years his energy and vitality as an artist were remarkable, fully justifying the preference he received from his royal patrons. Despite having a relatively casual attitude about his own attainments, Boucher as a teacher succeeded in conveying his enthusiasm to several gifted students, notably Deshays and Fragonard.

4. *Joseph Presenting his Father and Brothers to Pharaoh*
Oil on canvas, 22¾ x 28½ in. (58 x 72.5 cm.)
Signed (lower left): *boucher*
Columbia, South Carolina, The Columbia Museum

PROVENANCE: [?] coll. M. Prevost, sale, Paris, January 8, 1810, no. 277; London, private collection; sale, London, Sotheby's May 20, 1953, no. 99 (as *The Continence of Scipio*); London, coll. H. D. Molesworth; New York, coll. Samuel H. Kress, 1956; allocated to the Columbia Museum, 1957.

EXHIBITIONS: Tokyo, Metropolitan Art Museum, and Kumamoto, Prefectural Museum of Art, *François Boucher*, 1982, no. 1; Atlanta, High Museum of Art, *The Rococo Age*, 1983, no. 3, ill. in color p. 25; New York, Metropolitan Museum of Art, *François Boucher 1703–1770*, 1986, no. 5, ill.

BIBLIOGRAPHY (selected): H. Voss, "Boucher's early development," *Burlington Magazine*, 1954, pp. 206–210 (as *Evilmerodach*); A. Pigler, *Barockthemen*, Budapest, 1956, I, p. 89 (as *Joseph*); A. Ananoff, *François Boucher*, Lausanne and Paris, 1976, I, p. 162, no. 9, ill.; C. Eisler, *Paintings from the Samuel H. Kress Collection: European Schools excluding Italian*, Oxford, 1977, pp. 315–316; A. Ananoff, *L'Opera Completa di Boucher*, Milan, 1980, no. 9, ill. pl. 1; Pierre Rosenberg, *Musée du Louvre: Catalogue de la donation Othon Kauffmann et François Schlageter au Département des peintures*, Paris, 1984, pp. 33–34 (as *Joseph*).

The subject of this early work was formerly thought to be: "Evilmerodach, son and successor of Nebuchadnezzar, frees Jehoiachin from the chains in which he had been kept for so long."[1] This obscure biblical story, taken from II Kings 25:27–30 and Jeremiah 52:31–34, was the prescribed theme with which Boucher won the *Prix de Rome* competition in 1723. Recently Alastair Laing has more plausibly identified the subject as that of Joseph presenting his family to Pharaoh.[2] The youthful, richly dressed central figure, the crowned ruler on a throne at the left, and the aged father are consistent with this interpretation. The kneeling brothers are shown with their shepherds' staffs; the youngest brother, Benjamin, may be the figure at the far right.

Though no commission for this composition is known, the story of Joseph was immensely popular throughout the century: *Joseph Recognized by his Brothers* was twice assigned as the *Prix de Rome* competition theme, in 1700 and 1789. Joseph's rise from enslavement and imprisonment in Egypt to power as Pharaoh's minister provided an exceptional illustration both of divine providence and the reward of virtue.

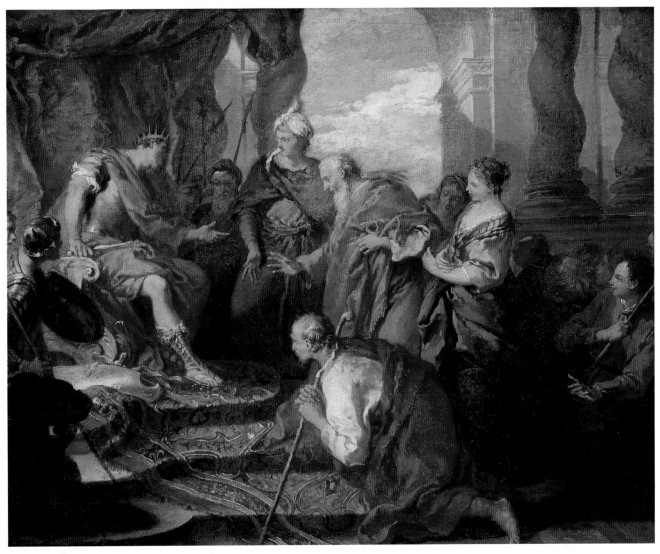

Cat. No. 4

Various authors have noted a compositional resemblance to Boucher's drawings of 1721 for subjects from the *Histoire de la France,* including *Admiral d'Andelot Presenting the Huguenots' Request to the King*[3] and *Homage Paid to Louis XII by the Arch-duke.*[4] The grandly hieratic arrangement using a flight of stairs, the ahistorical costume and architecture (largely Roman), and the deep, rich colors all suggest the influence of Venetian art from Titian through Boucher's older contemporary, Sebastiano Ricci. Boucher painted a number of small pictures on Old Testament themes in the mid-1720s, including a *Bethuel Welcoming the Servant of Abraham* (Strasbourg, Musée des Beaux-Arts) and two scenes from the story of Noah (Fort Worth, priv. coll.). Since at this period Boucher had not yet been to Italy, the combination of small scale and monumental conception may reflect the influ-ence on the young artist of Nicolas Vleughels, an enthusiast of Venetian painting.[5]

[1]Voss, "Boucher's early development."
[2]See the discussion by Laing in New York, Metropolitan Museum, *François Boucher,* no. 5.
[3]Atlanta, *The Rococo Age,* p. 34, fig. I.1.
[4]New York, Metropolitan Museum, *François Boucher,* fig. 76.
[5]*Ibid.,* pp. 100–101.

François Boucher
Paris 1703–1770 Paris

5. *Virgin and Child*
Oil on canvas, oval, 17 x 13¾ in. (42.9 x 35.6 cm.)
Signed (lower right, on chair arm): *Boucher*
The Fine Arts Museums of San Francisco

PROVENANCE: Coll. Favre, sale, Paris, January 11, 1773, no. 87; coll. de La Ferté, sale, Paris, February 20, 1797, no. 91; Paris, coll. Jean-Baptiste-Pierre Le Brun; anonymous sale [C. P. Gérard?], Paris, February 22–23, 1850, no. 40; gift of Mr. Brooke Postley to the M. H. De Young Memorial Museum, San Francisco, 1957.

BIBLIOGRAPHY: André Michel, *François Boucher*, Paris, 1906, no. 740; *Art Quarterly*, XX, 1957, p. 205, fig. 212; San Francisco, De Young Museum, *European Works of Art in the M. H. De Young Memorial Museum*, 1966, p. 182, ill.; Alexandre Ananoff, *François Boucher*, II, p. 288, no. 662, ill. fig. 1732.

This small work from the end of Boucher's career retains all the charm and painterly qualities of the artist's late altarpieces for Madame de Pompadour, such as the *Nativity* in Lyons (fig. 21). There is little to separate this treatment of a time-honored religious theme from a genre depiction of a mother and child; indeed, Ananoff relates the composition to a nearly identical group at the left center of a large genre painting by Boucher, *The Return from the Market*, that is dated 1769 (Boston, Museum of Fine Arts).[1] The principal compositional differences are in the clothing and in the addition of a chair and of the rose held by the child. In contrast to the figure in the genre scene he opens his mouth and seems to look fearfully at the rose; with its red coloring and, perhaps, its sharp thorns it may prefigure the Passion of Christ. In another, more genrelike version, engraved in reverse by Gilles Demarteau (1729–76), the child sleeps with his head on the Virgin's shoulder.[2]

The San Francisco painting has much in common with the informal, freely brushed, warmly colored treatments of the same theme from the 1750s by Boucher's pupil Fragonard (versions in the Baltimore Museum of Art and New Haven, Yale University Art Gallery), and we may legitimately speculate on a possible reciprocal influence of the younger on the older artist.

[1]Ananoff, *François Boucher*, no. 661, ill. figs. 1722 and 1735.
[2]*Ibid.*, cat. no. 662/4, ill. fig. 1733.

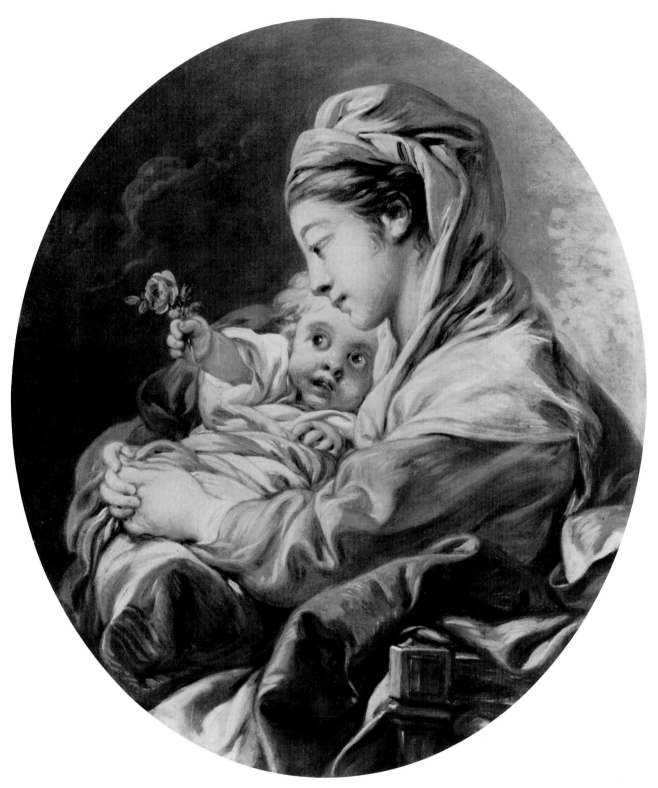

Cat. No. 5

Louis de Boullogne the younger
Paris 1654–1733 Paris

Boullogne studied with his father, a founding member of the Academy. A winner of the *Grand Prix* in 1673, Boullogne resided in Rome from 1675 to 1680, copying Raphael for the Gobelins tapestry works. He rose from membership in the Academy in 1681 through various offices to be director in 1722. In the course of a brilliant official career he was ennobled in 1724 and made *Premier Peintre du Roi* the following year.

Soon established as a specialist in mythological and religious painting, Boullogne worked at Versailles, the Trianon, Meudon, and Fontainebleau. For the high altar of the chapel at Versailles he provided an *Annunciation*, while for the Saint Augustine chapel of Saint-Louis-des-Invalides he painted a life of Augustine in six pictures.[1] At the Salon in 1699 Boullogne showed easel paintings, including *Martha and Mary Magdalene at the Feet of the Saviour, A Crucifix, Joseph Sold into Slavery,* and, in 1704, *Tobit Regaining his Sight.* He also painted a rare modern subject, *François I as Patron of the Arts and Learning* (1701; Fontainebleau, Château).

Boullogne is probably best known for such mythological paintings as *Diana and her Companions* (1707; Tours, Musée des Beaux-Arts); their lightness, elegance, and charm prefigure much of Rococo painting. His religious compositions of the same period have a stricter construction that recalls the quiet grandeur of seventeenth-century French classicism.

[1]See A. Schnapper, "Esquisses de Louis de Boullogne sur la vie de Saint Augustin," *Revue de l'Art,* IX, 1970, pp. 58–64.

6. *Saint Augustine Preaching*, c. 1702–04
Oil sketch on canvas, 27¾ x 18½ in. (70.5 x 47 cm.)
Notre Dame, Indiana, The Snite Museum of Art, University of Notre Dame

PROVENANCE: Bingham collection; New York, coll. Hans Rosenwald, gift to Museum, 1954.

BIBLIOGRAPHY: Schnapper, "Esquisses de Louis de Boullogne sur la vie de Saint Augustin," ill. fig. 9; Conisbee, *Painting in Eighteenth-Century France,* Ithaca, N.Y., 1981, p. 54, ill. fig. 42.

At the beginning of the eighteenth century Boullogne was involved in two major projects concerning the life of Saint Augustine. The first was a series of paintings for the Augustinian church of the Petits Pères (now Notre-Dame-des-Victoires); Boullogne's work on ten paintings recounting the life of the saint seems to have begun around 1703, while Paolo de Matteis was painting his frescoes for the ceiling of the library there. These pictures, such as the large *Baptism of Saint Augustine* now in Bordeaux, were horizontal in format.[1]

The second series, for one of which the Snite Museum's canvas is a sketch, was intended for the chapel of St. Augustine in Saint-Louis-des-Invalides; this project was more or less contemporary with the Petits Pères series. The other scenes painted for the Invalides showed the *Conversion, Baptism, Ordination, Dispute with the Donatists, Death,* and, in the cupola, the *Apotheosis* of the saint. Sketches similar in size and vertical format to the Snite Museum picture are known for the *Conversion* (formerly London, coll. Brinsley Ford), *Baptism* and *Ordination* (Dijon, Musée des Beaux-Arts).[2]

The Notre Dame sketch shows the young saint preaching before the aged Bishop Valerius, a unique privilege in Augustine's time. As has been noted, both Boullogne's painting and the later treatment of the same subject by Carle Van Loo (1755; Paris, Notre-Dame-des-Victoires) derive compositionally from Eustache Le Sueur's *Saint Bruno Listening to Raymond Diocrès Preaching* (fig. 44; 1645–48, Louvre).[3] This seems to have been a popular source for preaching scenes; Diderot, in his *Salon de 1761,* compared Noël Hallé's *Saint Vincent de Paul Preaching* closely and unfavorably to Le Sueur's painting.[4]

A sketchy preliminary drawing for Boullogne's picture is in the Cabinet des Dessins of the Louvre.[5] The oil sketch shows minor changes in the architectural background as well as the addition of a young acolyte at the far right of the composition.

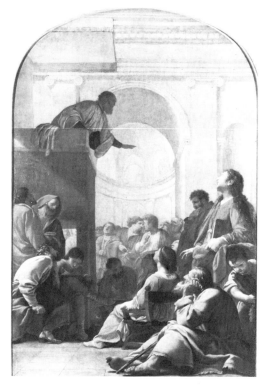

Fig. 44—Eustache Le Sueur
Saint Bruno Listening to Raymond Diocrès Preaching
Paris, Musée du Louvre

Boullogne gives most of the dramatic force to the figure of Augustine, who leans forward energetically. The bishop listens intently, while the rest of the audience relate passively or speak among themselves. Boullogne's emphasis is more on the grand setting than on the differentiation of psychological reaction that is crucial to Van Loo's mid-century version of this theme.

[1]Schnapper, fig. 1.
[2]*Ibid.,* figs. 2, 5, and 7.
[3]Conisbee, *Painting in Eighteenth-Century France,* p. 54.
[4]Denis Diderot, *Salons,* ed. Jean Seznec and Jean Adhémar, I, Oxford, 1957, pp. 117–118.
[5]Schnapper, fig. 10.

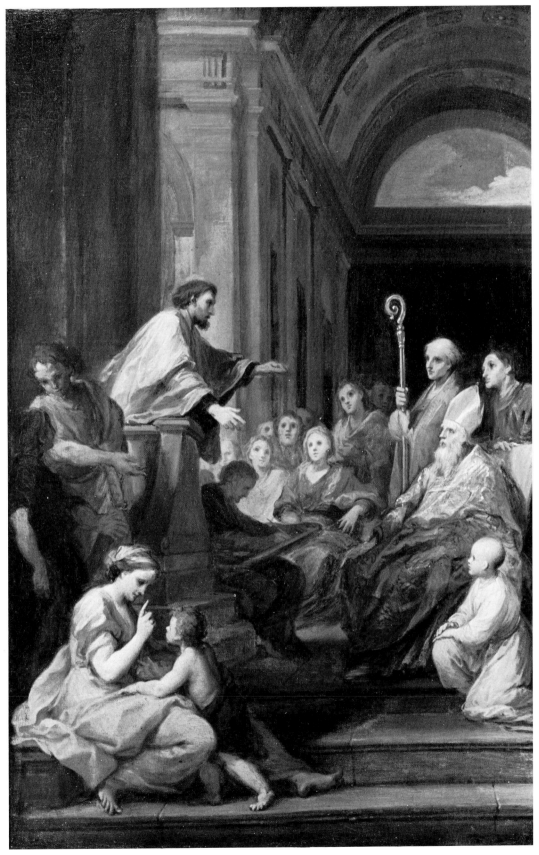

Cat. No. 6

Nicolas-Guy Brenet
Paris 1728–1792 Paris

One of the most important history painters of the generation preceding David's, Brenet is believed to have worked first in the studios of Charles-Antoine Coypel and François Boucher. At the Ecole des Elèves Protégés he also studied with Carle Van Loo and M.-F. Dandré-Bardon. While in Rome he painted an academy study, a *Sleeping Endymion* (1756; Worcester Art Museum) showing the influence of Boucher's color and brushwork. Brenet exhibited at the Salon of 1763 a *Saint Denis Praying for the Establishment of the Faith among the Gauls;* it was to be the first of his pictures dealing with the early history of France and also the first of many important church commissions for the artist. His reception piece at the Academy, *Theseus Receiving his Father's Weapons* (Salon of 1769) was admired by such diverse critics as d'Angiviller, the *Premier Peintre* Pierre, and Diderot.

As early as 1773 Brenet had been given a commission for a medieval French subject, *Saint Louis Receiving the Ambassadors* (Paris, Ecole Militaire, chapel). In 1776 he received one of the series of major commissions created by d'Angiviller and Pierre that were designed to restore honor to history painting and revive the praise of virtue and patriotic feelings: this was the large *Death of Du Guesclin* (1777; Versailles; fig. 3). At the same Salon he exhibited an equally large Classical subject praising the virtues of agriculture: *Caius Furius Cressinus Accused of Sorcery* (Toulouse, Musée des Augustins). In the following years the prolific artist produced many scenes illustrating both Classical heroism and French virtue, working in an increasingly sober and monumental style.

Though he moved away from the animation of his early technique, inspired by Boucher, Brenet retained a warmth of color and solidity of form, derived ultimately from Rubens, that is not found among the younger generation of Neoclassical artists who followed him. His study of the seventeenth-century Bolognese school is also evident in his careful compositions and his tendency to avoid scenes of violent action in his pictures. Perhaps his greatest contributions were his concerns with the accurate reconstruction of historical events in regard to setting and costume and with the depiction on a grand scale of subjects demonstrating noble and virtuous conduct.[1]

[1]See Detroit Institute of Arts, *The Age of Revolution,* 1975, pp. 336–339, and Marc Sandoz, *Nicolas-Guy Brenet, 1728–1792,* Paris, 1979.

7. *Piety and Generosity of the Roman Women,* 1785
Oil on canvas, 32 x 25½ in. (81.4 x 65 cm.)
Signed and dated (lower left): *Brenet 1785*
Salt Lake City, Utah Museum of Fine Arts

PROVENANCE: Possibly Brenet sale, Paris, 1792; private collection, France; private collection, U.S.A., 1900; New York, Newhouse Galleries, 1980.

BIBLIOGRAPHY: Marc Sandoz, "Nicolas-Guy Brenet, peintre d'histoire (1728–1792)," *Bulletin de la Société de l'Histoire de l'Art Français,* 1960, pp. 33–50 [?], and *Nicolas-Guy Brenet 1728–1792,* Paris, 1979 [?].

According to Plutarch's *Life of Camillus,* after the capture of the town of Veii by the Romans, Camillus vowed to offer a golden bowl to Apollo at the temple of Delphi to commemorate the victory. The military tribunes charged with buying gold for the bowl were unable to obtain enough, so the Roman women offered their gold and jewels to the state. Such themes of patriotic self-sacrifice were popular both with the royal art bureaucracy and with more politically radical elements in the years immediately preceding the Revolution.

The large version (330 x 258 cm.) of this painting (Fontainebleau, Musée National) was completed in the same year and shown at the Salon of 1785,[1] after which it was purchased for the King's collection. The Salt Lake City painting, which resembles the larger version in all details, is identified by Robert Rosenblum[2] with an oil sketch for this composition that appeared in the sale of Brenet's estate in 1792.[3]

The large version had been commissioned by *Directeur général* d'Angiviller in 1785 for the sum of 3,000 *livres;* the Salon catalogue indicated that Brenet's immediate literary source was the Abbé Rollin's *Histoire romaine.* The work received extensive critical coverage, generally favorable, though some critics complained of coldness or excessive evenness in the execution. A Gobelins tapestry after the composition was considered but never executed.[4] A smaller sketch (53 x 40 cm.) signed and dated in 1784 is in the Musée de Silguy, Quimper; though some of the figures differ from the later versions, the compositional arrangement is already fixed.[5]

Despite the reservations of Brenet's contemporaries, the *Piety and Generosity of the Roman Women,* as seen in the Salt Lake City version, is warmer and more attractive in color and brushwork than many contemporary Neoclassical works by David and his younger followers. Brenet's early training in the Rococo manner lingers both in these stylistic characteristics and in the choice of a pleasing, nonviolent subject of Antique virtue. The massive architectural background, echoing the monumentality of the figures, marks the transitional status of this work by an older artist adapting to the emerging Neoclassical style. Given the finished nature of the picture, it is possible that it is not a preparatory sketch but an autograph repetition of a successful composition for a favored patron.

[1]Salon of 1785, no. 7. See Rosenblum, *Transformations in Late Eighteenth Century Art,* pp. 86–87 and fig. 86.
[2]In an unpublished report, February 18, 1980.
[3]*Vente Brenet,* Paris, April 16, 1792, no. 26 (no dimensions given); see Sandoz, 1960, p. 47, and 1979, pp. 119–120, cat. no. 104Bb.
[4]See Sandoz, 1979, no. 104A.
[5]*Ibid.,* no. 104Ba, ill. pl. XIV, 2.

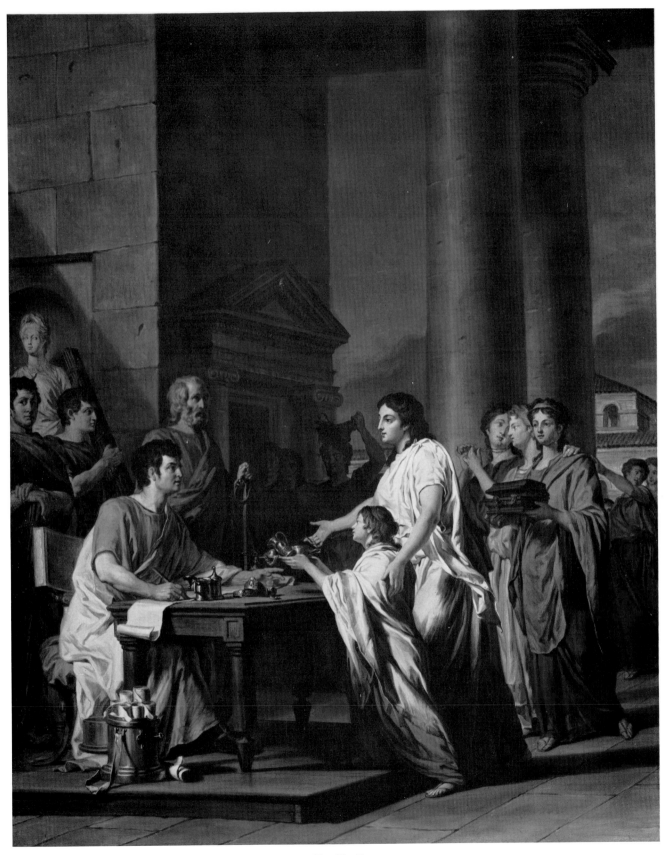

Cat. No. 7

71

Nicolas Colombel
Sotteville-lès-Rouen 1644–1717 Paris

A pupil of Pierre de Sève, Colombel was in Rome by 1682, when he sent four religious paintings to Paris. In 1686 he was named a member of the Roman Academy of St. Luke. Though still in Rome in 1691, he was received into the Academy in Paris in 1694, becoming a professor in 1705.

At the Salon of 1699 Colombel showed several religious and mythological subjects, including *Jesus Curing the Blind, Jesus Driving the Moneychangers from the Temple, Magdalene before Christ, Noli me Tangere, Amor and Psyche, The Hunt of Diana,* and *Hippomenes and Atalanta;* in 1704 he showed *Aeneas and Aphrodite, Fabius Maximus, Diana, Flora Accompanied by Maidens and Children, Bathing Women, Adam and Eve after the Fall,* and the *Adoration of the Magi* (cat. no. 8).

Colombel was harshly critical of the works of contemporary artists. Dézallier d'Argenville[1] found him to be a competent draftsman, yet a timid and unoriginal classicizing artist. Certainly Colombel's compositions are based heavily on the mature style of Nicolas Poussin. His work is characteristic of the survival of seventeenth-century French classicism into the beginning of the eighteenth century.

[1]See A. J. Dézallier d'Argenville, *Abrégé de la vie des plus fameux peintres,* Paris, 2nd ed., 1762, IV, pp. 224–229; A. Blunt, "Nicolas Colombel," *Revue de l'Art,* IX, 1970, pp. 27–36.

8. *The Adoration of the Magi;* Salon of 1704
Oil on canvas, 45 x 58½ in. (114.6 x 148.8 cm.)
New Orleans Museum of Art

PROVENANCE: Maximilien Titon, 1711; Eduard Titon du Tillet; Jacques Seligman and Co., New York; Museum purchase, Women's Volunteer Committee Fund, 1973.

EXHIBITIONS: Paris, Salon of 1704; Orléans, Musée des Beaux-Arts, *Peintures françaises du Museum of Art de la Nouvelle Orléans,* 1984, no. 4.

BIBLIOGRAPHY: Blunt, *Revue de l'Art,* 1970, pp. 28 and 30, fig. 16; New Orleans Museum of Art, *Handbook of the Collection,* 1980, p. 49, ill.; New York, Metropolitan Museum of Art, *France in the Golden Age,* p. 350, no. 5, fig. 4.

The New Orleans picture is a good example of Colombel's conservative adherence to Nicolas Poussin's compositional tenets of the 1630s. The design is a reversal of Poussin's 1633 treatment of the subject (fig. 45; Dresden, Staatliche Kunstsammlungen): the friezelike arrangement and the pointing figure are retained, though in Colombel's smaller canvas the number of figures is reduced and their scale increased. The lively movement within the figural group reduces the archaeological prominence of the ruins that dominate the background in the Poussin work.

A smaller (64 x 80 cm.) copy that appeared on the New York auction market in 1985[1] shows numerous changes in the composition and costuming. The wooden architectural background has been partially replaced by grandiose stone ruins, while the palm tree prominently displayed behind the black king in the New Orleans picture has been moved to the edge of the canvas. The positions of two figures have been changed to avoid obstructing the figure of a boy holding the horse at the far left.

Edward Caraco has suggested[2] that the picture may have been painted as much as a decade before the Salon of 1704, since Colombel showed his works in groups at the rare Salons of the period. On the other hand, the artist did not include the picture in the substantial group of works he showed at the Salon

Fig. 45—Nicolas Poussin
Adoration of the Magi
Dresden, Staatliche Kunstsammlungen

of 1699. At least one painting Colombel exhibited in 1704, the *Fabius Maximus,* was signed and dated in that year. Blunt believes that Colombel underwent the influence of Pierre Mignard in the 1690s but returned to a more severe Poussinesque manner after 1700; the New Orleans picture could well fit into this stylistic late phase.

[1]Sale, Sotheby's, New York, January 17, 1985, no. 19, ill. in color (as by Colombel).
[2]In Orléans, Musée des Beaux-Arts, 1984, no. 4.

Cat. No. 8

Nicolas Colombel
Sotteville-lès-Rouen 1644–1717 Paris

9. *The Finding of Moses*
Oil on canvas, 28⅜ x 38 in. (72.2 x 96.6 cm.)
Greenville, S.C., Bob Jones University Art Gallery and Museum

PROVENANCE: Private collection, England; gift of the Potter-Shackelford Construction Company to the Museum, 1959.

BIBLIOGRAPHY: *Art Quarterly, XXIII,* 1960, ill. p. 98; *The Bob Jones University Collection of Religious Paintings,* Greenville, 1962, I, No. 105, ill.; Blunt, *Revue de l'Art,* 1970, p. 30, fig. 19.

Blunt suggests that this may be a *Moïse sauvé* described by Dézallier d'Argenville in 1745 as having Colombel's best color. In the 1762 edition he mentioned a picture, possibly different, of the same subject painted for the Château de Meudon; Blunt notes a payment of 600 *livres* in the *Comptes des Bâtiments* dated October 1, 1703, for the Meudon picture. The Greenville canvas may be one of those mentioned by Dézallier d'Argenville. A *Moses Cast on the Waters* of nearly identical dimensions (73 x 98 cm.; Texas, priv. coll.) is convincingly proposed as a pendant to the Greenville picture.[1] The dating of the picture remains an open question. Blunt tends to date most of Colombel's works in close proximity to paintings known to have been produced in the early 1680s. It is implausible, however, that so much of the artist's surviving work should date from the beginning of his career; more likely, his style did not vary greatly over a period of several decades. Despite Colombel's reputation as a doctrinaire follower of Poussin, the colors he uses in the costumes here (as in cat. no. 8) show a certain softening from the metallic hues of the Poussin works of the 1630s that served as his principal models.

[1]Blunt, *Revue de l'Art,* 1970, fig. 18; a closely variant drawing (fig. 20) is in the Staedel Institut, Frankfurt.

Cat. No. 9

Antoine Coypel
Paris 1661–1722 Paris

Antoine, the most famous of the Coypel dynasty of painters, was son and pupil of Noël Coypel, who was appointed director of the French Academy in Rome in 1672. Considered a prodigy, he was awarded a prize at the age of twelve by the Roman Academy of St. Luke, and in 1676 received a second prize at the Paris Academy school for an *Adam and Eve Driven from Paradise*. He was admitted to the Academy in 1681 at the age of twenty on the presentation of his picture *The Glory of Louis XIII*.

Specializing as a history painter, Coypel showed numerous Old Testament and mythological pictures at the Salon of 1699 and again in 1704, the latter group including another *Adam and Eve* (cat. no. 10). He was even more active as a decorative painter, thanks to the patronage of the royal family. He worked at the Château de Choisy, the Hôtel Lambert, the Academy of Sciences, and the royal chapel at Versailles (1707–10). For the Dauphin Coypel worked at Meudon, and in 1688 he was appointed first painter to the King's brother, the Duc d'Orléans (*Premier Peintre de Monsieur*).

Perhaps Coypel's greatest patron was the duke's son Philippe, later Regent during the minority of Louis XV. At Philippe d'Orléans's residence, the Palais Royal, Coypel painted the ceiling of the Gallery of Aeneas (1702–05), adding a series of large easel paintings along the walls in 1714–18.[1] This celebrated decorative ensemble was largely destroyed in 1784, though some of the wall canvases survive. The project was based on earlier painted galleries by Annibale Carracci and Charles Le Brun, but executed in a somewhat more painterly and colorful technique.

Coypel was made rector of the Academy and *Premier Peintre* in 1716 and ennobled the following year, though his career was halted soon thereafter by poor health. An admirer of the grace of Correggio (whose works he studied in Italy) and of Rubens, Coypel also retains the dramatic gestures associated with the school of Poussin. His style is one of compromise, yet of elegance and charm, and it is characteristic of the differing currents in French history painting at the turn of the eighteenth century.

[1] A. Schnapper, "Antoine Coypel: la Galerie d'Enée au Palais-Royal," *Revue de l'Art*, V, 1969, pp. 33–42.

10. *God Reproving Adam and Eve*, Salon of 1704
Oil on canvas, 46¼ x 35¾ in. (117.5 x 91 cm.)
Museo de Arte de Ponce, Puerto Rico, The Luis A. Ferré Foundation

PROVENANCE: Marquess of Bute, sale, London, Sotheby's, November 16, 1960, no. 30 (as Gerard de Lairesse); Museum purchase, 1961.

EXHIBITIONS: Paris, Salon of 1704; San Juan, Instituto de Cultura Puertoriqueña, 1961, no. 28 (as Charles Le Brun); Toledo-Chicago-Ottawa, *The Age of Louis XV*, 1975–76, no. 19, ill. pl. 2.

BIBLIOGRAPHY: Julius S. Held, *Museo de Arte de Ponce, Catalogue, I, Paintings of the European and American Schools*, Ponce, 1965, p. 44, fig. 92 (as Antoine Coypel).

Antoine Coypel is best known today for his large decorative ensembles for the Chapelle Royale, Versailles, and the now dispersed Galerie d'Enée in the Palais Royal. Nevertheless, he also painted contemporary history (the tapestry cartoon for *The Arrival of the Ambassador Mehmet Effendi in Paris*, 1721) and produced many easel-sized pictures on religious and mythological subjects. The Ponce composition was engraved c. 1724–26 by Pierre-Imbert Drevet (1697–1739);[1] it is probably the *Adam and Eve who, After their Sin, Attempt to Escape the Presence of God* that Coypel exhibited at the Salon of 1704. Included in the exhibition were a variety of other subjects by the artist, including *The Sacrifice of Abraham, Jacob and Laban, Esther before Ahasuerus, Bacchus and Amor*, and *Rinaldo and Armida*. This level of production since Coypel's equally large showing at the Salon of 1699 was impressive, particularly as it was during these years that the artist was working on the ceiling paintings for the Galerie d'Enée.

The scene chosen for depiction is rarer iconographically than that of Adam and Eve being driven from the Garden by an angel, the subject Coypel had already treated as a youth in 1676. The emphatic gestures, but otherwise rather frozen movement, are also found in Coypel's later paintings for the Palais Royal, such as *Aeneas Appearing to Dido* of c. 1715 (fig. 7).

[1] Daniel Wildenstein, "L'oeuvre gravé des Coypel, II," *Gazette des Beaux-Arts*, LXIV, 1964, p. 142, fig. 4.

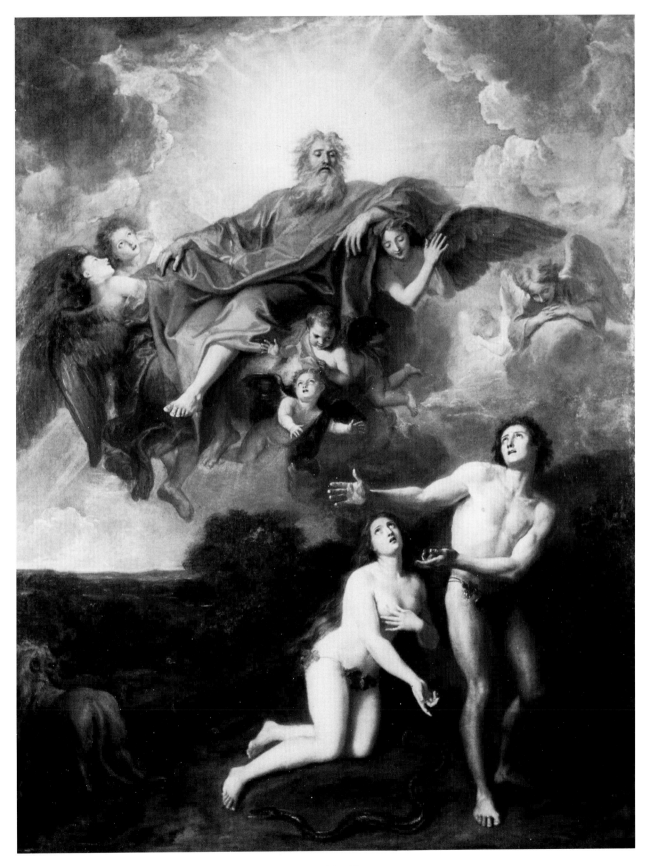

Cat. No. 10

Charles-Antoine Coypel
Paris 1694–1752 Paris

Son of Antoine and nephew of Noël-Nicolas Coypel, Charles-Antoine entered the Academy in 1715 with the submission of his *Jason and Medea*. He was to rise through the hierarchy of the institution, becoming director by 1747. After the death of Antoine in 1722 he inherited the positions of director of the royal painting and drawing collections and first painter to the Regent, the Duc d'Orléans. Coypel's brilliant official career was crowned by his appointment, like his father before him, to the post of *Premier Peintre du Roi*. Working with the *Directeur général des bâtiments*, Lenormant de Tournehem, Coypel sought to reorganize and strengthen the Academy, and was involved in the founding of the *Ecole des Elèves Protégés*.

Coypel's *Perseus and Andromeda* for the 1727 concours, though not a prizewinner, was bought by the King, and the artist showed regularly at the Salon from 1737 onward. He was a prolific creator of mythological and Old Testament pictures and illustrations of literary subjects, such as his series of Gobelins tapestry cartoons of *Don Quixote*, begun in 1716. Coypel also had a literary bent that was unusual for an artist of his time: he wrote comedies and tragedies that were successfully produced at court and published works of art criticism, such as the *Parallèle de l'eloquence et la peinture* (1751). Many of his paintings have a "theatrical" emphasis on dramatic gestures, flat backgrounds, and strong, harsh colors that even in his lifetime were criticized as antirealistic.

11. *Joseph Recognized by his Brothers*, 1740
Oil on canvas, 50½ x 63½ in. (128 x 162 cm.)
Signed and inscribed (lower left): *Peint pour la seconde fois par Charles Coypel avec beaucoup de changements, 1740*
New York, Mr. and Mrs. Morton B. Harris (**See pg. 102**)

PROVENANCE: Coypel de Saint-Philippe collection, sale, Paris, June 11, 1777, no. 25; London, Trevelyan Turner; Minneapolis, Walker Art Center; sale, New York, Parke-Bernet, Oct. 22, 1970, no. 52, ill.

EXHIBITIONS: Paris, Salon of 1741, no. 3; Los Angeles, UCLA Art Galleries, *French Masters: Rococo to Romanticism*, 1961, ill. p. 14 (as *The Clemency of Abasuerus*); Atlanta, High Museum of Art, *The Rococo Age* (cat. by Eric M. Zafran), 1983, no. 7, color pl. 7.

BIBLIOGRAPHY: Antoine Schnapper, " 'Le chef-d'oeuvre d'un muet' ou la tentative de Charles Coypel," *La Revue du Louvre*, XVIII, 1968, pp. 254, 259–260, ill. fig. 6.

The story of Joseph was one of the Old Testament narratives most frequently painted in eighteenth-century France: another example is Hallé's *Joseph Accused by Potiphar's Wife* (cat. no. 26), a subject treated by Coypel himself in 1737. *Joseph Recognized by his Brothers* depicts the moment from Genesis 45 in which Joseph, now minister to Pharaoh, reveals himself to the brothers who had sold him into Egypt and embraces his youngest brother Benjamin. As the artist noted in the inscription, he had painted the subject earlier, in 1725, as a large tapestry cartoon (Cluny, Saône-et-Loire, Musée) executed for the Gobelins works as part of a series of Old Testament scenes that had been commissioned from his father, Antoine Coypel (d. 1722), and left unfinished. The earlier version had a somewhat less formal setting: the background opened onto a garden and the central group was not placed on a pair of steps.

The 1740 picture, like the 1737 *Joseph Accused by Potiphar's Wife* and a scene from Racine's tragedy *Athalie* that Coypel also showed at the Salon of 1741,[1] demonstrates the artist's increasing interest in the theater. The steps, pillars on high bases at the side, and open center revealed by a heavy curtain all follow the conventions of the eighteenth-century stage, as do the poses and emphatic gestures of the protagonists. Schnapper suggests that this picture, like the *Athalie*, is a transcription of a theatrical performance, in this case possibly of the Abbé Genest's tragedy *Joseph*, staged at the Théâtre Français in 1710 and 1711.[2]

The fact that the central group has been mistaken for Ahasuerus and Esther, rather than Joseph and Benjamin, gives some indication of the importance of descriptive Salon titles for history paintings of this kind. Critics of the period concentrated less on formal elements like color and drawing than on the appropriateness of pose and expression to convey the story at hand. One reviewer of the Salon of 1741 wrote:

> Especially fine is the way in which Joseph and Benjamin are united skillfully by a spirited embrace in a most theatrical manner that allows us to observe all of their action. On these two noble faces we can easily read their emotions; the tender surprise of one and the generous sensitivity of the other. One perceives the tears they are about to shed and the contrasting emotions behind them.[3]

He added, less generously:

> One may find a rather similar manner in the faces, however, but that may be excused here, since they are all brothers, among whom it is natural that one may resemble another.[4]

In addition to its literary or theatrical references, the painting represents a mixture of seventeenth-century stylistic influences. The poses, particularly of the kneeling brothers, seem a direct attempt on Coypel's part to revive the grand manner of Poussin and Le Brun. The influence of artists who worked in Italy, such as Salvator Rosa and Claude Vignon, may be detected in some of the figures. Moreover, the interest here in Oriental costume and the painterly handling of a warm but relatively limited range of colors suggest a Rembrandtesque current that is not often seen in French history painting of the mid-century.

[1] See Schnapper, " 'Le chef-d'oeuvre d'un muet'," figs. 4 and 5.
[2] *Ibid.*, p. 260.
[3] Anon., "Lettre à M. de Poiresson-Charmarande...au sujet des tableaux exposés au Salon du Louvre," *Les Nouveaux Amusements du Coeur et de l'Esprit*, XI, 1741, pp. 29–30; translated in Zafran, *The Rococo Age*, p. 38.
[4] "Lettre," quoted in I. Jamieson, *Charles-Antoine Coypel, Premier Peintre de Louis XV et auteur dramatique (1694–1752)*, Paris, 1930, p. 19.

Noël-Nicolas Coypel
Paris 1690–1734 Paris

The half-brother of Antoine Coypel, but only four years older than Antoine's son Charles-Antoine, Noël-Nicolas was somewhat overshadowed by his famous family. Although he studied with his father Noël, formerly director of the French Academy in Rome, Noël-Nicolas never visited Italy. In 1716 he was *agréé* at the Academy with his *Transfiguration*, and admitted to full membership in 1720 with *The Rape of Amymone by Neptune*. Coypel was made a professor in 1733, less than a year before his death; he also maintained a studio and was a teacher of the great still life and genre painter Chardin.

Coypel did not exhibit at the Salon, but did show an historical subject, *Roman Charity*, at the *Exposition de la Jeunesse* in 1724. In 1727 he participated in the royal *concours* for academicians, offering a *Rape of Europa* (Philadelphia Museum of Art) that was the favorite of the public because of its beautiful color and draftsmanship; the prize, however, was awarded to François Lemoine and J.-F. de Troy. A court official, the Comte de Morville, responded by giving Coypel an amount nearly equal to the prize that had been offered.[1]

Though mainly a mythological painter, Coypel received several commissions for church decorations, beginning with the early *Moses Striking the Rock* and *The Manna in the Desert* for the church of St.-Nicolas du Chardonnet, Paris. For the Chapelle de la Vierge, church of Saint-Sauveur, Paris, he worked with the sculptor Jean-Baptiste Lemoyne to produce an illusionistic ceiling painting of *The Reception of the Virgin into Heaven*, while for the high altar he painted an *Assumption of the Virgin* (1731; destroyed 1778). He also engraved religious and mythological subjects.

Noël-Nicolas lacked his half-brother's talents as a courtier and spent much of his career in financial difficulty. Despite his obscurity during his lifetime, his posthumous reputation has fared better than those of the other members of his family. The elegance, colorism, and flowing movement of his *Rape of Europa* look forward to such masterpieces of the Rococo period as François Boucher's *Birth of Venus*.

[1]Dézallier d'Argenville, *Abrégé*, 1762, IV, pp. 442–443.

12. *The Rest on the Flight into Egypt*, 1724
Oil on canvas, 39 x 28¼ in. (99 x 71.5 cm.)
Signed and dated (lower right): *N. Coypel f. 1724*
New York, Mr. and Mrs. Arthur Frankel (**See pg. 80**)

PROVENANCE: Vienna, Fröhlich collection, 1936; Barbara B. von Goetz, 1969.

EXHIBITIONS: Atlanta, High Museum of Art, *The Rococo Age*, (cat. by Eric M. Zafran), no. 5, color pl. 5.

BIBLIOGRAPHY: David Lomax, "Noël-Nicolas Coypel (1690-1734)," *Revue de l'Art*, LVII, 1982, p. 42, ill. fig. 24.

Subdued in color and movement in comparison with the brilliantly theatrical *Rape of Europa* of 1727, this work, sober yet tender in feeling, recalls the *gravitas* of seventeenth-century French religious painting. Coypel later used the popular oval form masterfully for a pair of mythological paintings of 1734 now in the Louvre,[1] and also for his major lost ceiling painting for Saint-Sauveur, *The Reception of the Virgin into Heaven*, known from an oil sketch (1731; Nancy, Musée Lorrain).[2] The subject, an extremely popular one in the early eighteenth century, may be seen in other versions in the exhibition by such artists as Henri de Favanne. The nature of the commission for this work is unknown.

The full-bearded Saint Joseph with parted, flowing hair is very close in treatment to the protagonist of the *Saint James and the Magician*, a small work of 1726 (Cleveland Museum of Art),[3] and may be painted from the same model. That painting demonstrates the adaptability of Coypel's style to the subject at hand: the figures make dramatic, sweeping gestures in the manner of Jouvenet before a grand architectural background. The inspiration for *The Rest on the Flight into Egypt* may be Poussin, but the figures are more monumental and closer to the picture plane than in most of the seventeenth-century master's paintings of the Holy Family.

[1]Lomax, "Noël-Nicolas Coypel," figs. 30 and 31.
[2]*Ibid.*, fig. 27.
[3]Zafran in *The Rococo Age*, no. 5.

13. *The Nativity*, 1728
Oil on canvas, 39¾ x 42½ in. (101 x 108 cm.)
Original dimensions (octagonal): 38 x 39 in. (96.5 x 99 cm.)
Signed and dated (left center): *n.n./coypel/f. 1728*
New York, Didier Aaron, Inc. (**See pg. 81**)

PROVENANCE: France, private collection; New York, Didier Aaron, Inc.

EXHIBITIONS: New York, Didier Aaron, Inc., *French Paintings of the Eighteenth Century*, 1983, no. 7, ill.

It is interesting to compare this rendering of the Holy Family with that in *The Rest on the Flight into Egypt*, painted four years earlier (see preceding entry). Coypel again uses an atypical format, in this case an octagonal canvas, the corners of which have subsequently been filled in. The figures and costumes recall the earlier composition, as does the position of the reclining child. The interior setting, however, with its artificial lighting in the center, creates a more luminous and ecstatic mood that derives ultimately from North Italian Renaissance painting, particularly Correggio. The placement of the animal in the foreground is closely related to Jean-François de Troy's *Adoration of the Shepherds* of 1725,[1] though in other respects this painting varies considerably from de Troy's more naturalistic scene.

[1]London, Wildenstein, *Religious Themes in Painting from the 14th Century Onwards*, 1962, no. 41, ill.; see New York, Didier Aaron, Inc., *French Paintings*, no. 7.

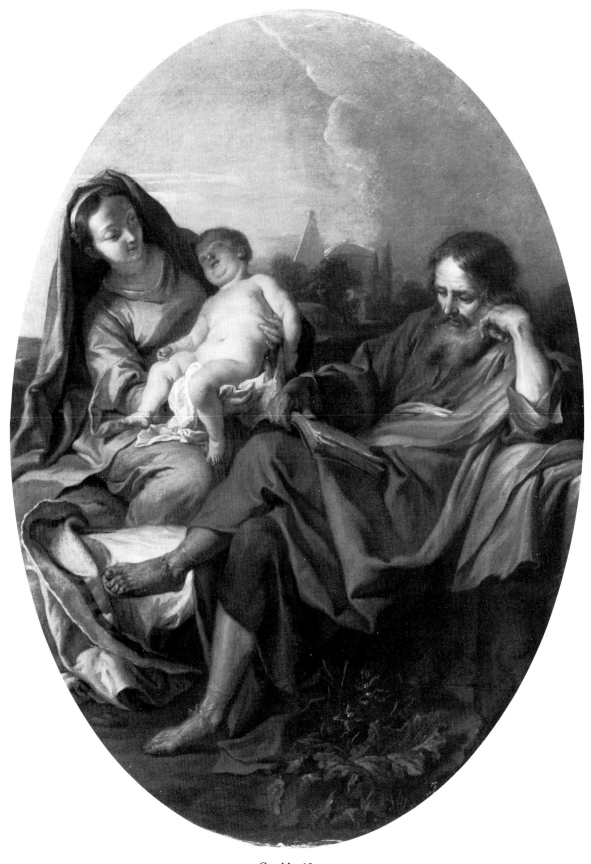

Cat. No. 12

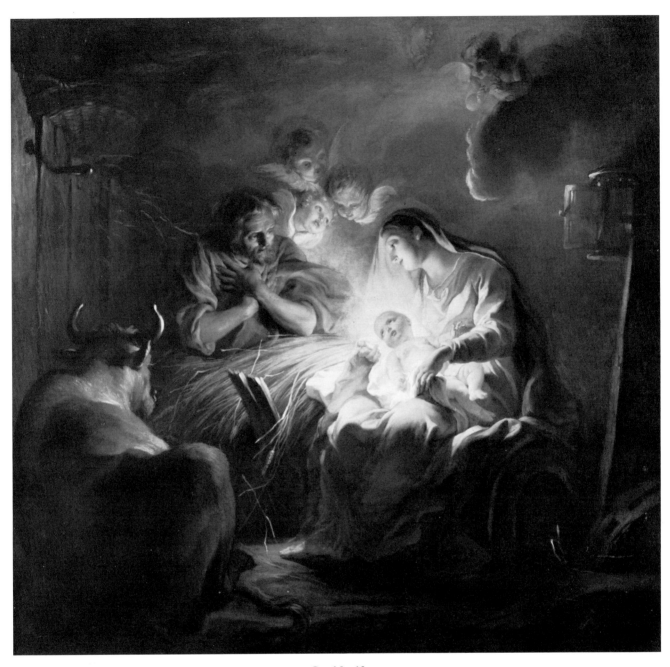

Cat. No. 13

Jacques-Louis David
Paris 1748–1825 Brussels

David was the leading artist of the French school for more than thirty years and the greatest master of Neoclassicism. He was a pupil of the history painter Joseph-Marie Vien by 1768 and again from 1775 to 1780 in Rome, where Vien had been appointed director of the French Academy. Slow to mature as an artist, David won the *Prix de Rome* competition only on his fourth attempt, in 1774, with *The Illness of Antiochus* (Paris, Ecole des Beaux-Arts).

The works executed by David during his stay in Rome are transitional. Some, like *Saint Roch Interceding for the Plague-Stricken* (Marseilles, Musée des Beaux-Arts), show the influence of Italian Baroque artists, particularly Caravaggio and Guercino. Other works, notably the equestrian *Portrait of Count Stanislas Potocki* (Warsaw, National Museum) betray an admiration for Rubens and Van Dyck that David usually attempted to suppress, but to which he yielded at different moments in his career. His first "Davidian" work, *Belisarius* (1781; Lille, Musée de Beaux-Arts), which had a great success at the Salon of 1781, showed the artist's new interest in the classicizing art of Poussin. This direction intensified in David's great paintings of the 1780s, *Hector and Andromache, The Oath of the Horatii, The Death of Socrates,* and *The Lictors Bringing Back to Brutus the Bodies of his Sons,* giving the artist an unquestioned position of leadership among French history painters.

During the Revolution David's artistic production was more limited, due to his active participation in political events. A radical deputy to the Convention in 1792 and a member of the Committee of Public Safety in 1793, David was imprisoned for a time after the fall of Robespierre. His *Death of Marat* (Brussels, Musées Royaux des Beaux-Arts), perhaps his greatest work, conveys the intense political emotions of this period. The *Marat* also signals the shift in emphasis in David's best works to scenes of contemporary history, even though some were left incomplete or destroyed as a result of political events.

Settling old grudges, David instigated the abolition of the Royal Academy in 1793 and was a founding member of its replacement, the Institute, two years later. An early supporter of Bonaparte, David became the leading court painter under the Empire. His best works of this period are not his increasingly academic Classical themes, but such Rubensian contemporary pictures as *The Coronation of Napoleon and Josephine* (Louvre). Exiled to Brussels after the fall of the Empire in 1815, David continued to produce mythological paintings in a style that is a highly personal amalgam of idealization and realistic detail (*Mars Disarmed by Venus and the Three Graces*, 1824; Brussels, Musées Royaux). Though he executed portraits and even a landscape, David believed firmly in the primacy of history painting, and he reestablished in France a dominance of this genre that was to last for nearly a century.

14. *The Death of Seneca*, 1773
Oil sketch on canvas, 17 x 21 in. (43 x 53 cm.)
Paris, Musée du Petit Palais

PROVENANCE: Sedaine family [?]; M. de Brisay de l'Isle Adam [?]; Baron Bethmann (by 1913), sale, Paris, June 21–22, 1923, no. 149; R. Kieffer, sale, May 29, 1969, no. 84 (Museum purchase).

EXHIBITIONS: Toledo Museum of Art, *The Age of Louis XV,* 1975 (cat. by Pierre Rosenberg), no. 25, ill. pl. 121.

BIBLIOGRAPHY: Charles Saunier, "La 'Mort de Sénèque' par Louis David," *Gazette des Beaux-Arts,* 3rd per., XXXIII, 1905, pp. 233–236, ill. facing p. 234; Anita Brookner, *Jacques-Louis David,* New York, 1980, p. 42; Antoine Schnapper, *David,* New York, 1982, pp. 25–26, ill. fig. 4.

This work is an advanced oil sketch for David's third unsuccessful *Prix de Rome* effort; the larger work (129.5 x 196.2 cm.), in fragile condition, is in the Musée du Petit Palais, where it was joined by the sketch in 1969. As recounted in a celebrated passage of Tacitus's *Annals,* the philosopher Seneca, tutor of the Roman emperor Nero, was ordered by his former pupil to commit suicide. Acceding to the demand, Seneca destroyed documents posing a danger to others, sent Nero a sealed denunciation of his crimes, and had his veins opened in a bath. The selection of this tale of Stoic virtue as the subject of the *Prix de Rome* competition is indicative of the importance of the *exemplum virtutis* in official French patronage from the 1770s onward.

The winning entry by Pierre Peyron, though now lost, is known from an engraving by the artist.[1] Peyron chose to follow the inspiration of Poussin: before a grand architectural backdrop, set parallel to the picture plane, all the figures are disposed in a shallow, stagelike space. Seneca's wife Paulina, who volunteered to share his death, turns away in grief from the aged, gaunt philosopher. Peyron's somber *mise-en-scène* has been aptly described as "more Davidian than David's."[2]

By contrast, David's composition is still fully within the Baroque idiom. The architectural background is fantastic and recedes diagonally into the distance, as does the pyramidally shaped figural group. The grisly mode of Seneca's death is not very specifically treated, and the light blue and pink colors impart an almost Rococo gaiety to the canvas. The swaying poses of the two protagonists are not heroic but operatic; indeed, the subject of David's picture is not so much a Stoic death but a romantic farewell of lovers. The larger version is more highly finished and subdued in color: a brownish-gray has replaced the blue in the colossal columns and other background areas, yet the overall impression is not greatly changed.

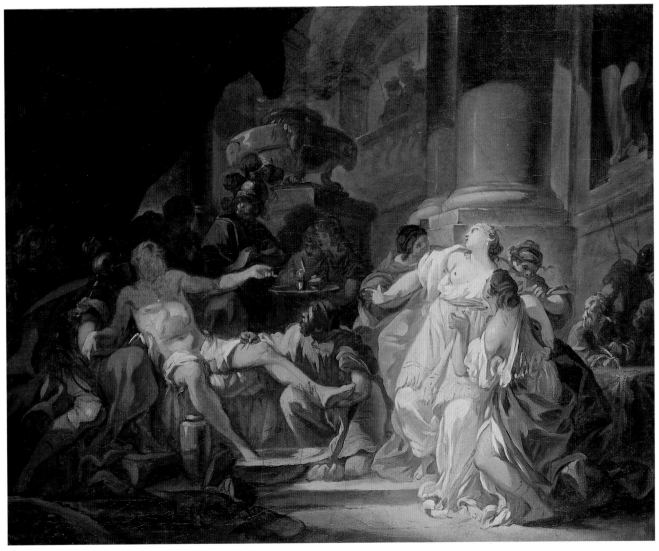

Cat. No. 14

It is not surprising that David's composition, despite its energy and colorism, was found less up to date than Peyron's, for the execution differs little from that of sketches by Fragonard. Though this may not yet be the "true" David, it already contains characteristic touches in the separation of the male and female groups to the left and right (see also in *The Oath of the Horatii* and the *Brutus*) and in the expression of emotional intensity, which David was able to bring into much stronger focus in his later works.

[1]Saunier, "La 'Mort de Sénèque'," ill. p. 235, and Brookner, *Jacques-Louis David*, fig. 9.

[2]Louis Hautecoeur, *Louis David*, Paris, 1954, p. 28.

Jacques-Louis David
Paris 1748–1825 Brussels

15. *The Lictors Bringing Back to Brutus the Bodies of his Sons*, 1789
Oil on canvas, 27½ x 36 in. (70 x 91 cm.)
Signed and dated (lower left): *L. David f. [bat] parisiis/anno 1789*
Hartford, Wadsworth Atheneum

PROVENANCE: Anonymous sale, Paris, Dec. 12, 1925; New York, Wildenstein & Co.; Museum purchase, Ella Gallup Sumner and Mary Catlin Sumner Collection, 1934.

EXHIBITIONS (selected): London, Burlington House, *French Art 1200–1900*, 1932, no. 274, ill. p. 135; Springfield, Mass., Springfield Museum of Fine Arts, *From David to Cézanne*, 1935, no. 10; Rochester, Memorial Art Gallery, *Rebels in Art*, 1936–37, ill. p. 9; New York, Wildenstein & Co., *The French Revolution*, 1943, no. 50, ill. p. 115; Toledo Museum of Art, *The Spirit of Modern France*, 1946, no. 14; New York, Knoedler Galleries, *Masterpieces from the Wadsworth Atheneum*, Hartford, 1958, ill. p. 96; Cleveland Museum of Art, *Neo-Classicism: Style and Motif*, 1964, no. 115, ill.; Washington, D.C., National Gallery of Art, *The Eye of Thomas Jefferson*, 1976, no. 270, ill. p. 163.

BIBLIOGRAPHY (selected): *Cleveland Museum of Art Bulletin*, XVI, Nov. 1929, ill. p. 166; "A Painting by David," *Wadsworth Atheneum Bulletin*, Oct.–Dec. 1934, pp. 36–38, ill. p. 37; David L. Dowd, *Pageant Master of the Republic: Jacques-Louis David*, Lincoln, Neb., 1948, p. 20; Germain Bazin, *The Loom of Art*, London, 1962, p. 267, no. 372; Robert L. Herbert, *David, Voltaire, "Brutus" and the French Revolution*, New York, 1973, p. 8; David Burnett, "Looking for the work of art: A stand on current art criticism," *ARTSCANADA*, nos. 234–235, Apr.–May 1980, ill. p. 11.

This picture is a reduced copy of one of David's most important history paintings, first shown at the Salon of 1789 (325 x 425 cm.; Louvre). After the successful exhibition of *The Oath of the Horatii* in 1785, discussions began regarding a painting to be commissioned by the King.[1] The following year, David considered painting a *Sword of Damocles* and in 1787 the subject of *Regulus Tearing Himself Away from His Family to Return to Carthage, where Torture Awaited Him*. The subject of *Coriolanus* (see cat. no. 22) was proposed by d'Angeviller, but David, perhaps independently, settled on *Brutus* as the subject of his commission by 1788 and showed the picture the following year, soon after the fall of the Bastille. Much of the massive literature that has grown around this composition[2] has attempted to determine whether the picture conveys sentiments related to the Revolution in which David was soon to take part.

The full title given the large painting at the Salon was: "Brutus, the first consul, returns to his home after having condemned his two sons who had joined the Tarquins and had conspired against Roman liberty. The lictors bring back their bodies so that he may give them burial." After the rape of Lucretia by the son of King Tarquin the Proud, and her subsequent suicide, Brutus had led others in vowing to avenge her death and drive the monarchy from Rome; the oath-taking scene had been depicted by such artists as Beaufort (see cat. no. 1). After becoming consul of the Republic, Brutus heard that his sons Titus and Tiberius were involved in a plot to restore the monarchy. According to the historians Livy and Plutarch, he watched impassively as they were executed at his command. The scene chosen by David is more private: Brutus, grieving at home beneath a statue of Roma, is distracted by the women of the family, who scream and faint as the bodies are brought in.

It is now generally accepted that no overtly political message was intended by David, who saw the picture as a dramatic depiction of Antique patriotic virtue being valued above personal concerns. The government had sponsored similar patriotic themes throughout the reign of Louis XVI and made no attempt to prevent the showing of the *Brutus*. The choice of subject may nevertheless reflect the libertarian views of Voltaire's tragedy *Brutus* (1730), which was briefly revived in 1786. The charged emotional state of the composition, the most intense of all David's historical paintings, also surely reflects the agitated political situation immediately preceding the outbreak of the Revolution. The use of uneven lighting and acid local colors, as in the red of the tablecloth, traits also found in David's earlier history paintings of the 1780s, heightens the effect of tension within the composition.

The only surviving oil sketch for the Louvre painting (Stockholm, Nationalmuseum) shows the composition in nearly final form. The Hartford version, despite its signature, as well as other reduced repetitions in Paris, Besançon, and Warsaw, are described by Herbert as "probably due to David's pupils." The problem of reduced versions or studies of David's major pictures is complex and needs further study. Like his earlier counterpart and sometime role model, Rubens, David had a large studio and collaborated to a greater or lesser extent with his pupils on many works. A number of repetitions that some art historians have assumed to be student copies are certainly in large part the work of David. A good example is the *Pope Pius VII and Cardinal Caprara* (Philadelphia Museum of Art, gift of Henry P. McIlhenny), a full-scale repetition on panel of two figures from David's great *Coronation of Napoleon and Josephine*. David is known to have shown the Philadelphia painting to visitors to his Paris studio as the work of his own hand.[3] Perhaps David, like Rubens, applied the finishing touches to some paintings by his best students before signing the works. Such may be the case in the fine Hartford version of the *Brutus*, though the extent of studio collaboration, if any, can no longer be established.

[1]On the history of this commission see Antoine Schnapper, *David*, New York, 1982, p. 89ff.
[2]See Herbert, *David, Voltaire, "Brutus" and the French Revolution*.
[3]Allentown Art Museum, *French Masterpieces of the 19th Century from the Henry P. McIlhenny Collection*, 1977, pp. 14–15.

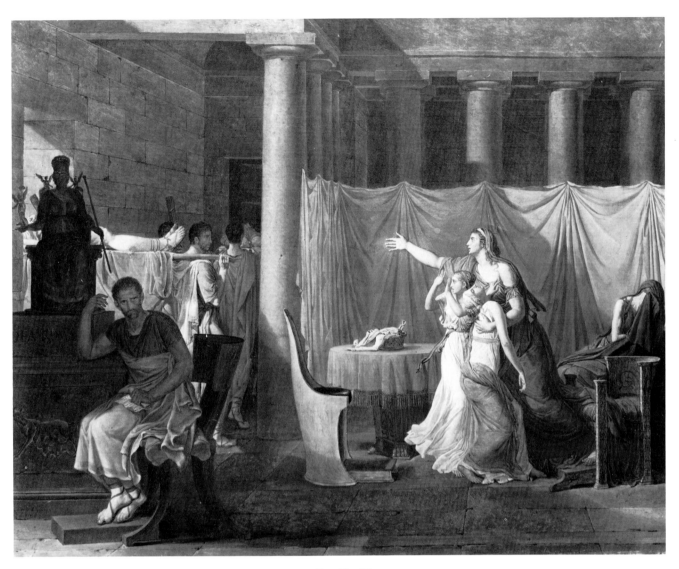

Cat. No. 15

Jean-Baptiste Deshays
Colleville, near Rouen 1729–1765 Paris

Deshays's brief career began with an extended period of study under his father, then with Collin de Vermont, Jean Restout, and François Boucher, whose daughter he married in 1758. Winner of the *Grand Prix* in 1751, Deshays studied for three years at the *Ecole des Elèves Protégés* under Carle Van Loo, then spent four years in Rome. Upon his return he was *agréé* in 1758 for *Venus Strewing Flowers on the Corpse of Hector* (Montpellier), received as a full member the following year, and made associate professor in 1760. He exhibited at the Salons from 1759 until his death.

The artist enjoyed extraordinary critical praise, particularly at the hands of Diderot, who proclaimed him *"le premier peintre de la nation"* by 1761. Though his career was cut off prematurely, Deshays experienced a full artistic development. His loose brushwork is related to that of Boucher and especially Fragonard, both in his specialty of religious painting and his other works, such as tapestry cartoons. Deshays's dramatic late-Baroque manner seems to look forward more to the Romantic style than to the Neoclassicism of his own generation.[1]

[1]Marc Sandoz, *Jean-Baptiste Deshays 1729–1765*, Paris, 1978.

16. *Saint Andrew Being Asked to Adore the Pagan Gods,* c. 1758
Oil sketch, 20⅞ x 11¹¹/₁₆ in. (53 x 29.5 cm.)
Albuquerque, University Art Museum, University of New Mexico

PROVENANCE: Private collection, on extended loan to the Museum.

EXHIBITIONS: Houston, Museum of Fine Arts, *French Oil Sketches from an English Collection,* 1973–75 (cat. by J. Patrice Marandel), no. 10, ill.

This is a sketch for the large painting that served as Deshays's reception piece to the Academy in 1758 and appeared at the Salon of 1759. By the time Deshays departed for Rome in 1753 he had already received a commission for an *Entombment of St. Andrew* for the church of Saint-André-de-la-Porte-aux-Fèves, Rouen, and he completed the work before his return. From c. 1757 to 1761 he was at work at two companion pictures, the composition of the Albuquerque sketch and a *St. Andrew Dragged to his Martyrdom,* shown at the Salon of 1761, where it was highly praised by Diderot. All three paintings are now in the Musée des Beaux-Arts, Rouen.[1]

Saint Andrew was one of the twelve Apostles and a brother of Saint Peter. In Greece he angered the proconsul Aegeas, whose wife Maximilla he had converted to Christianity. The composition shows the aged saint, condemned to flogging and execution, imploring angelic messengers for strength as he turns his back on the pagan idol. Below, an executioner prepares the X-shaped cross on which the saint will be crucified.

The composition was well received at the Salon and was engraved in the same year by Philippe Parizeau.[2] This sketch and another in a Parisian private collection differ from the final version in numerous details, particularly in the positioning of the idol, cross, and executioner. Both the whirling composition and the free paint handling of the sketch reveal Deshays's continuing dependence, in the latter part of the century, on the conventions of seventeenth-century Italian religious painting. It has also been suggested that the way in which the lower figures are cut off recalls the *Martyrdom of Saint Adrien* (1659; Rouen, Musée des Beaux-Arts) by the rather obscure Rouen painter Adrien Sacquespée (1629–after 1688).[3] Had it not been for his premature death, Deshays, like Doyen, would unquestionably have carried on the grand tradition of Baroque martyrdoms in his work until the end of the century.

[1]See Sandoz, *Jean-Baptiste Deshays,* nos. 48, 49, 59.
[2]Houston, *French Oil Sketches,* ill. p. 19.
[3]*Ibid.;* for Sacquespée see Rouen, Musée des Beaux-Arts, *Catalogue des peintures françaises XVIIème siècle* (cat. by Pierre Rosenberg), 1966, p. 114, no. 112.

Cat. No. 16

Jean-Baptiste Deshays
Colleville, near Rouen 1729–1765 Paris

17. *The Assumption of the Virgin*, c. 1758
Oil sketch on paper, 19¼ x 11⅜ in. (48.9 x 28.9 cm.)
The Minneapolis Institute of Arts

PROVENANCE: Paris, Paignon-Dijonval collection, 1810, no. 3597; London, H. L. Bishoffscheim, 1907; New York, M. Knoedler and Co.; New York, Charles E. Slatkin Galleries; Museum purchase, The Christina N. and Swan J. Turnblad Memorial Fund, 1961.

EXHIBITIONS: London, Whitechapel Art Gallery, Spring 1907, no. 25; Toledo Museum of Art, *The Age of Louis XV*, 1975 (cat. by Pierre Rosenberg), no. 27, ill. pl. 90; St. Petersburg, Florida, Museum of Fine Arts, *Fragonard and his Friends: Changing Ideals in Eighteenth-Century Art*, 1982–83, no. 37.

BIBLIOGRAPHY: Minneapolis Institute of Arts, *Catalogue of European Paintings*, 1970, p. 170–171, no. 89, ill. (as by François Boucher); Sandoz, *Jean-Baptiste Deshays*, 1978, no. 50Ba, ill. pl. V.

Though long given to Boucher, this sketch has been attributed convincingly to Deshays by Rosenberg, who compares the kneeling figures to an analogous passage in a sketch, now in Nîmes, for a *Saint Denis Preaching* that had been commissioned from Deshays for the church of Saint-Roch, Paris. Other sketches related to the Minneapolis painting are in the National Gallery of Scotland, Edinburgh, and the Musée Magnin, Dijon, but Rosenberg regards this work as Deshays's earliest idea for the composition. All of the sketches are probably related to a large *Assumption* the artist painted for the priory of Bellefonds, near Rouen, a work removed during the Revolution and subsequently lost. As the Virgin is raised bodily into the heavens in the Minneapolis sketch the brushwork is as energetic and free as any by Boucher, though the subject and composition, which are very much in the seventeenth-century Italian taste, would not have appealed to that artist.

Cat. No. 17

Bernard Duvivier
Bruges 1762–1837 Paris

Johannes Berdardus (called Bernard) Duvivier first studied at the Academy of his native Flemish city. His early works included genre scenes, seascapes, and allegorical portraits. By 1783 he was studying at the Paris Academy with his countryman Joseph-Benoît Suvée, whose dramatic manner and severe archaeological settings had a marked influence on Duvivier's historical compositions. In 1785 Duvivier received the second prize in the *Prix de Rome* competition for *Horatius Killing his Sister Camilla* (Fig. 46), a picture that shows the artist's great promise but that lacks the emotional force of Girodet's winning entry (Montargis, Musée).

Failing to win a pension in Rome, Duvivier traveled to Italy in 1790 with the assistance of a benefactor, and remained there for six years. He exhibited at the Salon from 1793 to 1827. In 1796 he showed a group of drawings after famous works by Raphael, Correggio, and Leonardo.[1] Thereafter Duvivier, who had taken French citizenship, concentrated his efforts for several years on a small (24 by 31 inches) Homeric picture, *Hector Mourned by the Trojans and his Family* (Salon of 1804, location unknown; watercolor sketch, 1793, Sotheby's Monte Carlo, sale, June 26, 1983, no. 530). In 1801 the Danish critic Bruun-Neergaard, who owned several works by Duvivier,[2] praised the drawing, expression, and color of this miniaturistic work at great length, remarking that it contained forty-six figures and had already been sold for 7,000 francs. At this time the artist was also working on a picture of a woman making an offering to Hippocrates and on some miniature portraits in oil.[3]

In his later career Duvivier seems to have moved away from the painstaking and time-consuming techniques of the *Hector*, though few of the many works he showed at the Salon can be located today; in addition to historical and mythological works he exhibited landscapes and portraits. Duvivier's reputation as a history painter is indicated by the numerous engravings and lithographs after his compositions, a few of which may have been executed by the painter himself. Much work remains to be done to reconstruct the oeuvre of Duvivier, one of the more interesting history painters of the generation immediately following that of Suvée and David.

[1] Bellier de la Chavignerie and Auvray, *Dictionnaire général*, I, pp. 509–510.

[2] Mireur, *Dictionnaire des ventes d'art*, II, p. 635.

[3] T. C. Bruun-Neergaard, *Sur la situation des beaux-arts en France*, Paris, 1801, pp. 144–148.

18. *Cleopatra Captured by Roman Soldiers after the Death of Mark Antony*, 1789
Oil on canvas, 45 x 58 in. (114 x 147 cm.)
Signed and dated (lower right): *B Duvivier 1789*
Memorial Art Gallery of the University of Rochester
Marion Stratton Gould Fund
84.40

PROVENANCE: Private collection, France, 1984; Patrick Weiller, Paris.

BIBLIOGRAPHY: D. Rosenthal, "A *Cleopatra* by Bernard Duvivier," *Porticus*, VIII, 1985, pp. 13–25.

The subject of this painting is a rarely depicted moment in the story of Antony and Cleopatra. According to Plutarch (*Life of Mark Antony*, 79), Antony died of a self-inflicted wound in Cleopatra's "monument," a fortified tomb in which the Egyptian queen had barricaded herself. Shortly thereafter, several of Octavian Caesar's men managed to enter the monument, seeking to capture Cleopatra alive. Plutarch's narrative, which was also adapted by Shakespeare,[1] continues:

> One of the two women who were shut up in the monument with her cried out, "Miserable Cleopatra, you are taken prisoner!" Upon which she turned quick, and, looking at Proculeius, drew out her dagger which she had with her to stab herself. But Proculeius ran up quickly, and seizing her with both his hands, "For shame," said he, "Cleopatra; you wrong yourself and Caesar much, who would rob him of so fair an occasion of showing his clemency, and would make the world believe the most gentle of commanders to be a faithless and implacable enemy." And so, taking the dagger

Fig. 46—Bernard Duvivier
Horatius Killing his Sister Camilla
Le Mans, Musée de Tessé

out of her hand, he also shook her dress to see if there were any poison hidden in it. After this, Caesar sent Epaphroditus, one of his freedmen, with orders to treat her with all the gentleness and civility possible, but to take the strictest precautions to keep her alive.[2]

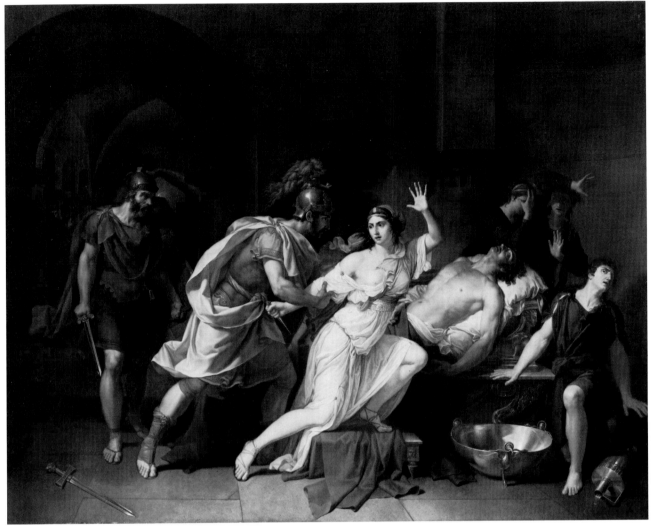

Cat. No. 18
(See cover)

As is well known, Cleopatra eventually succeeded in committing suicide, probably through the poisonous bite of an asp.

The scene of Cleopatra comforting the dying Antony was often depicted in the late eighteenth century by painters that included Pompeo Batoni, Nathaniel Dance, and Johann Heinrich Tischbein the Elder.[3] Depictions of Cleopatra's attempted suicide are so rare that one suspects the possibility of an assigned subject, perhaps for one of the preliminary rounds of the *Prix de Rome* competition.[4] Duvivier's *The Death of Camilla* in Le Mans, which won the second prize in 1785, is virtually identical in size to the *Cleopatra*. Not only the format but also the simple frame (probably original) of the Rochester picture is characteristic of *Prix de Rome* competition entries of the period.[5]

The *Cleopatra* is the work of a young artist, and several of the figures, including that of the queen and the kneeling youth at the right, are probably inspired by prints after Greek reliefs or Italian Renaissance paintings. The work nevertheless shows a considerable gain in dramatic power over *The Death of Camilla*, painted four years earlier. Though the subsequent evolution of Duvivier's style is not well documented, this early painting already embodies many of the qualities the critic Bruun-Neergaard praised in the artist's work in 1801: effective composition, careful study of the individual figures, and strong yet attractive color.[6]

[1] *Antony and Cleopatra*, V, ii.
[2] Plutarch, *The Lives of the Noble Grecians and Romans*, trans. John Dryden, New York, n.d., pp. 1148–49.
[3] A. Pigler, *Barockthemen*, Budapest/Berlin, 1956, II, p. 351.
[4] The final subject in the *Prix de Rome* competition for 1789 was *Joseph Recognized by his Brothers.*
[5] Washington, International Exhibitions Foundation, *The Grand Prix de Rome: Paintings from the Ecole des Beaux-Arts, 1797–1863*, 1984 (cat. by Philippe Grunchec).
[6] T. C. Bruun-Neergaard, *loc. cit.*

François-Xavier Fabre
Montpellier 1766–1837 Montpellier

Fabre studied at the Société des Beaux-Arts and the studio of Jean Coustou in his native Montpellier, then in Paris with Jacques-Louis David. He won the *Grand Prix* in 1787 with *Nebuchadnezzar Having the Children of Sedecias Killed in the Presence of their Father* (Paris, Ecole des Beaux-Arts) and left for Italy, where he was to spend his entire career.

While in Rome Fabre sent several works to Paris, including *The Death of Abel* (Salon of 1791; Montpellier, Musée Fabre). Although considered one of David's most promising students, Fabre was uncomfortable with the political atmosphere of the Revolution. In 1793 he fled from the dangerous situation in Rome to Florence; there he was befriended by the poet Count Vittorio Alfieri and Alfieri's mistress, the German-born Countess of Albany, widow of Charles Stuart, Pretender to the English throne. In Florence Fabre supported himself by painting portraits and copies of the old masters. Gradually he received some commissions for history paintings from wealthy English tourists such as Lord Holland, for whom he painted *Marius and the Gaul* (1796; see cat. no. 19) and *Theseus and Ariadne at the Entrance to the Labyrinth* (1797). For Lord Bristol he painted a very large *Neoptolemus and Ulysses Rob Philoc-* *tetes of the Arrows of Hercules* (1800; Louvre) and for Allen Smith several works, including an *Ajax Dragging Cassandra from the Altar of Minerva* (1797–98). His portraits of the period included *Lord Wycombe* (1793) and *Lady Charlemont as Psyche* (1796).

After 1800 Fabre continued to produce history paintings, such as the *Saul, Troubled by Remorse, Sees the Ghost of the High Priest Achimelech* (1803; Montpellier, Musée Fabre), which, like the *Neoptolemus,* was based on a poetic adaptation by Alfieri. Increasingly, however, the artist was absorbed in portraiture and in art collecting and dealing. After the death of Alfieri in 1803, Fabre presided over the Countess of Albany's salon in Florence until her death in 1824. By 1810 he had almost entirely abandoned history painting. In 1825 Fabre returned to Montpellier where, using his large collections, he endowed a school of painting, a library, and the museum that bears his name. Fabre was made a baron by Charles X in 1828.

By leaving Paris for the more provincial atmosphere of Florence, Fabre lost contact with the most advanced art currents of his time, and his later history paintings are somewhat *retardataire.* Nevertheless his best works, like the *Saul,* form a link between the high drama of the Davidian school and the more brooding and mysterious preoccupations of Romantic history painting.[1]

[1]Philippe Bordes, "François-Xavier Fabre, 'Peintre d'Histoire',"
Burlington Magazine, CXVII, 1975, pp. 91–98, 155–162.

19. *Marius and the Gaul,* 1796
Oil over ink on paper, mounted on canvas, 12½ x 15⅛ in. (31.8 x 38.5 cm.)
Inscribed (on the reverse): *"done by Fabre in 1796"*
Notre Dame, Indiana, The Snite Museum of Art, University of Notre Dame

PROVENANCE: Coll. Lord Holland; coll. Lady Agnew; London, Colnaghi; Shaker Heights, Ohio, coll. Mr. and Mrs. Noah Butkin; on extended loan to the Museum from Mrs. Butkin.

EXHIBITIONS: New York, Wildenstein and Co., *Consulat-Empire-Restauration: Art in early XIX Century France,* 1982, p. 97, ill. p. 49.

BIBLIOGRAPHY: Bordes, "François-Xavier Fabre," pt. 1; Snite Museum, *A Guide to the Snite Museum of Art,* c. 1981, p. 52, ill. in color.

Dating from Fabre's early years in Florence, this painting is a sketch for a larger work commissioned by Lord Holland (Melbury, England, Lady Agnew Collection). The sketch also belonged to Lady Agnew, a friend of Lord Holland, who was close to this commission. Several other preparatory works related to the large canvas have survived and are now in Montpellier.[1]

As recounted in Plutarch's *Life of Marius,* this noted Roman general, after defeating the Cimbrians, aroused the hostility of the Senate. After Sulla seized power in 89 B.C., Marius fled alone to the marshes of Minturnae, where he was captured. A Cimbrian soldier was sent to kill him, but Marius said, "Fellow, darest thou kill Gaius Marius?" The soldier fled, crying, "I will never be able to kill Marius."

Several authors have noted the close dependence of Fabre's composition on the large *Marius at Minturnae* (1786; Louvre) by David's short-lived pupil Jean-Germain Drouais.[2] The latter work created a sensation when it was exhibited in Rome in 1786; in the same year it was sent to Paris, where Fabre could have seen it. Drouais's painting was also engraved by Louis Darcis (Salon of 1796, no. 807) in 1796, the year of Fabre's work.[3] Drouais's composition is reversed by Fabre. Aside from the decor, the principal difference is the more dramatic *mise-en-scène* used by Drouais, whose Marius gestures forcefully with his free hand toward the soldier, while the latter covers his face with his cloak. If Fabre's work lacks the Davidian theatrical effect of Drouais's painting, it nevertheless conveys the tension of the situation through understatement. This is characteristic of Fabre's preference for frozen scenes of maximum tension, such as the Montpellier *Saul Crazed by his Remorse* or the Dayton *Roman Charity,* rather than for the depiction of violence. The moment chosen also is slightly later: the soldier, vanquished by Marius's commanding personality, has already dropped his sword and is about to flee. The Davidian echoes of the mid-1780s in the Notre Dame picture are indicative of Fabre's marginal position in Florence relative to the mainstream of French history painting during the Revolutionary period.

[1]Musée Fabre, inv. 837-1-400 and 837-1-401.
[2]See Detroit Institute of Arts, *The Age of Revolution,* pp. 401-403, 410, and color pl. 18.
[3]*Ibid.,* p. 403.

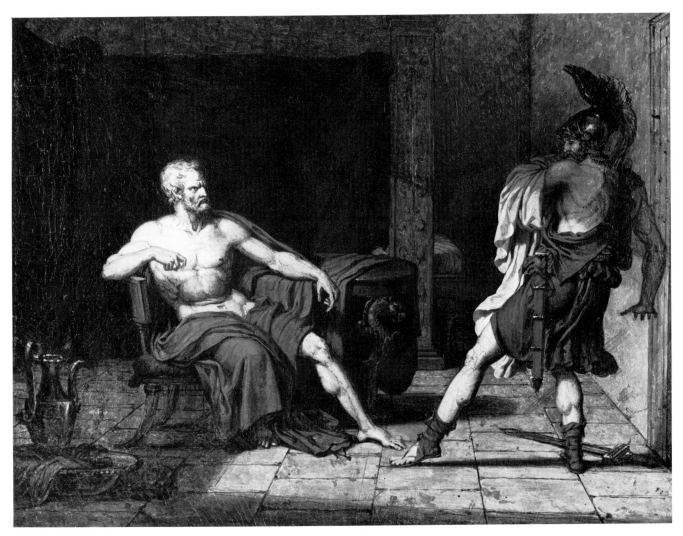

Cat. No. 19

Henri de Favanne

London 1668–1752 Paris

Favanne was raised in England, the son of a master of the hunt to Charles II, but spent some time in Paris in the early 1680s. Though named a "first huntsman" to James II, Favanne took a leave of absence in 1687 to study painting in Paris. There he worked with René-Antoine Houasse and made copies of paintings by Le Brun. A winner of the grand prize with his *Rebecca and Isaac* in 1693, Favanne spent the years 1695–1700 in Rome.

Reçu at the Academy in 1704 with *Spain Offering the Crown to Philippe, Duc d'Anjou* (Versailles), Favanne passed much of the following decade in Spain, where he worked for Phillip V in Madrid and at the Escorial. Upon his return he was engaged for nearly four years (1713–16) on a huge project—decorating the gallery, salon, and chapel of the chateau of a M. d'Aubigny at Chanteloup, near Amboise. The iconographic program for this lost series included a series depicting Phillip V for the gallery and an ambitious group of works on the life of the Virgin for the chapel.

Favanne worked at Versailles and took part in the *concours* of 1727 and in numerous Salons. In his later years he seems to have specialized in mythological scenes, but few of the works given to him by a contemporary biographer[1] are known today. The artist's work is stylistically diverse, ranging from complex allegorical and mythological compositions (*The Triumph of Justice*, Louvre) to more simplified, frieze-like religious and historical scenes that display more directly the influence of the seventeenth-century history painters Poussin and Le Brun.

[1]Cousin de la Contamine, *Mémoire pour servir à la vie de M. de Favanne...*, Paris, 1753; reprinted in *Revue Universelle des Arts*, XIV, 1861, pp. 245–268.

20. *The Adoration of the Magi*, c. 1710
Oil on canvas, 32½ x 17⅞ in. (82.5 x 45.5 cm.)

21. *The Rest on the Flight into Egypt*, c. 1710
Oil on canvas, 32½ x 18⅜ in. (82.5 x 46.8 cm.)
Detroit Institute of Arts

PROVENANCE: Corby Castle, Cumbria, England, coll. Catherine Mary Howard (by 1819–1849); New York, Auslander and Wittgenstein, Inc.; Founders Society purchase, Edgar R. Thom Bequest Fund and Matilda R. Wilson Fund, 1984.

These little-known finished sketches depict familiar subjects from the childhood of Christ. The dignified mood, planar compositions, and subdued colors mark these paintings as late exemplars of the school of Poussin. The stately architectural background of the *Rest on the Flight*, likewise typical of the school, includes a mixture of Classical and Egyptian elements. A stylistic peculiarity of these paintings is the bulbous, idealized shape of the heads, most extreme in the figure of the Christ Child. Several of the subsidiary figures have the small, dark, intense eyes that are a hallmark of Favanne's style. The larger commissions, if any, to which these unpublished studies may be related are not recorded.

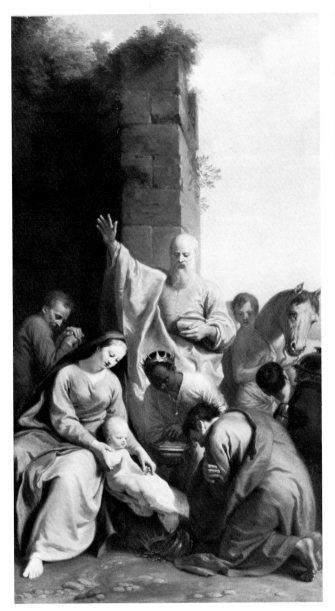

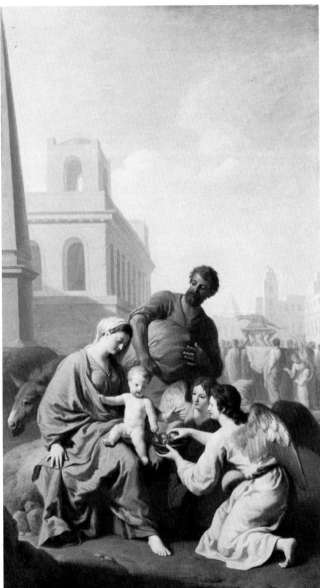

Cat. No. 20 Cat. No. 21

Henri de Favanne
London 1668–1752 Paris

22. *Coriolanus Taking Leave of his Family to Fight against his Country*, 1725
Oil on canvas, 38¼ x 50¾ in. (97 x 129 cm.)
Auxerre, Musées d'Art et d'Histoire d'Auxerre

PROVENANCE: Sale, Paris, Hôtel Drouot, 1971; Museum purchase.

EXHIBITIONS: Paris, Place Dauphine, *Exposition de la Jeunesse*, 1725 [?]; Toledo Museum of Art, *The Age of Louis XV*, 1975 (cat. by Pierre Rosenberg), no. 35, ill. pl. 31.

BIBLIOGRAPHY: *Mercure de France*, June, 1725, Vol. II, p. 1403 [?]; Cousin de la Contamine, *Mémoire*, 1861, p. 257; Antoine Schnapper, "Deux tableaux de Henri de Favanne," *Revue du Louvre*, XXII, 1972, pp. 361–364, fig. 2.

The story depicted in Favanne's painting has received numerous celebrated treatments in the arts, ranging from Shakespeare's drama of c. 1608 to Beethoven's *Coriolan* orchestral overture, composed in 1807. Gaius Marcius Coriolanus, a Roman patrician of the fifth century B.C., had done great service for the Republic as a general in capturing the Volscian city of Corioli. Because of his haughty temperament and contempt for the common people, however, Coriolanus failed to win election to the office of consul. Enraged, he went over to the Volscians and led them in a major attack on Rome. According to the historians Livy and Plutarch, Coriolanus, after rejecting embassies from his countrymen, was finally persuaded to abandon the war only by the entreaties of his wife and mother.

This picture and its pendant, *Coriolanus Entreated by his Wife and Mother* (also in Auxerre) have been attributed to Favanne by Antoine Schnapper[1] on the basis of their similarities to signed or documented works by the artist. Among the characteristics of Favanne's style seen here are: volumetric figures, simple costumes, contorted poses that do not overlap, arrested gestures, and small, dark, round eyes. The setting of all the action parallel to the picture plane before an architectural backdrop is strongly reminiscent of Poussin, perhaps more so than in any other surviving work of Favanne. The companion picture takes up a subject that had been treated in a large picture by Poussin (c. 1648; Les Andelys, Hôtel de Ville), and is also related, in both subject and composition, to the celebrated *The Family of Darius before Alexander* (1661; Louvre) by Poussin's disciple Charles Le Brun.[2]

The two Auxerre paintings may be the "two little subjects with Coriolanus" by Favanne that the *Mercure de France* noted at the Place Dauphine exhibition in 1725. These works seem to have been known to Favanne's biographer Cousin de la Contamine, who commented: "Scrupulously submissive to the laws of costume, he gave no magnificence to the Romans before Augustus. Coriolanus departing to make war on his country, and the entreaties of his wife and mother for the salvation of this republic, subjects moreover that he treated very well, show this sufficiently."[3]

Favanne's *Coriolanus* pendants are significant for continuing the techniques of Poussinesque history painting at the height of the supposed taste for the "petite manière." The artist's interest in telling the story clearly and expressing the passions forcefully forms a link between the classicism of the previous century and the Neoclassical style of the latter part of the eighteenth century. Only the colors, less hard than those used by Poussin, betray the origin of the picture in a period of less heroic ambitions.

[1]Schnapper, "Deux tableaux de Henri de Favanne," p. 362.
[2]*Ibid.*, p. 363.
[3]Cousin de la Contamine, *Mémoire*, p. 257.

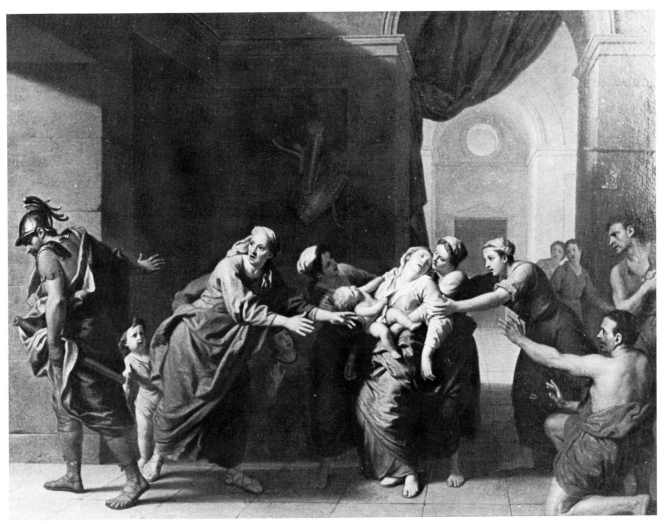

Cat. No. 22

Jean-Honoré Fragonard
Grasse 1732–1806 Paris

Fragonard, the greatest genre painter of the latter half of the century, was a pupil of Boucher, whose manner he followed closely in his earliest works. After the *Grand Prix* (1752), three years at the *Ecole des Elèves Protégés*, and the trip to Rome (1755–61), Fragonard was prepared for a brilliant career as a history painter. The huge *The High Priest Coresus Sacrificing Himself to Save Callirrhoë*, for which Fragonard was *agréé* by the Academy in 1765, seemed to bear out the great promise of the artist's academic career.

As has been discussed earlier, Fragonard did not continue to pursue this direction as an artist; instead, he became a painter of genre and boudoir subjects, working for private patrons and rarely exhibiting at the Salon. He never submitted his reception picture to the Academy. A prolific artist who seldom signed his works, Fragonard was often copied, and the connoisseurship and dating of his work are still problematical. Most of the religious paintings appear to be early; they were gradually supplanted by such famous genre series as the *Figures de Fantaisie* (1769; eight in the Louvre) and by *The Progress of Love* (New York, Frick Collection), painted for Madame du Barry's Louveciennes in 1771–73.

In his maturity Fragonard traveled again to Italy (1773–74) and probably to the Netherlands. Long an admirer of Rembrandt's warm tones and free brushwork, he also studied the Dutch landscapists of the seventeenth century and painted a number of splendid landscapes under this influence. Although the chronology of his later work is obscure, he seems to have adapted his manner to changes in taste, moving from sensuous, freely painted works such as *The Lock* (late 1770s; Louvre) to the more prim, tightly painted, Ter Borch-like *The Kiss* (c. 1785–88; Leningrad, Hermitage). Fragonard was appointed a curator at the Louvre through David's influence in 1793, but he was aversely affected by the Revolution, which ruined his clientele and made his chosen subject matter seem old-fashioned.

Though often bracketed with Boucher, Fragonard is quite distinct from his master in his use of warmer tones and particularly in his highly energized draftsmanship, evident in both his figures and landscapes. If *The Progress of Love* approaches the high finish of Boucher's works, many of Fragonard's smaller paintings are executed with extremely rapid, free brushwork that produces a greater effect of spontaneity. Even more striking is the difference between the two artists in subject matter: the nude Venuses of Boucher's mythological paintings become anonymous girls in Fragonard's playful boudoir scenes. Like his contemporary, Greuze, Fragonard heralded the rise of genre and the decline of history painting that were to characterize the nineteenth century.

23. *Saint John the Baptist*
Oil on canvas, 13⅜ x 10⅛ in. (34 x 25.6 cm.)
Private collection

PROVENANCE: Grasse, Maubert collection; Grasse, Malvilan collection; Grasse, Messrs. de Blic; New York, Wildenstein & Co.; Buenos Aires, Mercedes Saavedra Zelaya.

EXHIBITIONS: Buenos Aires, Wildenstein Arte, *Primera Exposición de Maestros de Pintura Antigua*, 1942, no. 11, and *Obras Maestras de la Pintura Francesa del Siglo XVIII*, 1945, no. 10; Tokyo, National Museum of Western Art, *Fragonard*, 1980, no. 21, ill. in color.

BIBLIOGRAPHY: Georges Wildenstein, *The Paintings of Fragonard*, London, 1960, p. 215, no. 87, ill. fig. 63; Daniel Wildenstein and Gabrielle Mandel, *L'Opera completa di Fragonard*, Milan, 1972, p. 90, no. 95, ill.

This small work, like many of Fragonard's religious subjects, probably dates from the early period 1748–52, when the artist was still in Boucher's studio. It may have remained in his possession, since he returned to his native town of Grasse during the Revolution. Painted in Fragonard's most rapid manner, the picture may be a sketch for a larger painting (118 x 69 cm.), now lost, that was sold with the de Villars collection in 1868:

> The precursor of Jesus is in a delightful landscape in which the painter's impetuous nature is marvelously suggested. He holds the emblematic cross with one hand and with the other collects in a bowl the water from a spring.
> His lamb is at his feet . . . [1]

The saint's animal skin garment refers to his youthful period of wandering in the wilderness, while the bowl prefigures his role in baptizing Christ.

Boucher and Largillierre treated the same subject on a monumental scale and with some attempt at seriousness of expression (figs. 22 and 31). In this colorful sketch, in contrast, the more playful Fragonard makes the figure as light and insubstantial as a cloud-borne putto; or, in the words of a nineteenth-century critic, "Take away the cross from the hand of Saint John the Baptist and it is Daphnis who appears beneath his gracefully feminine features."[2]

[1] F. de Villars collection, sale, Paris, Hôtel Drouot, March 13, 1868, no. 30.
[2] *Ibid.* (text by Henri Haro).

Cat. No. 23

Jean-Baptiste Greuze
Tournus 1725–1805 Paris

Few artists' works have had such drastically changing critical fortunes as those of Greuze. Famous after his first showing at the Salon, extravagantly praised by Diderot, Greuze was largely neglected during the last twenty-five years of his career. For many years Greuze's name was considered synonymous with maudlin sentimentality, yet within the past two decades he has received serious study as one of the morally committed artists of his time.

Little is known about Greuze's early years. He trained in Lyons with a minor painter, Charles Grandon, then went to Paris around 1750 to study at the Academy school. *Agréé* by the Academy in 1755, Greuze created a sensation at the Salon by exhibiting his *A Father Reading the Bible to his Children*, a psychologically convincing, morally "uplifting" scene from everyday life. At the time he was described as a painter of *bambochades*, or peasant genre scenes in the Dutch manner, and he showed considerable gifts as a portraitist.

Between 1755 and 1757 Greuze traveled in Italy with a patron, the Abbé Louis Gougenot. The trip does not seem to have affected his style greatly, though the "inspired" upward gaze of some of his later figures suggests the influence of the Bolognese painter Guido Reni. After his return Greuze repeated his great success at the Salon with *The Village Betrothal* (1761), which in its serious air, dramatic gestures, and shallow staging adapts the history paintings of Poussin to a bourgeois theme. Greuze, however, delayed submitting his reception picture for full membership in the Academy.

When he finally offered the large *Septimus Severus Reproaching Caracalla* (1769; see following entry) as his reception piece the picture was sharply criticized, and Greuze did not exhibit at the Salon again until 1800. He relied mainly on exhibits in his own studio and on prints after his works to spread interest in his career. After 1780 his style evolved little, and a growing taste for more dramatic historical subjects made his domestic scenes less fashionable. Though ruined financially by the Revolution, he continued to paint portraits (one of the last being of Napoleon) and single figures, often of young girls.

An historically important artist whose work is uneven in quality, Greuze sometimes displays an uneasy mixture of moralizing sentiment and eroticism, an ambivalence characteristic of the pre-Revolutionary period.[1]

[1]See Edgar Munhall, *Jean-Baptiste Greuze, 1725–1805*, Hartford, 1976.

24. *The Emperor Septimus Severus Reproaching his Son Caracalla*, 1769
Oil on canvas, 48¹³⁄₁₆ x 63¹⁄₁₆ in. (124 x 160 cm.)
Paris, Musée de Louvre

PROVENANCE: Paris, Académie Royale de Peinture et de Sculpture; transferred to Louvre.

EXHIBITIONS: Paris, Salon of 1769, no. 151; Cleveland Museum of Art, *Neoclassicism, Style and Motif*, 1964, no. 33; London, Royal Academy, *France in the Eighteenth Century*, 1968, no. 307; Antwerp, *Le Néoclassicisme*, 1972, no. 15; Paris, Louvre, *La "Mort de Germanicus" de Poussin du Musée de Minneapolis*, 1973, no. 92; Hartford, *Jean-Baptiste Greuze, 1725–1805*, 1976, cat. by Edgar Munhall, no. 70, ill.

BIBLIOGRAPHY (selected): [Daudet de Jossac], *Sentimens sur les tableaux exposés au Salon*, Paris, 1769, pp. 19–20; L. P. de Bachaumont, *Mémoires secrets pour servir à l'histoire de la république des lettres en France...*, London, 1777–89, XIII, pp. 54–57; C.-L. F. Lecarpentier, *Notice sur Greuze...*, Rouen, 1805, p. 4; C. de Valori, "Notice sur Greuze et sur ses ouvrages," in *Greuze, ou l'Accordée de village*, Paris, 1813, reprinted by A. de Montaiglon, ed., in *Revue Universelle des Arts*, XI, 1860, p. 369; J. G. Wille, *Mémoires et journal...*, ed. G. Duplessis, Paris, 1857, I, p. 415; Edmond and Jules de Goncourt, *L'Art du dix-huitième siècle*, I, Paris, 1880, pp. 306–310; J. Martin and C. Masson, *Catalogue raisonné de l'oeuvre peint et dessiné de J.-B. Greuze*, Paris, 1908, no. 16; Jean Locquin, *La peinture d'histoire en France de 1747 à 1785*, Paris, 1912, pp. 36, 168, 249, 250, 253, ill. pl. XIX; Louis Hautecoeur, *Greuze*, Paris, 1913, pp. 20, 65–68; Denis Diderot, *Lettres à Sophie Volland*, Paris, 1930, III, p. 215, and *Salons*, Oxford, 1957–65, IV, pp. 41–44, 103–107; Henry Bardon, "Les peintures à sujets antiques au XVIIIᵉ siècle d'après les livrets de Salons," *Gazette des Beaux-Arts*, ser. 6, LXI, 1963, p. 224, ill. fig. 1; Jean Seznec, "Diderot et l'affaire Greuze," *Gazette des Beaux-Arts*, ser. 6, LXVII, 1966, pp. 339–356, ill. fig. 1; Anita Brookner, *Greuze, The Rise and Fall of an Eighteenth-century Phenomenon*, London, 1972, pp. 67–70, 109–110, ill. pl. 41; P. Rosenberg, N. Reynaud, and I. Compin, *Musée de Louvre: Catalogue illustré des peintures, Ecole française XVIIᵉ et XVIIIᵉ siècles*, Paris, 1974, I, no. 319.

The presentation of this, Greuze's reception picture, at the Academy and Salon in 1769 created a major scandal, the details of which are well documented.[1] Greuze still had not presented the required work a dozen years after being *agréé* by the Academy, and for this reason he was barred from exhibiting in the Salon of 1767. Though successful as a genre specialist and portraitist, the ambitious artist sought to be admitted into the most prestigious category, that of history painter. For two years he experimented with a variety of historical and mythological subjects, including the large, unfinished *Aegina Visited by Jupiter* (New York, Metropolitan Museum of Art). Relatively early, however, his attention was attracted by the obscure subject from Roman history that he selected for the picture he submitted; the full title in the Salon *livret* was: *The Emperor Severus Reproaching his son Caracalla for having wished to assassinate him in the Passes of Scotland, and saying to him: "If you desire my death, order Papinian to kill me with this sword."*

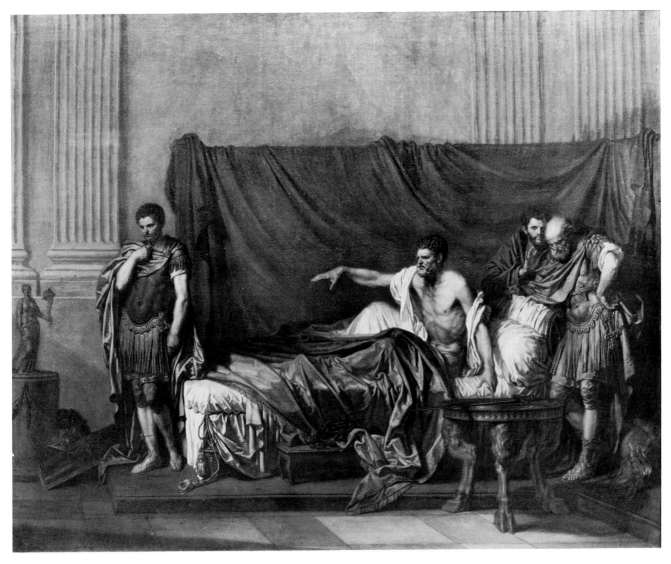

Cat. No. 24

The incident, which took place in A.D. 210, was probably known to Greuze through a French translation of Cassius Dio's *Roman History*. An early sketch seen by Diderot in 1767 placed the scene in a tent rather than a grandiose, pilastered hall. The critic had admired the open spaces of the composition, which seemed to him to give resonance to the Emperor's stern words. When the finished picture was shown in 1769, however, Diderot joined the nearly unanimous rejection of the work by academicians and Salon critics. Among the criticisms of the painting were its drab coloring, lack of expression, weakness of drawing (mainly in the figure of the Emperor), obscure subject, and literary rather than visual inspiration, which required a written explanation to clarify the action depicted. Greuze was admitted to the Academy, but only as a genre specialist rather than a history painter. Greuze, whose acerbic personality may have influenced his colleagues' judgment, was enraged by the decision and withdrew from participation in the Academy's activities.

Some of the criticisms offered in 1769 are justified, for the *Septimus Severus* lacks the emotional intensity and compositional complexity of Greuze's domestic dramas, such as *The Father's Curse*. Like those works, the *Septimus Severus* is strongly influenced by the freizelike compositions, flat backdrops, and emphatic gestures of Poussin's historical works, particularly in this case by the earlier artist's great *Death of Germanicus* (Minneapolis Institute of Arts). The painting deserves attention nevertheless for its precocious reference to Poussin, its attempt at archaeological correctness, and its presentation of an heroic, moralizing subject in an Antique setting. All of these traits prefigure the completely evolved Neoclassical style that was forged fifteen years later in the works of Jacques-Louis David.

[1]For a full discussion of the circumstances surrounding the reception of this picture see Seznec, "Diderot et l'affaire Greuze," and Munhall, *Jean-Baptiste Greuze, 1725–1805.*

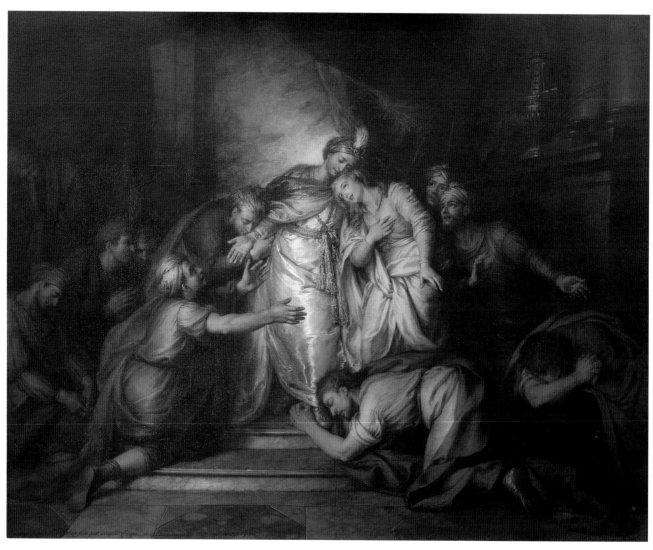

Cat. No. 11
(See pg. 78)

Noël Hallé
Paris 1711–1781 Paris

Noël studied with his father, the academician Claude-Guy Hallé, and with his brother-in-law Jean Restout. He won the *Grand Prix* in 1736 with *The Crossing of the Red Sea* and spent seven years in Rome. Upon his return he was *agréé* in 1746 and made a full member of the Academy two years later with *The Dispute of Minerva and Neptune to Name the City of Athens.*

Though primarily a history painter, the prolific Hallé also executed portraits, genre paintings, and engravings. He received numerous church commissions, such as his *Suffer the Little Children to Come Unto Me* (Paris, Saint-Sulpice). He was named inspector of the Gobelins tapestry works, and in 1775 undertook a mission to Rome to reorganize the French Academy there; for the latter service he received the prestigious order of

Chevalier de Saint-Michel, rarely awarded to artists. Shortly before his death Noël, like his father, became rector of the Academy.

Some of Hallé's later works have the morally inspiring Classical subjects that came into fashion after 1760: examples are the *Justice of Trajan* (Marseilles, Musée des Beaux-Arts), commissioned by Cochin in 1764 for a series on the virtuous acts of the Roman emperors for the Château de Choisy, and *Cornelia, Mother of the Gracchi* (Salon of 1779; Montpellier, Musée Fabre). Hallé's works of this kind are more notable for their easy grace than for their moral severity, and were severely criticized by the influential Diderot. Though attuned to the changing interests of his time, Hallé seems more a late practitioner of the Rococo style and sensibility.[1]

[1]Robert Rosenblum, *Transformations in Late Eighteenth Century Art,* Princeton, 1967, pp. 56f, 61f.

25. *Antiochus Falling from his Chariot,* c. 1738
Oil on canvas, 39¼ x 53½ in. (99.7 x 135.8 cm.)
Richmond, Virginia Museum of Fine Arts (**See pg. 104**)

PROVENANCE: Sweden, private collection; London, Heim Gallery, 1977; purchased by the Museum, the Williams Fund, 1980.

EXHIBITIONS: London, Heim Gallery, *Aspects of French Academic Art, 1680–1780,* 1977, no. 15; Atlanta, High Museum of Art, *The Rococo Age,* 1983 (cat. by Eric M. Zafran), no. 6, ill. in color p. 27.

BIBLIOGRAPHY: O. Estournet, "La famille des Hallés," *Réunion des Sociétés des Beaux Arts des Départements,* XXIX, 1905, p. 161, no. 13; David Lomax, "The early career of Noël Hallé," *Apollo,* CXVII, 1983, pp. 106–109, ill. fig. 1.

Hallé here depicts a story drawn from the Apocrypha (2 Maccabees, ch. ix), recounting how the Seleucid King Antiochus IV of Syria (reigned 175–164 B.C.) on his way to massacre the Jews "gave order to his charioteer to drive without ceasing and to dispatch the journey . . . But it came to pass moreover that he fell from his chariot as it rushed along, and having a grievous fall was racked in all the members of his body." A companion painting, now lost, of *Antiochus after his Fall Dictating his Will* showed the aftermath of the incident: the king, on his deathbed, repented of his actions against the Jews and recommended them to his son and successor, Antiochus Eupator. Such a tale of evil punished might, in the late eighteenth century, have been drawn from Classical or even genre material (Greuze's *The Father's Curse*). In the earlier part of the century such moralizing historical subjects were still derived from scriptural sources, though the clarity of the lesson illustrated by Hallé is precocious.

While a student at the French Academy in Rome, Hallé spent much of his time making copies of Raphael's frescoes in the Vatican Stanze and of Baroque works such as Guercino's *Doubting Thomas.* The influence of seventeenth-century art is particularly evident in the Richmond canvas, Hallé's earliest surviving work. The warm colors, and the diagonal recession into space created by the figure of the fallen Antiochus and the soldier who reaches toward him, place the work in the Baroque

idiom when compared to Hallé's more "advanced" *Joseph Accused by Potiphar's Wife* (cat. no. 26), completed only a few years later. Another likely source is Michel-François Dandré-Bardon's *Tullia Driving her Chariot over the Body of her Father* (1735; Montpellier, Musée Fabre),[1] a reception piece that Hallé would have seen in the rooms of the Academy in the Louvre. In particular, the motifs of the fallen king and the rearing horses seem derived from Dandré-Bardon's painting, though that composition is more planar than Hallé's work.

Hallé made etchings after the pendant composition in 1738 and after the Richmond painting in 1739.[2] In the early *Antiochus Falling from his Chariot* Hallé displays a painterly energy and dramatic force that he rarely sought to duplicate in his more mature works.

[1]Lomax, "The early career of Noël Hallé," p. 106 and fig. 4.
[2]*Ibid.,* figs. 2 and 3.

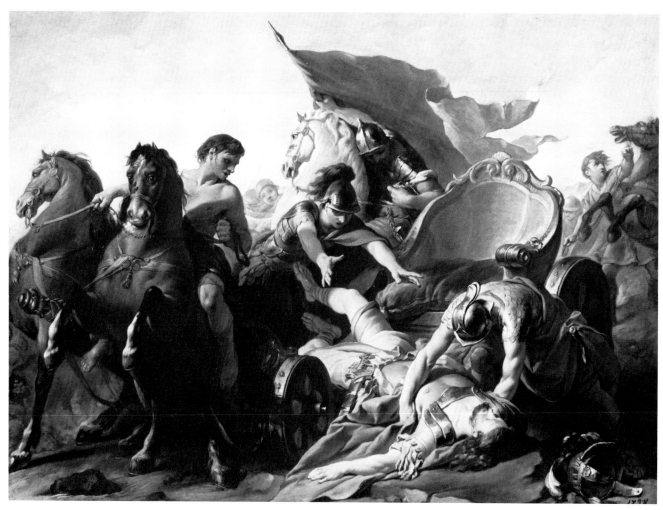

Cat. No. 25
(See pg. 103)

Cat. No. 26
(See pg. 106)

Noël Hallé
Paris 1711–1781 Paris

26. *Joseph Accused by Potiphar's Wife,* c. 1740–44
Oil on canvas, 55¼ x 65⅛ in. (140.5 x 165.5 cm.)
The David and Alfred Smart Gallery, The University of Chicago

PROVENANCE: Hallé estate sale, July 2, 1781, no. 21, not put up for sale; by descent in Hallé family; Paris, Pétin collection; anonymous sale, Paris, Hôtel Drouot, salle 14, November 6, 1972, not in catalogue or attributed; Paris and London, Heim Gallery; purchased 1974, gift of the Mark Morton Memorial Fund and Mr. and Mrs. Eugene Davidson.

EXHIBITIONS: Paris, Salon of 1748, no. 49; London, Heim Gallery, *Religious and Biblical Themes in French Baroque Painting,* 1974, no. 19, ill.; Toledo, *The Age of Louis XV,* 1975 (cat. by Pierre Rosenberg), no. 45, ill. pl. 67.

BIBLIOGRAPHY: Paris, *Mercure de France,* September 1748, p. 162; Estournet, "La famille des Hallés," 1905, p. 195, no. 3; Paris, *Le Monde,* February 23, 1973; Bernard S. Myers, ed., *Encyclopedia of World Art,* XVI, New York, 1983, ill. pl. XLVIII; London, Heim Gallery, *Portraits & Figures in Paintings & Sculpture, 1570–1870,* 1983, no. 16 (mentioned); Monte Carlo, Sotheby's, sale, June 26, 1983, p. 82 (mentioned); Lomax, "The early career of Noël Hallé," 1983, p. 107, ill. fig. 5.

According to Estournet, who apparently relied on a family tradition, this early work was painted before Hallé's return from Rome in 1744. Little survives from Hallé's Roman period, but this painting suggests the influence of Italian, particularly Venetian, painting on the young artist, notably in the rich coloring, the relatively free brushwork, and the Tiepolo-like Oriental attire worn by Potiphar.

As recounted in the Book of Genesis (39:1–20), after he had been sold into Egypt, Joseph prospered as an overseer of the household of Potiphar, captain of Pharaoh's guard. Potiphar's wife attempted unsuccessfully to seduce Joseph, catching him by his garment, which he left in her hand as he fled. In Hallé's picture she accuses Joseph, who protests his innocence, before the outraged Potiphar as a servant girl holds the garment. As a result of the accusation Joseph was put in prison, where he subsequently came to the attention of Pharaoh and eventually became his chief minister.

There are several other versions of this composition, including a canvas, about one-third the size of the Chicago painting, in a cooler color scheme (London, Heim Gallery, by 1969) that is perhaps an eighteenth-century copy. Another version recently on the art market[1] has been reduced at the top and bottom (119 x 159 cm.) though it is otherwise similar in detail. The ambitious scale of the Chicago picture suggests that Hallé intended it as a major display piece, perhaps ultimately for the Salon. Despite the severely Classical architectural background, "advanced" for the time, the figures, such as the elongated, swaying Joseph, lack dramatic energy and are wholly in the Rococo taste. A related work, *Joseph Interpreting the Dreams of Pharaoh's Officers* (113 x 96 cm.; Salon of 1747, no. 121), though shown earlier, seems to have been painted after the Chicago picture.[2] Here the figures appear more massive and stable, their gestures simpler against a somber and powerful architectural background, indicative of the growing sobriety of history painting at mid-century.

[1]Monte Carlo, Sotheby's, sale, June 26, 1983, no. 474.
[2]London, Heim Gallery, *Portraits and Figures,* 1983, no. 16.

27. *The Education of the Virgin,* late 1740s
Oil sketch on canvas, 24⅛ x 16 in. (61.4 x 40.9 cm.)
Albuquerque, University Art Museum, University of New Mexico

PROVENANCE: Private collection, on extended loan to the Museum.

EXHIBITIONS: Albuquerque, *French Eighteenth-Century Oil Sketches from an English Collection,* 1980 (cat. by Peter Walch), no. 32.

The attribution to Hallé is by Walch, who compares the composition, with the Virgin's mother, St. Anne, seated in profile facing left, to an earlier sketch of the subject by the much younger Fragonard (version Los Angeles, Armand Hammer Collection). Similarities of treatment do not extend beyond the pose of St. Anne, however, and the compositions may simply be part of a general repertory to which artists of the period resorted when dealing with this subject.

Walch compares the Albuquerque picture with late works by Hallé such as a 1764 genre sketch, *The Education of the Rich* (Paris, Cailleux coll.).[1] *The Education of the Virgin* has affinities with this picture, and even with the much earlier *Joseph Accused by Potiphar's Wife,* in Hallé's preference for "lost" profiles, elongated necks, and youthful faces. The use of relatively pale, cool colors and precise drawing (the work, though small, is highly finished) relates this painting to the products of the later phase of Hallé's career. The larger version, now lost, was engraved by Etienne Fessard in 1749, however; the work had been commissioned by the Confraternity of St. Anne of the Maîtres Menuisiers de la Ville et Banlieue de Paris, associated with the Carmelite church of the Billettes.[2]

Unlike most other works in the exhibition, this painting has a highly elaborated decorative border in grisaille with garlands, some lively putti, and an empty medallion suitable for an inscription at the bottom center. A similar sketch for a Gobelins tapestry, *The Spirit of Science,* was completed in 1761 but never used. *The Education of the Virgin* might therefore belong to a series of framed designs commissioned by the Confraternity of St. Anne from Hallé or other artists.

[1]See Walch, pp. 21–22.
[2]Nicole Willk-Brocard, in a letter of August 27, 1986, citing Jean Gaston, "Les images des Confréries parisiennes avant la Révolution," *Société d'Iconographie Parisienne,* 2ᵉ année, 1909 (1910), p. 10, no. 28, ill. (engraving).

Cat. No. 27

107

Jean Jouvenet
Rouen 1644–1717 Paris

The most distinguished member of a large artist family, Jouvenet studied with his father, Laurent Jouvenet the younger, then at the Royal Academy school in Paris from 1661. His *Jesus and the Paralytic,* painted in 1673 for the goldsmiths' guild as a decoration for Notre Dame Cathedral, had a great success, and the painter was taken up by Le Brun as an assistant in the decoration of Versailles.

Though he never went to Italy, Jouvenet from the mid-1680s onward became the most admired painter of large religious pictures of his time. Among the many commissions from his later career were an *Apotheosis of the Apostles* for the church of the Invalides, begun c. 1702, a *Descent of the Holy Spirit* (Versailles, Chapelle Royale, 1709), and four large paintings of the life of Christ, completed in 1706, for the church of Saint-Martin-des-Champs (Louvre); the latter group was repeated in a series of Gobelins tapestries. On the basis of his fame as a history painter Jouvenet rose from member of the Academy in 1675 to director and rector in 1707. Paralyzed in his right hand in 1713, Jouvenet learned to paint with his left, allegedly with the advice of his friend Sebastiano Ricci, who visited Paris in 1712 and 1716–17.[1]

Because of the rarity of Salons during Jouvenet's career he showed only in 1699, with several religious works, mythologies, and portraits, and again with a group of ten paintings in 1704. Jouvenet's eclectic style originally depended heavily on Poussin, though he was also influenced by Le Sueur, Le Brun and in particular by the Italian Baroque: Jouvenet was sometimes called "the Carracci of France." Some of his works, such as the Toledo *Deposition* (cat. no. 28), also show the influence of the dramatic gestures of Rubens, though in harder and cooler colors than used by the Flemish master. In the nineteenth century, when Baroque religious painting was out of fashion, Jouvenet's work was regarded as false and declamatory. Today Jouvenet's graceful multifigural compositions and ambitious scale are again admired, and he is considered one of the great artists of the turn of the eighteenth century. In him the moral seriousness of seventeenth-century French history painting is passed on to the succeeding century as part of a tradition that continues as a subsidiary current until the time of David.

[1]Antoine Schnapper, *Jean Jouvenet (1646–1717) et la peinture d'histoire à Paris,* 1974, pp. 126 and 167.

28. *The Deposition,* 1709
Oil on canvas, 70½ x 54 in. (179 x 137 cm.)
Signed and dated (lower center): *Jouvenet 1709*
The Toledo Museum of Art (See pg. 120)

PROVENANCE: Languedoc, de Boussayrolles family, to 1945; Montpellier, André Fabre, 1945–74; London, Heim Gallery; acquired by Museum, gift of Edward Drummond Libbey, 1974.

EXHIBITIONS: London, Heim Gallery, *Religious and Biblical Themes in French Baroque Painting,* 1974, no. 14, ill.; Toledo Museum of Art, *The Age of Louis XV,* 1975 (cat. by Pierre Rosenberg), no. 49, color pl. 1.

BIBLIOGRAPHY: B. N. (Benedict Nicolson), *Burlington Magazine,* CXVI, 1974, p. 41; Schnapper, *Jean Jouvenet,* 1974, pp. 26, 143–144, 214, 216, cat. no. 126, fig. 141; Toledo Museum of Art, *European Paintings,* 1976, p. 87, pl. 190; Frank Schulze, "A consistently discriminating connoisseurship," *Art News,* LXXVI, no. 4, 1977, p. 67.

Late in his career Jouvenet undertook several related versions of *The Deposition.* One, now lost but known from an engraving by Alexis Loir,[1] is perhaps the picture shown at the Salon of 1704 as *Jesus Christ Brought down from the Cross and Laid on a Shroud.*[2] A larger (292 x 193 cm.) picture signed and dated 1708 (Pontoise, church of Saint-Maclou)[3] differs from the engraving in a number of details, particularly the removal of a group of soldiers and turbaned figures in the distance at one side, the addition of a footrest on the cross, and some changes in costume. There are numerous variants and close copies of the Pontoise picture, one of which in 1985 was on the London art market.[4]

The Toledo composition is closer to the Loir engraving in the absence of the footrest and the presence of a helmeted soldier with a ladder in the left background. There have been extensive additions at the right: an aged, bearded mourner stands holding an end of the shroud before the cross of one of the thieves. The kneeling Saint John, who had held the shroud in the other compositions, now gestures in sorrow. An extension of the painting below the still life in the foreground sets the figures more deeply into the picture space. The resulting composition is more square than the Pontoise canvas and its copies.

If the hard blues and reds in the costumes derive from Poussin, the weighty figures and stately gestures recall the religious works of Rubens and of his pupil Van Dyck, under whose name a copy of the Toledo picture (126 x 100 cm.) sold in Berlin in 1913. Jouvenet's nineteenth-century reputation as a declamatory artist is belied by this picture, which admirably illustrates the effect of restrained yet intense emotion sought by many French religious painters in the early eighteenth century.

[1]Schnapper, *Jean Jouvenet,* fig. 134.
[2]*Ibid.,* pp. 142–143.
[3]*Ibid.,* cat. no. 122, fig. 135.
[4]131 x 81.5 cm.; London, Colnaghi, ill. *Burlington Magazine,* CXXVII, August 1985, p. xiv.

Fig. 47—Jean Jouvenet
Resurrection of the Son of the Widow of Naim
Versailles, Cathédrale Saint-Louis, Sacristy

Jean Jouvenet
Rouen 1644–1717 Paris

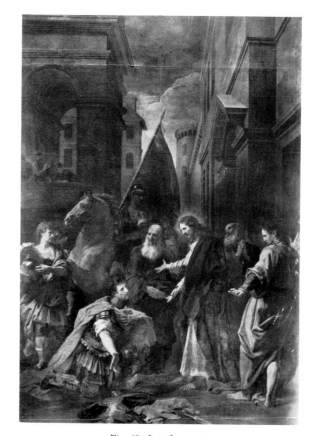

Fig. 48—Jean Jouvenet
The Centurion Imploring Christ to Heal his Servant
Tours, Musée des Beaux-Arts

29. *The Centurion Imploring Christ to Heal his Servant,* 1712
Oil on canvas, 36 x 28 in. (91.4 x 71.1 cm.)
Initialed (lower left): *J. J.*
Greenville, South Carolina, Bob Jones University Art Gallery and Museum

PROVENANCE: Possibly sale, F. de N., Paris, April 11–12, 1836, no. 62; Julius Weitzner, London and New York; Museum purchase, 1981.

EXHIBITION: Raleigh, North Carolina Museum of Art, *Baroque Paintings from the Bob Jones University Collection,* 1984 (cat. by David H. Steel, Jr.), no. 24.

BIBLIOGRAPHY: Schnapper, *Jean Jouvenet,* p. 219, no. 134.

This is a finished sketch for or, more likely, a replica after a large (365 x 245 cm.) altarpiece painted for the church of the Récollets at Versailles in 1712 (fig. 47; Tours, Musée des Beaux-Arts). The two compositions are virtually identical except that the top of the altarpiece extends the massive architectural background upward.[1] A preparatory drawing for the figure of Christ,[2] now in the Louvre, shows the right arm raised as if in blessing; the intention may have been to link this figure with the commanding gesture of Christ in a larger companion work, *The Resurrection of the Son of the Widow of Naim* (Versailles, Cathédrale Saint-Louis, Sacristy, fig. 48). The latter picture, painted for the same church in 1708, has been described as one of Jouvenet's finest religious works in its balance of idealism and realism, solidity and movement.[3] The two works were probably intended to contrast the dominating and compassionate sides of Christ's personality.

The miracle depicted here is mentioned in Matthew 8:5–13 and Luke 7:1–10. When Jesus had entered Capernaum a centurion came, begging Jesus to heal his servant, who was afflicted with palsy. Jesus promised to come to the man's house, but the centurion said he was unworthy to receive Jesus' visit, adding "speak the word only, and my servant shall be healed." Jesus, impressed with the centurion's faith, said "as thou hast believed, so be it done unto thee," and the servant was healed immediately. Jouvenet's version follows Matthew, in which the centurion comes in person to seek Christ, rather than Luke, in which the man sends first elders, then friends, because of his own unworthiness.

[1] Schnapper (*Jean Jouvenet,* no. 134 and fig. 151) indicates that this upper part had long been folded over; whether this was done by the artist or at a later date is unknown.
[2] Raleigh, *Baroque Paintings from the Bob Jones University Collection,* fig. 19.
[3] Schnapper, *Jean Jouvenet,* p. 144.

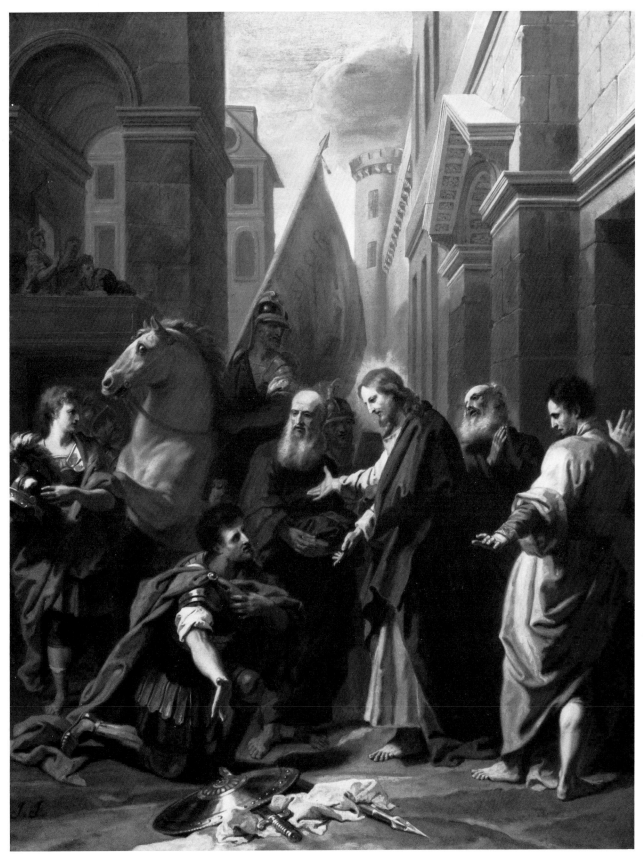

Cat. No. 29

111

Charles de La Fosse
Paris 1636–1716 Paris

La Fosse studied with the miniature painter and engraver François Chauveau and with Charles Le Brun. Sent to Italy on a royal stipend, he spent two years in Rome and, unusually, three in Venice. This experience is reflected in his taste for warm colors and the growing influence on his later work of the free brushwork of Titian, Veronese, and Rubens.

On his return to France, La Fosse worked closely with Le Brun on important decorative commissions at Versailles, the *Salon de Diane* and the *Salon d'Apollon* (*Coriolanus*, *Vespasian Ordering the Building of the Colisseum*). Later, the *Directeur général des Bâtiments* Hardouin-Mansart commissioned La Fosse to plan the entire decoration of the church of the Invalides. Other artists protested, and the great project was divided: La Fosse painted only the cupola of the dome (*St. Louis Giving his Crown and Sword into the Hands of Christ*) and

the pendentives (*The Four Evangelists*). La Fosse traveled to London in 1690 to decorate Montagu House; in 1709, for the royal chapel at Versailles, he painted a *Resurrection* in the apse. These were only the most important of a flood of public and private decorative commissions directed to the prolific artist.

Admitted to the Academy in 1673 with *The Rape of Proserpina*, La Fosse advanced to director, rector, and in 1715 chancellor of the institution. By the standards of his time, however, his work is neither academic nor doctrinaire. From 1708 until his death he lived in the *hôtel* of the financier and collector Crozat, where the young Antoine Watteau also took up residence some time after 1712. La Fosse's influence on the younger artist is reflected in Watteau's loose brushwork; in this manner La Fosse serves as an important stylistic link between Rubens and the greatest French master of the early eighteenth century.[1]

[1]M. Stuffmann, "Charles de La Fosse et sa position dans la peinture française à la fin du XVIIème siècle," *Gazette des Beaux-Arts*, LXIV, 1964, pp. 1–121.

30. *Christ in the Wilderness Served by Angels*, c. 1710
Oil on canvas, 36¼ x 46⅛ in. (92 x 111.7 cm.)
Private collection

PROVENANCE: Coll. Cardinal Fesch, sale, Rome, March 27–28, 1845, no. 361-2954; coll. Thomas Jefferson Bryan, New York; gift to the New York Historical Society, 1867; sale, New York, Sotheby's, December 2, 1971, no. 117.

EXHIBITIONS: Providence, R.I., Department of Art, Brown University and Museum of Art, Rhode Island School of Design, *Rubenism*, 1975, pp. 75 and 88–89, no. 24, ill.

BIBLIOGRAPHY: Anon., "Vente de la Galerie Fesch, à Rome," *Le Cabinet de l'Amateur et de l'Antiquaire*, IV, 1845–46, p. 290, no. 361; New York Historical Society, *Catalogue of the Museum and Gallery of Art*, 1873, p. 47, no. 416; Stuffmann, "Charles de La Fosse," p. 112, no. 70.

This is the latest of at least four versions by La Fosse of a subject that was also treated by his teacher, Charles Le Brun. Christ is shown at the end of a period of meditation and fasting in the desert, during which he triumphed over the blandishments of Satan. Seven youthful angels bring rich offerings of food and drink in celebration of Christ's victory.

A larger version of the 1690s (143 x 193 cm.; Leningrad, Hermitage) is close in composition to this picture.[1] The principal difference is in the treatment of Christ, who in the earlier work is less isolated and idealized, more naturalistic and restrained in gesture. In the later version the poses of some of the other figures are more studied, as in the kneeling angel in the center, who recalls a sibyl from Michelangelo's Sistine ceiling. The gesture of the angels, who cross their hands ecstatically on their breasts, is paralleled in other compositions by La Fosse, including a charcoal drawing of a *Holy Family*.[2] The artist also tried out a vertical arrangement in a small depiction of c. 1700 now in Grenoble,[3] reversing the composition and placing the angels in a more highly structured pyramidal grouping leading the eye toward the figure of Christ.

The strongest evidence for the late date of this picture is

found in its rich, saturated colors and atmospheric brushwork, which predominate over line in establishing the forms. Other religious artists of La Fosse's generation, notably Jouvenet, had been influenced by the monumental, sculptural style used by Rubens in his early works such as the *Descent from the Cross* (Antwerp, Cathedral). La Fosse's painting derives from the later, more coloristic style of Rubens's *Life of Marie de' Medici* series (Louvre) and from late Titian, though here he may go beyond the earlier masters in his reliance on color as the primary mode of expression. The loosely painted, backlighted foliage is especially significant as a bridge from the late landscapes of Rubens to the mature style of Watteau, with whom La Fosse was in close contact soon after this picture was painted.[4]

[1]Stuffmann, "Charles de La Fosse," cat. no. 44.
[2]Sale, New York, Anderson Galleries, November 7–8, 1923, ill.
[3]Stuffmann, cat. no. 58.
[4]Providence, *Rubenism*, pp. 75 and 88, cat. no. 24.

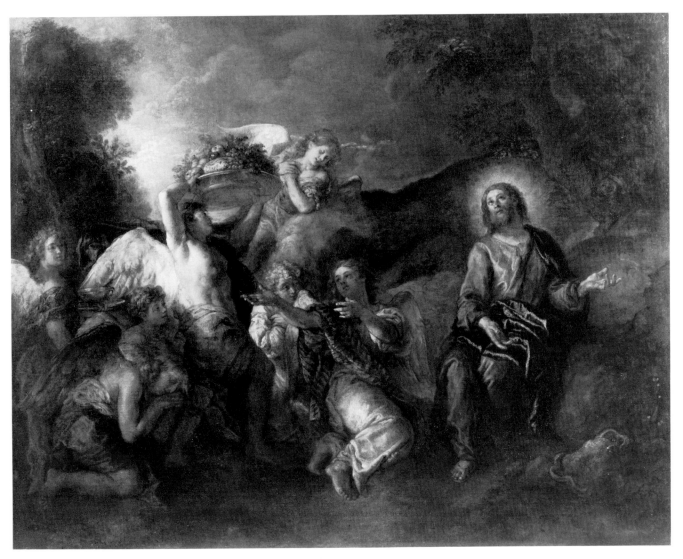

Cat. No. 30

Jean-Jacques Lagrenée
(called Lagrenée *le jeune*)
Paris 1739–1821 Paris

Often confused today with his elder brother and teacher Louis-Jean-François *l'aîné*, Lagrenée had a highly successful career as a history painter. He followed his brother to the Russian court at St. Petersburg in 1760, returning to Paris in 1763. Although he had won only a second place in the *Prix de Rome* competition, Lagrenée, as a result of the unpredictable official favoritism of the period, was given a pension in Rome from 1763 to 1768. He exhibited at the Salons from 1771 to 1804, showing a large number of historical and decorative paintings. His first offering was a sketch for his *morceau de réception*, *Winter*, an allegorical painting completed in 1775 for the splendid Galerie d'Apollon in the Louvre. In addition to working at Versailles, where he executed a ceiling painting for the theater of the Petit Trianon, Lagrenée was also employed for many years as a designer for the royal Sèvres porcelain factory.

As his career progressed Lagrenée moved toward a Poussinesque classicism. His late works, like *Psyche in the Enchanted Palace* (1797–98; Paris, private collection),[1] show a rather hard, precise draftsmanship and much archaeological detail, yet retain a certain mid-eighteenth-century charm, particularly in their colors. Lagrenée also worked as an etcher, particularly in his youth, painted miniature portraits, and experimented with novel technical processes.[2]

[1] Detroit Institute of Arts, *The Age of Revolution*, no. 114.
[2] See Marc Sandoz, "Jean-Jacques Lagrénée, peintre d'histoire (1739–1821)," *Bulletin de la Société de l'Histoire de l'Art Français*, 1962, pp. 121–133.

31. *Holy Family*, c. 1770–75
Oil on canvas, 21½ x 15¼ in. (54.8 x 38.8 cm.)
Albuquerque, University Art Museum, University of New Mexico

PROVENANCE: Private collection, on extended loan to the Museum.

EXHIBITIONS: Albuquerque, *French Eighteenth-Century Oil Sketches from an English Collection*, 1980 (cat. by Peter Walch), no. 34.

The influences on Lagrenée during his years in Italy were many: North Italian Renaissance artists such as Correggio and the Bolognese classicists of the seventeenth century had particular importance for him. Italian sources are evident in this finished study, which may date closely in time to the *Presentation in the Temple* (Salon of 1771; Versailles, Musée National).[1] The stately composition and soft focus, particularly in the background, recall the north Italians, while the choice of subject, a "Madonna of the stairs," is one that was favored by the Baroque classicist Nicolas Poussin. The general compositional structure and sharpness of the drapery folds anticipate that of such later, stylistically more rigid altarpieces as the *St. John Preaching in the Desert* (Salon of 1783; Grenoble, Musée de Peinture et de Sculpture) and *The Finding of Moses* (Salon of 1785; Chambéry, Préfecture).[2] Though the attribution to the young Lagrenée is convincing, the origin and purpose of the *Holy Family* composition remain unknown.

[1] Jean Seznec, ed., *Diderot Salons*, IV, Oxford, 1967, fig. 86; discussed in Walch.
[2] Marc Sandoz, "Jean-Jacques Lagrénée," figs. 2 and 1.

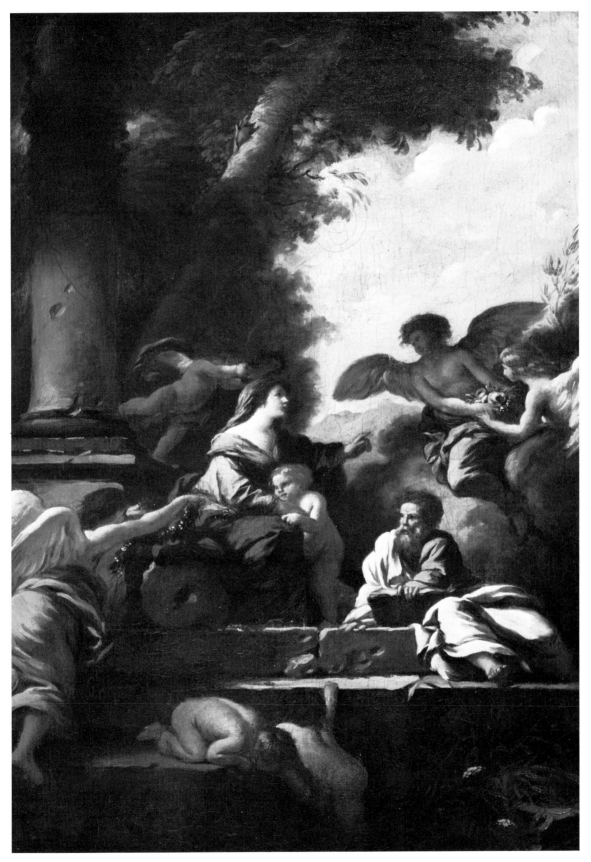

Cat. No. 31

Etienne de Lavallée
(called Lavallée-Poussin)
Rouen 1733–1793 Paris

Lavallée had a typical formation as a history painter: study with Jean-Baptiste Descamps and with Pierre, first prize in the *Prix de Rome* competition in 1759 for *The Prophet Elias and the Poor Widow,* then three years at the Ecole des Elèves Protégés. From 1762 to 1777 he was in Rome, where he was a member of the Academy of the Arcades. During these years he painted historical landscapes in the manner of Nicolas Poussin, whose name he added to his own.

He did not become a member of the Academy in Paris until 1789, when he submitted a *Return of the Young Tobias.* Despite his reputation as an academic classicist Lavallée was not prolific as a history painter. Much of his attention seems to have been taken up by decorative paintings, including numerous designs for arabesques that were subsequently engraved. He also provided sketches for two series of Beauvais tapestries: *The Conquest of the Indians* (1785) and *The Story of Alexander* (1792). The surviving works of Lavallée have an intimacy that is closer in feeling to genre painting than to the *grande manière* of either Rococo or Neoclassical religious and historical subjects.

32. *Anacreon, Sappho, Eros and a Female Dancer,* c. 1790
Oil on canvas, 60¼ x 52 in. (153 x 132 cm.)
Salt Lake City, Utah Museum of Fine Arts

PROVENANCE: New York, Wildenstein & Co., 1976; gift of an anonymous donor, 1984.

EXHIBITIONS: New York, Wildenstein & Co., *French Neoclassicism,* 1976, no. 9.

BIBLIOGRAPHY: Salt Lake City, Utah Museum of Fine Arts, *Brief Gallery Guide to the Collections of the Utah Museum of Fine Arts,* p. 7, no. 4, ill.

Depictions of the Greek poet and *bon vivant* Anacreon were very popular, particularly during the Rococo period. (See the discussion of the large painting of this subject by Leprince, cat. no. 35.) The poet is identified by a scroll at the base of his chair inscribed: *Ode/Anacreon.* He is accompanied by his still more famous colleague, the poet Sappho of Lesbos (c. 612–565 B.C.), who recites to the accompaniment of her lyre while a lightly clad girl dances. The historical figures are joined, as in the Leprince painting, by a fanciful winged Eros.

In the eighteenth century the poems of Anacreon and Sappho were often published together.[1] Their joint depiction here is something of an anachronism, since Sappho was the older of the two by forty years. Both, however, were outstanding lyric poets specializing in the monody or solo song; this usually dealt with love and was delivered to a small audience of disciples (in the case of Sappho's school for girls) or a drinking party (in Anacreon's activity as a court poet).[2]

Though late in date and large in size, Lavallée's canvas exemplifies some of the conventions of Rococo genre painting. The figures are relatively small and are painted with a porcelainlike finish; the decorative arbor and statue of a nude Apollo receive an almost equal visual emphasis. The architectural backdrop, with its prominent, anti-illusionistic, grotesque masks, is surely derived from a contemporary publication illustrating ancient Roman decorative paintings excavated at Pompeii and Herculaneum. The closest stylistic parallel is probably in Vien's antique genre subjects of the 1760s (*The Seller of Cupids*), with their combination of classicizing archaeological detail and Rococo erotic charm.

[1]Henry Cohen, *Guide de l'amateur de livres à figures et à vignettes du XVIII^e siècle,* 3rd ed., Paris, 1876, cols. 9–10.
[2]William E. McCulloh, "Introduction," p. 5, to Willis Barnstone, transl., *Greek Lyric Poetry,* New York, 1962.

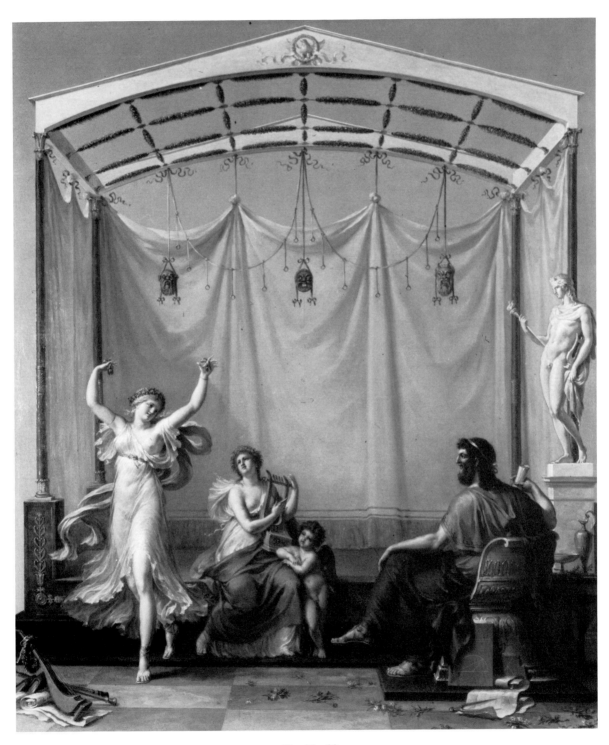

Cat. No. 32

François Lemoine
Paris 1668–1737 Paris

The most ambitious and successful painter of large decorations in the first half of the century, Lemoine was trained by his stepfather, Robert Tournières, and by Louis Galloche. Though a winner of the *Grand Prix* in 1711, he did not go to Rome; by 1718 he had been admitted to the Academy as a history painter. From the beginning of his career he hoped to receive major decorative commissions. In 1720, irritated that the commission for the Banque de France ceiling had been awarded to Pellegrini, an Italian, rather than to a Frenchman, he painted a sketch of his own idea for the ceiling (Paris, Musée des Arts Decoratifs) that was subsequently engraved by Silvestre.

Lemoine's first major opportunity was a large *Transfiguration* begun in 1723 in the choir vault of Saint-Thomas d'Aquin, Paris. Completion of the work was interrupted by a trip to Italy in 1723–24 with his patron François Berger; there he particularly admired Veronese's works in Venice. In the 1727 *concours* for academicians Lemoine shared the first prize with Jean-François de Troy for his elegant, slightly mannered *The Continence of Scipio*. The result was indicative of the rivalry of the two painters for dominance of the French school, a struggle eventually won by Lemoine when he was appointed *Premier Peintre* in 1736.

The most important commission undertaken by Lemoine was the vast *Apotheosis of Hercules* on the ceiling of the *Salon d'Hercule* at Versailles (1733–36). Such ambitious illusionistic ceilings were rare in French art after Le Brun, and derive from Italian (particularly Venetian) prototypes. This rather overwhelming decoration was to have no successors for the rest of the century, but it was well received at the time. Nevertheless Lemoine, insecure and suspicious, developed delusions of persecution and committed suicide within a year after the completion of the project.

Critical opinion about Lemoine has always been mixed. He is often viewed as a superficial artist, and his work is seen to better effect in his large decorations than in his easel paintings. His elegant colorism and eroticism helped establish the French Rococo style, however, and were passed on to his distinguished pupils Charles-Joseph Natoire and François Boucher.

33. *Cleopatra*, 1724
Oil on canvas, 40½ x 29¼ in. (107.9 x 74.3 cm.)
The Minneapolis Institute of Arts

PROVENANCE: Rome, Alberto di Castro; Museum purchase, The William Hood Dunwoody Fund, 1969.

EXHIBITIONS: Atlanta, High Museum of Art, *The Rococo Age*, 1983 (cat. by Eric Zafran), pp. 33–34, no. 2, ill. in color p. 24; Columbus, Ohio, Ohio State University Gallery of Fine Arts, *Painter's Painters*, 1984.

BIBLIOGRAPHY: *Minneapolis Institute of Arts Bulletin*, LVII, 1969, p. 100; Andrea Busiri Vici, "Opere Romane di Jean de Troy," *Antichità Viva*, IX, 1970, no. 2, pp. 3–20, ill. fig. 17; Pierre Rosenberg, "On Lemoine," *Minneapolis Institute of Arts Bulletin*, LX, 1971–73, pp. 55–59, ill. fig. 3; Jean-Luc Bordeaux, *François Le Moyne and his Generation, 1668–1737*, Neuilly-sur-Seine, 1985, p. 92, no. 45, ill. fig. 40; New York, Stair Sainty Matthiesen, *The First Painters of the King*, 1985, p. 138, ill. no. 120.

This attractive work, first offered for sale as by Pellegrini, has also been attributed to the Piedmontese artist Claudio Francesco Beaumont (1694–1766) and (by Busiri Vici) to Jean-François de Troy. More recently Jean-Luc Bordeaux[1] and Pierre Rosenberg have given the painting to François Lemoine, de Troy's principal rival as a decorative painter in the 1720s and 1730s. Rosenberg compares the *Cleopatra* stylistically to early works Lemoine created before or during his Italian trip of 1723–24, such as the *Hercules and Omphale* (Louvre). The subject's flowing hair, full, sensual, rather boneless forms and slightly parted lips are seen in other female figures by the artist, as in the *Perseus and Andromeda* of 1723 (London, Wallace Collection). Her upward glance recalls that of heroines in Italian Baroque paintings, such as those of Guido Reni. Another version of the painting, with variations, was in a private collection in Detroit.[2]

Cleopatra's gesture of dissolving a pearl in wine at a banquet, thus demonstrating her extravagance to Mark Antony, was frequently portrayed in Venice, a city whose artists made a considerable impression on Lemoine during his Italian journey. The theory that a history painting must include more than one figure is belied by this work; the subject's costume and gestures both identify her and comment on the personality traits that led to her rise and downfall.

[1]Bordeaux, *François Le Moyne*, 1985, no. 45 (39¼ x 32 in.).
[2]New York, Stair Sainty Matthiesen, *The First Painters*, p. 138, no. 119.

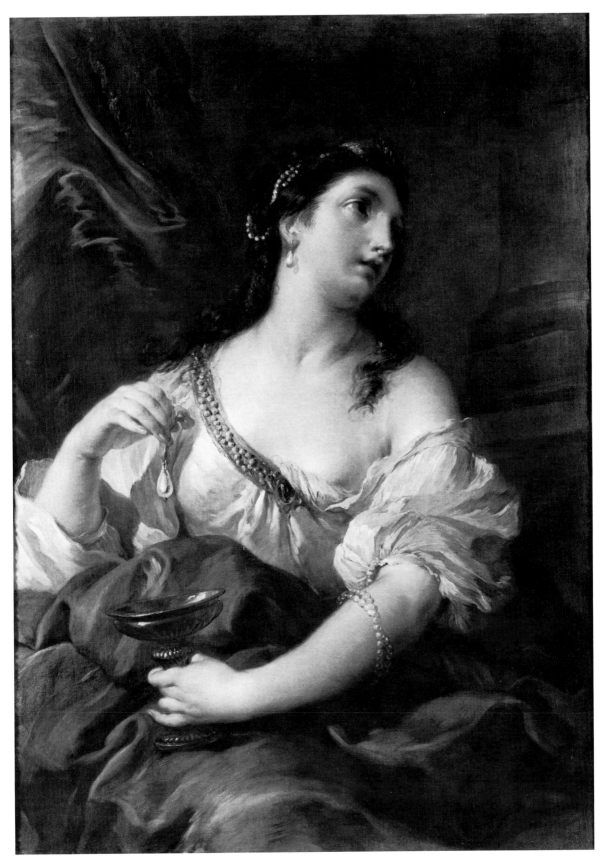

Cat. No. 33

119

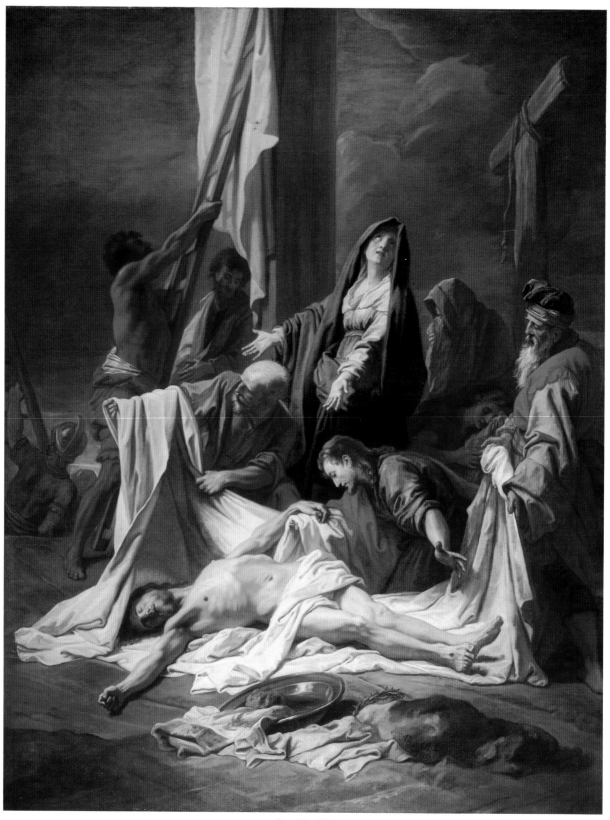

Cat. No. 28
(See pg. 108)

Nicolas-Bernard Lépicié
Paris 1735–1784 Paris

Lépicié studied with his father, the engraver François-Bernard Lépicié, permanent secretary of the Academy, and later with Carle Van Loo. He exhibited at the Salons from 1765 onward and was a professor at the Academy by 1777. Initially he saw himself as a history painter, showing a variety of religious pictures (*The Baptism of Christ*, 1763), mythologies (*The Anger of Neptune*), and even an early "nationalistic" subject from French history (*William the Conqueror Invading England*, Salon of 1765; Caen, Lycée Malherbe). These efforts met with little encouragement from Diderot or other critics of the period.

At the same time Lépicié had begun a career as a painter of a wide range of genre subjects; the main influences on this part of his work were the Dutch seventeenth-century tradition and the domestic genre scenes of Chardin. His best-known work, *Le Lever de Fanchon* (1773; Saint-Omer, Musée de l'Hôtel Sandelin) is a naturalistic view of a sleepy, rather untidy servant girl in her room. Other works range from informal portraits (*Young Boy with a Sketchbook*, The Hague, Mauritshuis) to large cityscapes with many figures (*Interior of a Customhouse*, 1775; Lugano, Thyssen-Bornemisza Collection). This aspect of Lépicié's work was popular with the public and he concentrated on it increasingly during the latter part of his career, though without entirely giving up historical subjects.

Though Lépicié has been compared to Greuze as a genre painter, he lacks both the sentimentality and the grand ambitions of the older artist. Lépicié's sober, detailed, objective genre works have always had admirers, but his historical works remain little studied today.

34. *The Visitation*, c. 1769
Oil on canvas, 23¾ x 13⅜ in. (60.5 x 34 cm.)
Albuquerque, University Art Museum, University of New Mexico

PROVENANCE: Private collection, on extended loan to Museum.

EXHIBITIONS: Possibly Salon of 1769, no. 128; *French Eighteenth-Century Oil Sketches from an English Collection*, Albuquerque, 1980 (cat. by Peter Walch), no. 40.

BIBLIOGRAPHY: Jean Seznec, *Diderot Salons*, IV, Oxford, 1967, pp. 39, 101.

In 1768 Lépicié received a commission for a large painting of this subject for the choir of the cathedral of Bayonne. The version shown at the Salon of 1769 was described as being 21 by 12 inches, and the larger work (now lost) was mentioned as already in place. The smaller painting could have been either the Albuquerque picture or another version of slightly different dimensions (56 x 35 cm.), formerly in the Féral collection,[1] that was signed and dated 1769 on the steps.

The subject, one of the most often depicted from the life of the Virgin, shows her meeting her older cousin St. Elizabeth, to whom she has traveled after the Annunciation. Like the Virgin, the elderly Elizabeth will miraculously give birth to St. John the Baptist, predecessor of Christ. In the background at the right Joseph embraces Elizabeth's husband Zacharias.

Though Diderot described the picture shown in 1769 as an "excellent sketch," the Albuquerque picture is a relatively highly finished painting. As is often the case with a small-format religious picture of this period, one may question whether it is a sketch for or a reduced version after the larger work. The grand figures, stately Italianate composition, and subdued colors recall the Bolognese classicist painters, who had a strong influence on Lépicié's teacher Carle Van Loo.

[1]Sale, Paris, April 22–24, 1901, no. 44, bought by the dealer Michel. Cited in Philippe Gaston Dreyfus, *Catalogue raisonné de l'oeuvre peint et dessiné de Nicolas-Bernard Lépicié (1735–1784)*, Paris, 1923, p. 31, and in Walch. This is perhaps the version now in a New York private collection.

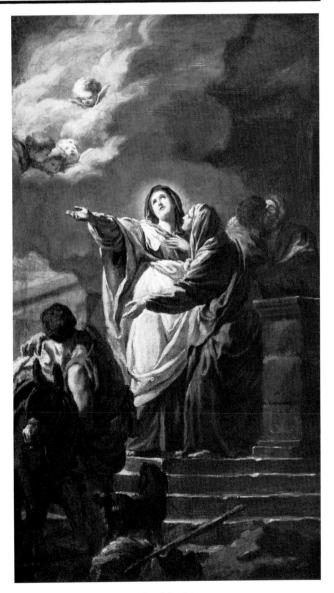

Cat. No. 34

Jean-Baptiste Leprince

Metz 1734–1781 Saint-Denis-du-Port, near Lagny

One of the most famous genre painters of the eighteenth century, Leprince came from a family of master gilders. Without resources, he studied first in Metz, where he obtained the patronage of the governor, the Maréchal de Belle-Isle. Placed in the studio of François Boucher in Paris, Leprince was soon producing small Boucher-like erotic pastoral scenes. Following a stormy marriage in 1752 to a wealthy older woman, Leprince spent two years in Rome, where he executed drawings of ruins for the well-known antiquarian, the Abbé de Saint-Non. His Roman experience does not seem, however, to have exerted much influence on his subsequent work.

Still searching for his own style, Leprince traveled in 1758 first to Holland, where he studied the famous genre masters, then to Russia, where he spent the next five years. In addition to executing numerous decorations for the Winter Palace in St. Petersburg, he traveled extensively in the provinces, making many drawings of Russian peasant life. Forced by poor health to return to Paris, he created a sensation with his new works and established a vogue for Russian exoticism paralleling the established popularity of Orientalist subjects. In 1764–65 Leprince published several series of etchings of Russian genre subjects. He was received into the Academy with his *Russian Baptism*, which he showed with related subjects at the Salon of 1765 to great acclaim. He also designed a series on *Russian Games* for the Beauvais tapestry works (1767–69).

Leprince had wide theoretical interests: he developed an improved method for producing aquatints in 1768, and in 1773 read a treatise to the Academy on landscape painting, supplemented by a series of drawings that were engraved as *Principes du dessin*. When critics, such as Diderot, who originally welcomed his Russian scenes began to find them repetitious, Leprince turned his interests to landscape painting. In the late 1770s, a semi-invalid, Leprince retired to his country house near Lagny, producing some large, splendid landscapes derived from the tradition of Dutch masters like Jacob van Ruisdael.

Although primarily a genre specialist, Leprince occasionally tried his hand at historical subjects such as *Hannibal Visiting the Daughters of Lycomedes*[1] and *Rest on the Flight to Egypt*.[2] Initially an imitator of Boucher, Leprince developed a personal style and is interesting as both a draftsman and colorist.[3]

[1]Anonymous sale, Paris, November 22, 1940.
[2]Anonymous sale, Paris, June 9–10, 1953.
[3]See Rémy G. Saisselin, "A Leprince Landscape," *Porticus*, II, 1979, pp. 27–33.

35. *The Poet Anacreon*, 1767

Oil on canvas, 38¼ x 54¾ in. (97.2 x 139.1 cm.)
Signed and dated (lower right): *Le Prince 1767*
Lawrence, Kansas, Spencer Museum of Art, University of Kansas

PROVENANCE: Xavier Scheidwimmer, Munich; Museum purchase, 1958.

EXHIBITIONS: Notre Dame, Indiana, University Art Gallery, *Eighteenth Century France: A Study of its Arts and Civilization*, 1972, no. 58, ill.

BIBLIOGRAPHY: Francis H. Dowley, "Anacreon and Le Prince," *The Register*, Spencer Museum of Art, II, no. 6, 1961, pp. 8–23; Saisselin, "A Leprince Landscape," p. 30, ill. fig. 5.

This large, atypical work was painted at the height of Leprince's preoccupation with Russian genre scenes. It is similar in size and format to another painting dated 1767 by Leprince of *Homer* (fig. 49; Athens, private collection), and Dowley suggests the two may have been pendants.[1] The two canvases might have been intended for a series of four pictures of lyric, heroic, pastoral, and satiric poets, or for pairs of Greek and Latin poets, though no other evidence of such a commission has come to light.

Anacreon (c. 570–c. 480 B.C.) was an historical figure who took on mythological dimensions even during his own lifetime. The lyric poet, born at Teos in Ionia, lived at the courts of the tyrants Polycrates of Samos and Hipparchus of Athens. Poems by or attributed to this author describe him as old, often drunk, and given to pleasure. His name was proverbially associated with a hedonistic existence, and translations of his works were popular among *littérateurs* and gallants of the Rococo period. Historical or mythological scenes concerning Anacreon were painted by, among others, Antoine Coypel, Restout, Doyen, Fragonard,[2] and Etienne de Lavallée (see cat. no. 32).

Leprince's depiction gives the traditional view of the Greek poet: he lies crowned with roses on a bed strewn with flowers. The materials are luxurious, and the background is partially filled by an elaborate censer burning perfumed incense and by a sensuous sculpture of a nude woman. The image is as much mythological as historical, since a winged putto pours wine into the cup the poet holds in his left hand, while two more putti, one holding the poet's lyre, watch him write on a scroll. Though the aged figure lacks the sober, intense concentration of the *Homer*, he is not without dignity. Leprince's transitional style, midway between Rococo lightness and the sober naturalism more characteristic of the end of the century, is best seen in landscapes like *The Visit* (1779; Memorial Art Gallery of the University of Rochester). In the Lawrence canvas, he depicts an ancient world in which intellectual and artistic creativity are associated not with stern self-sacrifice but with the pleasures of life.

[1]Dowley, "Anacreon and Le Prince," p. 8.
[2]*Ibid.*, p. 16ff and p. 18, fig. c.

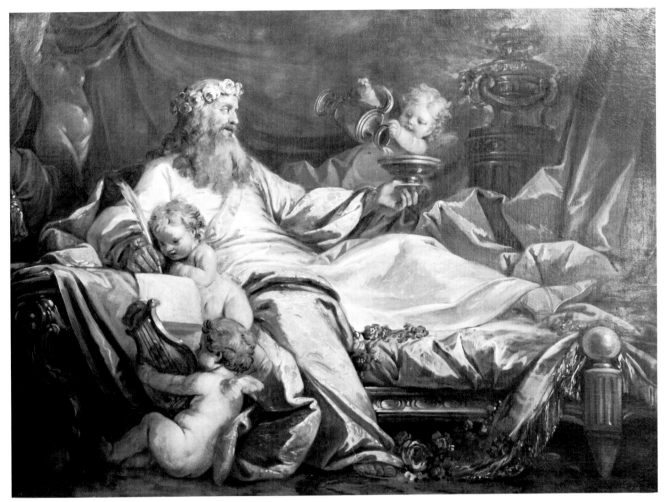

Cat. No. 35

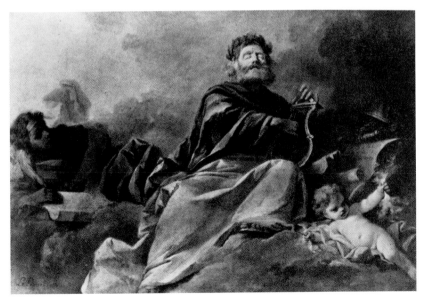

Fig. 49—Jean-Baptiste Leprince
Homer
Athens, private collection

Guillaume Lethière

Sainte-Anne (Guadeloupe) 1760–1832 Paris

Guillaume Guillon, called Lethière or Guillon-Lethière, studied with the history painter Jean-François Doyen. In 1784 he received the second prize in the *Prix de Rome* competition for *The Canaanite Woman at the Feet of Christ* (Angers, Museum). From 1786 to 1790 he was a student at the French Academy in Rome, despite his failure to win the grand prize. He began to exhibit at the Salon in 1793. After 1800 Lethière had a signifi-

cant teaching career as director of the French Academy in Rome (1807–16) and later as professor at the Academy in Paris.

Lethière was friendly with Ingres and knew such important younger Romantics as Géricault and Auguste. He, however, continued to work in a rather stiff Neoclassical manner that was already fully formed in his large *Philoctetes at Lemnos* (Salon of 1798; Cluny [Saône-et-Loire], Museum). In such works the radical dramatic innovations of the art of the 1780s became academic formulas on which the artist executed variations for half a century.

36. *The Death of Camilla*, 1785
Oil on canvas, 46 x 58 in. (116.8 x 147.3 cm.)
Providence, Museum of Art, Rhode Island School of Design

PROVENANCE: Paris, B. G. Verte; purchased (as "school of Vien"), Mary B. Jackson Fund, 1972.

BIBLIOGRAPHY: *Gazette des Beaux-Arts*, 6th ser., LXXXI, February 1973, p. 135, no. 489; J. Patrice Marandel, "The death of Camille: Guillaume Guillon Lethière and the 1785 Prix de Rome," *Antologia di Belle Arti*, IV, nos. 13–14, 1980, pp. 12–17, ill. fig. 1.

As recounted by the Roman historian Livy (I, 24–26), Camilla was betrothed to one of the enemies of Rome whom her three brothers, the Horatii, had vowed to defeat. When the sole surviving brother returned victorious after having killed their enemies, Camilla's curses drove him to kill her with his sword. This grim subject had wide currency among the French painters of the 1780s: David's *Oath of the Horatii* (1784) was the sensation of the Salon of 1785, and in the same year the subject of the Providence canvas was chosen as the prize theme for the *Prix de Rome* competition. The moment selected was that in which Horatius, having killed his sister, exclaims: "Thus may any Roman woman who is an enemy of her country perish."[1] Both the subject and the standardized size of this painting ensure that it was made for the 1785 *concours*.

The attribution of this work to Lethière is by Marandel. Surviving pictures from the 1785 competition are particularly numerous: the best-known version may be that of Girodet (Montargis, Musée);[2] a second-prize winner is by Bernard Duvivier (see fig. 46). The winning picture, in vertical format, was submitted by Victor-Maximilien Potain, while another first prize went to Jean-Baptiste Desmarais (both versions Paris, École Nationale Supérieure des Beaux-Arts).[3] Lethière's picture was well received by the academicians, who failed to give him a second prize only because of a political intrigue in favor of Desmarais. When the details of the affair became known the *Directeur général des Bâtiments* found a place for Lethière the following year as a *pensionnaire* at the French Academy in Rome.

Marandel convincingly relates the Providence canvas stylistically to two late paintings by Lethière on a similar theme, *The Death of Virginia* (1828; Louvre, and c. 1800; London, private collection).[4] *The Death of Camilla* is "advanced" in its friezelike composition and the Classical details of some of the figures, traits that continued to characterize Lethière's work for the rest of his long career. This early painting shows the artist's style at its most vigorous, before it turned into a formula. An oil sketch for the picture is in the Musée Magnin, Dijon, and another in 1986 was on the London art market;[5] these small but painterly works illustrate Lethière's roots in an earlier eighteenth-century tradition, most notably that seen in the paintings of his teacher, Gabriel-François Doyen.

[1] Simon Lee, in a letter, August 19, 1983.
[2] Marandel, "The death of Camille," fig. 9.
[3] *Ibid.*, figs. 6 and 7.
[4] *Ibid.*, figs. 10 and 11.
[5] *Ibid.*, figs. 5 and 14.

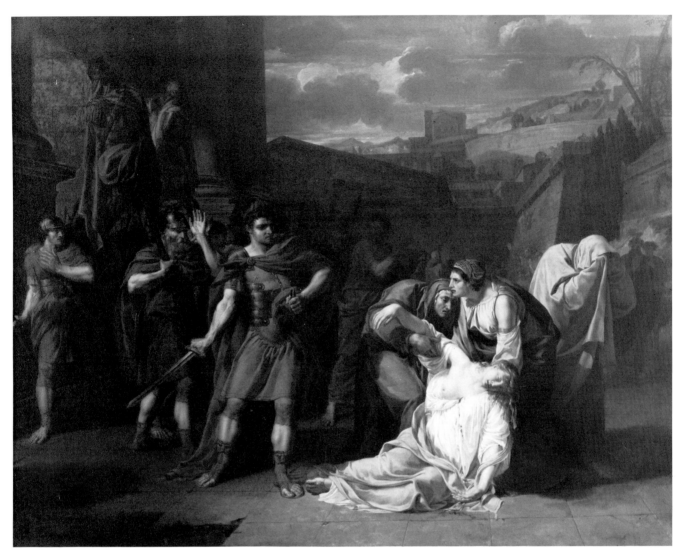

Cat. No. 36

Paolo de Matteis
Piano del Cilento 1662–1728 Naples

Paolo de Matteis studied in Naples with Luca Giordano and by 1683 in Rome with Gianmaria Morandi, a follower of Carlo Maratta. His mature style, formed by the 1690s in many decorative works like his frescoes for the pharmacy of the Certosa di San Martino, Naples (1699), combined Baroque and classicizing elements derived from these sources. The artist's high reputation in Naples as a decorative painter led to his stay in Paris (1702–05) at the invitation of the Comte d'Estrées. De Matteis's artistic activity and critical reception in France have already been discussed.

After his return to Naples de Matteis continued to develop in the direction of an advanced classicizing manner in works like *Hercules at the Crossroads* (Leeds, Art Gallery), commissioned by Lord Shaftesbury in 1712. Such works foreshadow the stylistic direction taken by other Italian artists by mid-century, particularly in Rome. De Matteis's work after 1715 is sometimes regarded as increasingly stiff and academic. The restrained compositions and cool colors of de Matteis's best works mark a movement away from the Baroque style and prefigure some aspects of Rococo painting.[1]

[1]See Detroit Institute of Arts, *The Golden Age of Naples*, 1981, I, pp. 53–54 and 122.

37. *Allegory of the Peace of Utrecht and of Rastatt*, c. 1714
Oil on canvas, 30 x 40 in. (77.2 x 106.6 cm.)
Houston, The Sarah Campbell Blaffer Foundation
(Shown only in Rochester)

PROVENANCE: London, Colnaghi, 1979; purchased by the Foundation.

EXHIBITIONS: London, Colnaghi, *Old Master Paintings and Drawings*, 1979, no. 15; Naples, Museo di Capodimonte, *Civiltà del '700 a Napoli, 1734–1799*, 1979, I, no. 61; Detroit Institute of Arts, *The Golden Age of Naples*, 1981, I, pp. 53–54 and no. 30, ill. color pl. III; Winston-Salem, N.C., Wake Forest University, *Treasures of Italian Painting from the Sarah Campbell Blaffer Foundation*, 1984, no. 16.

BIBLIOGRAPHY: Naples, Villa Pignatelli, *Mostra delle Acquisizione 1960–75*, 1975, pp. 172–174 (discussion of related works); Oreste Ferrari, "Considerazioni sulle vicende artistiche a Napoli durante il viceregno austriaco (1707–1734)," *Storia dell' Arte*, XXXV, 1979, p. 26, ill. fig. 24; Terisio Pignatti, *Five Centuries of Italian Painting 1300–1800 from the Collection of the Sarah Campbell Blaffer Foundation*, Houston, 1985, pp. 162–164, ill. in color.

Though the subjects of de Matteis's lost decorative paintings of 1702–05 in Paris are unknown, we may assume they were largely allegorical, as were the works later supplied by the Venetians Ricci and Pellegrini in response to French commissions. The Houston composition, painted after de Matteis's departure for Naples, contains many elements that must have been common to the artist's Parisian "galleries," yet also includes unique personal references. Like many allegories of the period, it was painted in response to a contemporary political event: in this case, the signing of the treaties of Utrecht and Rastatt in 1713–14. This series of agreements ended the War of the Spanish Succession and redrew the boundaries of nearly all the major states of western Europe. In return for renouncing his claim to the Spanish throne the Emperor Charles VI was guaranteed Austrian hegemony over the Spanish Netherlands (Flanders), Milan, and de Matteis's homeland, Naples.

The artist depicts himself painting an easel-sized canvas, surrounded by a swirl of allegorical figures. The canvas shows the figures of Austria (represented by the double eagle) and Flanders (with a lion) holding hands; since this aspect of the agreement was confirmed only in the later treaty of Rastatt, the painting could not have been begun before 1714. The allegorical figures, masterfully orchestrated, convey a symbolism typical for subjects of this kind. In the lower part of the picture Mars and the evils of war are driven out by messengers of peace. Above are personifications of Peace and Plenty, while to the upper right figures of Faith, Hope, and Charity allude to the Pope's mediation in the treaty. The "real" part of the picture space, referring more directly to the historical event of the treaty signing, is occupied by the canvas and by de Matteis's self-portrait; an erupting Vesuvius in the background identifies the locale as Naples.

The self-portrait is surprising in such an allegory, both for its prominence within the composition and for the artist's casual attire of a cap and dressing gown. Nearby a monkey, the imitative symbol of the artist, watches the allegorical figures with curiosity. The painting is not an intimate personal composition, however, for the definitive version to which the Houston canvas is related was a massive picture of which only a fragment, including the life-sized self-portrait, survives (170 x 118 cm.; Naples, Museo di Capodimonte).[1] The eighteenth-century critic de Domenici described the inclusion of the self-portrait as a "lowly idea" that was criticized by everyone when the large painting was exhibited at the Monte de' Poveri.[2] Ferrari, rather implausibly, sees the informal self-portrait as an ironic comment by the artist on the "grand manner" of the figures that fill the rest of the composition.[3]

A version of similar size in the Jedding collection, Hamburg, resembles the large fragment in Naples more closely than the Houston picture in the treatment of the cap and the position of the monkey and the flying figure to the left. It also includes a still life of the attributes of the arts and sciences in the foreground, an area that is empty in the Houston canvas. In view of the high quality of the Houston painting, it is likely that it is a finished preliminary sketch by the artist, while the Hamburg

Cat. No. 37

picture is a replica of the finished work. Though the picture has dark areas, the reds, blues, and golds of the costumes have a lightness and brilliance that may also have characterized de Matteis's lost ceiling decorations and may have influenced French practice well before the advent in Paris of Ricci and Pellegrini. A related *Allegory of Peace*, vast in size though somewhat careless in execution (253 x 358 cm.; Mainz, Mittelreinisches Landesmuseum) was in the Parisian collection of Duc Philippe de Noailles and was sold during the Revolution, though the content and early history of that commission have not been identified.[4]

[1]Naples, Villa Pignatelli, *Mostra*, ill.
[2]Bernardo de Domenici, *Vite dei pittori, scultori ed architetti napolitani*, Naples, 1742; 1846 ed., IV, p. 343.
[3]In Detroit Institute of Arts, *The Golden Age of Naples*, p. 54.
[4]Ferrari, "Considerazioni," fig. 22.

Paolo de Matteis
Piano del Cilento 1662–1728 Naples

38. *Saint Nicholas of Bari Felling a Tree Inhabited by Demons*, c. 1727
Oil on canvas, 34½ x 54⅝ in. (87.6 x 139.7 cm.)
Atlanta, High Museum of Art
(Shown only in Rochester)

PROVENANCE: New York, Frederick Mont; New York, New-house Galleries; Museum purchase, Fay and Barrett Howell Fund, 1982.

BIBLIOGRAPHY: Eric M. Zafran, *European Art in the High Museum*, Atlanta, 1984, pp. 63–64, ill. in color p. 22.

This work belongs to the last phase of de Matteis's career, long after the artist's return from France. It has been related stylistically to de Matteis's works of 1727–28 in San Paolo d'Argon, Bergamo, and may have been intended for the choir of San Nicola alla Carita, Naples, for which the artist also painted a *Death of Saint Nicholas*.[1] The painting is characterized by careful pyramidal composition of figural groups and rather sober colors. Perhaps a study for an overdoor decoration, the dramatic composition is treated with dignified restraint.

Stories about the immensely popular Saint Nicholas, Bishop of Myra in Asia Minor in the fourth century, were conflated with accounts of a sixth-century saint who was bishop of nearby Pincra. According to a Greek account of the latter Saint Nicholas, a sacred tree in the village of Plakoma was inhabited by a demon that frightened the villagers and killed anyone who tried to cut down the tree. The saint, implored for help, prepared to chop down the tree with an axe:

> When he was about to fell this sacred tree, the servant of God said, "Assemble up the slope on the North side." For it was expected that the tree would fall to the West. The unclean spirit thought at that moment to frighten the crowd. And he made the tree lean toward the North where the crowd stood watching, so that they all screamed with fear, saying with one voice: "Servant of God, the tree is coming down on top of us, and we will perish." The servant of God Nicholas made the sign of the cross over the tree, pushed it back with his two hands, and said to the sacred tree: "In the name of Jesus Christ I command you: turn back [in the other direction] and go down where God has ordained you." Forthwith, the tree swayed by the will of God and moved toward the West, where it crashed. From that time on, the unclean spirit was no longer seen within those parts.[2]

[1]Zafran, *European Art in the High Museum*, p. 64.
[2]*Ibid.*, pp. 63–64 (translation by Nancy P. Sevcenko).

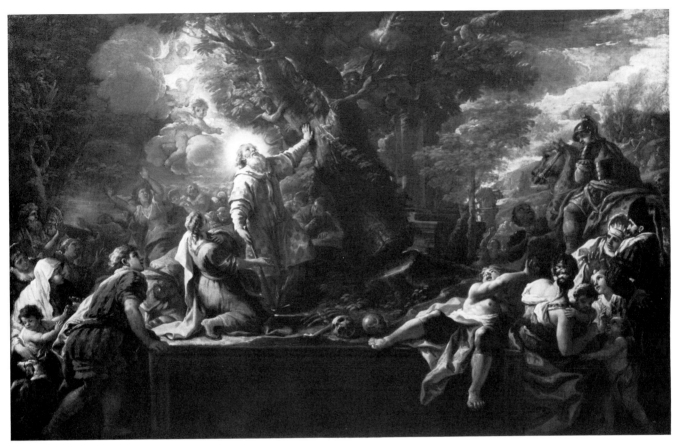

Cat. No. 38

François-Guillaume Ménageot
London 1744–1816 Paris

Son of the art dealer and landscape painter Augustin Ménageot, François-Guillaume was brought as a child to Paris, where he subsequently studied with Jean-Baptiste Deshays and François Boucher. A promising student, Ménageot won the *Grand Prix* in 1766 with *Tomyris Ordering the Head of Cyrus Plunged into a Bowl of Blood*. He spent the years 1769–74 at the French Academy in Rome, then under the directorship of Vien, and developed a great admiration for the seventeenth-century Bolognese classicists. *Agréé* by the Academy in Paris in 1773, he attained full membership three years later with a large allegorical picture, *Learning Holding Back Time* (Paris, Ecole Nationale Supérieure des Beaux-Arts).

Ménageot soon began to receive numerous commissions for religious and historical subjects, of which *The Death of Leonardo da Vinci*, shown at the Salon of 1781, had the greatest public and critical success. Like his teacher Boucher, Ménageot also painted smaller erotic mythological scenes, though most are now lost.

Ménageot painted a number of "modern" histories or allegories besides the *Leonardo*, including *The Plague of Milan* (Paris, Saint-Nicolas du Chardonnet); *Allegory of the Birth of the Dauphin* (1782; Louvre); and *Allegory of the Peace of 1783* (1785; lost); *Dagobert I Ordering the Construction of the Church of Saint-Denis* (Douai, Eglise Saint-Pierre); and under Napoleon, *The Marriage of Prince Eugene Beauharnais* (Versailles).

Director of the French Academy in Rome by 1787, Ménageot had to deal with rising revolutionary fervor among the students and resigned in 1792. Subsequently, under intense political criticism in Paris, the artist settled in Vicenza, returning to France only in 1801 to undertake his duties as a professor at the Academy. Ménageot's last submissions to the Salon, however, were not well received. The artist reached the peak of his career in the early 1780s, before David's rise to prominence. An eighteenth-century artist in his attention to attractive color and design, Ménageot never fully succeeded in adapting his style to the rising Neoclassical taste with which his name is now often associated.[1]

[1]Nicole Willk-Brocard, *François-Guillaume Ménageot (1774–1816), peintre d'histoire*, Paris, 1978.

39. *The Death of Leonardo da Vinci*, c. 1781
Oil on canvas, 21½ x 21½ in. (54.5 x 54.5 cm.)
Albuquerque, University of New Mexico Museum of Art

PROVENANCE: Coll. Comtesse de Provence [?], 1781; coll. Anne-Louis Girodet-Trioson, sale, Paris, April 11–25, 1825, no. 414; Walferdin collection, sale, Paris, April 12–16, 1880, no. 146; coll. Henri Haro, sale, Paris, March 18–20, 1912, no. 195; Paris, coll. Louis Moiret, by 1935–before 1948; Geneva, private collection; London, M. J. Tully, 1976; sale, New York, Christie's, Jan. 15, 1986, no. 81, ill.; private collection, on extended loan to the Museum.

EXHIBITIONS: Hartford, Wadsworth Atheneum, 1983–84.

BIBLIOGRAPHY: F. Antal, "Reflections on classicism and romanticism," *Burlington Magazine*, LXVI, 1935, p. 162, ill. pl. II B; M. Florisoone, *La peinture française: Le dix-huitième siècle*, Paris, 1948, pl. 155; Denis Diderot, *Salons*, ed. J. Seznec and J. Adhémar, Oxford, IV, 1967, ill. p. 330; B. Lossky, "Léonard de Vinci mourant dans les bras de François Ier," *Bulletin de l'Association Léonard de Vinci*, XLV, 1967, ill. p. 50; Willk-Brocard, *François-Guillaume Ménageot*, p. 67, cat. no. 12, ill. fig. 23; Paris, Hôtel de la Monnaie, *Diderot et l'art de Boucher à David: Les Salons, 1759–1781*, 1984–85, p. 330.

The larger version of this composition (Amboise, Hôtel de Ville) was commissioned in 1780 by the Bâtiments du Roi to serve as a model for a Gobelins tapestry in the *History of France* series. Other paintings that belonged to this important series of commissions included Brenet's *Death of Du Guesclin*, Durameau's *Continence of Bayard*, Vincent's *Président Molé Manhandled by Insurgents*, and Suvée's *Assassination of Admiral de Coligny*.

Ménageot's greatest success, the painting was admired by nearly every critic when it was shown at the Salon of 1781. Diderot, who could find only minor details to criticize, praised the work for its color, painterly handling, and moving subject. The story is derived from Vasari's *Lives of the Artists*. François I, who had called Leonardo to France, often visited the ailing artist at the chateau of Amboise. One day as François entered, Leonardo sought to rise to greet him, but fell back. The king sought to comfort him and the artist, conscious of the great honor being offered to him, expired in François's arms. Ennobling both the artistic profession and the French monarchy, the subject was in the air at this period, having recently been treated in England by Angelica Kauffmann and Richard Cosway.[1]

The Albuquerque canvas, a preliminary sketch, shows the originally square format of the larger version (327 x 327 cm.). Typical of Ménageot's oil sketches, the work roughly blocks out the figures and the principal areas of light and dark. The large version is now horizontal, having been cut down at the top and extended on the sides; the new format gives the painting a sense of Baroque movement and recession into depth. The original format, as seen here, emphasizes the great bed with its baldaquin. The composition is more centralized and static, but also more solemn and grand in feeling. The qualities of color and brushwork that were appreciated in the final version are already in evidence here. The sketch may have belonged to the Comtesse de Provence, a member of the royal house, since the engraving of the composition by F. P. F. Garreau, executed in 1781, bears her arms, while the large version had gone immediately into the King's possession.[2]

[1]See Paris, Hôtel de la Monnaie, *Diderot*, p. 328.
[2]Willk-Brocard, *Ménageot*, p. 67, citing Lossky, "Léonard de Vinci mourant," p. 50.

Cat. No. 39

Charles Meynier
Paris 1768–1832 Paris

Only the beginning of Meynier's career falls in the eighteenth century. A pupil of Vincent, he shared the *Grand Prix* in 1789 with Anne-Louis Girodet for *Joseph Recognized by his Brothers*. Forced by the political situation to leave Rome after a short stay, Meynier returned to Paris, where he exhibited at the Salon from 1795 to 1824. In 1793 he took part in a competition for a painting on a Revolutionary theme authorized by the Committee of Public Safety; his *France Encouraging Science and the Arts* (Boulogne-Billancourt, Bibliothèque Marmottan) won a second prize.

Under the Empire and Restoration Meynier received numerous commissions for decorative projects, including his designs for the decoration of the Arc de Triomphe du Carrousel in 1806. He became a member of the Institute in 1815. Meynier's style developed from a taste for rich color to a more sober, "correct," Neoclassical style under the Empire.

40. *Joseph Recognized by his Brothers*, 1789
Oil on canvas, 18 x 21⅜ in. (46 x 55 cm.)
Private collection.

PROVENANCE: Coll. Ulysse Moussali; Paris, Galerie Cailleux; private collection.

REFERENCES: Detroit Institute of Arts, *French Painting 1774–1830: The Age of Revolution*, 1975, p. 544.

EXHIBITIONS: Paris, Galerie Cailleux, *Autour du néoclassicisme*, 1973, no. 27, ill.; New York, Didier Aaron, Inc., *French Paintings of the Eighteenth Century*, 1983, no. 27, ill. in color.

In 1789, as in 1700, the Academy chose Joseph's recognition by his brothers in Egypt as the theme for the *Prix de Rome* competition. Related aspects of the story had already been painted by Charles-Antoine Coypel and François Boucher, among many other artists. This sketch qualified Meynier for the final round in which his finished painting (Paris, Ecole Nationale Supérieure des Beaux-Arts) shared first prize with the version by Anne-Louis Girodet. Compositionally the sketch is notable for the planar arrangement of the figures when compared to earlier depictions such as that by Charles-Antoine Coypel. The standing, kneeling and bowing figures ascend in nearly heraldic pairs toward the central figure of Joseph. Their gestures, in accordance with the Academic doctrine codified in the previous century by Charles Le Brun, indicate standardized expressions of abjection, astonishment, humility, or love. The emotional tone of the scene is more rigid than in the flowing and theatrical depiction of family reconciliation in the painting by Charles-Antoine Coypel.

The freedom of paint handling, characteristic of oil sketches of the period, would rarely have been carried over to the more finished version. While there are warm tones in the flesh and costume of the kneeling figure at the left, the colors, as in many works of the Neoclassical period, are harder than in versions of the same story produced earlier in the eighteenth century. As does the *France Encouraging Science and the Arts* at Boulogne-Billancourt, this painting shows the young Meynier's penchant for elongated figures and "Greek" profiles.

Cat. No. 40

Charles-Joseph Natoire
Nîmes 1700–1777 Castelgandolfo

Natoire was, after Boucher, the best decorative painter of the Rococo period. The son of the architect and sculptor Florent Natoire, he was sent in 1717 to Paris, where he studied with Louis Galloche and François Lemoine. He won the *Grand Prix* in 1721 for *The Sacrifice of Manoah* (Paris, Ecole Nationale Supérieure des Beaux-Arts) and spent the years 1723–28 in Rome. There his academic success continued, and he was awarded a first prize by the Accademia di San Luca in 1725 for a drawing, *Moses Descending from Mt. Sinai.*

After his return Natoire was admitted to the Academy in 1734 with *Venus Begging Arms from Vulcan* and soon was appointed a professor. Around this time (1736–39) Natoire completed what is still his best-known work, the decorative panels of the *Story of Psyche* for the Salon de la Princesse, designed by Germain Boffrand for the Hôtel de Soubise, Paris (now the Archives Nationales). Natoire received many commissions, including those for a *Don Quixote* series for the Beauvais tapestry works in the 1730s and a *Story of*

Mark Antony series (of which only three were completed) for the Gobelins works in the 1740s and 1750s. His most important religious commission, for the Chapelle des Enfants-Trouvés, Paris (consecrated 1751; destroyed), included paintings of the Adoration of the Shepherds and the Magi, together with illusionistic architectural ruins by Gaetano and Paolo Antonio Brunetti. Natoire also undertook a landmark historical series for Philibert Orry, the *Directeur général des Bâtiments,* between 1731 and 1740. This was the *History of Clovis* (Troyes, Musée des Beaux-Arts), one of the first large commissions based on medieval history and glorifying one of the early kings of France.

Natoire was the teacher of Pierre and Vien; in 1751 he was appointed director of the French Academy in Rome. There he attempted to encourage the study of landscape, a strong artistic interest of his own in his later years. Fragonard and Hubert Robert were among the students who worked with Natoire early in his tenure in Rome. Forced to resign for lax administration in 1774, the painter remained in Italy for the rest of his life. Though his work suffers when compared to that of Boucher, Natoire was a painter of graceful movement and refined color.

41. *Jacob and Rachel Leaving the House of Laban,* 1732
Oil on canvas, 39½ x 56 in. (100.3 x 142.3 cm.)
Atlanta, High Museum of Art

PROVENANCE: Louis-Antoine de Gondrin de Pardaillan, Duc d'Antin (d. 1736) from 1732; Eglise de Saint-Antoine, Compiègne, sold in 1857; M. de Laporte, Senlis; private collection, New York; Museum purchase, 1983.

EXHIBITIONS: Atlanta, High Museum of Art, *The Rococo Age,* 1983, no. 4, ill. in color p. 25.

BIBLIOGRAPHY: F. Boyer, "Catalogue raisonné de l'oeuvre de Charles Natoire," *Archives de l'Art Français,* 1949, p. 34, and p. 63, no. 235 (as lost); Patrick Violette, "Chronologie," in *Charles-Joseph Natoire,* Troyes, 1977, p. 41; Eric M. Zafran, *European Art in the High Museum,* Atlanta, 1984, pp. 128–29, ill. in color p. 89.

The story of Jacob and Laban, told in Genesis 31, was frequently represented during this period; another episode, *Laban Searching for his Household Gods,* was depicted by Gabriel de Saint-Aubin (cat. no. 49). Jacob, feeling he had been mistreated by his father-in-law Laban, left Laban's home secretly and in haste. The moment depicted is from verses 17–18: "Then Jacob rose up, and set his sons and his wives upon camels; And he carried away all his cattle." Prominently displayed are a camel and a goat representing Jacob's large flock. Rachel gestures toward a box of goods, perhaps containing the household gods that she stole from her father.

The painting is one of a group of three commissioned in 1732 by the Duc d'Antin, former *Directeur général des Bâtiments,* and installed in his Paris residence. A pendant painting, *The Meeting of Jacob and Rachel at the Well* (cat. no. 42; priv. coll.), shows an earlier moment in the story;[1] the third picture (Paris, Louvre) depicts *Hagar and Ishmael in the Desert.*[2] Several preliminary drawings for the Atlanta canvas are known. One (Strasbourg, Musée des Beaux-Arts) establishes the composition in

Fig. 50—Charles-Joseph Natoire
Study of Two Female Figures, drawing
Sacramento, Crocker Art Museum

nearly final form,[3] while another (Sacramento, Crocker Art Museum, fig. 50) is a preparatory sketch for the figure of Rachel.[4] Though the subject chosen is one that provides little opportunity for drama, the decorative, pleasing colors are indicative of Natoire's debt to Venetian painting, from the Renaissance master Veronese to such contemporaries as Pellegrini and Sebastiano Ricci.

[1] Atlanta, *The Rococo Age,* p. 35.
[2] *Ibid.,* fig. I.3.
[3] *Ibid.,* p. 36, fig. I.4.
[4] Zafran, *European Art in the High Museum,* p. 129.

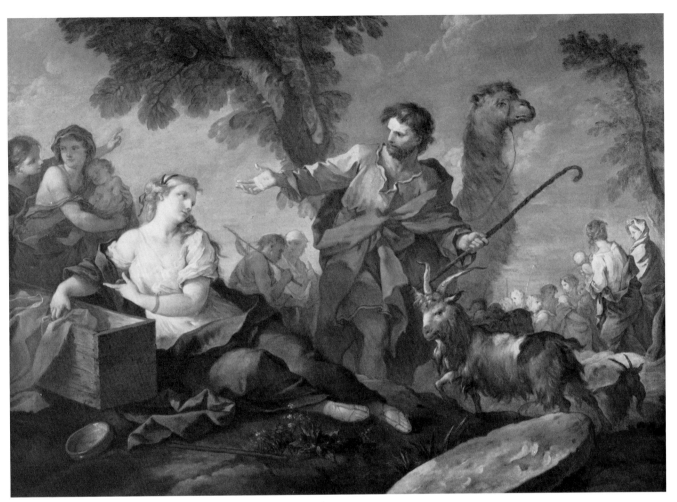

Cat. No. 41

Charles-Joseph Natoire
Nîmes 1700–1777 Castelgandolfo

42. *The Meeting of Jacob and Rachel at the Well*, 1732
Oil on canvas, 39½ x 56 in. (100.3 x 142.3 cm.)
Private collection

PROVENANCE: See preceding entry.

EXHIBITIONS: Bayeux, Abbaye de Mondaye, *Exposition Restout*, 1956, no. 37b (with pendant, as by Restout), exh. cat. published in *Art de Basse-Normandie*, no. 2, summer 1956, p. 38; London, Wildenstein & Co., *Religious Themes in Painting from the 14th Century Onwards*, 1962, no. 42 (as by Restout), ill.

BIBLIOGRAPHY: J. Messelet, "Jean Restout," *Archives de l'Art Français*, 1938, p. 139, no. 4 (as by Restout); Boyer in *Archives de l'Art Français*, 1949, pp. 34 and 63, no. 236 (as lost); Rouen, Musée des Beaux-Arts, *Jean Restout* (cat. by Pierre Rosenberg and Antoine Schnapper), 1970, p. 217, no. 01 (as by Natoire); Violette, *Charles-Joseph Natoire*, p. 41; Atlanta, *The Rococo Age*, cited under no. 4, ill. p. 35, fig. I.2; Joseph Baillio, "French Rococo painting: A notable exhibition in Atlanta," *Apollo*, CXIX, no. 253, 1984, p. 17; Zafran, *European Art in the High Museum*, p. 129; Jean-Luc Bordeaux, *François Le Moyne and his Generation*, Neuilly-sur-Seine, 1984, pp. 43, 44–45, 50n.55, ill. fig. 401.

The pendant to the *Jacob and Rachel Leaving the House of Laban* in Atlanta depicts an earlier moment in the story, taken from Genesis 29. Jacob had been sent by his father Isaac to seek a wife among the daughters of Laban. Here he meets his cousin Rachel, who tends her father Laban's sheep; shepherds move a stone covering the top of the well so that the sheep may drink. Though the two incidents take place years apart, the attire of the principal figures is rather similar in both works, as is the placement of the subordinate figures and animals. The paintings came into the possession of the Duc d'Antin, but they were charged to the King's household in 1732 and apparently were originally intended for one of the royal apartments.[1] A signed preparatory drawing for this work, executed in black and white chalk, is in the Städelsches Kunstinstitut, Frankfurt.

[1] F. Engerand, *Inventaire des tableaux commandés et achetés par la Direction des Bâtiments du Roi (1709–1792)*, Paris, 1900, pp. 309–310.

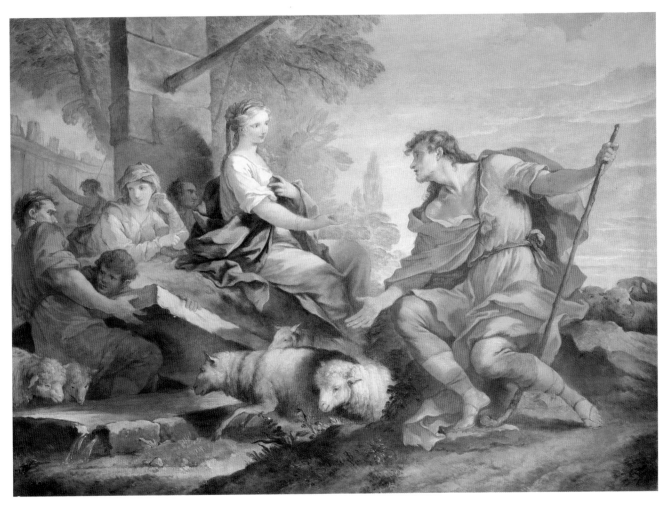

Cat. No. 42

Giovanni Antonio Pellegrini
Venice 1675–1741 Venice

Pellegrini was, with Paolo de Matteis, the most important Italian master to receive major commissions in eighteenth-century France. As a young member of Paolo Pagani's shop he worked for six years in Austria (1690–96). Returning to Venice and probably visiting Rome, Pellegrini became familiar with the colorful, fluid decorative styles of Sebastiano Ricci and Giovanni Battista Gaulli. In 1701 he married the sister of the celebrated Venetian pastel portraitist Rosalba Carriera, who was later to have a great success in Paris.

After completing numerous religious commissions in Venice, Pellegrini in 1708 went to England with Marco Ricci in the entourage of the Earl of Manchester. He painted various decorative ensembles both in London and in country houses (Kimbolton Castle), most of which have been lost. Perhaps spurred by a rivalry with Sebastiano Ricci, who arrived in 1713, Pellegrini entered the service of the Elector Palatine Johann Wilhelm at Düsseldorf. He began traveling widely, joining the Antwerp Guild of St. Luke in 1716 and The Hague painters' guild two years later. His visits to Paris in 1719 and 1720 resulted in the commission from John Law to paint the ceiling of the Banque Royale and in an invitation to join the Academy, though he did not submit his reception picture until 1733. The influence of the Banque Royale ceiling on French painters and its critical reception have already been described (see figs. 38 and 39). During the 1720s and 1730s Pellegrini continued his peripatetic existence, working rapidly and dividing his time mainly between northern Italy and the Germanic countries.

Pellegrini's early work, around the turn of the century, is typical of the period in being relatively dark with strong chiaroscuro. By 1710 (the *Sophonisba Receiving the Cup of Poison*, Toledo Museum of Art) he had developed a new manner that was to be characteristic of his maturity. Pellegrini's work is significant as an early precursor of the international Rococo style practiced around mid-century in Italy, Austria, and France. His brilliant, high-toned colors, theatrical gestures, and fluid brushwork that threaten to break down pictorial unity did not find favor with French critics who, at their most liberal, preferred the more solid technique and compositions of Rubens and his French followers. The Banque Royale ceiling may nevertheless have influenced the work of Lemoine and of his artistic successors Boucher and, more particularly, Fragonard in the development of an important Rococo decorative style in France.[1]

[1]See Klára Garas, "Le plafond de la Banque Royale de Giovanni Antonio Pellegrini," *Bulletin du Musée Hongrois des Beaux-Arts*, no. 21, 1962, pp. 75–93, and Art Institute of Chicago, *Painting in Italy in the Eighteenth Century*, 1970, pp. 82–83.

43. *Sophonisba Receiving the Cup of Poison*
Oil on canvas, 73⅛ x 60¾ in. (185.7 x 154.3 cm.)
The Toledo Museum of Art

PROVENANCE: England, private collection; Rome, G. Gasparini; London, Colnaghi; Museum purchase, gift of Edward Drummond Libbey, 1966.

EXHIBITIONS: Art Institute of Chicago, *Painting in Italy in the Eighteenth Century*, no. 30 (entry by B. Hannegan), ill. in color p. 83.

BIBLIOGRAPHY: "La chronique des arts," *Gazette des Beaux-Arts*, LXIX, Feb. 1967, p. 83, ill. no. 304; B. Fredericksen and F. Zeri, *Census of Pre-Nineteenth Century Italian Paintings in North American Collections*, Cambridge, Mass., 1972, p. 160; Toledo Museum of Art, *European Paintings*, 1976, p. 124, ill. pl. 32, and *Guide to the Collections*, 1976, no. 10, ill. in color p. 46; Eric Young, "European Paintings, The Toledo Museum of Art," *Connoisseur*, 196, no. 787, 1977, p. 68.

According to the Ancient historian Livy (*Roman History*, XXX, 15) Sophonisba, daughter of the Carthaginian general Hasdrubal, had been captured and hastily married by the Numidian king Masinissa during the Punic Wars (c. 205 B.C.). Sophonisba made her husband swear he would not let her fall into Roman hands. After the Roman commander Scipio insisted Sophonisba be arrested, Masinissa sent her a cup of poison:

> When the slave bearing . . . the poison had reached Sophonisba she said, "I receive the wedding gift, and it is not unwelcome if my husband has been able to bestow nothing better upon his wife. But tell him this, that it would have been easier for me to die if I had not married at my funeral." No less high-spirited than her words was her acceptance of the cup, fearlessly drained without a sign of wavering.[1]

The story of Sophonisba, like that of the Roman heroine Lucretia, was popular throughout the Baroque period as an example of antique feminine virtue carried to suicidal lengths. Rembrandt, who painted *Lucretia* twice, also produced a large, early canvas (1634; Madrid, Prado) showing a heroine being brought a shell chalice of poison, to which she reacts with greater restraint than Pellegrini's protagonist. The Rembrandt figure, however, is traditionally identified as *Artemisia*, who voluntarily drank her husband's ashes mixed in the potion. Pellegrini's work is the largest and most splendid of his four versions of the subject. The two earliest, which are half-lengths, are darker in coloration and appear to date from c. 1700. The Toledo canvas was probably painted during the artist's period (1708–13) in England, where the picture is said to have come from an aristocratic collection.

Though it precedes Pellegrini's activity in France by a decade, the *Sophonisba* is an outstanding example of his precocious Rococo style, notably in the bright red, yellow, and blue tonalities and the jagged brushstrokes that impart an electric vitality to the figures.

[1]Transl. by Frank Gardner Moore, vol. VIII, Cambridge, Mass., and London, 1921, p. 421.

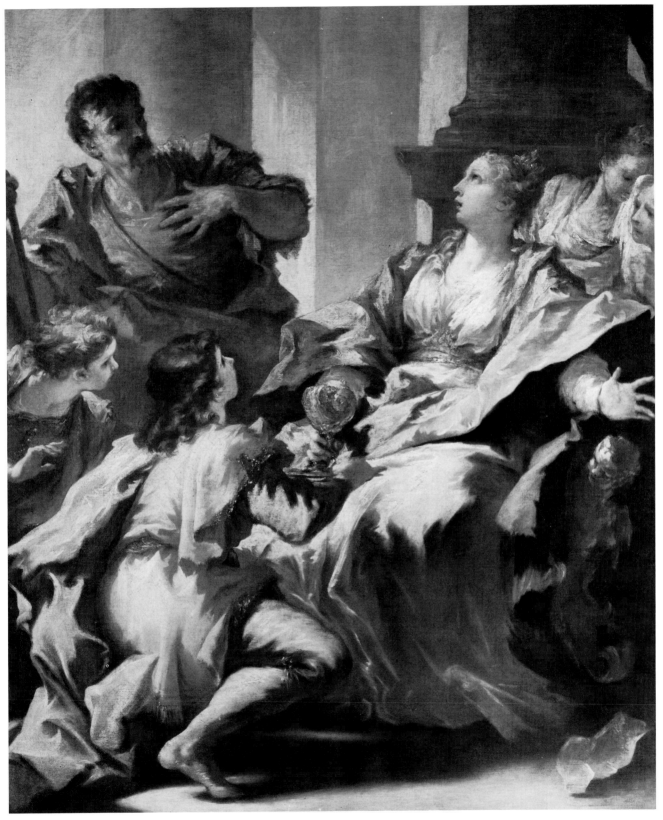

Cat. No. 43

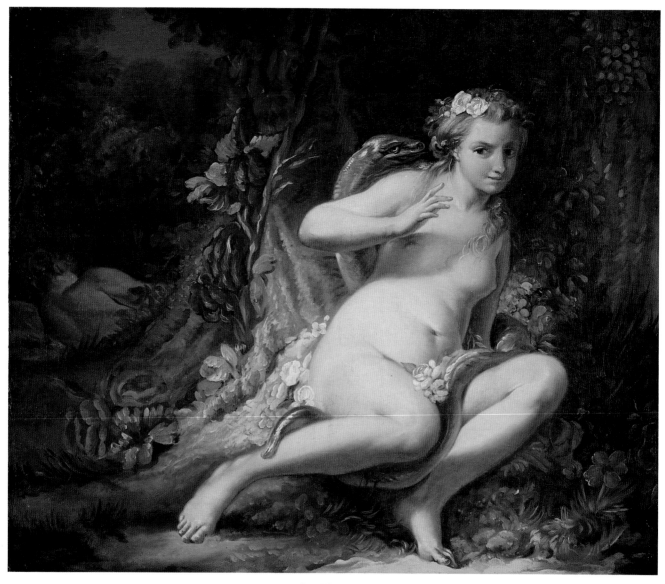

Cat. No. 44

Jean-Baptiste-Marie Pierre
Paris 1713–1789 Paris

One of the most successful academic painters of the century, Pierre came from an affluent family of jewelers. A pupil of Natoire, he won the *Grand Prix* in 1734 and spent the years 1735–40 in Rome. He was received into the Academy in 1742 with *Diomedes Killed by Hercules and Devoured by his own Horses* (Montpellier, Musée Fabre). Pierre was soon given various official positions, including the titles of *Premier Peintre* to the Duc d'Orléans and chief inspector of the Gobelins tapestry works, for which he painted several mythological subjects.

Following the death of François Boucher in 1770 Pierre was made both *Premier Peintre* to the King and director of the Academy. Under Angivillier, Louis XVI's *Directeur général des Bâtiments*, Pierre held a very powerful position. He was instrumental in the suppression of the *Ecole des Elèves Protégés* and, despite his early work with Natoire, it was on his advice that the older painter was removed as director of the French Academy in Rome during a reorganization. In 1783 Pierre was named chief curator of the proposed museum, subsequently established in the Louvre. He also directed a busy atelier: his students included Louis-Jacques Durameau, Jacques-Antoine Beaufort, Jean-Baptiste Restout, and Nicolas-Bernard Lépicié.

Pierre's own work increasingly went into eclipse as he became more involved in administration; Diderot, in his *Salon of 1763*, remarked that the painter's talent had been degenerating for a dozen years. He last exhibited at the Salon in 1769 and painted very little thereafter. Wealthy, and ennobled with the exclusive order of Saint-Michel, Pierre presented an imperious personality and had a reputation for favoritism and intrigue. In his prime he was, nevertheless, an artist of considerable force, working with late-Baroque realism and colorism, yet anticipating the increased severity and restraint that were to characterize Neoclassicism.

44. *The Temptation of Eve*, c. 1745–50
Oil on canvas, 19 x 22½ in. (48.2 x 57.2 cm.)
The Dayton Art Institute

PROVENANCE: London, Heim Gallery, Museum purchase with funds provided by Charles H. Huber in honor of Mr. and Mrs. Herbert C. Huber, 1977.

EXHIBITIONS: London, Heim Gallery, *Aspects of French Academic Art, 1680–1780*, 1977, no. 10 (as by Charles-Joseph Natoire).

BIBLIOGRAPHY: Dominique H. Vasseur, "*The Temptation of Eve*: A new attribution to Jean-Baptiste-Marie Pierre," *Dayton Art Institute Bulletin*, XXXIX, December 1984, pp. 1–5, ill. fig. 1.

Formerly given to Natoire, this painting has recently been attributed convincingly to Pierre, his pupil.[1] The figural type of Eve, shown frontally but with her legs drawn up and turned sharply to the side, is seen in works by both artists. Its probable source is Natoire's *Adam and Eve after the Fall* (Salon of 1740; now lost but known through an engraving by Jean-Jacques Flipart, Salon of 1755).[2] Aspects of the pose, including the sharp turn of the head in the opposite direction, appear in other works by Pierre such as *Athena Surprising Ulysses and a Nymph* (Göteborg, Konstmuseum).[3] The figure's physical type, more full-fleshed than Natoire's women, is paralleled in Pierre's *Bacchus and Ariadne* (versions in the Stanford University Museum of Art and Paris, priv. coll.). The Paris picture provides an approximate chronological reference for the Dayton work: it is dated 1755 and was engraved by Louis-Simon Lempereur in 1757.[4]

In many respects *The Temptation of Eve* characterizes Pierre's position as a transitional artist at mid-century. The subject, though taken from Genesis, is fully in the erotic Rococo taste: the serpent coils suggestively about the nude Eve and whispers to her as Adam sleeps innocently at the left. At the same time a sternness or lack of charm in the face and in the movement of the hand, when compared with figures by Natoire, seems to prefigure the more sober approach subsequently adopted by Vien and, still later, by the Neoclassical school.

[1] In Vasseur, "*The Temptation of Eve*."
[2] *Ibid.*, fig. 2. Natoire's composition is also known through a finished drawing (Saint-Germain-en-Laye, Musée Municipal). For an earlier version of this theme, by Antoine Coypel, see cat. no. 10.
[3] *Ibid.*, fig. 4.
[4] Monique Halbout and Pierre Rosenberg, "A propos de Jean-Baptiste-Marie Pierre," *The Stanford Museum*, IV–V, 1975, pp. 13–19.

Jean Restout
Rouen 1692–1768 Paris

Restout came from an important artistic dynasty: he studied first with his father, Jean Restout the elder, and in Paris from 1707 with his uncle, Jean Jouvenet. By the time of Jouvenet's death in 1717 Restout was ready to succeed to his uncle's position as the leading specialist in religious commissions in France. He was *agréé* at the Academy in that year and admitted in 1720 with a mythological picture, *Alpheus and Arethusa* (Compiègne, Château). Restout was invited to take part in the decoration of the Hôtel du Grande Maître at Versailles in 1724. Although a winner of the *Grand Prix* in the Rome competition, he never went to Italy.

Restout's outstanding qualities as an artist were seriousness of purpose, sobriety of color, forceful, emotionally charged compositions, avoidance of extremes in gesture, and realism of detail in drawing. For the 1727 *concours* at the Academy, to which most of his rivals sent light mythological paintings, Restout offered a somber *Hector Bidding Farewell to Andromache* (France, Vésier coll.). His reputation was made with a pair of large commissioned religious pictures, *The Death of St. Scholastica* and *The Ecstasy of St. Benedict* (1730, Tours, Musée). Restout rose to be director of the Academy in 1760 and chancellor in 1761. His students included Jean-Baptiste Deshays, who carried on his style, Jean Barbault, and the engraver and author C.-N. Cochin.

Restout continues the style of Jouvenet in religious painting, though in a more sober, restrained manner; through him a continuous tradition of French religious painting runs back to seventeenth-century artists like Eustache Le Sueur, and forward, through his pupil Deshays, to the beginning of the Neoclassical era. With Restout's emphasis on authenticity of expression and intensity of feeling, he had no rival as a religious painter except the expatriate Subleyras.[1]

[1]Pierre Rosenberg and Antoine Schnapper, *Jean Restout (1692–1768)*, exh. cat., Rouen, Musée des Beaux-Arts, 1970.

45. *Saint Hymer in Solitude,* 1735
Oil on canvas, 23⁷⁄₁₆ x 28¾ in. (59.5 x 73 cm.)
The Art Institute of Chicago

PROVENANCE: Paris, Galerie Cailleux; restricted gift of the Old Masters Society, 1982.

In 1735 Restout completed, signed, and dated a large (185 x 191 cm.) altarpiece on this subject for the abbey chapel (now parish church) of Saint-Hymer, Calvados.[1] The work was commissioned by the Jansenist Henri de Roquette and had a pendant picture, *The Charity of St. Martin.*[2] In all probability the pair were meant to illustrate the complementary virtues of prayer and good works. There was a direct connection between the two saints, however: Saint Hymer, a seventh-century Swiss saint from the Basel region, had built a chapel at Susinghen and dedicated it to Saint Martin.

This little-known sketch appears to be an autograph study for the larger painting; it is less likely to be a repetition of the latter work, which is nearly square in format while the Chicago composition has been extended on the right side. Saint Hymer, illuminated by a shaft of light, gazes heavenward with a fervor recalling that seen in Italian Baroque religious paintings, though the emotional restraint of the picture is more characteristic of the French school. The saint's chapel is seen in the background, while his tools, scattered about, emphasize his role as a builder as well as an exemplar of the contemplative life.

[1]Rosenberg and Schnapper, *Jean Restout*, no. 12, pl. XIII.
[2]*Ibid.,* pl. XII.

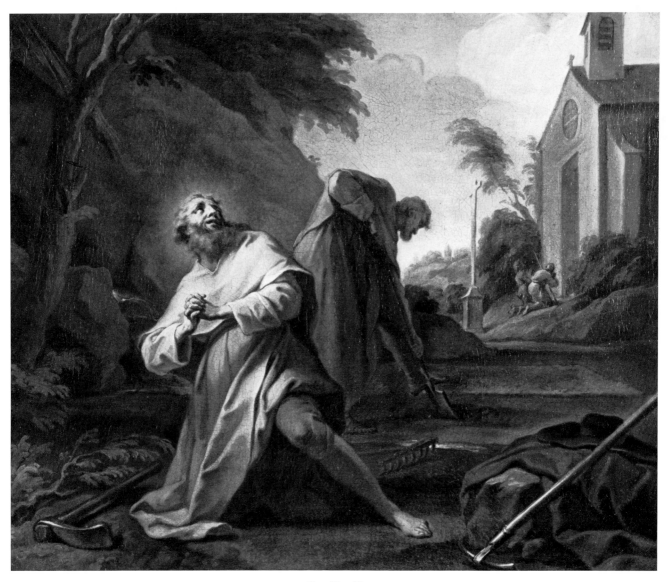

Cat. No. 45

Sebastiano Ricci
Cividal di Belluno 1659–1734 Venice

Ricci was trained first in Venice and from 1678 in Bologna, where he was influenced by the classicism of the local school. He then proceeded to Rome to study the great monuments of the High Baroque. From 1694 he traveled widely, completing major decorative commissions in Venice, Vienna, and at the Palazzo Marucelli, Florence (1706–07). By the turn of the century Ricci was painting large works in a style recalling the bright colors and grand settings of the Venetian Renaissance master Veronese, though in a more fluid technique.

In 1712 Marco Ricci called his uncle Sebastiano to London, where the older artist was well received and where he remained for several years before returning to Venice. From this period onward the uncle and nephew frequently collaborated, Marco supplying the landscape backgrounds for Sebastiano's paintings. Sebastiano's visit to France in 1716, discussed earlier, was

relatively brief; he was received by the Academy on May 28, 1718, having presented a small allegorical picture depicting *France Trampling Ignorance* (Louvre). Through the collector Crozat Ricci was introduced to Antoine Watteau, several of whose drawings were copied by the Italian master.

Sebastiano was probably the most successful European decorative painter of the early eighteenth century. Mariette, who met Sebastiano in Venice, praised his rich compositions and brilliant colorism, finding fault only with the imperfection of his drawing.[1] In France Sebastiano's influence was indirect; it was evident largely through the work of Pellegrini and its subsequent effect on Lemoine and Boucher. He was, however, friendly with Jean Jouvenet at the end of the latter's career, and is said to have encouraged Jouvenet to paint with his left hand after his right became paralyzed.[2]

[1]Mariette, *Abécédario*, IV, p. 392.
[2]See Schnapper, *Jean Jouvenet*, pp. 126 and 167, and Pierre Rosenberg, "Sebastiano Ricci et la France: A propos de quelques textes anciens," in Udine, *Atti del Congresso internazionale di studi su Sebastiano Ricci e il suo tempo*, 1975, pp. 122–125.

46. *The Last Supper*
Oil on canvas, 29½ x 49½ in. (75 x 125.7 cm.)
Houston, The Sarah Campbell Blaffer Foundation

PROVENANCE: England, private collection; London, Thomas Agnew; sale, London, Christie's, December 4, 1936, no. 86, to W. Smith; New York, Paul Drey Gallery; Foundation purchase.

EXHIBITIONS: Charleston, S.C., Gibbes Art Gallery, *Masterpieces of Italian Art*, 1982; Columbus, Ohio, Columbus Museum of Art, *Italian Masters 1400–1800*, 1983.

BIBLIOGRAPHY: Jeffery Daniels, *Sebastiano Ricci*, Hove, Sussex, 1976, p. 80, no. 263; Teresio Pignatti, *Five Centuries of Italian Painting 1300–1800 From the Collection of the Sarah Campbell Blaffer Foundation*, Houston, 1985, p. 182, ill. in color p. 183.

The fine, little-known Houston composition was not Ricci's first depiction of this time-honored theme. While in England around 1713–14 the artist had been commissioned to paint the Duke of Portland's chapel at Bulstrode House, Gerrards Cross, Buckinghamshire. The paintings, including a *Last Supper* on the south wall, were destroyed in the nineteenth century but are known from literary descriptions and oil sketches. The sketch for this *Last Supper* (Washington, National Gallery of Art) appears in an arched, painted architectural framework adorned with allegorical sculptures in grisaille. The table is placed at a diagonal angle to the picture plane, a compositional arrangement derived from Tintoretto's version of the theme in the Scuola di San Rocco, Venice.[1] In this Mannerist arrangement the figure of Christ is pushed well into the background, and the largest and most central figure is that of Judas, who strides away from the table. According to a contemporary source, the artist depicted himself as a figure standing directly behind Christ in the Bulstrode *Last Supper*.

The Houston composition differs sharply from the earlier version. It seems to postdate Ricci's visits to France, and probably belongs to the period after the artist's return to Venice in

1719. Two themes are combined: Christ consecrates the Eucharist, while also announcing that one of the disciples will betray Him. The tense Judas, clutching his purse of money, rises from his seat but remains at the table. Here the principal inspiration for the color, composition, genre staffage, and grand architectural background is in the works of Paolo Veronese. The return to Renaissance compositional precedents gives the work a classicizing quality and a dignified restraint that many artists in the French tradition could have admired. The color in the costumes of the central figures, freer and more brilliant than that used by Veronese, heralds the Rococo style that was shortly to become dominant in both France and Italy.

A version nearly identical to the Houston canvas in size but different in color is at Worcester College, Oxford.[2] It is uncertain how well religious paintings like this one were known to Ricci's French contemporaries. The artist nevertheless influenced French practice through his work for the French Academy in Rome, his reception piece in the collection of the Academy in Paris, and (perhaps) through his personal contacts with leading French artists, including Jouvenet and Watteau.

[1]Daniels, *Sebastiano Ricci*, p. 40.
[2]A copy of similar size, now attributed to F. Fontebasso, is in the Accademia, Venice, and other copies are in Padua and New York. A sketch for the head of Christ and an apostle is at Windsor Castle. See Pignatti, *Five Centuries*, p. 182.

Cat. No. 46

Hubert Robert
Paris 1733–1808 Paris

This famous painter of architecture and architectural fantasies first studied drawing with the sculptor Michel-Ange Slodtz. In 1754 he found employment as a draftsman with the French ambassador to Rome, the future Duc de Choiseul; he did not return to Paris until 1765. While in Rome he admired the architectural caprices of Giovanni Paolo Panini, a painter close to the French community, and he also seems to have known the visionary engravings of antique monuments by Giovanni Battista Piranesi. He visited Naples with the Abbé de Saint-Non and sketched at Tivoli with his close friend, the young Fragonard. First admitted to the French Academy in Rome through the influence of the ambassador, he was eventually made a pensioner under Natoire in 1759–62.

Returning to Paris, Robert was *agréé* and received as a member by the Academy in 1766. From 1767 to 1798 he exhibited at the Salons, producing a large number of architectural views, first largely of Italy but later of the French countryside, including some of its best-known monuments. Though many of his views of ruins have a light mood recalling that of the early eighteenth century, other are more somber, showing a strong pre-Romantic sensibility for the passage of time, the transience of life, and the pleasures of reverie. In addition to his many commissions Robert received royal favor as designer of the King's gardens, and he was involved in planning the museum proposed for the Louvre.

Imprisoned during the Revolution, Robert was made a curator at the Louvre after his release; many of his later paintings are projects, real and fanciful, for the development of the museum. He also executed some much-admired views of daily life in Paris and Versailles, such as the *Demolition of the Houses on the Pont au Change* (c. 1788, Paris, Musée Carnavalet). Though not a history painter, he occasionally executed paintings of historical subjects in the guise of architectural fantasies, such as his *Adoration of the Magi* (before 1785; Pittsburgh, Frick Museum), set in the ruins of a classical temple. Often delightful and deservedly popular, Robert is an important transitional figure in the development leading to early nineteenth-century Romanticism.

47. *The Finding of the "Laocoön,"* 1773
Oil on canvas, 47 x 64 in. (119.4 x 162.5 cm.)
Signed and dated (lower right, on column base): *H. Robert 1773*
Richmond, Virginia Museum of Fine Arts

PROVENANCE: Château de Prégny, Switzerland, coll. Baron Maurice de Rothschild; New York, Rosenberg and Stiebel; purchase, The Glasgow Fund, 1962.

EXHIBITIONS: Hartford, Wadsworth Atheneum, *Homage to Mozart*, 1956, no. 51, ill. fig. 24; Poughkeepsie, N.Y., Vassar College Art Gallery, *Hubert Robert*, 1962, no. 6; Cleveland Museum of Art, *Neo-Classicism: Style and Motif*, 1964, no. 36; London, Royal Academy of Arts, *France in the Eighteenth Century*, 1967, no. 587, ill. fig. 253; New York, Wildenstein and Company, *Gods and Heroes*, 1968, no. 36, ill.; Storrs, Conn., William Benton Museum, *Rome in the 18th Century*, 1973, no. 106; Toledo Museum of Art, *The Age of Louis XV* (cat. by Pierre Rosenberg), 1975, no. 90, ill. pl. 124; Washington, D.C., National Gallery of Art, *The Eye of Jefferson*, 1976; Richmond, Virginia Museum of Fine Arts, *Antiquity Discovered: Classical Themes in 18th Century Prints*, 1982.

BIBLIOGRAPHY: Paul Grigaut, "Ruins and rose petals," *Arts in Virginia*, Winter 1964, pp. 26–29; Robert Rosenblum, "Neoclassicism surveyed," *Burlington Magazine*, CVII, 1965, p. 33; Sheldon Nodelman, "After the high Roman fashion," *Art News*, LXVII, November 1968, pp. 34–37, 65–66, ill.

In 1506 the celebrated Antique sculptural group of the *Laocoön* was found in a vineyard on the Esquiline Hill in Rome in the ruins of Nero's *Domus aurea*. Robert has reset this historical event in an imaginary ancient Roman basilica that, despite its vast size, is largely intact. As in his other ruin fantasies, Robert populates the scene with lively figures of peasants who witness the momentous discovery. The great hall, depicted in sharp perspectival reduction, recalls the colossal fantasy architectures of Piranesi and prefigures Robert's later sketches of the ruins of the Grand Gallery of the Louvre.

Diderot, one of the strongest defenders of the importance of history painting, also admired the painting of ruins and saw this specialization as potentially an aspect of historical painting. Writing of a ruin scene in his *Salon de 1767*, Diderot imagines adding a Latin inscription to the scene:

> These ruins would speak to me…I would commune with the variety of things of this world if I read, above the head of a herb-seller, *To the Divine Augustus, To the Divine Nero,* and with the baseness of men who could deify a condemner, a crowned tiger. Look at the beautiful territory open to ruin painters if they would dare to have ideas and to feel the connection between their genre and the understanding of history.[1]

If Robert's picture does not venture into the realm of ideas, it presents a famous work of art in an imaginary setting truly worthy of its glory. To a viewer who had visited Rome on his Grand Tour, the Richmond picture might have evoked many memories of St. Peter's and the Vatican: the interior of the great church, the architectural background of Raphael's *School of Athens* in the papal apartments, or perhaps Bernini's grandiose Scala Regia.[2] Large and boldly conceived, the Richmond canvas combines the mid-eighteenth century lightness of the figures with a taste for archaeological reconstruction and a brooding, pre-Romantic "pleasure of ruins."

[1]Cited in Roland Mortier, *Diderot and the 'Grand Goût',* Oxford, 1982, p. 7.
[2]Nodelman, "After the high Roman fashion," p. 66.

Cat. No. 47

Hubert Robert
Paris 1733–1808 Paris

48. *Camille Desmoulins in Prison*
Oil on canvas, 12⅝ x 15⅞ in. (32 x 40 cm.)
Signed (on bed frame): *H. Robert Pinxit*
Hartford, Wadsworth Atheneum

PROVENANCE: Paris, Baron du Thiel; New York, Wildenstein; purchase, 1937, The Ella Gallup Sumner and Mary Catlin Sumner collection.

EXHIBITIONS: New York, Wildenstein, *Hubert Robert*, 1935, no. 17; Hartford, Wadsworth Atheneum, *43 Portraits*, 1937, no. 33, ill.; New York, World's Fair, *Masterpieces of Art*, 1940, p. 219; New York, Parke Bernet Galleries, 1942, no. 55; New York, Wildenstein, *The French Revolution*, 1943, no. 9, ill. p. 101; Hartford, Wadsworth Atheneum, *In Retrospect: Twenty-one Years of Museum Collecting*, 1949, no. 24; New York, Wildenstein, *Jubilee Loan Exhibition, 1901–51*, ill. p. 28; Poughkeepsie, N.Y., Vassar College Art Gallery, *Hubert Robert*, 1962, no. 9; London, Royal Academy, *France in the Eighteenth Century*, 1968, no. 594, ill. pl. CXVII.

BIBLIOGRAPHY: *Art News*, XXXV, Jan. 30, 1937, p. 18; *Parnassus*, XII, May 1940, p. 11, ill.

On October 29, 1793, during the Reign of Terror, Hubert Robert was arrested and sent to the prison of Sainte-Pélagie in Paris. The reason for his denunciation is not clear but may have stemmed from his work on the royal gardens or as a "garde du tableau du Roi" after 1784 at the museum (subsequently the Louvre). The poet Roucher wrote to his daughter that Robert was extremely bored in prison, not having the means to continue his work on paintings of ruins; she responded by sending the painter Savary's volume *Voyage en Egypte* to stimulate his imagination.[1] While at Sainte-Pélagie Robert apparently was able to make drawings but not paintings.

Transferred to another prison, Saint-Lazare, on January 30, 1794, Robert was able to make numerous watercolor portraits of other prisoners, and he painted some compositions on wooden trays that were sold for him by a guard. He seems to have been very prolific during this period, and he met a number of famous prisoners, such as the poet André Chénier, who were later executed. The fall of Robespierre in July 1794 led to Robert's release.

The subject of the painting, Camille Desmoulins (1760–94), was a lawyer and journalist who was involved in the Revolution from the storming of the Bastille. Though a member of the most radical faction, he and Danton came into conflict with Robespierre, who had them arrested and subsequently executed. There is no definite evidence that Robert and Desmoulins met, though the picture is consistent with Robert's activity as a portraitist during his imprisonment. Desmoulins is shown in a garretlike room that has little to identify it as a cell beyond the bars on the window and door. On the table is a portrait of Desmoulin's wife Lucille, who soon followed him to the guillotine. Although the painting may now be regarded as historical because of the subject's political prominence, Robert treats it in the small format traditional for genre scenes, and without any of the theatrics associated with "historical" portraits of other leaders of the Revolutionary period.[2]

[1]See Pierre de Nolhac, *Hubert Robert 1733–1808*, Paris, 1910, p. 80ff., for the relevant documents.

[2]A good example is the large portrait of Mirabeau, shown in the act of delivering an important address, by Joseph Boze and Robert Lefèvre (1789–90; Aix-en-Provence, Musée Granet). Portraits of this type are discussed in detail in William Olander, *Pour Transmettre à la Postérité: French Painting and Revolution, 1774–1795*, dissertation, New York University, 1983.

Cat. No. 48

Gabriel-Jacques de Saint-Aubin
Paris 1724–1780 Paris

Saint-Aubin is atypical among the artists in this exhibition in that he never became a member of the Royal Academy. The son of an affluent embroiderer to the King, he studied drawing with J.-B Sarrazin, then enrolled as a student at the Academy, where he was under the successive direction of Etienne Jeaurat, Hyacinthe Collin de Vermont, and François Boucher.

An unsuccessful competitor for the *Grand Prix* in 1752 (*The Reconciliation of Absalom and David*, lost), 1753 (*Laban Searching for his Household Gods*, Louvre), and 1754, Saint-Aubin left the Academy school and abandoned the pursuit of a career as a history painter. As D'Oench[1] points out, Saint-Aubin failed to follow the other, less difficult avenues to membership in the Academy, nor did he subsequently seek out the usual sources of patronage open to a genre painter. Instead, he devoted himself to his first love, drawing, and wandered the streets, exhibition galleries, and auction houses of Paris, making thousands of rapid sketches in pencil or crayon.

Saint-Aubin never entirely gave up painting: he became a member of the less prestigious Academy of Saint Luke, where he taught, as he did at the *Ecole des Arts* of Jacques-François Blondel (d. 1774). He exhibited paintings at the Academy of Saint Luke in 1774 and at the short-lived *Exposition du Colisée* in 1776. At his death there were eighty paintings in his studio, in addition to four or five thousand drawings; only about fourteen of Saint-Aubin's paintings are known today. Most are delightful genre views of Paris streets, like the *Parade du boulevard* (London, National Gallery) and its pendant, *La promenade* (Perpignan, Musée Rigaud) of 1760.

Saint-Aubin seems to have made his living as an engraver and a designer of book decorations; his many sketches made at auction sales suggest he may also have been a self-employed dealer or dealer's assistant. Many of his illustrations in the margins of exhibition or sale catalogues, including a group recently identified in the John G. Johnson collection, Philadelphia,[2] provide valuable information about the art of his time. Saint-Aubin was considered an eccentric, and there are numerous published references to his proverbial obsession with sketching. Isolated from the major trends of his time, he is nevertheless highly regarded today as a brilliant observer of Parisian life.

[1]In Victor Carlson, Ellen D'Oench, and Richard S. Field, *Prints and Drawings by Gabriel de Saint-Aubin 1724–1780*, exh. cat., Middletown, Conn., Davison Arts Center, 1975, pp. 5–13.
[2]*Ibid.*, nos. 60–62, ill.

49. *Laban Searching for his Household Gods*
Oil on canvas, 18 x 22½ in. (45.6 x 57.3 cm.)
The Cleveland Museum of Art

PROVENANCE: [Victor D. Spark, New York]; Ruth and Sherman E. Lee, Cleveland, 1964; gift of Ruth and Sherman E. Lee in memory of their parents, George B. Ward, and Emery and Adelia Lee, 1965.

BIBLIOGRAPHY: Henry S. Francis, "Annual report for 1965: Paintings," *Cleveland Museum Bulletin*, LIII, 1966, p. 140; Wolfgang Stechow, "Bartolomé Esteban Murillo: *Laban Searching for His Stolen Household Gods in Rachel's Tent*," *Cleveland Museum Bulletin*, LIII, 1966, pp. 374, 377n.27, fig. 8; Louis S. Richards, "Gabriel de Saint-Aubin: *Fête in a Park with Costumed Dancers*," *Cleveland Museum Bulletin*, LIX, 1967, p. 217; Carlson, D'Oench, and Field, *Prints and Drawings by Gabriel de Saint-Aubin*, p. 39; Rosenberg, *The Age of Louis XV*, p. 7n.12, p. 25; Pierre Rosenberg, "La donation Herbette," *Revue du Louvre et des Musées de France*, XXVI, 1976, pp. 96–97, 98n.17, fig. 8; *Cleveland Museum of Art Handbook*, 1978, ill. p. 182; Cleveland Museum of Art, *Catalogue of Paintings*, III, *European Paintings of the 16th, 17th, and 18th Centuries*, 1982, pp. 140–142, no. 57, ill. fig. 57.

This sketch won Saint-Aubin first place in the preliminary competition for the *Prix de Rome* in 1753, but the final version (111 x 144 cm.; Paris, Louvre)[1] was not successful. The biblical story, taken from Genesis 31:33–35, was a very popular one, a later moment of which is illustrated in a large painting by Charles Natoire (see cat. no. 41). In the center Laban accuses his daughter Rachel, who conceals the household idols she had stolen from him, while her brother searches through a trunk at the left.

The canvas displays the Rembrandtesque costumes and bright colors often chosen by French painters of Old Testament subjects in the mid-eighteenth century. The Cleveland sketch is an early version of Saint-Aubin's composition, since a preparatory drawing (Berlin, Staatliche Museen, Kupferstichkabinett) shows the quite different Louvre composition in virtually complete form. In the final version Saint-Aubin added many subsidiary figures and pushed the central group further back in the picture space. Despite its sketchiness, the Cleveland composition is superior to the larger picture in its energy and dramatic force.

[1]Cleveland Museum of Art, *Catalogue*, 1982, fig. 57a.

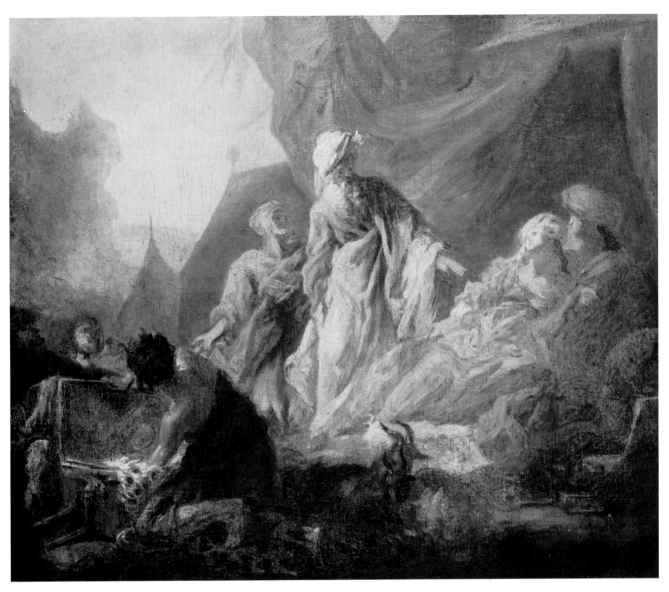

Cat. No. 49

Pierre Subleyras

Saint Gilles-du-Gard, Languedoc 1699–1749
Rome

Subleyras is one of the few French artists in the exhibition who made his career largely outside Paris. He studied first with his father Mathieu Subleyras at Uzès and, from 1714, in the studio of Antoine Rivalz in Toulouse. Sent to Paris in 1726, he won the *Grand Prix* the following year with *The Brazen Serpent*. He was able, thanks to influential patronage, to extend his stay at the Academy in Rome from 1728 to 1735, and then to take up permanent residence in the city. Subleyras married Felice Maria Tibaldi, a well-known miniaturist, in 1739, and was received the following year into the Roman Academy of Saint Luke.

The artist's sober, realistic, restrained approach responded to the growing taste for classicism in Rome in the 1730s and 1740s: he was deluged with commissions by Pope Benedict XIV (whose portrait he painted in 1741) and important prelates. In particular he was a favored painter of religious orders such as the Olivetans and the Camillans, who admired his reserved seriousness. Though busy with large altarpieces, Subleyras also found time to execute superb genre pictures like *The Artist's Studio* (Vienna, Academy), portraits, still life, and some etchings. In failing health by the mid-1740s, he moved to Naples for a time but returned to Rome shortly before his death at the age of forty-nine.

Subleyras had only a few pupils, including the portraitist Joseph-Siffred Duplessis, and did not show his work in Paris. Nevertheless he was, with Restout, the leading French religious painter of the century, and his paintings were well known and influential among the students of the French Academy in Rome. His work must be seen in relation to the Classical style being developed by Roman artists like Marco Benefial and Pompeo Batoni, who in turn were aware of Subleyras's dignified realism. A major exhibition of Subleyras's work scheduled for Paris and Rome in 1987 will focus new light on the career of this exceptional artist.

50. *Study for Saint Ambrose Absolving the Emperor Theodosius*, c. 1745
Oil on canvas, 23 x 16½ in. (58.5 x 42 cm.)
Stanford, California, Stanford University Museum of Art

PROVENANCE: Chicago, coll. John Maxon; Museum purchase, gift of the Committee for Art at Stanford, 1979.

BIBLIOGRAPHY: *The Stanford Museum*, vols. VIII–IX, 1978–79, ill. p. 23.

In 1744 Subleyras received a commission to paint an altarpiece of *Saint Benedict Reviving a Peasant's Son* for the Olivetan church of Monte Morcino Nuovo, Perugia. In the following year the Olivetan order requested the pendant work for which the Stanford canvas is a study. Both paintings were removed from the church by Napoleon's forces in 1810; the *Saint Benedict* is now in an Olivetan church in Rome, Sta. Francesca Romana, while the *Saint Ambrose* is in the Galleria Nazionale dell'Umbria, Perugia (fig. 51).

Saint Ambrose (c. 340–397) was made bishop of Milan in 374. Considered one of the Fathers of the Church, he was famous for insisting on its supremacy over the civil power. Because of the massacre that the Emperor Theodosius I perpetrated at Thessalonica, Ambrose excommunicated the Emperor and demanded his public penance in the Cathedral of Milan. The act of excommunication had been shown by a number of earlier artists, including Van Dyck (London, National Gallery); Subleyras in his composition for Perugia chose the moment of reconciliation. In the final version (327 x 215 cm.), signed and dated 1745,[1] Ambrose sits on a dais before a billowing drapery while the Emperor, in military attire, kneels humbly before him. Several soldiers, priests, and acolytes regard this scene of the subordination of political power to superior moral force. The mood of all the figures in the composition is hushed and thoughtful.

The Stanford canvas is a good example of the kind of single-figure studies from which large history paintings were developed during this period. It is undoubtedly painted from a model

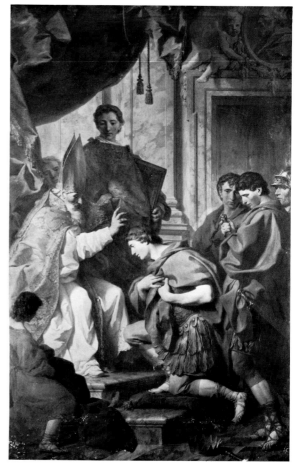

Fig. 51—Pierre Subleyras
Saint Ambrose Absolving the Emperor Theodosius
Perugia, Galleria Nazionale dell'Umbria (Photo Alinari.)

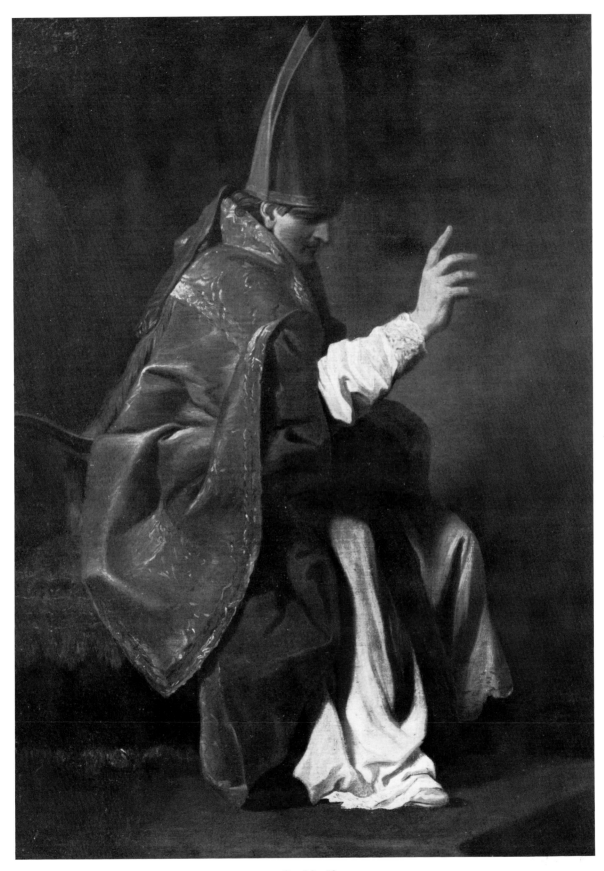

Cat. No. 50

Pierre Subleyras
Saint Gilles-du-Gard, Languedoc 1699–1749
Rome

who, as in the *Saint Benedict* sketches, is a young man, though in the final versions of both works the protagonist is an aged patriarch. The figure of Ambrose is adopted with few other modifications, though the arm raised in benediction is extended in a more horizontal position and there is a brighter coloration in the bishop's cape and miter. A sketch for the entire composition, seized from the collection of Comte d'Angiviller during the Revolution, is now in the Louvre,[2] and other sketches are known, including several for the figure of Theodosius.[3]

[1]Giovanni Cecchini, *La Galleria Nazionale dell'Umbria in Perugia*, Rome, 1932, p. 219, no. 543.

[2]P. Rosenberg, N. Reynaud, and I. Compin, *Musée du Louvre, Catalogue illustré des peintures, Ecole française, XVII^e et XVIII^e siècles*, Paris, 1974, II, no. 787, ill. p. 110.

[3]See L. Dimier, ed., *Les peintres français du XVIII^e siècle*, II, Paris, 1930, pp. 49–92, painting cat. nos. 38–41, drawing cat. nos. 29 and 53. An additional sketch is in the Accademia delle Belle Arti, Perugia.

51. *Study for The Mystic Marriage of Saint Catherine of Ricci*, 1746
Oil on canvas, 9 1/16 x 11 13/16 in. (23.1 x 30 cm.)
Northampton, Mass., Smith College Museum of Art

PROVENANCE: Comte de Malézieu; Paris, Stephen Higgins; purchased 1957.

EXHIBITIONS: Hartford, Trinity College, *Austin Arts Center Opening Exhibition*, 1965, no. 56; Paris, Grand Palais, *Pierre Subleyras*, 1987.

BIBLIOGRAPHY: *Art Quarterly*, XX, 1957, p. 477, ill. p. 473.

Saint Catherine of Ricci (1535–90) was born to an aristocratic Florentine family. She took the habit of the Third Order of Saint Dominic at San Vincenzo, Prato, where she was prioress from 1560 until her death. Catherine was said to have received from Christ an engagement ring and the stigmata; regarded as a mystic and a performer of miracles, she was in contact with other eminent saints, such as Saint Philip Neri. She was canonized by Pope Benedict XIV on June 29, 1746.

This painting is a sketch for a larger work now in the collection of the Marchese Sacchetti, Rome. The large version was commissioned by the Dominican order on the occasion of the canonization. For another canonization taking place at the same time Subleyras painted for the Order of the Camillans a *Saint Camillo de Lellis Saving Patients of the Ospedale di Santo Spirito in 1598* that was subsequently presented to the Pope (205 x 280 cm.; Rome, Museo di Roma). The grave genre realism of that picture, appropriate to the saint's practical heroism, contrasts stylistically with the scene drawn from the story of the more mystical Saint Catherine of Ricci. She is shown kneeling against a cloud-filled background before Christ, who places a ring on her finger as saintly figures look on.

Even in this small sketch the intense yet restrained feeling characteristic of Subleyras's large altarpieces is effectively communicated. The Dominican Saint Thomas Aquinas, standing at the right, holds his treatises and looks outward, directly engaging the viewer. Another study for the figure of Aquinas is in the Alte Pinakothek, Munich.

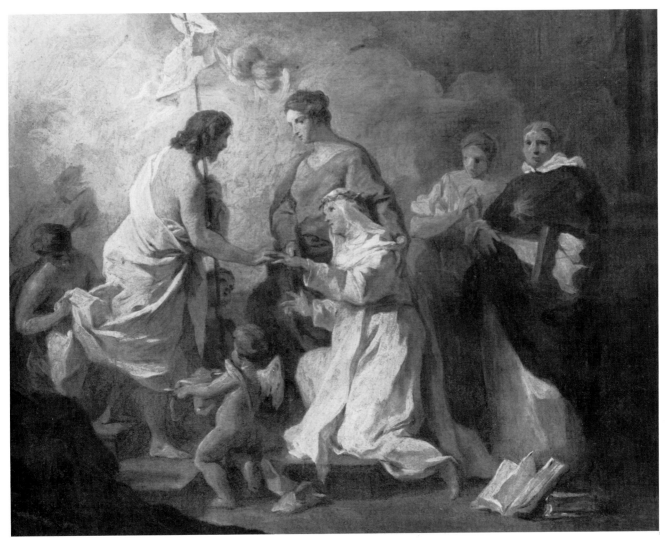

Cat. No. 51

Jean-Charles Tardieu
Paris 1765–1830 Paris

Tardieu came from an artistic family, and both of his parents, Jacques Nicolas Tardieu and Elizabeth Tournay, were active as engravers. From 1786 to 1789 he studied at the Academy school under Regnault. He won second place in the 1790 *Prix de Rome* competition with a *Judgment of David*, but failed to win the grand prize in 1791–92. He nevertheless had a successful career as a history painter, receiving numerous public decorative commissions under Napoleon and the Restoration.

In addition to mythological and Homeric subjects, Tardieu's surviving works include scenes from the Old Testament (*Susannah at the Bath*, Le Havre, Musée), French history (*Henri IV before Paris*, Versailles, Musée National, and *Henri IV at Ivry*, Dieppe, Musée), and contemporary history (*Napoleon Receiving Queen Luisa of Prussia at Tilsit, July 6, 1807*, and *Halt of the French Army at Aswan*, both at Versailles).

52. *Joseph Recognized by his Brothers*, 1788
Oil on canvas, 45 x 57½ in. (114.3 x 146.1 cm.)
Monogrammed (on back of canvas) and dated: *1788*
New York, Wheelock Whitney & Company

EXHIBITIONS: New York, Wheelock Whitney & Company, *Nineteenth Century French Paintings*, 1983, no. 2, ill. in color.

Like Charles Meynier, who shared the first prize with Anne-Louis Girodet, Tardieu was one of the six finalists in the *Prix de Rome* competition for 1789. His painting did not find enough favor with the judges, however, who also awarded two second prizes to François Gérard and Charles Thévenin. Though Tardieu's composition, a pyramid culminating in the richly garbed figure of Joseph, seems stable enough, it lacks the rigid planarity of Meynier's composition, the sketch for which may also be seen in this exhibition. Tardieu's use of a slick, highly finished surface and hard local colors in the costumes is typical of the dominant style at the end of the century. The reason for the dating of the canvas in the year preceding the competition is unclear.

Tardieu places the scene before an ambitious classicizing architectural background, with numerous Egyptian decorative elements such as the sphinx holding a pyramid. Meynier, by comparison, used a simple but massive architecture that might as easily be primitive Doric as Egyptian. The graceful, choreographed movements of Tardieu's figures recall the easy assurance of Charles-Antoine Coypel's version of 1740. For this reason Tardieu's painting, despite its Poussinesque emphasis on fine drawing and finish and its newly fashionable archaeological detail, may have seemed old-fashioned to the Academy jury in 1789.

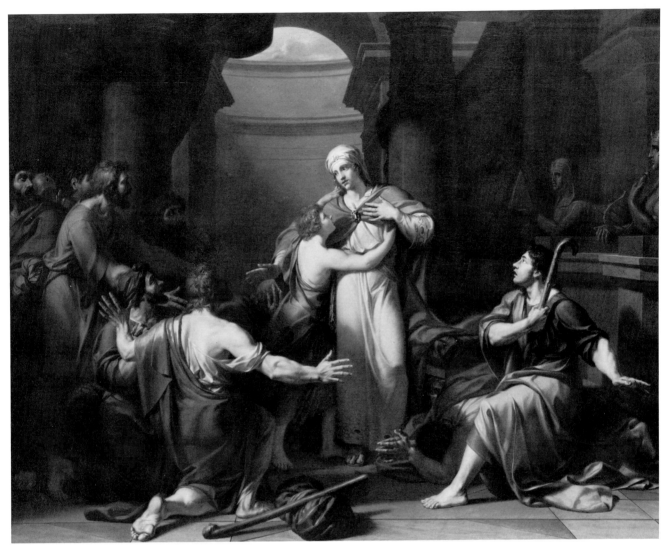

Cat. No. 52

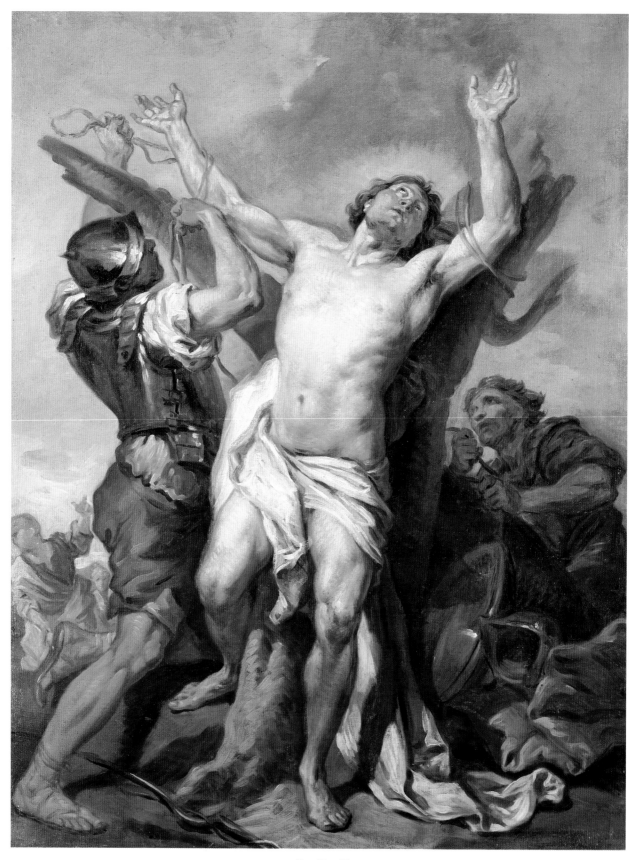

Cat. No. 53

Carle Van Loo
Nice 1705–1765 Paris

The Van Loo were among the most important artistic dynasties of eighteenth-century France. The Dutch painter Jacob Van Loo, Carle's grandfather, had settled in Paris in the latter half of the preceding century and become a member of the Academy. Carle was raised by his much older brother Jean-Baptiste, who took the boy to Rome around 1714. He studied there with the painter Benedetto Luti and in Turin with the sculptor Pierre Legros the younger. In Paris by 1719, he won the *Grand Prix* in 1724 and was back in Italy by 1728. From 1732 to 1734 he worked in Turin, where he painted decorations for the palace of Stupinigi. While in Italy the artists he most admired were Roman and Bolognese classicists such as Raphael, Domenichino, the Carracci, and Carlo Maratti.

Van Loo rose to all the honors available to an artist of his period: director of the Ecole des Elèves Protégés, *chevalier* of the Order of Saint-Michel, director of the Academy, and *Premier Peintre* (1762). Among his most important religious commissions were the *Vow of Louis XII at the Siege of La Rochelle* (1746; Paris, Notre-Dame-des-Victoires) and a series of *The Life of Saint Augustine* for the same church from the 1750s. Shortly before his

death he was planning a series on *The Life of Saint Gregory* for a chapel at the church of Saint-Louis des Invalides, Paris, but he was unable to complete the full-scale paintings.

With the versatility of his period, Van Loo also executed portraits (*Marie Leczinska*, Louvre), allegorical decorations, etchings, and genre scenes such as his splendid *Hunt Breakfast*, painted in 1737 for Fontainebleau (Louvre). As in the case of de Troy, it is for these genre scenes and his exotic *turqueries* that Van Loo is best remembered today. He also operated a studio that trained many painters, including Lagrenée *l'aîné* and François-Gabriel Doyen.

At the peak of his career Van Loo was widely regarded as the greatest history painter of France, if not of Europe. After his death, however, his reputation declined rapidly: among the students of David at the end of the century, the worst insult was "Van Loo!" Although he is still often regarded as the most insipid of Rococo painters, there is a strong classicizing element in Van Loo's work. The restrained, sober style of his late religious paintings seems to herald the advent of Neoclassicism and expresses well the spiritual aspirations of the period.[1]

[1]Marie-Catherine Sahut and Pierre Rosenberg, *Carle Vanloo, Premier peintre du roi*, exh. cat., Nice, Musée Chéret, 1977.

53. *The Martyrdom of Saint Sebastian*, c. 1739
Oil on canvas, 25 x 19⅛ in. (63.5 x 48 cm.)
Private collection

PROVENANCE: With present owner by 1968.

EXHIBITIONS: Huntington, N.Y., Heckscher Museum, *The Last Flowering of Religious Art*, 1968, no. 8 (as *Martyrdom of St. Andrew*); Hartford, Wadsworth Atheneum, *In the Antique Taste: Carle Vanloo's "Offering to Love"* (cat. by Linda Horvitz), 1982, pp. 2 and 13, ill. fig. 1.

At the Salon of 1739 Van Loo showed an altarpiece (260 x 130 cm.) of a *Saint Sebastian* for that saint's chapel in the church of the Collège de Saint-Nizier, Lyons. The work was seized for the Lyons museum during the Revolution in 1793 but is now lost.[1] While this sketch could have been a first idea for the Saint-Nizier painting, that work seems to have been a different composition: "Saint Sebastian, bound and pierced by arrows; an angel appears to remove them. The figures are life size."[2] In the sketch the saint, identified by his armor and the bow on the ground, is shown, in an unusual representation, at the moment before his martyrdom; the holy women who later tended his wounds are seen in the background at the left.

The sketch is rather close in composition to another altarpiece, a *Saint Andrew*, that Van Loo exhibited at the Salon of 1741 (174 x 130 cm.; Angers, Musée des Beaux-Arts).[3] The poses of the two figures are very similar, though the *Saint Andrew* has no subsidiary figures except for a flying *putto*. Both works probably derive from an Italian Baroque prototype: Bernardo Strozzi's large and well-known *Saint Sebastian* (c. 1635; Venice, San Benedetto),[4] in which the saint, being tended after his

attempted execution, is shown frontally in a reversed pose. The freedom of paint handling in the Van Loo sketch, typical of the period, would have been smoothed over considerably in the larger and more finished altarpiece. The emphasis on the nude, on dramatic gesture and expression, and the relatively warm colors indicate the influence of Van Loo's long and still recent stay at the French Academy in Rome and elsewhere in Italy.

[1]Sahut and Rosenberg, *Carle Vanloo*, no. 231.
[2]Salon of 1739, *livret*, p. 12.
[3]Sahut and Rosenberg, *Carle Vanloo*, no. 82, ill.
[4]Luisa Mortari, *Bernardo Strozzi*, Rome, 1966, fig. 382.

Carle Van Loo
Nice 1705–1765 Paris

54. *The Adoration of the Magi*
Oil on canvas, 51 x 41½ in. (129.5 x 105.5 cm.)
Los Angeles County Museum of Art

PROVENANCE: Paris, Van Loo studio sale, September 12, 1765, no. 7; Paris, Doucet collection; Wiesbaden, coll. Prof. Dr. Wedeiver; New York, Arnold Seligman, Rey and Co., sale, Parke-Bernet, June 23, 1947, no. 258; Newark, coll. Maria Jeritza Seery, sale, New York, Sotheby's, June 11, 1981, no. 51; New York, Christophe Janet Gallery; Museum purchase.

EXHIBITIONS: Detroit Institute of Arts, *Christmas Art*, 1933; Des Moines Exhibition of Fine Arts, *Christmas Exhibition*, 1939; Hartford, *In the Antique Taste*, 1982, p. 13.

BIBLIOGRAPHY: *Inventaire après décès*, August 5, 1765, Paris, Archives Nationales, Minutier Central, LVI, 122, no. 56 ("Une Adoration des Rois presque fini"); Rosenberg and Sahut, *Carle Vanloo*, 1977, p. 91, no. 196a (as lost); New York, Christophe Janet/Maurice Segoura Gallery, *From Watteau to David: A Century of French Art*, 1982, ill. fig. 2; Hartford, Wadsworth Atheneum, *In the Antique Taste: Carle Vanloo's "Offering to Love"* (cat. by Linda J. Horvitz), 1982, p. 2.

This painting is the kind of grandly conceived religious subject on which Van Loo's tremendous reputation primarily was based. The theme, with its hieratic presentation and lack of violence, appealed to royal and aristocratic patrons; Van Loo's great rival François Boucher completed a contemporary *Nativity* (Lyons, Musée des Beaux-Arts, fig. 21) for Madame de Pompadour that is more romantic in mood but comparable in composition and execution.

Because the painting was left only partially finished at Van Loo's death it has sometimes been regarded as a late work, but it may have been begun as early as 1750 for an unknown patron. Van Loo showed a very large (485 x 328 cm.) earlier version of the subject at the Salon of 1739 (Paris, Eglise de l'Assomption).[1] In that composition the Virgin stands before a dramatically receding Baroque architectural background, producing a more remote, less intimate image than in the Los Angeles picture. The stable, classicizing composition of the later work, carefully built of interlocking pyramidal figural groups, shows Van Loo's admiration for Italian art of the Renaissance (Titian) and Baroque periods (the Bolognese school).

The range of figures, from the highly finished St. Joseph to the sketchy kneeling king, indicates that Van Loo worked on the picture from left to right; in the completed work all the figures would have been as finished as the St. Joseph, though the brushwork in that figure is freer than in the face of the Virgin. The enamel-like surface and rather cool colors of the finished areas are characteristic of Van Loo's very "modern" style in the 1750s.

[1]Rosenberg and Sahut, *Carle Vanloo*, no. 67.

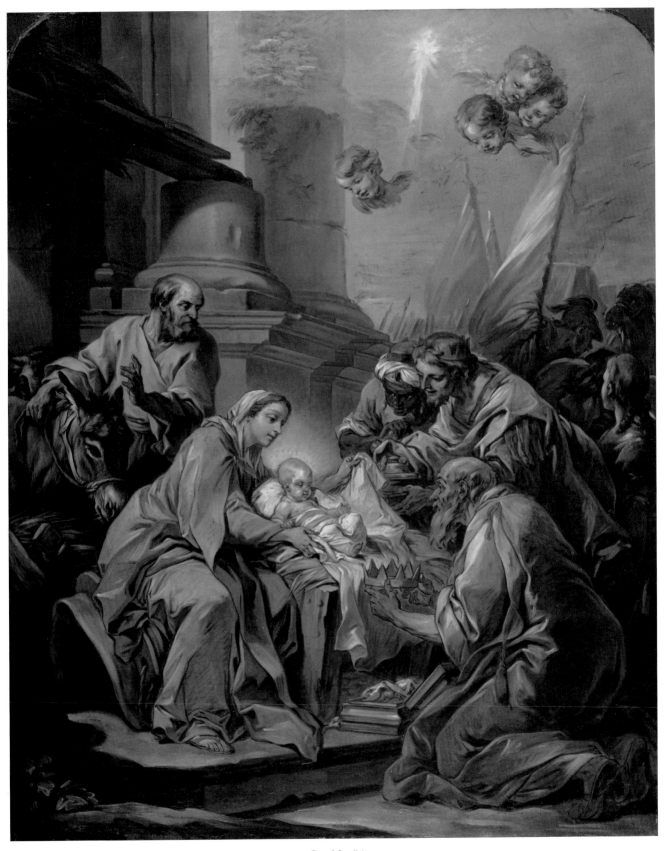

Cat. No. 54

Carle Van Loo
Nice 1705–1765 Paris

55. *Cardinals and Priests Paying Homage to Saint Gregory at his Installation as Pope*, 1764
Oil on canvas, 39¾ x 28¼ in. (101 x 72 cm.)
Signed (bottom center): *Carle Vanloo*
Originally inscribed (lower left and right and later re-written, lower left): *St. Grégoire au / moment de son installation reçoit / l'adoration des Cardinaux / et de son Clergé.*
New York, Didier Aaron, Inc.

PROVENANCE: Paris, estate of the artist, *Inventaire après décès*, no. 82; sale, Paris, September 12, 1765, no. 6; Paris, coll. Louis-Michel Van Loo; St. Petersburg, coll. Empress Catherine II; St. Petersburg, Castle of St. Michael, after 1796; St. Petersburg, Hermitage, by 1838; University of Vilna, Lithuania, by 1852; Stockholm, Strelitz, 1949; Norway, private collection; New York, Didier Aaron, Inc.

EXHIBITIONS: Paris, Salon of 1765, no. 4; New York, Didier Aaron, Inc., *French Paintings of the Eighteenth Century*, 1983, no. 19, ill., and no. 20, ill. in color.

BIBLIOGRAPHY (selected): E. C. Fréron, "Exposition de tableaux dans le Grand Salon du Louvre," *L'Année Littéraire*, 1765, pp. 148–149; D. Diderot, *Salon de 1765*, ed. J. Seznec and J. Adhémar, Oxford, 1960, II, pp. 69, 70–71; M.-F. Dandré-Bardon, *Vie de Carle Vanloo*, Paris, 1765, 1973 ed., pp. 36–42, 57, 65; Diderot, *Salon de 1769*, Oxford, 1963, p. 88 (*Homilies*); Conte de Fortia de Piles, *Voyage de deux Français en . . . Russie et Pologne, Fait en 1790–92*, Paris, 1796, III, p. 27; A. von Kotzebue, *L'Année la plus remarquable de ma vie . . .*, Paris, 1802, II, p. 191; J. Locquin, *La peinture d'histoire en France de 1747 à 1785*, Paris, 1912, pp. 182–183, 268; S. Ernst, "Notes sur deux tableaux français de l'Ermitage," *La Revue de l'Art Ancien et Moderne*, LXVIII, 1935, pt. 2, pp. 242–244; L. Réau, "Carle Vanloo (1705–1765)," *Archives de l'Art Français*, XIX, 1938, pp. 31, 34–35, nos. 16 and 15; A. Boinet, *Les églises parisiennes*, Paris, III, 1964, pp. 156–157, 158; M. Sandoz, "La chapelle Saint Grégoire de l'église Saint Louis des Invalides," *Gazette des Beaux-Arts*, LXXVII, 1971, pp. 131, 136, 139–144; N. Nemilova, "Contemporary French art in eighteenth-century Russia," *Apollo*, CLX, 1975, p. 434; Rosenberg and Sahut, *Carle Vanloo*, p. 95, nos. 222 and 223.

The chapel of St. Gregory in the great church of Saint Louis des Invalides, Paris, was first painted in 1700–02 by Michel Corneille, who provided seven scenes from the life of the saint for the cupola. Faulty roofing caused the works to deteriorate, and in 1764 the commission to replace them was awarded to Van Loo. He produced seven sketches, including the New York paintings, but died the following year before work could begin on the large paintings for the church. The sketches were shown posthumously at the Salon and were soon bought by the Empress Catherine II of Russia. Though all seven were at one time in the Hermitage, Leningrad, only a circular sketch for the dome, *The Apotheosis of Saint Gregory*, is now in that museum;[1] the location of the remaining four sketches is unknown. The commission for the chapel was subsequently given to Gabriel-François Doyen, who completed the decorations in an agitated proto-Romantic style in 1772.

The development of the initial stages of Van Loo's project has been charted by Sandoz. Michel Corneille's ruined paintings for the chapel had been published in 1736 in engravings by C.-N. Cochin that included elaborate decorative frames. Van Loo pasted sheets, cut to fit into the frames, onto the engravings and made a series of compositional drawings (New York, Metropolitan Museum of Art).[2] In some cases, such as the *Apotheosis*, Van Loo followed Corneille's choice of themes, while in others, including the New York compositions, he invented new subjects. The seven finished oil sketches, as shown in contemporary engravings,[3] differed in many details from the drawings. There also may have been an intermediate series of sketches, since a modello of the *Miracle of the Host* from the project (Lyons, Musée des Beaux-Arts)[4] is closer in composition to the preliminary drawing than to the finished engraved sketch.

In general, Van Loo's progression from the drawings to the finished sketches is toward greater simplicity and stronger dramatic effect. In the *Cardinals and Priests Paying Homage to Saint Gregory* the composition has been reversed, and the group of bishops standing around Saint Gregory has been eliminated. The drawing of *Saint Gregory Dictating his Homilies* is set in a candlelit study lined with books. In the finished sketch the scene takes place in a bare chamber into which sunlight, symbolizing divine inspiration, enters through a large window. Gregory, partly hidden from us in the earlier version, is now viewed over the secretary's shoulder and appears more monumental in scale.

Of the surviving sketches the *Apotheosis* is, by the nature of its subject, the most "Baroque" in conception, with the saint, angels, and putti soaring upward in a cloud-filled sky. The engraving of *Gregory Declining the Papacy* has a similar emphasis on dramatic gesture and lighting. The two New York sketches, on the other hand, particularly *Saint Gregory Dictating his Homilies*, are among Van Loo's most restrained and classicizing religious compositions, stressing their subject's ascetic spirituality. Again the cool colors of Van Loo's late style anticipate the more fully developed Neoclassical style of the end of the century.

[1] Rosenberg and Sahut, *Carle Vanloo*, no. 180, ill.
[2] Marc Sandoz, "La chapelle Saint Grégoire," figs. 1–7.
[3] Rosenberg and Sahut, *Carle Vanloo*, p. 95.
[4] Sandoz, "La chapelle Saint Grégoire," fig. 17.

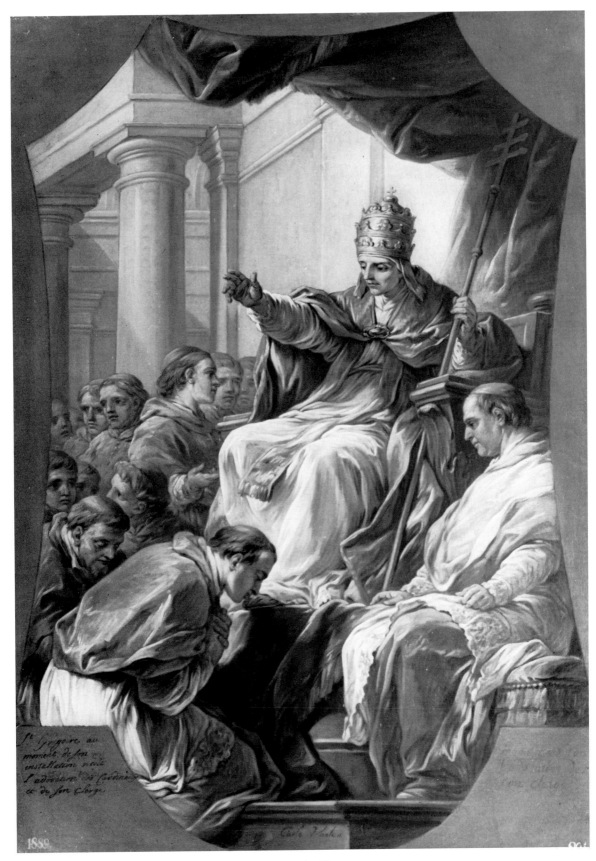

Cat. No. 55

163

Carle Van Loo
Nice 1705–1765 Paris

56. *Saint Gregory Dictating his Homilies to a Secretary,*
1764
Oil on canvas, 39¾ x 25½ in. (101 x 65 cm.)
Inscribed (upper left): *St. Grégoire dictant / ses homélies à
un / Secrétaire.*
(See preceding entry)

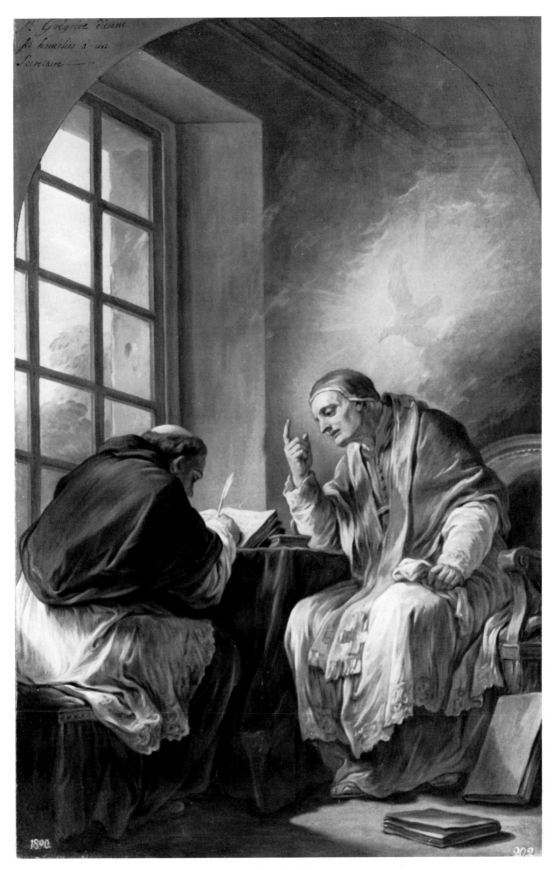

Cat. No. 56

165

Claude-Joseph Vernet
Avignon 1714–1789 Paris

Of modest origins, Vernet worked as a painter of overdoor decorations and studied with Jacques Viali in Aix-en-Provence. Some local art patrons sent Vernet in 1734 to Rome, where he remained with few interruptions for nearly twenty years. He continued his studies there with the Lyons artist Adrien Manglard and the marine specialist Bernardo Fergioni. He also became familiar with the landscapes of Claude Lorrain and Salvator Rosa, from whose works he derived some elements of his style.

Specializing early in landscapes and seascapes, Vernet had an international clientele by 1740. He met the future Marquis de Marigny in Rome in 1750 and soon began to receive royal commissions. *Agréé* by the Academy in 1745, he showed regularly at the Salon in Paris from 1746 on; he became a full academician in 1753, when he returned to France.

Vernet's most important commission was for a series on the *Ports of France*, for which he painted fifteen large canvases, most of which are in the Musée de la Marine, Paris. These ambitious works were greatly admired by Diderot, who believed Vernet's landscapes, through their combination of precise detail and grandeur of conception, rose to the level of history painting. Other critics admired the "sublime" quality of Vernet's numerous views of storms and shipwrecks. The artist occasionally undertook literary subjects that were congenial to his talent, such as the *Death of Virginie* (1789; Leningrad, Hermitage), based on Bernardin de Saint-Pierre's popular novel *Paul et Virginie*. Highly prolific and much imitated, Vernet is an artist of relatively narrow range. He was nevertheless the most gifted landscape specialist of his time, and he founded an artistic dynasty continued by his son and grandson, Carle and Horace Vernet.

57. *Hagar and the Angel,* 1753
Oil on canvas, 19 x 25¼ in. (48 x 64 cm.)
Signed and dated (lower left): *Vernet/1753*
New York, private collection

PROVENANCE: Painted with the pendant *Jonah Emerging from the Belly of the Whale* for a print dealer, M. Buldet, 1753; Brunot coll., sale, Paris, Feb. 12, 1827, no. 23 (with pendant), as dated 1753 and painted in Rome; Marcille coll., sale, Paris, Jan. 12, 1857, nos. 143–144 (with pendant); art dealer, Quai Voltaire, Paris (before 1864); New York, private collection.

BIBLIOGRAPHY: Léon Lagrange, *Joseph Vernet et la peinture du XVIII^e siècle*, Paris, 1864, pp. 342–343, no. 194 (with pendant, as dated 1753); Florence Ingersoll-Smouse, *Joseph Vernet, peintre de marine 1714–1789*, Paris, 1926, I, pp. 37 and 96, no. 784 (as 1763).

Subjects from the Old Testament and Apocrypha, though rare in Vernet's oeuvre, are not completely unknown. He seems to have painted a study of *Judith,*[1] and his small *Greek Girl Emerging from the Bath* (Salon of 1757) in the museum at Hanover is perhaps a *Bathsheba.*[2] Although the figure of David is not readily visible on the rooftops in the background of the latter work, the poses of the figures have analogies to those in Rembrandt's treatment of the subject.

There is no question concerning the authorship of the New York painting, which, according to Vernet's *livre de raison,* was painted with its pendant *Jonah Emerging from the Belly of the Whale* (Germany, priv. coll.) for the print dealer Buldet in 1753 and was engraved in reverse by Jean-Baptiste Tillard (1740–1813).[3] In both works the principal figure is on the left side, and one edge of the picture, as in Vernet's more typical landscapes, is closed by craggy rocks topped by silhouetted branches. A landscape is balanced by a coastal scene, but both biblical subjects share the theme of salvation from physical destruction through the intervention of divine providence. Here Hagar and her son Ishmael, cast out into the desert, are shown the way to safety by an angelic figure.

If the craggy rocks derive from the gloomy landscapes of the Neapolitan Salvator Rosa, the bright coloration of the central area, and the delicately floating figure of the large-winged angel, seem to relate to contemporary Venetian painting. One wonders to what extent Vernet, who traveled widely in Italy, may have been familiar not only with the history paintings of Giovanni Battista Tiepolo, but also with the rural scenes of such secondary Venetian masters as Francesco Zuccarelli and Giuseppe Zais. Like such other "genre specialists" as Largillierre, Rigaud, Watteau, and Oudry, Vernet does not hesitate to undertake a commission for religious subjects when the opportunity arises, though the principal elements of his style remain as evident as in his works of pure genre.

[1] New York, Stebbins sale, 1889; cited in Bénézit, *Dictionnaire,* X, 1976, p. 467.
[2] *Ibid.*
[3] Ingersoll-Smouse, *Joseph Vernet,* fig. nos. 201 and 200.

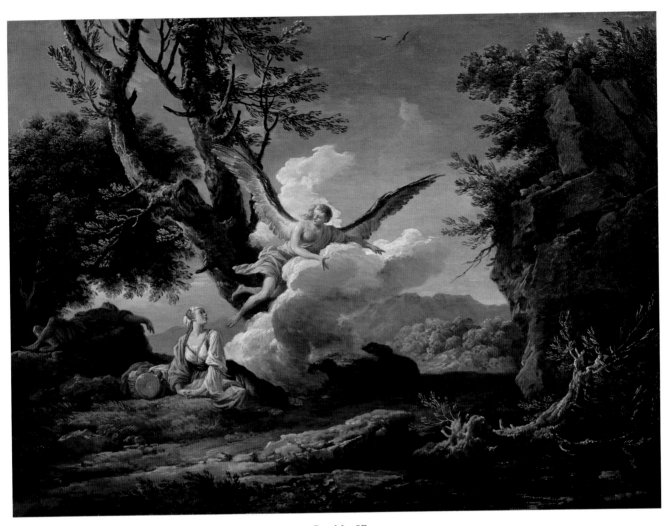

Cat. No. 57

Joseph-Marie Vien
Montpellier 1716–1809 Paris

One of the most influential European painters of the mid-century, Vien first studied with local artists in Montpellier before entering the Academy school in Paris in 1740. He experienced the influence of Natoire and, in Rome from 1744 to 1750, that of the other leading Rococo painter, de Troy, director of the French Academy. At the same time he studied antiquities and became acquainted with classicizing artists like Pompeo Batoni and Pierre Subleyras. His early style, seen in a series of paintings on the life of Saint Martha (1747–51; Tarascon, church of Sainte-Marthe) and a *Sleeping Hermit* (Salon of 1753) combines Italian Baroque influences with a strong tendency toward realism.

During the 1750s Vien was increasingly successful as a member of the Academy in Paris and became friendly with the noted antiquarian the Comte de Cay-lus, with whom he experimented in reviving the ancient technique of encaustic painting. His mature style of Antique subjects in a porcelainlike technique and pure, cold colors was first seen in the *Young Corinthian Girl Decorating a Bronze Vase with Garlands* (Salon of 1761) and the famous *Seller of Cupids*, derived from an ancient work found in the excavations at Pompeii and Herculaneum (Salon of 1763; Fontainebleau, Château). By 1773 Vien's style was so fashionable that he was asked by Madame du Barry to execute a series of paintings on love for Louveciennes to replace those that had been commissioned from Fragonard. Vien, who was director of the French Academy in Rome from 1775 to 1781, conveyed his "Neo-Greek" style to an influential group of students that included David, Peyron, Suvée, and Vincent. He was made *Premier Peintre* in 1789 and a Count of the Empire under Napoleon. Though his latest works are rather hard and repetitive in style, Vien was revered by David and others of his generation as a precursor of the Neoclassical revival in French history painting.

58. *Saint Theresa*, 1755
Oil on canvas, 43½ x 36 in. (110.5 x 91.4 cm.)
Signed and dated (center left, on cover of book): *Vien 175[5?]*
New York, Stair Sainty Matthiesen

EXHIBITIONS: New York, Stair Sainty Matthiesen, *The First Painters of the King: French Royal Taste from Louis XIV to the Revolution*, 1985 (cat. by Colin B. Bailey), no. 20, ill. in color.

BIBLIOGRAPHY: Francis Aubert, "Joseph-Marie Vien," *Gazette des Beaux-Arts*, XXIII, 1867, p. 180.

Saint Theresa of Avila (1515–82), a Spanish Carmelite nun, was one of the leading figures of the Catholic Counter Reformation. A celebrated mystic and author of works on spiritual subjects, she also had formidable practical talents and founded the reformed order of the Discalced (Barefoot) Carmelites. The visions of this influential saint were represented innumerable times in the seventeenth and early eighteenth centuries, perhaps most memorably in the Roman sculptor Gianlorenzo Bernini's great marble group *The Ecstasy of Saint Theresa*.

In the upturned eyes and imploring hands, Vien's composition contains reminiscences of such Baroque prototypes as Guido Reni's *The Madonna and Child Appearing to Saint Philip Neri* (Rome, S. Maria in Vallicella).[1] (Vien virtually copied the latter work in reverse in his *Saint Germain L'Auxerrois and Saint Vincent*.[2]) Nevertheless, the artist has avoided supernatural intrusions, restricting Theresa's divine inspiration to the ray of light falling upon her. She is shown working on her writings, appropriately for a Doctor of the Church, in a bare convent cell; her costume, though treated in a painterly manner, is appropriately subdued in color. The sobriety of the handling reflects the influence of artists with whom Vien was in contact in Rome during the 1740s, particularly that of the French expatriate Pierre Subleyras. Vien's naturalism here marks a preliminary step toward the classicizing style for which the artist later was to become famous.

Vien, in his *Mémoires*, reported that in 1756 the Comte de Caylus had expressed his enthusiasm to the artist on seeing the head of the *Saint Theresa* completed. Caylus commented that the saint no doubt resembled a young Carmelite whose beauty Vien had praised to him and who, at the request of her Mother Superior, had put on her ceremonial costume so that the artist could see how nuns dressed when taking part in the service.[3] Caylus, who was trying to marry off his protégé, commented on the beauty of the figure and on Vien's passionate Provençal nature. Given the subject and the moderate size of the picture, it was probably commissioned for private use in a Carmelite convent rather than for public display.[4]

[1] See Bailey, *The First Painters*, no. 20.
[2] Aubert, "Joseph-Marie Vien," XXII, engr. facing p. 504.
[3] *Ibid.*, XXIII, p. 180.
[4] Bailey, *loc. cit.*

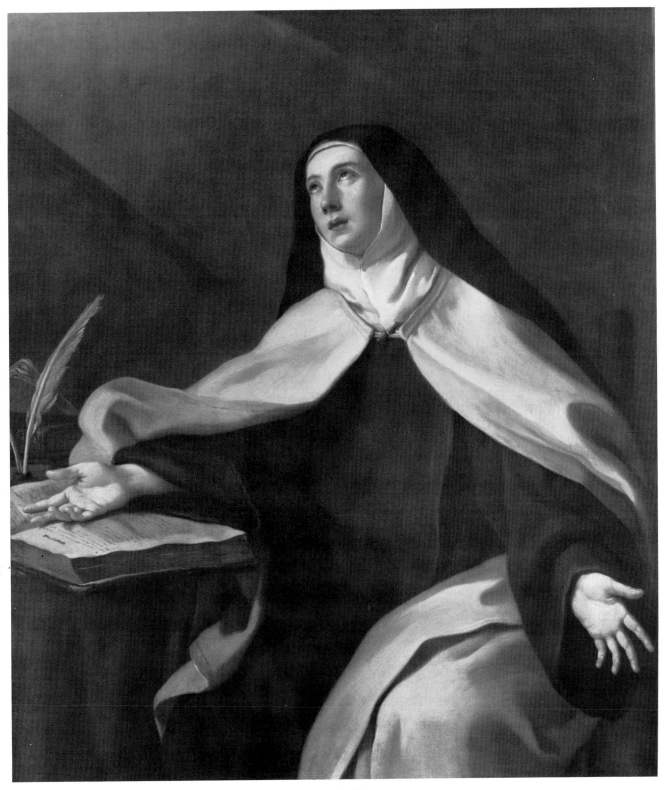

Cat. No. 58

François-André Vincent
Paris 1746–1816 Paris

During the early 1780s Vincent was considered one of David's leading rivals for leadership among the younger French painters. He had studied with his father François-Elie, a miniaturist from Geneva who settled in Paris, and in the studio of Vien. In 1768 he won the *Grand Prix* for *Germanicus Putting Down Rebellion in his Camp* (Paris, Ecole des Beaux-Arts). While in Rome (1771–75) Vincent concentrated on portraits and caricatures, but upon his return he began immediately to make his name as a history painter. At the Salon of 1777 he showed no fewer than fifteen paintings, including a *Belisarius* (Montpellier, Musée Fabre), the subject of David's famous painting of 1781.

The showing of *President Molé Manhandled by Insurgents* (Paris, Chambre des Députés) at the Salon of 1779 made Vincent famous. Paintings of subjects from modern French history were still very unusual, and Vincent was to exert a considerable influence on subsequent French historical painting, particularly during the Romantic period. His other "modern" subjects included series on the *Life of La Galaizière* and the *Life of Henri IV*, as well as the *William Tell Overturning Gessler's Boat*, commissioned by the government in 1791 (Salon of 1795; Toulouse, Musée des Augustins).

Vincent's Classical subjects, like *Zeuxis Choosing the Most Beautiful Women of Crotona as his Models* (Salon of 1789; Louvre) were more conventional, and he gradually lost to David his position as a leading radical. During the Napoleonic period he produced some pictures based on contemporary history, but experienced poor health and painted less actively. Among the works of these years are the huge *Battle of the Pyramids* (Salon of 1806, Versailles; sketch c. 1800–03, Gisors, priv. coll.), which had to be finished by another painter, and the very strange *Allegory of the Freeing of the Prisoners of Algiers by Jerome Bonaparte* (1806; Kassel, Staatliche Kunstsammlungen), commemorating a diplomatic agreement negotiated by Napoleon's brother in 1805.

Dramatic, realistic, and forcefully rendered, Vincent's works are important for the evolution of history painting on patriotic themes during the reign of Louis XVI. His pupils included the outstanding portraitist Adélaïde Labille-Guiard (whom he married in 1800), Charles Thévenin, and Charles Meynier.

59. *Saint John the Evangelist*
Oil on canvas, 28¾ x 24⅜ in. (73 x 61.9 cm.)
Signed and dated (lower right, on parchment): *Vincent / 9 17[7?] 3*
Detroit Institute of Arts

PROVENANCE: Purchase, Founders Society Acquisition Fund, 1980.

BIBLIOGRAPHY: *Detroit Institute of Arts Bulletin*, LVIII, 1979–80, p. 227, ill. fig. 31.

Depictions of the Evangelists in the act of writing their Gospels are among the most ancient themes in Christian art. The iconography of this picture is quite traditional: Saint John, shown as a youth and accompanied by his symbol, the eagle, gazes upward for divine inspiration as he writes. The intensity of the expression and sharp focus of the lighting recall Baroque figures of saints; the "modern" aspect of the painting derives from the naturalism of treatment of both the figure and the heraldic eagle.

Vincent was active as a portraitist throughout his career, and this religious subject, closely studied from the model, should be seen in the context of this aspect of his work. Half-length figures set against a plain background, with one shoulder placed slightly forward, may be seen in examples from the *Portrait of a Young Boy* (1778)[1] to the *Portrait of the Actor Dazincourt* (1792; Marseilles, Musée des Beaux-Arts).[2]

The dating of the Detroit picture poses some difficulties. The date has been read as 9 1793, and the relatively hard local colors of Saint John's garment and the background might accord with this late date. On the other hand, a reading of 1773 seems equally plausible and would agree with the writing of the date on the *Portrait of a Young Boy*. September 1793 was a singularly unpropitious time for the creation of a religious picture: most important works of this kind owned by churches and convents were being seized by the Revolutionary government. Vincent's career seems to have gone into eclipse at this time as well. Many of the artist's Christian subjects were, in fact, shown in his early Salons of 1777 (*Saint Jerome, The Pilgrims of Emmaus*) and 1779 (*The Healing of the Blind Man*, sketch for *The Paralytic at the Pool of Bethesda*). In 1773 Vincent was a young student in Rome, and the *Saint John* resembles the half-length nude studies that were expected of aspiring members of the Academy. The forcefulness of the modeling and vigor of the brushwork are personal traits that marked Vincent as a rising star among history painters of the period.[3]

[1] Coll. Mme. H. S., sale, Amsterdam, Frederik Muller & Cie., June 19–20, 1913, no. 150, ill.

[2] Detroit Institute of Arts, *French Painting 1774–1830: The Age of Revolution*, 1975, no. 200, ill. p. 127.

[3] Patrice Marandel (in conversation, July 14, 1986) concurs that the date should be read as 1773.

170

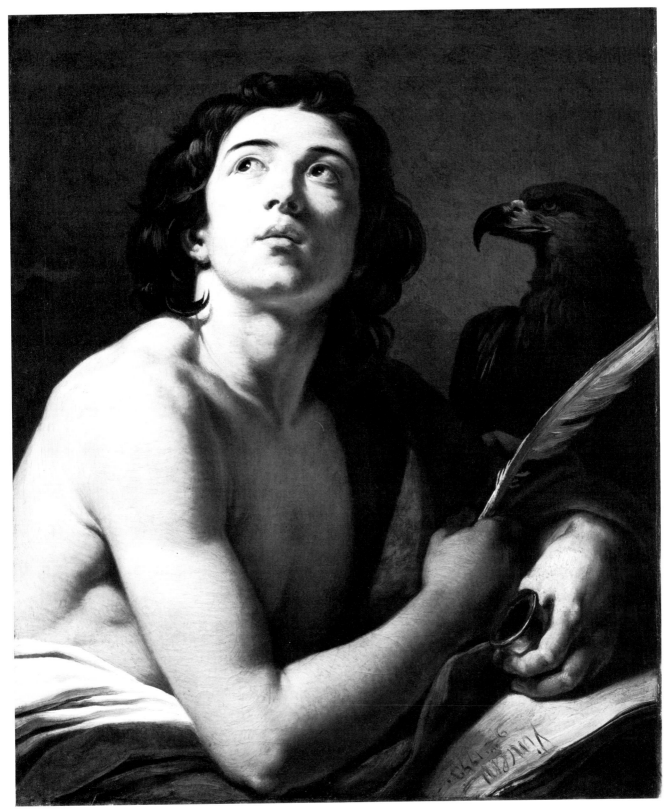

Cat. No. 59

François-André Vincent
Paris 1746–1816 Paris

60. *Democritus among the Abderitans*, Salon of 1791
Oil on canvas, 17⅞ x 21¹¹⁄₁₆ in. (45.2 x 55 cm.)
Albuquerque, University Art Museum, University of
New Mexico

PROVENANCE: Private collection, on extended loan to the
Museum.

EXHIBITIONS: Paris, Salon of 1791, no. 348; Houston, Mu-
seum of Fine Arts, *French Oil Sketches from an English Collection*,
1973 (cat. by J. Patrice Marandel), no. 89, ill.

BIBLIOGRAPHY: A. N. Dézallier d'Argenville, *Explication et
critique impartiale . . . de toutes les peintures . . . exposées au Louvre*,
Paris, 1791.

In addition to his numerous paintings based on Roman,
Christian, and French history Vincent showed a number of
ancient Greek subject pictures, such as the *Zeuxis* of 1789 and a
Socrates and Alcibiades (Montpellier, Musée Fabre). The subject
of the small but finished Albuquerque canvas is the celebrated
Greek philosopher Democritus of Abdera (c. 460–370 B.C.). De-
mocritus, who espoused a materialist theory according to which
all matter is composed of tiny atoms in continual movement, is
shown here contemplating a skull, a traditional pose for wise
men or saints reflecting on their mortality.

Despite the presence of distinguished men like Democritus,
the Abderitans were proverbial in antiquity for their stupidity. In
this painting one of the fellow citizens observing Democritus
raises his hands, a conventional gesture for astonishment. In the
background another Abderitan points to his forehead, indi-
cating that the brooding philosopher must be mad. The choice
of subject is consistent with Vincent's preference for person-
alities from antiquity who were outstanding for political, artistic
or intellectual achievement, often depicted by the artist in rela-
tively static poses.

The Albuquerque picture is in all probability that shown at
the Salon of 1791. Vincent exhibited a half-dozen pictures that
year, including two huge Hellenistic subjects, the *Zeuxis*, first
shown in 1789, and a *Young Pyrrhus at the Court of Glaucias*[1] that
was poorly received.[2] The disparity in size between these works
and the *Democritus* suggests that the latter could be a finished oil
sketch, though no larger version of the composition is known.
Though Dézallier d'Argenville referred to the painting's "thick
and heavy" brushwork,[3] the handling seems relatively smooth
and polished when compared to the free technique of many
earlier eighteenth-century oil sketches.

[1]No. 750. Engraved by Sands, 1808, ill. in Anon., *Historic Gallery of
Portraits and Paintings*, III, London, 1815, n.p. The text indicates this
composition was woven as a tapestry at the order of Louis XVI.
[2]Henry Lemonnier, *L'art moderne (1500–1800): Essais et esquisses*,
Paris, 1912, p. 243.
[3]Dézallier d'Argenville, *Explication*, cited in Marandel, *French Oil
Sketches*, p. 92.

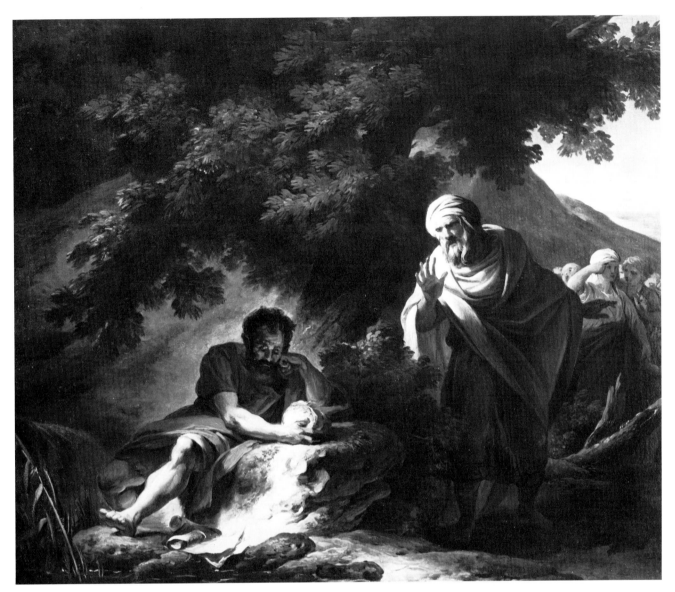

Cat. No. 60

Selected Bibliography

BOOKS AND EXHIBITION CATALOGUES

Ananoff, Alexander, *François Boucher*, Lausanne and Paris, 1976.

Atlanta, High Museum of Art, *The Rococo Age: French Masterpieces of the Eighteenth Century*, exh. cat. by Eric M. Zafran and Jean-Luc Bordeaux, 1983.

Banks, Oliver, *Watteau and the North*, New York and London, 1977.

Behrmann, Elmer H., *The Story of the Old Cathedral*, rev. ed., St. Louis, 1984.

Bellier de la Chavignerie, E., and L. Auvray, *Dictionnaire général des artistes de l'école française*, 5 vols., Paris, 1882–87.

Bordeaux, Musées de Bordeaux, *La peinture française: collections américaines*, 1966.

Brice, Germain, *Description nouvelle de la ville de Paris*, Paris, 1706.

Brooker, Anita, *Greuze: The Rise and Fall of an Eighteenth-Century Phenomenon*, London, 1972.

Bryson, Norman, *Word and Image: French Painting of the Ancien Régime*, Cambridge, 1981.

Carlson, Victor, Ellen D'Oench, and Richard S. Field, *Prints and Drawings by Gabriel de Saint-Aubin 1724–1780*, Middletown, Conn., Davison Art Center, Wesleyan University, 1975.

Chapel Hill, N.C., William Hayes Ackland Memorial Art Center, *Catalogue of the Collection*, I, *Paintings and Selected Sculpture*, 1971.

Cleveland Museum of Art, *European Painting of the 16th, 17th, and 18th Centuries*, 1982.

Colomer, Claude, *La famille et le milieu social du peintre Rigaud*, Perpignan, 1973.

Conisbee, Philip, *Painting in Eighteenth-Century France*, Ithaca, N.Y., 1981.

Crow, Thomas, *Painters and Public Life in Eighteenth-Century Paris*, New Haven and London, 1985.

Detroit Institute of Arts and New York, Metropolitan Museum of Art, *French Painting 1774–1830: The Age of Revolution*, 1975.

Dézallier d'Argenville, Antoine Joseph, *Abrégé de la vie des plus fameux peintres*, 4 vols., Paris, 1762.

Dézallier d'Argenville, Antoine Nicolas, *Voyage pictoresque de Paris*, Paris, 1749.

Diderot, Denis, *Salons*, ed. J. Adhémar and J. Seznec, 4 vols., Oxford, 1957–67.

Dussieux, L., *Les artistes français à l'étranger*, 3rd ed., Paris and Lyons, 1876.

————, et al., *Mémoires inédits sur la vie et les ouvrages des membres de l'Académie Royale de peinture et de sculpture*, 2 vols., Paris, 1854–56.

Engerand, F., *Inventaire des tableaux commandés et achetés par la Direction des Bâtiments du Roi (1709–1792)*, Paris, 1901.

Franzwa, G. M., *The Old Cathedral, Archdiocese of St. Louis*, Basilica of St. Louis, 1965.

Fried, Michael, *Absorption and Theatricality: Painting and Beholder in the Age of Diderot*, Berkeley and Los Angeles, 1980.

Hartford, Wadsworth Atheneum, *In the Antique Taste: Carle Vanloo's "Offering to Love,"* exh. cat. by Linda J. Horvitz, 1982.

Hercenberg, Bernard, *Nicolas Vleughels*, Paris, 1975.

Houston, Museum of Fine Arts, *French Oil Sketches from an English Collection: 17th, 18th, and 19th Centuries*, exh. cat. by J. Patrice Marandel, 1973 [–75].

Kalnein, Wend, and Michael Levey, *Art and Architecture of the Eighteenth Century in France*, Harmondsworth, 1972.

Lanson, René, *Le goût du Moyen Age en France au XVIIIᵉ siècle*, Paris and Brussels, 1926.

Lefrançois, Thierry, *Nicolas Bertin (1668–1736): Peintre d'histoire*, Neuilly-sur-Seine, 1981.

Lépicié, Bernard, *Vies des premiers peintres du roi*, Paris, 1752.

Locquin, Jean, *La peinture d'histoire en France de 1747 à 1785*, Paris, 1912.

London, Royal Academy of Arts, *France in the Eighteenth Century*, exh. cat. by Denys Sutton, 1968.

Marcel, Pierre, *La peinture française au début du dix-huitième siècle 1690–1721*, Paris, 1906.

Mariette, P.-J., *Abécédario* in *Archives de l'Art Français*, 6 vols., Paris, 1851–60.

Montaiglon, A. de, ed., *Procès-verbaux de l'Académie Royale de peinture et de sculpture, 1648–1792*, 10 vols., Paris, 1875–92.

————, and J. J. Guiffrey, eds., *Correspondance des directeurs de l'Académie de France à Rome avec les surintendants des Bâtiments*, 17 vols., Paris, 1887–1912.

Mortier, Roland, *Diderot and the "Grand Goût": The Prestige of History Painting in the Eighteenth Century*, Oxford, 1982.

Munhall, Edgar, *Jean-Baptiste Greuze, 1725–1805*, Hartford, 1976.

New York, Didier Aaron, Inc., *French Paintings of the Eighteenth Century*, 1983.

————, Maurice Segoura Gallery, *Eighteenth Century French Academic Art*, exh. cat., 1979.

————, Maurice Segoura Gallery, *From David to Watteau: A Century of French Art*, exh. cat., 1982.

————, Stair Sainty Matthiesen, *The First Painters of the King: French Royal Taste from Louis XIV to the Revolution*, 1985.

————, Wildenstein & Co., *Gods and Heroes: Baroque Images of Antiquity*, 1969.

Notre Dame, Ind., University Art Gallery, *Eighteenth Century France*, 1972.

Olander, William, *Pour Transmettre à la Postérité: French Painting and Revolution, 1774–1795*, dissertation, New York University, 1983 (Ann Arbor, University Microfilms International).

Opperman, Hal, *J.-B. Oudry 1686–1755*, exh. cat., Fort Worth, Kimbell Art Museum, 1983.

Paris, Galerie Cailleux, *Autour de Néoclassicisme*, 1973.

————, Grand Palais, *Les artistes du Salon du 1737*, 1930.

————, Hôtel de la Monnaie, *Diderot & l'art de Boucher à David: Les Salons 1759–1781*.

Posner, Donald, *Antoine Watteau*, Ithaca, N.Y., 1984.

Princeton University Art Museum, *Eighteenth-Century French Life-Drawing*, exh. cat., intro. by Pierre Rosenberg, cat. by James H. Rubin and David Levine, 1977.

Pupil, François, *Le style troubadour*, Nancy, 1985.

Roman, J., *Le livre de raison du peintre Hyacinthe Rigaud*, Paris, 1919.

Rosenberg, Pierre, *The Age of Louis XV: French Painting 1710–1774*, exh. cat., Toledo Museum of Art, 1975–76.

————, *France in the Golden Age: Seventeenth-Century French Paintings in American Collections*, exh. cat., Metropolitan Museum of Art, New York, 1982.

————, *French Master Drawings of the 17th and 18th Centuries in North American Collections*, London, 1972.

————, and Antoine Schnapper, *Jean Restout (1692–1768)*, exh. cat., Musée des Beaux-Arts de Rouen, 1970.

————, and Marie-Catherine Sahut, *Carle Vanloo, Premier peintre du roi*, Nice, 1977.

Rosenblum, Robert, *Transformations in Late Eighteenth Century Art*, Princeton, 1967.

Rosenfeld, Myra Nan, *Largillierre and the Eighteenth-Century Portrait*, exh. cat., Montreal Museum of Fine Arts, 1981 [1982].

St. Petersburg, Fla., Museum of Fine Arts, *Fragonard and His Friends: Changing Ideals in Eighteenth Century Art*, 1982, cat. by Marion Lou Grayson.

Sandoz, Marc, *Jean-Baptiste Deshays 1729–1765*, Paris, 1978.

Schnapper, Antoine, *Jean Jouvenet (1644–1717) et la peinture d'histoire à Paris*, Paris, 1974.

Steel, David H., *Baroque Paintings from the Bob Jones University Collection*, Raleigh, 1984.

Sydney, Art Gallery of New South Wales, *French Painting: The Revolutionary Decades, 1760–1830*, 1980.

Toulouse, Musée Paul-Dupuy, *Pierre-Henri de Valenciennes*, 1956 (cat. by R. Mesuret).

Vergnet-Ruiz, Jean and Michel Laclotte, *Petits et grands musées de France: La peinture française des primitifs à nos jours*, Paris, 1962.

Volle, Nathalie, *Jean-Simon Berthélemy (1743–1811)*, Paris, 1979.

Walch, Peter, *French Eighteenth-Century Oil Sketches from an English Private Collection. New Mexico Studies in the Fine Arts*, V, Albuquerque, 1980.

Washington, International Exhibitions Foundation, *The Grand Prix de Rome: Paintings from the Ecole des Beaux-Arts, 1797–1863*, cat. by Philippe Grunchec, 1984.

————, National Gallery of Art, *Gods, Saints and Heroes: Dutch Painting in the Age of Rembrandt*, 1980.

Wildenstein, Daniel, *Documents inédits sur les artistes français du XVIIIe siècle*, Paris, 1966.

————, *Inventaires après décès d'artistes et de collectionneurs français du XVIIIe siècle*, Paris, 1967.

Wildenstein, Georges, *The Paintings of Fragonard*, Garden City, N.Y., 1960.

Willk-Brocard, Nicole, *François-Guillaume Ménageot (1744–1816), peintre d'histoire*, Paris, 1978.

Zafran, Eric M., *European Art in the High Museum*, Atlanta, 1984.

ARTICLES

Bardon, Henry, "Les peintures à sujets antiques au XVIIIe siècle d'après les livrets de Salons," *Gazette des Beaux-Arts*, ser. 6, LXI, 963, pp. 217–250.

Blunt, Anthony, "Nicolas Colombel," *Revue de l'Art*, IX, 1970, pp. 27–36.

Bordes, Philippe, "François-Xavier Fabre, 'Peintre d'Histoire'," *Burlington Magazine*, CXVII, 1975, pp. 91–98, 155–162.

Brejon de Lavergnée, Arnauld, "Le Régent, amateur d'art moderne," *Revue de l'Art*, LXII, 1983, pp. 45–48.

Crow, Thomas, "The Oath of the Horatii in 1785; Painting and Pre-Revolutionary radicalism in France," *Art History*, I, 1978, pp. 424–471.

Garas, Klára, "Le plafond de la Banque Royale de Giovanni Antonio Pellegrini," *Bulletin du Musée Hongrois des Beaux-Arts*, XXI, 1962, pp. 75–93.

Halbout, Monique, and Pierre Rosenberg, "Jean-Baptiste-Marie Pierre's *The Adoration of the Shepherds*," *Bulletin of the Detroit Institute of Arts*, LVI, no. 3, 1978, pp. 169–175.

Haskell, Francis, "Contre Goncourt," *London Review of Books*, 18–31 March 1982, pp. 14–15.

Ivanoff, Nicolas, "La France et Venise au dix-huitième siècle: Relations artistiques," in Paris, Musée de l'Orangerie, *Venise au dix-huitième siècle*, 1971, pp. 17–29.

Lastic, Georges de, "Largillierre à Montréal," *Gazette des Beaux-Arts*, 6th per. CII, 1983, pp. 35–38.

————, "Nicolas de Largillierre: Documents notariés inédits, *Gazette des Beaux-Arts*, 6e series. XCVIII, 1981, pp. 1–27.

Levey, Michael, "France and Italy: artistic contacts in the eighteenth century," *Apollo*, n.s., LXXVII, 1963, pp. 177-181.

Maison, Françoise, and Pierre Rosenberg, "Largillierre peintre d'histoire et paisagiste," *Revue du Louvre*, XXIII, 1973, pp. 89-94.

Munhall, Edgar, "Les dessins de Greuze pour 'Septime Sévère'," *L'Oeil*, 124, April, 1965, pp. 23-29.
_____, "Quelques découvertes sur l'oeuvre de Greuze," *La Revue du Louvre et des Musées de France*, XVI, pt. 1, 1966, pp. 85-92.

Oudry, J.-B., "Reflexions sur la manière d'étudier la couleur en comparant les objets des uns avec des autres," read to Académie Royale, June 7, 1749, pub. in: E. Piot, *Cabinet de l'Amateur et de l'Antiquaire*, III, 1844, pp. 33-52.

Rosenberg, Pierre, "Diderot, critique d'art conformiste?," *Revue de l'Art*, 66, 1984, pp. 5-8.
_____, "Diderot et la peinture," *in* Paris, Hôtel de la Monnaie, *Diderot el l'art de Boucher à David*, 1984, pp. 97-100.
_____, "On Lemoine," *The Minneapolis Institute of Arts Bulletin*, LX, 1971-73, pp. 55-59.
_____, "S. Ricci et la France: à propos de quelques textes anciens," in *Atti del Congresso internazionale di studi su Sebastiano Ricci e il suo tempo*, Udine, 1975, pp. 122-125.

Rosenthal, Donald, "A *Cleopatra* by Bernard Duvivier," *Porticus*, VIII, 1985, pp. 13-25.

Saisselin, Rémy, "Neoclassicism: Images of public virtue and realities of private luxury," *Art History*, IV, 1981, pp. 14-36.

Schnapper, Antoine, "Antoine Coypel: La Galerie d'Enée au Palais-Royal," *Revue de l'Art*, V, 1969, pp. 33-42.
_____, "A propos d'un tableau de N. Bertin," *La Revue du Louvre*, XXII, 1972, pp. 357-360.
_____, "Deux tableaux de Henri de Favanne," *La Revue de Louvre*, XXII, 1972, pp. 361-364.
_____, "Esquisses de Louis de Boullogne sur la vie de Saint Augustin," *Revue de l'Art*, IX, 1970, pp. 58-64.

Sells, Christopher, "Jean-Baptiste Regnault in Louisville," *J. B. Speed Art Museum Bulletin*, XXVIII, no. 2, April 1973, pp. 1-15.
_____, "Jean-Baptiste Regnault's *Judgment of Paris*," *Bulletin of the Detroit Institute of Arts*, LIII, 1975, pp. 119-126.

Seznec, Jean, "Diderot and historical painting," in Earl R. Wasserman, ed., *Aspects of the Eighteenth Century*, Baltimore, 1965, pp. 129-142.

Smith, Anthony D., "The 'historical revival' in late 18th-century England and France," *Art History*, II, 1979, pp. 156-178.

Wind, Edgar, "The revolution of history painting," *Journal of the Warburg Institute*, II, 1938-39, pp. 116-127.

Zmijewska, H., "La critique des Salons en France avant Diderot," *Gazette des Beaux-Arts*, 6ᵉ series, LXXVI, 1970, pp. 6-144.